T0133138

Maya Python for Games and Film

Maya Python for Games and Film

A Complete Reference for Maya Python and the Maya Python API

Adam Mechtley

Ryan Trowbridge

AMSTERDAM • BOSTON • HEIDELBERG • LONDON
NEW YORK • OXFORD • PARIS • SAN DIEGO
SAN FRANCISCO • SINGAPORE • SYDNEY • TOKYO

Morgan Kaufmann Publishers is an imprint of Elsevier

Acquiring Editor: Laura Lewin
Development Editor: Sara Scott
Project Manager: Sarah Binns
Designer: Alisa Andreola

Morgan Kaufmann Publishers is an imprint of Elsevier.
225 Wyman Street, Waltham MA 02451

This book is printed on acid-free paper.

Library of Congress Cataloging-in-Publication Data
Application submitted

British Library Cataloguing-in-Publication Data
A catalogue record for this book is available from the British Library.

ISBN: 978-0-12-378578-7

For information on all Morgan Kaufmann publications,
visit our Web site at *www.mkp.com* or *www.elsevierdirect.com*

Typeset by: diacriTech, India

11 12 13 14 15 5 4 3 2 1

Printed in the United States of America

Contents

PART 3 MAYA PYTHON API FUNDAMENTALS

Acknowledgments

We would like to thank the many people who made this book possible. Foremost, we want to thank our wives, Laurel Klein and Brenda Trowbridge, without whose unflagging support we would have been hopeless in this endeavor. We would also like to thank the various contributors to this project for their individual efforts, including Seth Gibson of Riot Games for Chapters 3 and 5, Kristine Middlemiss of Autodesk for Chapter 8, and Dean Edmonds of Autodesk for his technical editing, a man whose power to explain is surpassed only by his knowledge of the topics covered herein.

We would also like to thank the team at Focal Press who has helped out on this project, including Sara Scott, Laura Lewin, and Anaïs Wheeler. Your support and patience has been a blessing. Thanks also to Steve Swink for putting us in touch with the wonderful people at Focal Press.

We want to thank all of the people in the Maya Python and API community who have been essential not only for our own growth, but also for the wonderful state of knowledge available to us all. Though we will undoubtedly leave out many important people, we want to especially thank Chad Dombrova, Chad Vernon, Paul Molodowitch, Ofer Koren, and everyone who helps maintain the tech-artists.org and PyMEL communities.

Last, but certainly not least, we want to thank our readers for supporting this project. Please get in touch with us if you have any feedback on the book!

Introduction: Welcome to Maya Python

Imagine you are creating animations for a character in Maya. As you are creating animations for this character, you find that you are repeating the following steps:

- Reference a character.
- Import a motion capture animation.
- Set the frame range.
- Reference the background scene.
- Configure the camera.

If you are working on a large production, with 10 to 50 animators, these simple steps can pose a few problems. If we break down this process, there are many good places for tools:

- First, animators need to look up the correct path to the character. This path may change at any given time, so having animators handpick this file could result in picking the wrong file. A simple tool with a list of characters can make this task quick and reliable.
- Next, you would want a tool to organize and manage importing the motion capture data correctly onto the character's controls. This tool could also set the frame range for the animation and move the camera to the correct location in the process.
- The last step, referencing the correct background scene, could easily take a minute each time an animator manually searches for the correct file. You could create another simple tool that shows a list of all the backgrounds from which to pick.

Hopefully you can see that such tools would save time, make file selection more accurate, and let the animators focus on their creative task. The best way to create such tools is by using one of Maya's built-in scripting languages—particularly Python.

Python is a scripting language that was originally developed outside of Maya, and so it offers a powerful set of features and a huge user base. In Maya 8.5, Autodesk added official support for Python scripting. The inclusion of this language built upon Maya's existing interfaces for programming (the MEL scripting language and the C++ API). Since Maya Embedded Language (MEL) has been around for years, you might wonder why Python even matters. A broader perspective quickly reveals many important advantages:

- *Community:* MEL has a very small user base compared to Python because only Maya developers use MEL. Python is used by all kinds of software developers and with many types of applications.
- *Power:* Python is a much more advanced scripting language and it allows you to do things that are not possible in MEL. Python is fully object-oriented, and it has the ability to communicate effortlessly with both the Maya Command Engine and the C++ API, allowing

you to write both scripts and plug-ins with a single language. Even if you write plug-ins in C++, Python lets you interactively test API code in the Maya Script Editor!

- *Cross-platform:* Python can execute on any operating system, which removes the need to recompile tools for different operating systems, processor architectures, or software versions. In fact, you do not need to compile at all!

- *Industry Standard:* Because of Python's advantages, it is rapidly being integrated into many other content-creation applications important for entertainment professionals. Libraries can be easily shared between Maya and other applications in your pipeline, such as MotionBuilder.

PYTHON VERSUS MEL

There are many reasons to use Python as opposed to MEL, but that doesn't mean you have to give up on MEL completely! If your studio already has several MEL tools there is no reason to convert them if they are already doing the job. You can seamlessly integrate Python scripts into your development pipeline with your current tools. Python can call MEL scripts and MEL can call Python scripts. Python is a deep language like C++ but its syntax is simple and very easy to pick up.

Nonetheless, Python handles complex data more gracefully than MEL. MEL programmers sometimes try to imitate complex data structures, but doing so often requires messy code and can be frustrating to extend. Since Python is object-oriented and it allows nested variables, it can handle these situations more easily. Moreover, Python can access files and system data much faster than MEL, making your tools more responsive for artists in production. Programmers also have many more options in Python than in MEL. Since Python has been around much longer, you might find another user already created a module to help Python perform the task you need to do.

If you don't understand some of the language used yet, don't worry. This book is here to help you understand all of these concepts and emerge production-ready!

COMPANION WEB SITE

This book is intended to be read alongside our companion web site, which you can access at *http://maya-python.com*.

The companion web site contains downloads for the example projects to which we refer throughout the book, as well as a host of useful links and supplemental materials.

NOTES ON CODE EXAMPLES AND SYNTAX

You will encounter many code examples throughout this book. Unfortunately, because this book will not only be printed, but is also available in a variety of e-book formats, we have no guarantees where line breaks will occur. While this problem is a nonissue for many programming languages, including MEL, Python is very particular about line breaks and whitespace. As such, it's worth briefly noting how Python handles these issues, and how we have chosen to address them throughout the text. Thereafter, we can move on to our first example!

Whitespace

Many programming languages are indifferent to leading whitespace, and instead use mechanisms like curly braces ({ and }) to indicate code blocks, as in the following hypothetical MEL example, which would print numbers 1 through 5.

```
for (int $i=0; $i<5; $i++)
{
    int $j = $i+1;
    print($j+"\n");
}
```

In this example, the indentation inside the block is optional. The example could be rewritten like the following lines, and would produce the same result.

```
for (int $i=0; $i<5; $i++)
{
int $j = $i+1;
print($j+"\n");
}
```

Python, on the other hand, uses leading whitespace to structure blocks. An example such as this one would look like the following lines in Python.

```
for i in range(5):
    j = i+1
    print(j)
```

While Python does not care exactly how you indent inside your blocks, they must be indented to be syntactically valid! The standard in the Python community is to either use one tab or four spaces per indentation level.

Because of how this book is formatted, you may not be able to simply copy and paste examples from an e-book format. We try to mitigate this problem by providing as many code examples as possible as downloads on the companion web site, which you can safely copy and paste, and leave only short examples for you to transcribe.

Line Breaks

Python also has some special rules governing line breaks, which is particularly important for us since we have no way to know exactly how text in this book will wrap on different e-book hardware.

Most programming languages allow you to insert line breaks however you like, as they require semicolons to indicate where line breaks occur in code. For example, the following hypothetical MEL example would construct the sentence "I am the very model of a modern major general." and then print it.

```
string $foo = "I am the very" +
"model of a modern" +
"major general");
print($foo);
```

If you tried to take the same approach in Python, you would get a syntax error. The following approach would not work.

```
foo = 'I am the very' +
'model of a modern' +
'major general'
print(foo)
```

In most cases in Python, you must add a special escape character (\) at the end of a line to make it continue onto the following line. You would have to rewrite the previous example in the following way.

```
foo = 'I am the very' + \
'model of a modern' + \
'major general'
print(foo)
```

There are some special scenarios where you can span onto further lines without an escape sequence, such as when inside of parentheses or brackets. You can read more about how Python handles line breaks online in Chapter 2 of Python Language Reference. We'll show you where you can find this document in Chapter 1.

Our Approach

Because of Python's lexical requirements, it is difficult to craft code examples that are guaranteed to be properly displayed for all of our readers. As such, our general approach is to indicate actual line endings in print with the optional semicolon character (;) as permitted by Python. We trust you to recognize them as line endings where there should be a return carriage and to adjust your indentation if necessary.

For instance, though we can be reasonably certain that the previous examples are short enough to have appeared properly for all our readers, we

would have rewritten them in the following way throughout the remainder of this book.

```
for i in range(5):
        j = i+1;
        print(j);
foo = 'I am the very model of a modern major general';
print(foo);
```

Since Python allows but does not require the semicolon, we avoid using it in our actual code examples on the companion web site, though we do show them in the text for readers who do not have the code examples on their computers in front of them.

Quotation Marks

It is also worth mentioning that some of our code examples throughout the book make use of double quotation marks ("), some make use of single quotation marks ('), and some make use of triple sequences of either type (""" or '''). While it should be clear which marks we are using when reading a print copy, double quotation marks may not copy and paste correctly. In short, make sure you double check any code you try to copy and paste from the book.

Comments

Finally, it is worth noting here that, like other programming languages, Python allows you to insert comments in your code. Comments are statements that only exist for the developer's reference, and they are not evaluated as part of a program. One way to create a comment is to simply write it in as a string literal. Though we will talk more about strings later, the basic idea is that you can wrap a standalone statement in quotation marks on its own line and it becomes a comment. In the following code snippet, the first line is a comment describing what the second line does.

```
'''Use the print() function to print the sum of 5 and 10'''
print(5+10);
```

Another way to insert comments is to prefix comment statements with a **#** symbol. You can use this technique to comment an entire line or to add a comment to the end of a line. The following two lines accomplish the same task as the previous code snippet.

```
# Use the print() function to print the sum of 5 and 10
print(5+10); # This statement should output 15
```

Many of our examples, especially transcriptions of code from example files on the companion web site, are devoid of comments. We opted to limit

comments to save printing space, but hope that you will not be so flippant as a developer! Most of our examples on the companion web site contain fairly thorough comments, and we tend to break up large sections of code in the text to discuss them one part at a time.

PYTHON HANDS ON

In our introduction to Python, we have told you how useful it will be to you in Maya. We'll now run through a brief example project to get a taste of things to come. Don't worry if you do not understand anything in the example scripts yet, as this project is for demonstration purposes only.

In this example, you are going to execute two versions of the same script, one written in MEL using only Maya commands, and the other written using the Maya Python API. These scripts highlight one example of the dramatically different results you can achieve when using Python in place of MEL.

The scripts each create a basic polygon sphere with 200 by 200 subdivisions (or 39,802 vertices) and apply noise deformation to the mesh. In essence, they iterate through all of the sphere's vertices and offset each one by a random value. This value is scaled by an amount that we provide to the script to adjust the amount of noise.

Please also note that the Python script in the following example makes use of functions that were added to the API in Maya 2009. As such, if you're using an earlier version of Maya, you can certainly examine the source code, but the Python script will not work for you.

1. Open the Maya application on your computer.
2. In Maya's main menu, open the Script Editor by navigating to **Window → General Editors → Script Editor**.
3. You should now see the Script Editor window appear, which is divided into two halves (Figure 0.1). Above the lower half you should see two tabs. Click on the Python tab to make Python the currently active language.
4. Download the polyNoise.py script from the companion web site and make note of its location.
5. Open the script you just downloaded by navigating to the menu option **File → Load Script** in the Script Editor window (rather than the main application window). After you browse to the script and load it, you will see the contents of the script appear in the lower half of the Script Editor window, where they may be highlighted.
6. Click anywhere in the bottom half of the Script Editor to place your cursor in it, and execute the script by pressing **Ctrl + Enter**.

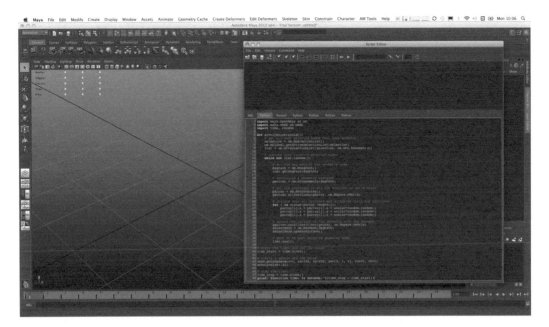

■ **FIGURE 0.1** The polyNoise.py script in the Maya Script Editor.

Once the script has executed, you will see a distorted sphere in your viewport, as in Figure 0.2. However, you will also see something interesting in the top half of the Script Editor window. In addition to the script that you just executed, you should see a line that says something like the following:

```
Execution time: 0.53 seconds.
```

This final line shows how long it took your computer to create the sphere, subdivide it, and apply noise to the mesh. In this particular case, it took our computer 0.53 seconds, though your result may be slightly different based on the speed of your computer.

Now, you will execute the MEL version of this script to see how long it takes to perform the same operation.

1. In Maya's Script Editor, click the MEL tab that appears above the bottom half of the window.
2. Download the polyNoise.mel script from the companion web site and make note of its location.
3. Open the script you just downloaded by navigating to the menu option **File → Load Script** in the Script Editor window. After loading the

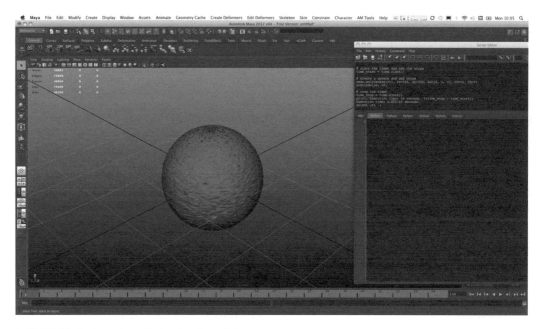

■ **FIGURE 0.2** A polygon sphere with the noise script applied.

script, you should see its contents appear in the lower half of the Script Editor window, and they may be highlighted.

4. Click anywhere in the bottom half of the Script Editor to place your cursor in it, and execute the script by pressing **Ctrl + Enter**.

You should very quickly notice a problem—or should we say very slowly. Maya will stop responding after executing the MEL script. Mac users will see the infamous "beach ball" loading cursor. Don't worry though! Maya has not crashed. It will create the sphere … eventually. You might want to go get a cup of coffee or two before you come back to check on Maya. After what seems like an eternity, Maya will finally create the sphere with the noise and print something like the following line in the top half of the Script Editor window.

```
Execution time: 203.87 seconds.
```

Because the Python script and the MEL script both perform the exact same task, you could theoretically use either one to get the job done. Obviously, however, you would want to use the Python version. If we created a MEL script that did this task it would be useless in production. No artist would want to use a script that takes a few minutes to execute. It would make the tool very difficult for artists to experiment with and most likely it would be abandoned.

There is only one catch: The Python script was created using the Maya Python API. If you compare the two scripts side-by-side, you will see that the Python script is slightly more complex than the MEL script as a result. Using the API is more complicated than just using Maya commands, yet MEL cannot use the API directly. This disadvantage on MEL's part is the primary reason the performance difference is so dramatic in this case.

Another issue to point out about the Python example script is that it is not complete. Because it uses API calls to modify objects, you cannot use undo like you could with MEL if you didn't like the result. Although Python can certainly use Maya commands just like MEL (and automatically benefit from the same undo support), we used the API in this case because it was necessary to gain the substantial speed increase. If we used Python to call Maya commands, however, the Python script would have been just as slow as the MEL script.

Although we chose not to in this example for the sake of simplicity, we would need to turn this script into a Python API plug-in to maintain undo functionality and still use the API to modify objects. There may in fact be many times you want to do this very same thing to mock up a working version before adding the final bits of script to create a plug-in. Don't worry— it isn't hard, but it is another step you will need to take. Fortunately for you, one of the main topics in this book is to explain how to work with the API using Python, so you will have no trouble creating lightning-fast tools yourself. Once you understand more about how Python works in Maya, you could write other scripts that work with meshes. As you can see, MEL tends to run very slowly on objects with large vertex counts, so this opens the door for new tools in your production.

Another convenient advantage to using the Python API is it uses the same classes as the C++ API. If you really needed additional speed, you could easily convert the Python script into a C++ plug-in. If you don't understand C++, you could pass on the script as a template for a programmer at your studio, as the API classes are identical in both languages. C++ programmers can also find the Python API useful because they can access the Python API in Maya interactively to test out bits of code. If you are using C++, on the other hand, you absolutely must compile a plug-in to test even one line of code. You can even mix the Maya API with Python scripts that use Maya commands.

With all of these features in mind, we hope you are excited to get started learning how to use Python in Maya. By the end of this book, you should be able to create scripts that are more complicated than even the example from this chapter. So without further delay, let's get to it!

Basics of Python and Maya

Maya Command Engine and User Interface

BY THE END OF THIS CHAPTER, YOU WILL BE ABLE TO:

- Compare and contrast the four Maya programming interfaces.
- Use the Command Line and Script Editor to execute Python commands.
- Create a button in the Maya GUI to execute custom scripts.
- Describe how Python interacts with Maya commands.
- Define nodes and connections.
- Describe Maya's command architecture.
- Learn how to convert MEL commands into Python.
- Locate help for Python commands.
- Compare and contrast command arguments and flag arguments.
- Define the set of core Python data types that work with Maya commands.
- Compare and contrast the three modes for using commands.
- Identify the version of Python that Maya is using.
- Locate important Python resources online.

To fully understand what can be done with Python in Maya, we must first discuss how Maya has been designed. There are several ways that users can interact with or modify Maya. The standard method is to create content using Maya's graphical user interface (GUI). This interaction works like any other software application: Users press buttons or select menu items that create or modify their documents or workspaces. Despite how similar Maya is to other software, however, its underlying design paradigm is unique in many ways. Maya is an open product, built from the ground up to be capable of supporting new features designed by users. Any Maya user can modify or add new features, which can include a drastic redesign of the main interface or one line of code that prints the name of the selected object.

In this chapter, we will explore these topics as you begin programming in Python. First, we briefly describe Maya's different programming options and how they fit into Maya's user interface. Next, we jump into Python by exploring different means of executing Python code in Maya. Finally, we explore some basic Maya commands, the primary means of modifying the Maya scene.

INTERACTING WITH MAYA

Although the focus of this book is on using Python to interact with Maya, we should briefly examine all of Maya's programming interfaces to better understand why Python is so unique. Autodesk has created four different

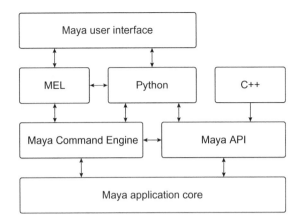

■ **FIGURE 1.1** The architecture of Maya's programming interfaces.

programming interfaces to interact with Maya, using three different programming languages. Anything done in Maya will use some combination of these interfaces to create the result seen in the workspace. Figure 1.1 illustrates how these interfaces interact with Maya.

Maya Embedded Language

Maya Embedded Language (MEL) was developed for use with Maya and is used extensively throughout the program. MEL scripts fundamentally define and create the Maya GUI. Maya's GUI executes MEL instructions and Maya commands. Users can also write their own MEL scripts to perform most common tasks. MEL is relatively easy to create, edit, and execute, but it is also only used in Maya and has a variety of technical limitations. Namely, MEL has no support for object-oriented programming. MEL can only communicate with Maya through a defined set of interfaces in the Command Engine (or by calling Python). We will talk more about the Command Engine later in this chapter.

Python

Python is a scripting language that was formally introduced to Maya in version 8.5. Python can execute the same Maya commands as MEL using Maya's Command Engine. However, Python is also more robust than MEL because it is an object-oriented language. Moreover, Python has existed since 1980 and has an extensive library of built-in features as well as a large community outside of Maya users.

C++ Application Programming Interface

The Maya C++ application programming interface (API) is the most flexible way to add features to Maya. Users can add new Maya objects and features that can execute substantially faster than MEL alternatives. However, tools developed using the C++ API must be compiled for new versions of Maya and also for each different target platform. Because of its compilation requirements, the C++ API cannot be used interactively with the Maya user interface, so it can be tedious to test even small bits of code. C++ also has a much steeper learning curve than MEL or Python.

Python API

When Autodesk introduced Python into Maya, they also created wrappers for many of the classes in the Maya C++ API. As such, developers can use much of the API functionality from Python. The total scope of classes accessible to the Python API has grown and improved with each new version of Maya. This powerful feature allows users to manipulate Maya API objects in ordinary scripts, as well as to create plug-ins that add new features to Maya.

In this book, we focus on the different uses of Python in Maya, including commands, user interfaces, and the Python API. Before we begin our investigation, we will first look at the key tools that Maya Python programmers have at their disposal.

EXECUTING PYTHON IN MAYA

Maya has many tools built into its GUI that allow users to execute Python code. Before you begin programming Python code in Maya, you should familiarize yourself with these tools so that you know not only what tool is best for your current task, but also where to look for feedback from your scripts.

Command Line

The first tool of interest is the Command Line. It is located along the bottom of the Maya GUI. You can see the Command Line highlighted in Figure 1.2.

The Command Line should appear in the Maya GUI by default. If you cannot see the Command Line, you can enable it from the Maya main menu by selecting **Display → UI Elements → Command Line**.

The far left side of the Command Line has a toggle button, which says "MEL" by default. If you press this button it will display "Python."

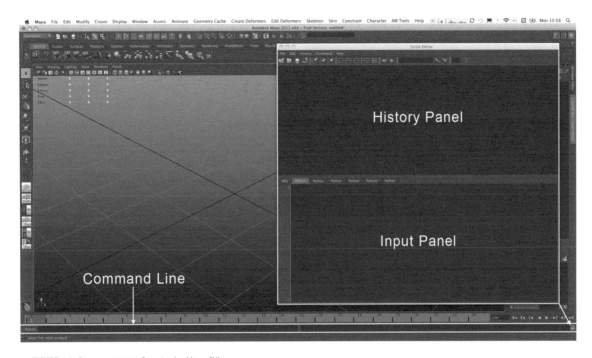

■ FIGURE 1.2 Programming interfaces in the Maya GUI.

The language displayed on this toggle button tells Maya which scripting language to use when executing commands entered in the text field immediately to the right of the button. The right half of the Command Line, a gray bar, displays the results of the commands that were entered in the text field. Let's create a polygon sphere using the Command Line.

1. Switch the Command Line button to "Python." The button is located on the left side of the Command Line.
2. Click on the text field in the Command Line and enter the following line of text.

   ```
   import maya.cmds;
   ```

3. Press **Enter**.
4. Next enter the following line of code in the text field.

   ```
   maya.cmds.polySphere();
   ```

5. Press **Enter**. The above command will create a polygon sphere object in the viewport and will print the following results on the right side of the Command Line.

   ```
   # Result: [u'pSphere1', u'polySphere1']
   ```

You can use the Command Line any time you need to quickly execute a command. The Command Line will only let you enter one line of code at a time though, which will not do you much good if you want to write a complicated script. To perform more complex operations, you need the Script Editor.

Script Editor

One of the most important tools for the Maya Python programmer is the Script Editor. The Script Editor is an interface for creating short scripts to interact with Maya. The Script Editor (shown on the right side in Figure 1.2) consists of two panels. The top panel is called the History Panel and the bottom panel is called the Input Panel. Let's open the Script Editor and execute a command to make a sphere.

1. Open a new scene by pressing **Ctrl + N**.
2. Open the Script Editor using either the button located near the bottom right corner of Maya's GUI, on the right side of the Command Line (highlighted in Figure 1.2), or by navigating to **Window → General Editors → Script Editor** in Maya's main menu. By default the Script Editor displays two tabs above the Input Panel. One tab says "MEL" and the other tab says "Python."
3. Select the Python tab in the Script Editor.
4. Click somewhere inside the Input Panel and type the following lines of code.

```
import maya.cmds;
maya.cmds.polySphere();
```

5. When you are finished press the **Enter** key on your numeric keypad. If you do not have a numeric keypad, press **Ctrl + Return**.

The **Enter** key on the numeric keypad and the **Ctrl + Return** shortcut are used only for executing code when working in the Script Editor. The regular **Return** key simply moves the input cursor to the next line in the Input Panel. This convention allows you to enter scripts that contain more than one line without executing them prematurely.

Just as in the Command Line example, the code you just executed created a generic polygon sphere. You can see the code you executed in the History Panel, but you do not see the same result line that you saw when using the Command Line. In the Script Editor, you will only see a result line printed when you execute a single line of code at a time.

6. Enter the same lines from step 4 into the Input Panel, but do not execute them.

7. Highlight the second line with your cursor by triple-clicking it and then press **Ctrl + Return**. The results from the last command entered should now be shown in the History Panel.

```
# Result: [u'pSphere2', u'polySphere2']
```

Apart from printing results, there are two important things worth noting about the previous step. First, highlighting a portion of code and then pressing **Ctrl + Return** will execute only the highlighted code. Second, highlighting code in this way before executing it prevents the contents of the Input Panel from emptying out.

Another useful feature of the Script Editor is that it has support for marking menus. Marking menus are powerful, context-sensitive, gesture-based menus that appear throughout the Maya application. If you are unfamiliar with marking menus in general, we recommend consulting any basic Maya user's guide.

To access the Script Editor's marking menu, click and hold the right mouse button (**RMB**) anywhere in the Script Editor window. If you have nothing selected inside the Script Editor, the marking menu will allow you to quickly create new tabs (for either MEL or Python) as well as navigate between the tabs. As you can see, clicking the **RMB**, quickly flicking to the left or right, and releasing the **RMB** allows you to rapidly switch between your active tabs, no matter where your cursor is in the Script Editor window. However, the marking menu can also supply you with context-sensitive operations, as in the following brief example.

1. Type the following code into the Input Panel of the Script Editor, but do not execute it.

```
maya.cmds.polySphere()
```

2. Use the left mouse button (**LMB**) to highlight the word polySphere in the Input Panel.
3. Click and hold the **RMB** to open the Script Editor's marking menu. You should see a new set of options in the bottom part of the marking menu.
4. Move your mouse over the **Command Documentation** option in the bottom of the marking menu and release the **RMB**. Maya should now open a web browser displaying the help documentation for the polySphere command.

As you can see, the Script Editor is a very useful tool not only for creating and executing Python scripts in Maya, but also for quickly pulling up information about commands in your script. We will look at the command documentation later in this chapter.

At this point, it is worth mentioning that it can be very tedious to continually type common operations into the Script Editor. While the Script Editor does allow you to save and load scripts, you may want to make your script part of the Maya GUI. As we indicated earlier, clicking GUI controls in Maya simply calls commands or executes scripts that call commands. Another tool in the Maya GUI, the Shelf, allows you to quickly make a button out of any script.

Maya Shelf

Now that you understand how to use the Command Line and the Script Editor, it is worth examining one final tool in the Maya GUI that will be valuable to you. Let's say you write a few lines of code in the Script Editor and you want to use that series of commands later. Maya has a location for storing custom buttons at the top of the main interface, called the Shelf, which you can see in Figure 1.3. If you do not see the Shelf in your GUI layout, you can enable it from Maya's main menu using the **Display →
UI Elements → Shelf** option.

You can highlight lines of code in the Script Editor or Command Line and drag them onto the Shelf for later use with the middle mouse button

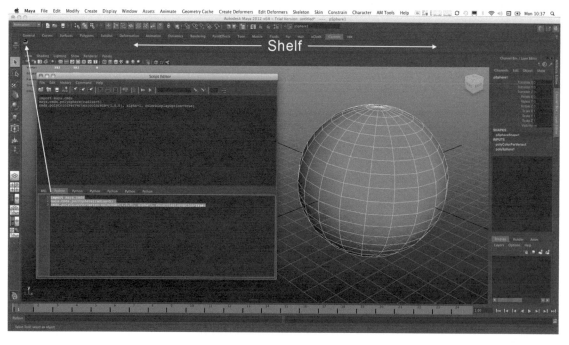

■ **FIGURE 1.3** The Shelf.

(**MMB**). In the following example, you will create a short script and save it to the Shelf.

1. Type in the following code into the Script Editor, but do not execute it (when executed, this script will create a polygon sphere and then change the sphere's vertex colors to red).

```
import maya.cmds;
maya.cmds.polySphere(radius=5);
maya.cmds.polyColorPerVertex(
    colorRGB=[1,0,0],
    colorDisplayOption=True
);
```

2. Click the Custom tab in the Shelf. You can add buttons to any shelf, but the Custom shelf is a convenient place for users to store their own group of buttons.
3. Click and drag the **LMB** over the script you typed into the Script Editor to highlight all of its lines.
4. With your cursor positioned over the highlighted text, click and hold the **MMB** to drag the contents of your script onto the Shelf.
5. If you are using Maya 2010 or an earlier version, a dialog box will appear. If you see this dialog box, select "Python" to tell Maya that the script you are pasting is written using Python rather than MEL.
6. You will now see a new button appear in your Custom tab. Left-click on your new button and you should see a red sphere appear in your viewport as in Figure 1.3. If you are in wireframe mode, make sure you enter shaded mode by clicking anywhere in your viewport and pressing the number **5** key.

You can edit your Shelf, including tabs and icons, by accessing the **Window** → **Settings/Preferences** → **Shelf Editor** option from the main Maya window. For more information on editing your Shelf, consult the Maya documentation or a basic Maya user's guide. Now that you have an understanding of the different tools available in the Maya GUI, we can start exploring Maya commands in greater detail.

MAYA COMMANDS AND THE DEPENDENCY GRAPH

To create a polygonal sphere with Python, the `polySphere` command must be executed in some way or other. The `polySphere` command is part of the Maya Command Engine. As we noted previously, the Maya Command Engine includes a set of commands accessible to both MEL and Python.

As we briefly discussed previously, Maya is fundamentally composed of a core and a set of interfaces for communicating with that core (see Figure 1.1). The core contains all the data in a scene and regulates all operations on these

data—creation, destruction, editing, and so on. All of the data in the core are represented by a set of objects called *nodes* and a series of *connections* that establish relationships among these nodes. Taken together, this set of relationships among nodes is called the *Dependency Graph* (DG).

For example, the polygon sphere object you created earlier returned the names of two nodes when you created it: a node that describes the geometry of the sphere and a **transform** node that determines the configuration of the sphere shape in space. You can see information on nodes in an object's network using the Attribute Editor (**Window → Attribute Editor** in the main menu) or as a visual representation in the Hypergraph (**Window → Hypergraph: Connections** in the main menu). Because this point is so important, it is worth looking at a brief example.

1. If you no longer have a polygon sphere in your scene, create one.
2. With your sphere object selected, open the Hypergraph displaying connections by using the **Window → Hypergraph: Connections** option from the main menu.
3. By default, the Hypergraph should display the connections for your currently selected sphere as in Figure 1.4. If you do not see anything,

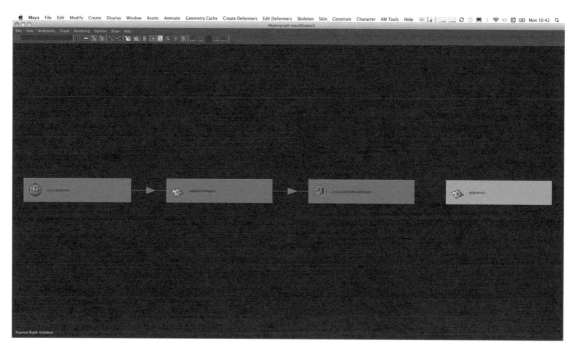

■ **FIGURE 1.4** The Hypergraph.

then select the option **Graph → Input and Output Connections** from the Hypergraph window's menu.

As you can see, a default polygon sphere consists of four basic nodes connected by a sequence of arrows that show the flow of information. The first node in the network is a **polySphere** node, which contains the parameters and functionality for outputting spherical geometry (e.g., the radius, the number of subdivisions, and so on). In fact, if you highlight the arrow showing the connection to the next node, a **shape** node, you can see what data are being sent. In this case, the **polySphere** node's **output** attribute is piped into the **inMesh** attribute of the **shape** node.

If you were to delete the construction history of this polygonal sphere (**Edit → Delete by Type → History** from the main menu), the **polySphere** node would disappear and the sphere's geometry would then be statically stored in the **shape** node (**pSphereShape1** in Figure 1.4). In short, if the **polySphere** node were destroyed, its mesh information would be copied into the **pSphereShape** node, and you would no longer be able to edit the radius or number of subdivisions parametrically; you would have to use modeling tools to do everything by hand.

While you can also see that information is piped from the **shape** node into a **shadingGroup** node (to actually render the shape), there is a node that appears to be floating on its own (**pSphere1** in Figure 1.4). This separate node is a special kind of object, a **transform** node, which describes the position, scale, and orientation of the polygonal sphere's geometry in space. The reason why this node is not connected is because it belongs to a special part of the DG, called the *Directed Acyclic Graph* (DAG). For right now, it suffices to say that the DAG essentially describes the hierarchical relationship of objects that have **transform** nodes, including what nodes are their parents and what transformations they inherit from their parents.

The Maya DG is discussed in greater detail in Chapter 11 in the context of the Maya API, yet this principle is critical for understanding how Maya works. We strongly recommend consulting a Maya user guide if you feel like you need further information in the meantime.

Although Maya is, as we pointed out, an open product, the data in the core are closed to users at all times. Autodesk engineers may make changes to the core from one version to another, but users may only communicate with the application core through a defined set of interfaces that Autodesk provides.

One such interface that can communicate with the core is the Command Engine. In the past, Maya commands have often been conflated with

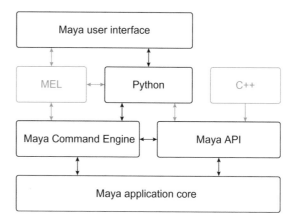

■ FIGURE 1.5 Python's interaction with the Maya Command Engine.

MEL. Indeed, commands in Maya may be issued using MEL in either scripts or GUI elements like buttons. However, with the inclusion of Python scripting in Maya, there are now two different ways to issue Maya commands, which more clearly illustrates the distinction.

Figure 1.5 highlights how Python interacts with the Maya Command Engine. While Python can use built-in commands to retrieve data from the core, it can also call custom, user-made commands that use API interfaces to manipulate and retrieve data in the core. These data can then be returned to a scripting interface via the Command Engine. This abstraction allows users to invoke basic commands (which have complex underlying interfaces to the core) via a scripting language.

MEL has access to over 1,000 commands that ship with Maya and has been used to create almost all of Maya's GUI. While Python has access to nearly all the same commands (and could certainly also be used to create Maya's GUI) there is a subset of commands unavailable to Python. The commands unavailable to Python include those specifically related to MEL or that deal with the operating system. Because Python has a large library of utilities that have grown over the years as the language has matured outside of Maya, this disparity is not a limitation.

Maya has documentation for all Python commands so it is easy to look up which commands are available. In addition to absent commands mentioned previously, there are some MEL scripts that appear in MEL command documentation as though they were commands. Because these are scripts rather than commands, they do not appear in the Python command

documentation and are not directly available to Python. Again, this absence is also not a limitation, as it is possible to execute MEL scripts with Python when needed. Likewise, MEL can call Python commands and scripts when required.[1]

Another important feature of the Maya Command Engine is how easy it is to create commands that work for MEL and Python. Maya was designed so that any new command added will be automatically available to both MEL and Python. New commands can be created with the Maya C++ API or the Python API. Now that you have a firmer understanding of how Maya commands fit into the program's architecture, we can go back to using some commands.

INTRODUCTION TO PYTHON COMMANDS

Let's return to Maya and open up the Script Editor. As discussed earlier in this chapter, the top panel of the Script Editor is called the History Panel. This panel can be very useful for those just learning how to script or even for advanced users who want to figure out what commands are being executed. By default, the History Panel will echo (print) most Maya commands being executed. You can also make the History Panel show all commands being executed, including commands called by the GUI when you press a button or open a menu. To see all commands being executed, select the **History → Echo All Commands** option from the Script Editor's menu. While this option can be helpful when learning, it is generally inadvisable to leave it enabled during normal work, as it can degrade Maya's performance. Right now, we will go through the process of creating a cube and look at the results in the History Panel (Figure 1.6).

1. In the menu for the Script Editor window, select **Edit → Clear History** to clear the History Panel's contents.
2. In the main Maya window, navigate to the menu option **Create → Polygon Primitives → Cube**.
3. Check the History Panel in the Script Editor and confirm that you see something like the following results.

   ```
   polyCube -w 1 -h 1 -d 1 -sx 1 -sy 1 -sz 1 -ax 0 1 0 -cuv 4 -ch 1;
   // Result: pCube1 polyCube1 //
   ```

The first line shown is the `polyCube` MEL command, which is very similar to the `polySphere` command we used earlier in this chapter. As you can see,

[1]MEL can call Python code using the `python` command. Python can call MEL code using the `eval` function in the maya.mel module. Note that using the `python` command in MEL executes statements in the namespace of the __main__ module. For more information on namespaces and modules, see Chapter 4.

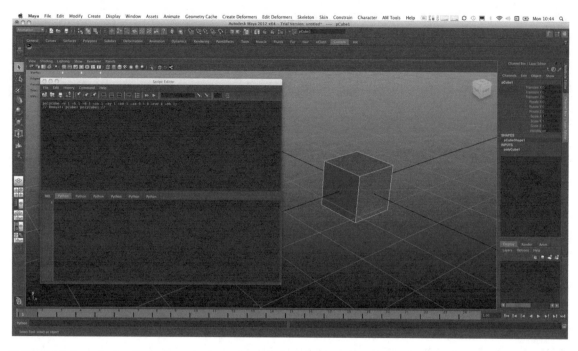

■ **FIGURE 1.6** The results of creating a polygon cube.

a MEL command was called when you selected the **Cube** option in the **Polygon Primitives** menu. That MEL command was displayed in the Script Editor's History Panel.

Because Maya's entire interface is written with MEL, the History Panel always echoes MEL commands when using the default Maya interface. Custom user interfaces could call the Python version of a command, in which case the History Panel would display the Python command.

This problem is not terribly troublesome for Python users though. It does not take much effort to convert a MEL command into Python syntax, so this feature can still help you learn which commands to use. The following example shows what the polyCube command looks like with Python.

```
import maya.cmds;
maya.cmds.polyCube(
    w=1, h=1, d=1, sx=1, sy=1, sz=1,
    ax=(0, 1, 0), cuv=4, ch=1
);
```

If you execute these lines of Python code they will produce the same result as the MEL version. However, we need to break down the Python version of the command so we can understand what is happening. Consider the first line:

```
import maya.cmds;
```

This line of code imports a Python module that allows you to use any Maya command available to Python. There is only one module that holds all Maya commands and you only need to import it once per Maya session. Once it is in memory you don't need to import it again (we only have you reimport it for each example in case you're picking the book back up after a break from Maya). We will discuss modules in greater depth in Chapter 4. The next line of code is the Python command.

```
maya.cmds.polyCube(
    w=1, h=1, d=1, sx=1, sy=1, sz=1,
    ax=(0, 1, 0), cuv=4, ch=1
);
```

As you can see, the name of the command, `polyCube`, is prefixed by the name of the module, `maya.cmds`. The period between them represents that this command belongs to the Maya commands module. We then supply the command several flag arguments inside of parentheses. A key-value pair separated by the equals sign, such as `w=1`, represents the name and value for the flag argument, and each of these pairs is separated by a comma.

Each flag may be added using a shorthand abbreviation or long version of the flag name. Although many Maya programmers tend to use the shorthand flag names in their code, it can make the code more difficult to read later. In the previous example, the command is using the shorthand flags so it is hard to understand what they mean. Here is the same version of the command with long flag names.

```
maya.cmds.polyCube(
    width=1,
    height=1,
    depth=1,
    subdivisionsX=1,
    subdivisionsY=1,
    subdivisionsZ=1,
    axis=(0, 1, 0),
    createUVs=4,
    constructionHistory=1
);
```

The long names are easier to read and so it can be good practice to use them when scripting. Code that is easier to read can be much easier to work with—especially if you or a coworker has to make any changes several months later! You may now be wondering how to find the long flag names in the future.

1. Type the following lines into the Script Editor and press **Ctrl + Return** to execute them.

```
import maya.cmds;
print(maya.cmds.help('polyCube'));
```

2. Look for the results in the History Panel, which should look like the following lines.

```
Synopsis: polyCube [flags] [String...]
Flags:
    -e -edit
    -q -query
   -ax -axis                    Length Length Length
  -cch -caching                 on|off
   -ch -constructionHistory     on|off
  -cuv -createUVs               Int
    -d -depth                   Length
    -h -height                  Length
    -n -name                    String
 -nds -nodeState                Int
    -o -object                  on|off
   -sd -subdivisionsDepth       Int
   -sh -subdivisionsHeight      Int
   -sw -subdivisionsWidth       Int
   -sx -subdivisionsX           Int
   -sy -subdivisionsY           Int
   -sz -subdivisionsZ           Int
   -tx -texture                 Int
    -w -width                   Length

Command Type: Command
```

As you can see, the result first displays the command for which help was requested—polyCube in this case. The following items in brackets, [flags] and [String...], show MEL syntax for executing the command. In MEL, the command is followed by any number of flag arguments and then any number of command arguments. We'll differentiate these two items momentarily.

Next, the output shows the list of flags for the command, displaying the short name on the left, followed by the long name in the middle column. Each flag is prefixed by a minus symbol, which is required to indicate a flag in MEL syntax, but which you can ignore in Python. To the very right of each flag name is the data type for each argument, which tells us what kind of value each flag requires.

We can see how flags work with the polyCube command. Consider the following example.

```
import maya.cmds;
maya.cmds.polyCube();
```

Executing this command causes Maya to create a polygon cube with default properties. The parentheses at the end of the command basically indicate that

we want Maya to do something—execute a command in this case. Without them, the command will not execute. We will discuss this topic further in Chapter 3 when we introduce functions. For now, it suffices to say that any command arguments we wish to specify must be typed inside of the parentheses, as in the following alternative example.

```
import maya.cmds;
maya.cmds.polyCube(name='myCube', depth=12.5, height=5);
```

If you execute the previous lines, Maya will create a polygon cube named "myCube" with a depth of 12.5 units and a height of 5 units. The first flag we set, `name`, is a string, as indicated in the help results. A *string* is a sequence of letters and numbers inside of quotation marks, and is used to represent a word or words. Immediately afterward is a comma before the next flag, `depth`. We specify that the depth should be the decimal number 12.5. Such values are listed as type Length in the help results. Last, we provided the `height` flag and supplied a value of 5. In this case, we used the long names of the flags, but we could also have used the short ones to do the same thing.

```
import maya.cmds;
maya.cmds.polyCube(n='myCube', d=12.5, h=5);
```

Looking at the help results, you can see that the `axis` flag takes three decimal numbers. To specify this kind of argument in Python, we use what is called a tuple. A *tuple* is basically a sequence of objects inside of parentheses, separated by commas. The following lines show an example of the same command using a tuple to specify a different axis.

```
import maya.cmds;
maya.cmds.polyCube(
    name='myCube',
    depth=12.5,
    height=5,
    axis=(1,1,0)
);
```

FLAG ARGUMENTS AND PYTHON CORE OBJECT TYPES

As you have seen, most Maya Python commands have flags, which allow you to change the default settings of the command being executed. Each flag argument must be passed a value. A flag's value can be one of several different built-in Python types. Table 1.1 lists Python's core object types that are used by Maya commands.

Note that Table 1.1 is not a complete list of Python core object types—there are many others that you may use for other purposes in your scripts.

Table 1.1 Python Core Object Types Used by Maya Commands

Type	Examples
Numbers	1 −5 3.14159 9.67
Strings	"Maya" 'ate' "my dog's" """homework"""
Lists	[1, "horse", 'town']
Tuples	(1, "two", 'three')
Booleans	True False 1 0

However, the core object types in this list are the only ones that Maya *commands* have been designed to use, so we may ignore the others for now. Other Python data types are discussed in Chapter 2. Let's focus for now on the five types in this list.

Numbers

Maya commands expecting Python numbers will accept any real number. Examples could include integer as well as decimal numbers, which correspond to int/long and float/double types, respectively, in other languages.

Strings

The string type is any sequence of letters or numbers enclosed in single quotation marks, double quotation marks, or a matching pair of triple quotation marks of either type. For instance, "boat", "house", and "car" are equivalent to 'boat', 'house', and 'car' as well as to """boat""", """house""", and """car""". However, the string "3" is different from the number object 3. Strings are typically used to name objects or parameters that are accessible from the Maya user interface.

Lists

A list is a sequence of any number of Python objects contained within the bracket characters [and]. A comma separates each object in the list. Any Python object may be in a list, including another list!

Tuples

The Python tuple is very similar to the list type except that it is not muta-
ble, which means it cannot be changed. We discuss mutability in greater
detail in Chapter 2. Tuples are contained inside of ordinary parentheses,
(and).

Booleans

A Boolean value in Python can be the word True or False (which must
have the first letter capitalized), or the numbers 1 and 0 (which correspond
to the values True and False, respectively). These values are typically used
to represent states or toggle certain command modes or flags.

Flag = Object Type

To find out what type of object a command flag requires, you can use the
`help` command. As you saw earlier in this chapter it will give you a list of
the command flags and what type of value they require. The argument type
is not an option—you must pass a value of the required type or you will get
an error. Using the `polyCube` command as an example, let's look at its
`width` flag and pass it correct and incorrect argument types.

1. Create a new scene by pressing **Ctrl + N**.
2. Execute the Maya `help` command for the `polyCube` command in the
 Script Editor:

    ```
    import maya.cmds;
    print(maya.cmds.help('polyCube'));
    ```

3. Look for the `width` flag in the results displayed in the History Panel
 and find its argument type on the right side:

    ```
    -w -width Length
    ```

As you can see, the `width` flag requires a Length type argument, as shown
to the right of the flag name. This is technically not a Python type but we
can deduce that `Length` means a number, so we should pass this flag some
sort of number. If the number needed to be a whole number, the flag would
specify `Int` to the right of the flag instead of `Length`. We can therefore also
deduce that the flag may be passed a decimal number in this case. Let's
first pass a correct argument.

4. Type the following command into the Script Editor and press **Ctrl +
 Return** to execute it.

    ```
    maya.cmds.polyCube(width=10);
    ```

You should see the following result in the Script Editor's History Panel.

```
# Result: [u'pCube1', u'polyCube1'] #
```

The result lets us know that the command succeeded and also shows that the command returned a Python list containing the names of two new nodes that have been created to make our cube object: "pCube1" (a **transform** node) and "polyCube1" (a **shape** node). Now, let's see what happens when we intentionally supply the width flag with the wrong data type.

5. Type the following command into the Script Editor and press **Ctrl + Return** to execute it.

```
maya.cmds.polyCube(width='ten');
```

This time the command returns an error.

```
# Error: TypeError: file <maya console> line 1: Invalid
arguments for flag 'width'. Expected distance, got str #
```

The error tells you that the argument for the width flag was incorrect and it expected a distance value. Even though the help command showed the width flag needed a Length type, Maya is now calling it a distance type. This can be confusing at first but most of the time it is very clear what the flag argument requires simply by looking at the flag in context. The help command does not describe what each flag does, but you can get more detailed descriptions using the Python Command Reference, which we will examine shortly.

COMMAND MODES AND COMMAND ARGUMENTS

Maya commands often have more than one mode in which they can work. Some commands may be available to use in create mode, edit mode, and/or query mode, while certain flags may only be available in certain modes.

Create Mode

Most commands at least have a create mode. This mode allows users to create new objects in the scene and specify any optional parameters. By default, the polyCube command operates in create mode.

1. Create a new Maya scene.
2. Execute the following lines in the Script Editor to create a new cube.

```
import maya.cmds;
maya.cmds.polyCube();
```

Note that you do not have to do anything special to execute commands in create mode. Leave the cube in your scene for the next steps.

Edit Mode

Another mode that many commands support is edit mode. This mode allows users to edit something the command has created.

3. Execute the following line in the Script Editor to change the cube's width.

```
maya.cmds.polyCube('pCube1', edit=True, width=10);
```

As you can see, you specified that the command should operate in edit mode by setting the edit flag with a value of True. In edit mode, you were able to change the width of the object named "pCube1" to a value of 10. It is worth mentioning that some flags in MEL do not require an argument, such as the edit flag (see help output previously). Such flags, when invoked from Python, simply require that you set some value (True) to indicate their presence.

Another important point worth noting is the syntax for operating in edit and query modes. The first argument we pass to the command is called a *command argument*, and specifies the name of the node on which to operate. As we saw in the help output previously, MEL syntax expects command arguments to follow flag arguments, while Python requires the opposite order. The reason for Python's syntax requirement will be discussed in greater detail in Chapter 3. Leave the cube in the scene for the next step.

Query Mode

The last mode that many commands support is query mode. This mode permits users to request information about something the command has already created.

4. Execute the following line in the Script Editor to print the cube's width.

```
maya.cmds.polyCube('pCube1', query=True, width=True);
```

The result in the History Panel should display something like the following line.

```
# Result: 10.0 #
```

As with edit mode, query mode requires that you specify a command argument first and then set the query flag with a value of True. Another point worth noting is that, although the width flag normally requires a decimal number (when being invoked from create or edit mode), you simply pass it a value of True in query mode. The basic idea is that in this case, the Command Engine is only interested in whether or not the flag has been set, and so it will not validate the value you are passing it.

As you can see, these three modes allowed you to create an object, change it, and finally pull up information about its current state. We also noted at the outset of this section that some flags are only compatible with certain command modes. While the help command will not give you this information, the Command Reference documentation will.

PYTHON COMMAND REFERENCE

Another place you can get more help on a command is from the Maya help documents. These documents detail every Python command available. The Python Command Reference is shown in Figure 1.7. Let's browse the Python Command Reference to find more information on the polyCube command.

1. In the main Maya window select the menu item **Help → Python Command Reference**.
2. At the top of the page is a text field. Click in the search field and enter the word polyCube.
3. The page will update to show you only the polyCube command. Select the polyCube command from the list under the label "Substring: polyCube". Clicking this link will show you detailed information for the polyCube

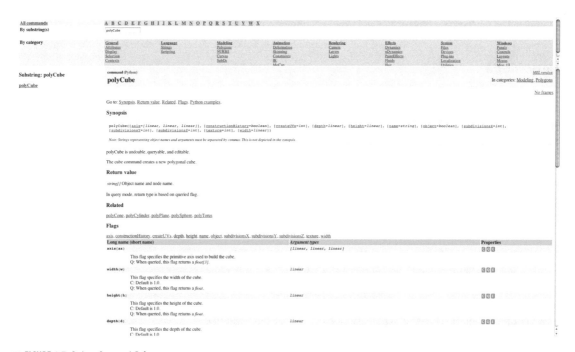

■ **FIGURE 1.7** Python Command Reference.

command. As you can see, the Command Reference documents break up information for all commands into different sections, which we will now look at in more detail.

Synopsis

The synopsis provides a short description of what the command does. In this case the synopsis states:

polyCube is undoable, queryable, and editable.
The cube command creates a new polygonal cube.

Return Value

The return value section describes what the command will return when it is executed. In this case the documentation states:

string[] *Object name and node name.*

This description shows us that it returns a list of string type objects, which will be the name of the object (**transform** node) and the (**polyCube**) node that were created.

Related

This section can help you with finding commands that are similar to the command at which you are looking. For the polyCube command, this section lists other commands for creating primitive polygon objects:

polyCone, polyCylinder, polyPlane, polySphere, polyTorus

Flags

For the polyCube command, the axis flag is listed first. It shows a short description of what the flag does and then it lists the argument type to pass to it. The documentation shows the following text:

[linear, linear, linear]

The command requires a Python list (or tuple) type and that list should hold three real numbers. If int is not specified for an argument type, then the argument may be a decimal number, though integer numbers are still valid. In this case, if we were to define the argument for the flag it could be something like [1.00, 0, 0].

As we noted earlier, the documentation also displays icons to represent the command mode(s) with which each flag is compatible.

- *C (Create)*: The flag can appear in the create mode.
- *E (Edit)*: The flag can appear in the edit mode.
- *Q (Query)*: The flag can appear in the query mode.
- *M (Multiuse)*: The flag can be used multiple times.

In MEL, multiuse flags are invoked by appending them multiple times after a command. In Python, however, you can only specify a flag once. As such, Python requires that you pass a tuple or list argument for a multiuse flag, where each element in the tuple or list represents a separate use of the flag.

Python Examples

This section can be very useful for those just learning how to script with Python or those learning how to work with Maya using Python. Here you can find working examples of the command in use. Some example sections can have several different samples to help you understand how the command works. The example for the `polyCube` command in the documents shows you how to create a polygon cube and also how to query an existing cube's width.

PYTHON VERSION

One final point that is worth discussing is how to locate which version of Python your copy of Maya is using. Python has been integrated into Maya since version 8.5, and each new version of Maya typically integrates the newest stable version of Python as well. Since newer versions of Python will have new features, you may want to investigate them. First, find out what version of Python your version of Maya is using.

1. Open up the Script Editor and execute the following lines.

```
import sys;
print(sys.version);
```

You should see a result print in the Script Editor's History Panel that looks something like the following lines.

```
2.6.4 (r264:75706, Nov 3 2009, 11:26:40)
[GCC 4.0.1 (Apple Inc. build 5493)]
```

In this example, our copy of Maya is running Python version 2.6.4.

PYTHON ONLINE DOCUMENTATION

Once you know what version of Python you are running, you can look up the Python documentation online. The Python web site is located at

http://www.python.org/. If you navigate to the Documentation section, you should see documentation for multiple versions of Python.

As you learn to program using Python you might also be interested in downloading Python for your operating system if it does not already include it. You can find the latest versions of Python at the Python web site. If you plan to write Python scripts that interact with Maya, it is advisable that you install the same version that Maya is using. For the most part, many versions of Python that you will see in Maya are almost identical. However, a newer version of Python, 3.x, may break a few things that work in older versions.

If you choose to install Python for your operating system, you will be able to use a Python interpreter, such as the Python IDLE, which acts just like the Maya Script Editor but for your operating system. This can be useful for creating tools outside of Maya that communicate with Maya using Python. Moreover, you could write tools using Python that have nothing to do with Maya, yet may be helpful for your project's organization or interaction with other software like MotionBuilder.

CONCLUDING REMARKS

In this chapter you have learned how Maya commands and Python work within Maya's architecture. We have introduced a few methods of entering Maya commands with Python to modify Maya scenes. We have also explained how to look up help and read the Python Command Reference documentation and how to find information about your version of Python. In the chapters that immediately follow, we will further explain some of the underlying mechanics and syntax of Python and then start creating more complicated scripts to use in Maya.

Python Data Basics

BY THE END OF THIS CHAPTER, YOU WILL BE ABLE TO:

- Define and manipulate data in variables.
- Compare and contrast Python's and MEL's typing systems.
- Recast variables as different data types.
- Prevent naming conflicts with built-in keywords.
- Explain how Python manages memory.
- Compare and contrast mutable and immutable types.
- Use variables in conjunction with commands to manipulate attributes.
- Describe the different numeric types in Python.
- Use mathematical operators with numeric types.
- Use logical and bitwise operators with Boolean variables.
- Use common operators with sequence types.
- Manipulate nested lists.
- Create Unicode and raw strings.
- Format strings that contain variable values.
- Compare and contrast sets and dictionaries with sequence types.

In Chapter 1, we covered executing commands in Maya using Python. To do anything interesting, however, we need more tools to create programs. In this chapter we will explore some of the basics for working with variables in Python. Because much of this information is available in the online Python documentation, we will not belabor it a great deal. However, because we make use of certain techniques throughout the text, it is critical that you have an overview here.

We begin by discussing variables in the context of the data types you learned in Chapter 1, and show how you can use variables along with some basic Maya commands. Thereafter, we discuss some more interesting properties of the basic sequence types we discussed in Chapter 1. Finally, we discuss two additional, useful container types.

VARIABLES AND DATA

The basic unit of data storage in any programming language is a variable. A *variable* is a name that points to some specific data type. The mechanism for creating a variable in Python is the assignment operator (=). Because Python does not require (or allow) declaration without an assignment,

creating a variable is as simple as separating a name and a value with the assignment operator.

1. Execute the following line in a Python tab in the Script Editor, or from the Command Line. This line simply creates a variable named `contents`, and assigns a string value to it.

```
contents = 'toys';
```

2. Once you create this variable, you can substitute in this name anywhere you would like this value to appear. Execute the following line of code. You should see the string "toys in the box" print on the next line.

```
print(contents+' in the box');
```

3. You can change the value assigned to this variable at any time, which will substitute in the new value anywhere the name appears. Execute the following lines of code, which should print "shoes in the box" in the History Panel.

```
contents = 'shoes';
print(contents+' in the box');
```

4. You can also assign completely different types of values to the variable. Execute the following line of code.

```
contents = 6;
```

Python is what is called a strong, dynamically typed language. The line of code in step 4 demonstrates dynamic typing. You are able to change the type of any Python variable on-the-fly, simply by changing its assignment value. However, because it is strongly typed, you cannot simply add this new value to a string.

5. Try to execute the following statement.

```
print('there are '+contents+' things in the box');
```

The console should supply an error message like the following one.

```
# Error: TypeError: file <maya console> line 1: cannot
concatenate 'str' and 'int' objects #
```

Because Python is strongly typed, you cannot so easily intermix different types of variables. However, you can now perform addition with another number.

6. Execute the following line of code, which should print the number 16.

```
print(contents+10);
```

In Python, to intermix types, you must explicitly recast variables as the expected type.

7. Execute the following line in Python to cast the number stored in contents to its string representation. You should see "there are 6 things in the box" in the History Panel.

```
print('there are '+str(contents)+' things in the box');
```

In this case, we called the **str()** function to recast contents as a string. We discuss functions in greater detail in Chapter 3. Table 2.1 lists some other built-in functions for recasting variables.

Python provides a built-in function, **type()**, which allows you to determine the type of a variable at any point.

8. Execute the following line to confirm the type of the contents variable.

```
type(contents);
```

You should see the following line in the History Panel, which indicates that the variable is currently pointing to an integer.

```
# Result: <type 'int'> #
```

As you can see, casting the variable to a string as you did in step 7 did not change its inherent type, but only converted the value we retrieved from the variable. As such, you would still be able to add and subtract to and from this variable as a number. You could also reassign a string representation to it by assigning the recast value.

9. Execute the following lines to convert the variable to a string.

```
contents = str(contents);
print(type(contents));
```

You should see the following output in the History Panel.

```
<type 'str'>
```

Table 2.1 Python Functions for Recasting Variable Types

Function	Casts To	Notes
float()	Decimal number	If argument is string, raises **ValueError** if not properly formatted
int()	Integer number	If argument is string, raises **ValueError** if not properly formatted
		If argument is decimal number, result is truncated toward 0
		Allows optional argument to specify non-base 10
str()	String	
unicode()	Unicode string	Allows optional argument to specify encoding

Variables in MEL

Variables in Python are incredibly flexible. Compare the previous example with a comparable MEL snippet.

1. Enter the following lines in a MEL tab in the Script Editor. You should again see the output "toys in the box" in the History Panel.

```
$contents = "toys";
print($contents+" in the box");
```

While MEL allows—but does not require—that you explicitly provide the variable's type, the variable $contents is statically typed at this point. It is a string, and so cannot now become a number. Those unfamiliar with MEL should also note that it requires variable names to be prefixed with a dollar sign (**$**).

2. Execute the following lines in MEL.

```
$contents = 6;
print("there are "+$contents+" things in the box");
```

Because you get the output you expect ("there are 6 things in the box"), you may think that MEL has implicitly handled a conversion in the print call. However, the number 6 stored in $contents is not in fact a number, but is a string. You can confirm this fact by trying to perform addition with another number.

3. Execute the following line in MEL.

```
print($contents+10);
```

Whereas the Python example printed the number 16 in this case, MEL has printed 610! In MEL, because the type of the variable cannot change, MEL implicitly assumed that the number 10 following the addition operator (**+**) was to be converted to a string, and the two were to be concatenated. While seasoned MEL developers should be well aware of this phenomenon, readers who are new to Maya will benefit from understanding this difference between MEL and Python, as you may occasionally need or want to call statements in MEL.

On the other hand, all readers who are as yet unfamiliar with Python would do well to remember that variable types could change on-the-fly. This feature offers you a great deal of flexibility, but can also cause problems if you're frequently reusing vague, unimaginative variable names.

Keywords

Apart from issues that may arise from vague variable names, Python users have some further restrictions on names available for use. Like any other language, Python has a set of built-in keywords that have special meanings.

You saw one of these keywords—**import**—in Chapter 1. To see a list of reserved keywords, you can execute the following lines in a Python tab in the Script Editor.

```
import keyword;
for kw in keyword.kwlist: print(kw);
```

The list of reserved keywords printed out are used for various purposes, including defining new types of objects and controlling program flow. We will be covering a number of these keywords throughout the text, but it is always a good idea to refer to the Python documentation if you would like more information. The important point right now is that these words all have special meanings, and you cannot give any of these names to your variables.

Python's Data Model

It is now worth highlighting a few points about Python's data model, as it has some bearing on other topics in this chapter (as well as many topics we discuss later in this book). Although we must be brief, we recommend consulting Section 3.1 of Python Language Reference online if you are interested in more information.

To maximize efficiency, statically typed languages allocate a specific amount of memory for different types of variables. Because this amount of memory is specified in advance, you cannot simply assign a new type to a name at some later point. On the other hand, as you have seen in this chapter, Python lets you change the type of a variable at any point. However, the underlying mechanisms are actually somewhat subtler.

In Python, variables are just names that point to data. All data are objects, and each object has an identity, a type, and a value.

- An object's *identity* describes its address in memory.
- An object's *type* (which is itself an object) describes the data type it references.
- An object's *value* describes the actual contents of its data.

While we will discuss objects in greater detail in Chapter 5, programmers coming from other languages may find this principle novel.

When you create a new variable and assign it a value, your variable is simply a name pointing to an object with these three properties: an identity,

a type, and a value.[1] Consider a situation where you cast an integer to a string, such as the following lines.

```
var = 5;
var = str(var);
```

In this case, you are not actually altering the data's underlying type, but are pointing to some different piece of data altogether. You can confirm this fact by using the built-in **id()** function, which provides the address to the data. For instance, printing the identity at different points in the following short sample will show you different addresses when the variable is an integer and when it is a string.

```
var = 5;
print('int id',id(var));
var = str(var);
print('str id',id(var));
```

Mutability

In Python, objects can be either mutable or immutable. Briefly construed, mutable objects can have their values changed (mutated), while immutable objects cannot.[2] We briefly mentioned this concept in Chapter 1 when comparing lists and tuples.

In fact, tuples, strings, and numbers are all immutable. As a consequence, when you assign a new integer value to a variable, instead of changing the underlying value of the object to which the variable is pointing, the variable instead points to another piece of data. You can see the effects of this concept in the following short code example, which will print the identity for the variable after different integer assignments.

```
var = 5;
print('5 id',id(var));
var = 6;
print('6 id',id(var));
```

[1] C++ programmers should note that although Python variables are references to data, they cannot simply be used like pointers. To shoehorn Python into the language of C++, it always passes parameters by value, but the value of a variable in Python is a reference. The consequence is that reassigning a variable inside of a function has no effect on its value outside the function. Chapter 9 discusses these consequences of Python's data model in Maya's API.

[2] Immutable containers that reference mutable objects can have their values changed if the value of one of the mutable objects in the container changes. These containers are still considered immutable, however, because identities to which they refer do not change. See the "Nested Lists" section in this chapter for more information.

■ **FIGURE 2.1** Two variables may point to the same object.

We examine the effects of mutability on sequence types later in this chapter.

Reference Counting

As part of its data model, Python uses a system known as reference counting to manage its memory. The basic idea is that rather than requiring developers to manually allocate and deallocate memory, data are garbage collected when there are no more names referencing them.

An interesting side effect of this paradigm is that two immutable variables with the same assignment (e.g., data with the same type and value) may in fact be pointing to the same data in memory (Figure 2.1). You can see this principle in action by assigning the same numeric value to two different variables and printing their identities.

```
v1 = 10;
v2 = 10;
print('v1 id', id(v1));
print('v2 id', id(v2));
```

In this case, both v1 and v2 are pointing to the same piece of data. If these two variables are assigned different data (e.g., some other number, a string, etc.), then the reference count for their previous data (the integer 10) drops to zero. When the reference count for objects drops to zero, Python normally automatically garbage collects the data to free up memory as needed. Although this concept has only a few consequences for our current discussion, it becomes more important in later chapters as we discuss modules, classes, and using the API.

It is important to note that while variables pointing to data with an immutable type may show this behavior, two *separate* assignments to mutable objects with the same type and value are always guaranteed to be different. For example, even though the following lists contain the same items, they will be guaranteed to have unique identities.

```
list1 = [1, 2, 3];
list2 = [1, 2, 3];
print('list1 id', id(list1));
print('list2 id', id(list2));
```

The assignment of one variable to another variable pointing to a mutable object, however, results in both pointing to the same data.

```
list1 = [1, 2, 3];
list2 = list1;
print('list1 id', id(list1));
print('list2 id', id(list2));
```

This concept has important consequences that we will cover later.

del()

Python has a built-in function, **del**(), which allows you to delete variables. Note that this process is not the same as deleting the data referenced by the variable: Python's garbage collector will still manage those data. Using this function with a variable name simply clears the name (and thus eliminates a reference to its data). The following example illustrates that, even though v1 and v2 will reference the same data, deleting v1 has no effect on v2. Trying to access v1 after this point would result in a **NameError**.

```
v1 = 5;
v2 = 5;
del(v1);
print(v2);
```

The None Type

Because we use it throughout the text in some cases, it is worth noting that, because of how Python's variables work, Python also implements a None type.

```
var = None;
```

One use of this type is to initialize a name without wastefully allocating memory if it is unnecessary. For instance, many of our API examples in this text use the None type to declare names for class objects whose values are initialized elsewhere. We will talk more about class objects starting in Chapter 5.

USING VARIABLES WITH MAYA COMMANDS

As we noted in Chapter 1, a Maya scene is fundamentally composed of nodes and connections. Each node has a number of different attributes, such as the radius of a **polySphere**, the height of a **polyCube**, or the maximum

number of influences in a **skinCluster**. Although we will talk about attributes in much greater detail when we introduce the API in later chapters, it suffices for now to say that they describe the actual data housed in a node.

You have already seen some multimodal, built-in commands designed to work with different node types. For example, the `polySphere` command not only creates nodes for a polygon sphere, but also allows you to query and edit **polySphere** nodes. You can use these commands along with variables very easily. Let's work through a quick example.

1. Create a new Maya scene and execute the following lines in the Script Editor.

   ```
   import maya.cmds;
   sphereNodes = maya.cmds.polySphere();
   ```

Recall that the results of the `polySphere` command return a list of object names (a **transform** node and a **shape** node). You can store this result in a variable when you create a cube. The `sphereNodes` list now contains the names of the two objects that were created. If you were to print this list, you would see something like the following line.

   ```
   [u'pSphere1', u'polySphere1']
   ```

Note that this list does not contain the Maya nodes themselves, but simply contains their names. For example, using the **del()** function on this list would not actually delete Maya nodes, but would simply delete a list with two strings in it.

2. We will discuss this syntax later in this chapter, but you can use square bracket characters to access items in this list. For example, you can store the name of the **polySphere** node ("polySphere1") in another variable.

   ```
   sphereShape = sphereNodes[1];
   ```

3. Now that you have stored the name of the shape in a variable, you can use the variable in conjunction with the `polySphere` command to query and edit values. For example, the following lines will store the sphere's radius in a variable, and then multiply the sphere's radius by 2. Remember that in each flag argument, the first name is the flag, and the second name is the value for the flag.

   ```
   rad = maya.cmds.polySphere(
       sphereShape, q=True, radius=True
   );
   maya.cmds.polySphere(sphereShape, e=True, radius=rad*2);
   ```

4. You could now reread the **radius** attribute from the sphere and store it in a variable to create a cube the same size as your sphere.

```
rad = maya.cmds.polySphere(
    sphereShape, q=True, radius=True
);
maya.cmds.polyCube(
    width=rad*2,
    height=rad*2,
    depth=rad*2
);
```

Hopefully you see just how easy it is to use variables in conjunction with Maya commands.

Capturing Results

In practice, it is critical that you always capture the results of your commands in variables rather than making assumptions about the current state of your nodes' attributes. For example, Maya will sometimes perform validation on your data, such as automatically renaming nodes to avoid conflicts.

Some Maya users may insist that this behavior makes certain tools impossible without advanced, object-oriented programming techniques. In reality, you simply need to take care that you use variables to store your commands' results, and do not simply insert literal values—especially object names—into your code. The following example illustrates this point.

1. Create a new Maya scene and execute the following lines in the Script Editor. This code will create a sphere named "head."

   ```
   import maya.cmds;
   maya.cmds.polySphere(name='head');
   ```

2. Now execute the following line to try to make a cube with the same name.

   ```
   maya.cmds.polyCube(name='head');
   ```

If you actually look at your cube in the scene, you can see that Maya has automatically renamed it to "head1" so it will not conflict with the name you gave the sphere. However, if you were writing a standalone tool that creates objects with specific names and then tries to use those specific names, your artists may run into problems if they already have objects in the scene with conflicting names.

3. Try to execute the following line, and you will get an error.

   ```
   maya.cmds.polyCube('head', q=True, height=True);
   ```

Always remember that Maya commands work with nodes and attributes on the basis of their names, which are simply strings. When using ordinary Maya commands, you should always capture the results of your commands

since there is no default mechanism for maintaining a reference to a specific node. In Chapter 5 we will see how the pymel module provides an alternative solution to this problem.

getAttr **and** setAttr

While there are many commands that pair with common node types, not all nodes have such commands (and sometimes not all attributes have flags). It may also become tedious to memorize and use commands with modes, flags, and so on. Fortunately, Maya provides two universal commands for getting and setting attribute values that will work with any nodes: getAttr and setAttr. We'll demonstrate a quick example.

1. Open a new Maya scene and execute the following lines of code. These lines will create a new locator and store the name of its **transform** node in a variable called loc.

```
import maya.cmds;
loc = maya.cmds.spaceLocator()[0];
```

2. Execute the following lines to store the locator's *x*-scale in a variable and print the result, which will be 1 by default.

```
sx = maya.cmds.getAttr(loc+'.scaleX');
print(sx);
```

The getAttr command allows you to get the value of any attribute on any node by simply passing in a string with the node's name, a period, and the attribute name. We'll talk more about working with strings shortly, but the complete string that we passed to the getAttr command was actually "locator1.scaleX" in this case.

3. Execute the following lines to double the sx value and assign the new value to the node's attribute.

```
sx *= 2;
maya.cmds.setAttr(loc+'.scaleX', sx);
```

The setAttr command works just like the getAttr command, and allows you to set any attribute value on any node by passing a string with the node's name, a period, and the attribute name.

Compound Attributes

Many attributes will simply be a string, a Boolean, or a number value. However, some attributes are called compound attributes, and may contain several values. It is important to note that these attribute types work differently with the getAttr and setAttr commands compared to other built-in commands.

The reason for this difference is that the `getAttr` and `setAttr` commands do not know what data type the particular attribute expects or contains until they look it up by name. Other commands only work with specific attributes on specific nodes, and so can work in a more straightforward way, as you will see in the remainder of this example.

4. In the scene you created in the previous steps, execute the following line to print the locator's translation using the `xform` command.

```
print(maya.cmds.xform(loc, q=True, translation=True));
```

As you would expect the result is simply a list: [0.0, 0.0, 0.0].

5. Likewise, when using the `xform` command, you can *set* a new translation value using a list, as in the following line.

```
maya.cmds.xform(loc, translation=[0,1,0]);
```

The `xform` command can work in this way because it is designed to work exclusively with **transform** nodes, and the command internally knows about the data type for the appropriate attribute. On the other hand, `getAttr` and `setAttr` are not so straightforward.

6. Execute the following line to print the locator's translation using the `getAttr` command.

```
print(maya.cmds.getAttr(loc+'.translate'));
```

As you can see from the output, the command returns a list that contains a tuple: [(0.0, 1.0, 0.0)].

7. Using `setAttr` for a compound attribute also uses a different paradigm. Execute the following line to set a new translation value for the locator.

```
maya.cmds.setAttr(loc+'.translate', 1, 2, 3);
```

As you can see, setting a compound attribute like translation using `setAttr` requires that you specify each value in order (*x*, *y*, *z* in this case).

`connectAttr` **and** `disconnectAttr`

The mechanism for transforming data in the Maya scene is to connect attributes: an output of one node connects to some input on another node. For instance, you saw in Chapter 1 how the **output** attribute of a **polySphere** node is connected to the **inMesh** attribute of a **shape** node when you execute the `polySphere` command. While Chapter 1 showed how you can delete the construction history of an object to consolidate its node network, the `connectAttr` and `disconnectAttr` commands allow you to reroute connections in altogether new ways.

The basic requirement for attributes to be connected is that they be of the same type. For example, you cannot connect a string attribute to a decimal number

attribute. However, Maya does perform some built-in conversions for you automatically, such as converting angle values into decimal numbers. The finer distinctions between these types of values will be clearer when we discuss the API later in this book. In the following short example, you will create a basic connection to control one object's translation with another object's rotation.

1. Open a new Maya scene and execute the following lines to create a sphere and a cube and store the names of their **transform** nodes.

```
import maya.cmds;
sphere = maya.cmds.polySphere()[0];
cube = maya.cmds.polyCube()[0];
```

2. Execute the following lines to connect the cube's *y*-rotation to the sphere's *y*-translation.

```
maya.cmds.connectAttr(cube+'.ry', sphere+'.ty');
maya.cmds.select(cube);
```

Use the Rotate tool (**E**) to rotate the cube around its *y*-axis and observe the behavior. The result is very dramatic! Because you are mapping a rotation in degrees to a linear translation, small rotations of the cube result in large translations in the sphere.

It is also worth mentioning that the connection is only one way. You cannot translate the sphere to rotate the cube. In Maya, without some very complicated hacks, connections can only flow in one direction. Note, too, that an output attribute can be connected to as many inputs as you like, but an input attribute can only have a single incoming connection.

3. Execute the following line to disconnect the two attributes you just connected.

```
maya.cmds.disconnectAttr(cube+'.ry', sphere+'.ty');
```

The disconnectAttr command works very similarly to the connectAttr command. It simply expects two strings that name the nodes and their attributes.

4. Execute the following lines to create a **multiplyDivide** node between the two attributes to scale the effect.

```
mult = maya.cmds.createNode('multiplyDivide');
maya.cmds.connectAttr(cube+'.ry', mult+'.input1X');
maya.cmds.setAttr(mult+'.input2X', 1.0/90.0);
maya.cmds.connectAttr(mult+'.outputX', sphere+'.ty');
maya.cmds.select(cube);
```

Now if you rotate the cube, the sphere translates 1 unit for every 90 degrees of rotation.

WORKING WITH NUMBERS

In Chapter 1, we introduced some basic object types with which Maya commands have been designed to work. Although we lumped numbers together generally, they are actually decomposable into more specific types. Because you may want to take advantage of these specific types' features, and because you may encounter them when testing the types of your variables, it is worth briefly discussing them.

Number Types

Although you can often intermix different types of numbers in Python, there are four types of numbers: integers, long integers, floating-point numbers, and complex numbers. We briefly cover them here, but you can read more about these different types in Section 5.4 of Python Standard Library.

As you saw in the beginning of this chapter, an integer is simply a whole (nonfractional) number. Integers can be positive or negative. The type of an integer in Python is given as int, as the following code illustrates.

```
var = -5;
print(type(var));
```

A long integer differs from an integer only in that it occupies more space in memory. In many cases, ordinary integers suffice and are more efficient, but long integers may be useful for computation that deals with large numbers. In a language like C or C++, a long integer occupies twice as many bits in memory as an ordinary integer. In Python, a long integer can occupy as much memory as you require. To create a long integer, you can simply assign a really long value to your variable and it will become a long integer automatically, or you can suffix the value with the character l or **L**. The type in Python is given as long.

```
var = -5L;
print(type(var));
```

Floating-point numbers are any numbers, positive or negative, with digits after a decimal point. You can explicitly indicate that a whole number value is to be a floating-point number by adding a decimal point after it. The type of a floating-point number is float.

```
var = -5.0;
print(type(var));
```

Finally, Python allows you to use complex numbers, which consist of both a real and an imaginary component. It is highly unlikely that you will need to work with complex numbers regularly. You can create a complex number by

suffixing the imaginary part with the character **j** or **J**. The type is given as complex.

```
var = -5+2j;
print(type(var));
```

You can also access the individual real and imaginary parts of complex numbers using the **real** and **imag** attributes.

```
print(var.real, var.imag);
```

Basic Operators

Once you start creating variables, you will want to do things with them. Operators are special symbols you can include in your code to perform special functions. (Note that we also include some related built-in functions and object methods in our tables.) Section 5 of Python Standard Library includes information on various operators, and Section 3.4 of Python Language Reference contains information on overloading operators, which allows you to assign special functionality to these symbols. Here, we briefly review some of the basic operators for working with numeric values.

Thus far, you've seen some of the basic math operators, such as **+** for addition and **–** for subtraction or negation. Section 5.4 in Python Standard Library contains a table of Python's built-in operators for working with numeric types. In Table 2.2 we have recreated the parts of this table containing the most common operators.

Note that many of these operators also allow in-place operations when used in conjunction with the assignment operator (**=**). For example, the following

Table 2.2 Important Numeric Operators

Operation	Result	Notes
$x + y$	Sum of x and y	
$x - y$	Difference of x and y	
$x * y$	Product of x and y	
x / y	Quotient of x and y	If x and y are integers, result is rounded down
$x // y$	Floored quotient of x and y	Use with floating-point numbers to return a decimal result identical to x/y if x and y were integers
$x \% y$	Remainder of x / y	
divmod(x, y)	Tuple that is $(x // y, x \% y)$	
pow(x, y)	x to the y power	
$x ** y$	x to the y power	

lines create a variable, `v1`, with a value of 2, and then subtracts 4 from the same variable, resulting in −2.

```
v1 = 2;
v1 -= 4;
print(v1);
```

Note that Python does not support incremental operators such as ++ and −−.

For those readers who are new to programming, it is important to point out how division works with integer numbers. Remember that integers are whole numbers. Consequently, the result is always rounded down. The following floating-point division results in 0.5.

```
1.0/2.0;
```

The following integer division results in 0.

```
1/2;
```

On the other hand, the following integer division results in −1.

```
-1/2;
```

You can also mix an integer and a floating-point number, in which case both are treated as floats. The following division results in 0.5.

```
1.0/2;
```

It is also worth mentioning, for those unacquainted with the finer points of computer arithmetic, that floating-point operations often result in minor precision errors as a consequence of how they are represented internally. It is not uncommon to see an infinitesimally small number where you might actually expect zero. These numbers are given in scientific notation, such as the following example.

```
-1.20552649145e-10
```

WORKING WITH BOOLEANS

Another basic type that is used with Maya commands is the Boolean type (called bool in Python). Recall that in practice, Boolean values True and False are interchangeable with 1 and 0, respectively. This principle becomes more important when using conditional statements, as you will see in Chapter 3.

Boolean and Bitwise Operators

Some operators are especially important when you are working with Boolean values. You will use these operators widely in Chapter 3 as we discuss using conditional statements to control program flow. In Table 2.3

Table 2.3 Important Boolean and Bitwise Operators

Operation	Result	Notes
x **or** *y*	True if either *x* or *y* is True	Only evaluates *y* if *x* is False
x **and** *y*	True only if both *x* and *y* are True	Only evaluates *y* if *x* is True
not *x*	False if *x* is True; True if *x* is False	
x \| *y*	Bitwise **or** of *x* and *y*	
x **&** *y*	Bitwise **and** of *x* and *y*	
x ^ *y*	Bitwise exclusive-or of *x* and *y*	

we have consolidated the most common operators from tables in Sections 5.2 and 5.4.1 of Python Standard Library.

When working with Boolean variables, the bitwise operators for and (&) and or (|) function just like their Boolean operator equivalents. The exclusive-or operator (^), however, will only return True if either *x* or *y* is True, but will return False if they are both True or both False.

There are more bitwise operators that we have not shown here only because we do not use them throughout this text. Programmers who are comfortable with binary number systems should be aware that bitwise operators also work with int and long types.[3]

WORKING WITH SEQUENCE TYPES

In Chapter 1, three of the variable types introduced can be called sequence types. Sequence types include strings, lists, and tuples. These types basically contain a group of data in a linear sequence. While each of these types is obviously unique, they also share some properties, which we briefly discuss in this section.

Operators

As with numbers and Booleans, sequence types have a set of operators that allow you to work with them conveniently. Section 5.6 of Python Standard Library has a table of operations usable with sequence types. We have selected the most common of these operations to display in Table 2.4. Because they are perhaps not as immediately obvious as math operators, some merit a bit of discussion.

[3]It is also worth noting that the bitwise inversion operator (~) is not equivalent to the Boolean **not** operator when working with Boolean variables. Booleans are not simply 1-bit values, but are built on top of integers. Consequently, ~False is −1 and ~True is −2.

Table 2.4 Important Sequence Operators

Operation	Result	Notes
x **in** *s*	True if *x* is in *s*	Searches for item in lists/tuples Searches for character sequence in strings
x **not in** *s*	True if *x* is not in *s*	(see **in** operator)
s + *t*	Concatenation of *s* and *t*	
s[*i*]	*i*th item in *s*	First index is 0 Negative value for *i* is relative to len(s)
s[*i:j*]	Slice of *s* from *i* to *j*	(see index operator) *i* is starting index, *j* is end of slice If *i* is omitted, *i* is 0 If *j* is omitted or greater than len(s), *j* is len(s)
s[*i:j:k*]	Slice of *s* from *i* to *j* with step *k*	(see index operator)
len(*s*)	Length of *s*	
min(*s*)	Smallest item in *s*	Corresponds to ASCII code for strings
max(*s*)	Largest item in *s*	Corresponds to ASCII code for strings
s.**index**(*x*)	Index of first *x* in *s*	
s.**count**(*x*)	Total occurrences of *x* in *s*	

Concatenation

The first operator worthy of a little discussion is the concatenation operator (+). As you saw in the examples at the outset of this chapter, MEL concatenated two strings that we expected to be numbers. Python allows sequence concatenation in the same way. Concatenation creates a new sequence composed of all of the elements of the first sequence, followed by all of the elements in the second sequence. You can concatenate any sequence types, but only with other sequences of the same type. You cannot concatenate a list with a tuple, for instance.

The following line produces the string "Words make sentences."

```
'Words' + ' ' + 'make' + ' ' + 'sentences.';
```

Likewise, the following line produces the list [1, 2, 3, 4, 5, 6].

```
[1,2,3] + [4,5,6];
```

Indexing and Slicing

An important operator for sequence types is the index operator, represented by the square bracket characters ([and]). At its most basic, it corresponds to the index operator found in most languages. Note also that sequence types all use zero-based indices (Figure 2.2). For example, the following line results in just the "**c**" character, as it occupies index 2 in the string.

string value: a b c d e
indices: 0 1 2 3 4

■ **FIGURE 2.2** Sequences use zero-based indices.

tuple elements: 1 2 3 4 5
negative indices: -5 -4 -3 -2 -1

■ **FIGURE 2.3** Negative indices are relative to sequence length.

string value: H o l y c a t s , P y t h o n i s a w e s o m e
indices: 0 1 2 3 4 5 6 7 8 9 10 11 12 13 14 15 16 17 18 19 20 21 22 23 24 25 26 27

■ **FIGURE 2.4** Slicing a string from index 5 to 9.

```
'abcde'[2];
```

Because lists are mutable, you can also use this operator to set individual values for a list. The following line would result in the list [0, 2, 3].

```
[1,2,3][0] = 0;
```

However, because they are immutable, you cannot use the index operator to change individual items in a tuple or characters in a string. The following two lines would fail.

```
'abcde'[2] = 'C';
(1,2,3)[0] = 0;
```

You can use a series of index operators to access elements from sequences embedded in sequences. For instance, the following example will extract just the "**x**" character.

```
('another', 'example')[1][1];
```

Another important feature of Python's index operator is that it allows you to supply a negative index. Supplying a negative index gives the result relative to the length of the sequence (which is one index beyond the final element; Figure 2.3). For example, the following line would print the number 4.

```
print((1,2,3,4,5)[-2]);
```

Python's index operator also offers powerful, concise syntax for generating slices from sequences. You can think of a slice as a chunk extracted from a sequence. The most basic syntax for a slice includes two numbers inside the square brackets, separated by a colon. The first number represents the start index, and the second number represents the end index of the slice (Figure 2.4). Consider the following example.

```
var = 'Holy cats, Python is awesome';
```

You could print just the word "cats" using the following slice. Note that the letter "s" itself is index 8.

```
print(var[5:9]);
```

As you can see, the end index for the slice is the index just beyond the last element you want to include.

Slicing syntax assumes that you want to start at index 0 if the first number is not specified. You could print "Holy cats" with the following slice.

```
print(var[:9]);
```

If you omit the second number, or if it is greater than the sequence's length, it is assumed to be equal to the sequence's length. You could print just the word "awesome" using the following snippet. The start index is specified using a negative number based on the length of the word "awesome" at the end of the string.

```
print(var[-len('awesome'):]);
```

Or you could print the string "Python is awesome" using the following line. The start index is specified using the **index()** method, which returns the index of the first occurrence in the sequence of the item you specify.

```
print(var[var.index('Python'):]);
```

Slicing syntax also offers the option of providing a third colon-delimited number inside the square brackets. This third number represents the step count for a slice, and defaults to 1 if it is left empty. Consider the following variable.

```
nums = (1, 2, 3, 4, 5, 6, 7, 8);
```

The following line would return a tuple containing the first four numbers, (1, 2, 3, 4).

```
nums[:4:];
```

Specifying a skip value would allow you to return a tuple containing all of the odd numbers, (1, 3, 5, 7).

```
nums[::2];
```

Specifying a skip value and a start index would return a tuple with all of the even numbers, (2, 4, 6, 8).

```
nums[1::2];
```

You can also specify a negative number to reverse the sequence! For instance, the following line would return the tuple (8, 7, 6, 5, 4, 3, 2, 1).

```
nums[::-1];
```

String Types

As with numbers, there are in fact multiple string types, which Maya commands allow you to use interchangeably. Recall that a string is a sequence of numbers or characters inside of quotation marks that is treated as though it were a word. However, Python also allows you to prefix strings with special characters to create raw and Unicode strings. Each of these requires that we first introduce you to escape sequences.

Escape Sequences and Multiline Strings

Ordinarily, you must use what are known as escape sequences to include certain special characters in your strings, such as Unicode characters (**\u**), a new line (**\n**), a tab (**\t**), or the same type of quotation marks you use to define your string (**\'** or **\"**). You create an escape sequence by including a backslash (\) before a certain ordinary ASCII character to indicate that it is special. See Section 2.4.1 of Python Language Reference for more information.

Suppose, for instance, you want to create a string that includes quotation marks in it. Either of the following lines would be equivalent.

```
var = '"I\'m tired of these examples."';
var = "\"I'm tired of these examples.\"";
```

Each of these examples would print the following result:

```
"I'm tired of these examples."
```

Similarly, if you wanted to include a line break, you would use one of the following three examples. (Note that we omit semicolons at line endings here for demonstration, since we can assume this sample is short enough to print correctly.)

```
var = 'line 1\nline 2'
var = "line 1\nline 2"
var = """line 1
line 2"""
```

If you were to print `var`, each of these three examples would produce the same result.

```
line 1
line 2
```

Note that using a pair of triple quotation marks allows you to span multiple lines, where your return carriage is contained in the literal value. Recall that we mentioned in the introduction that Python also lets you use a backslash character at the end of the line to carry long statements onto a new line.

However, this pattern does not translate into a literal return carriage. Consider the following lines.

```
var = 'line 1 \
line 2'
```

Contrary to the triple-quotation-mark example, this variable would print the following result.

```
line 1 line 2
```

Raw Strings

Python supports what are called raw strings. A raw string, though still a string according to its underlying type, allows you to include backslashes without escaping them. You can include the **r** or **R** character prefix for your value to indicate that the value is a raw string, and that backslashes should not be presumed to escape the following character. The following two examples produce the same result.

```
var = 'C:\\Users\\Adam\\Desktop';
var = r'C:\Users\Adam\Desktop';
```

Raw strings can be helpful when creating directory paths or regular expressions. Regular expressions are special patterns that allow you to search string data for particular sequences. While they are invaluable, they are also complex enough that they merit entire books on their own, so we do not cover them here. Consult the companion web site for some tips on using regular expressions in Maya.

Unicode Strings

A Unicode string allows you to handle special characters, irrespective of region encoding. For example, with ordinary strings, each character is represented internally with an 8-bit number, allowing for 256 different possibilities. Unfortunately, while 256 characters may suffice for any one language, they are insufficient to represent a set of characters across multiple languages (e.g., Roman characters, Korean, Japanese, Chinese, Arabic). You can create a Unicode string by prefixing the character **u** or **U** onto the value. Their type is Unicode.

```
var = u'-5';
print(type(var));
```

You can include escape sequences to print special characters. A table of their values is publicly available at *ftp.unicode.org*. The following line uses the Unicode escape sequence **\u** to print a greeting to our German readers: "Grüß dich!"

```
print(u'Gr\u00fc\u00df dich!');
```

Unicode strings benefit from most of the same operators and functions available to ordinary strings. Section 5.6.1 of Python Standard Library lists a variety of useful built-in methods for strings. We strongly recommend browsing these built-in methods, because there are a number of incredibly useful ones that will save you loads of time when working in Maya. You can also pull up a list of string methods directly in your interpreter by calling the built-in **help()** function.

```
help(str);
```

You may have also noticed that Maya returns object names as Unicode characters when you execute commands. For example, if you create a new cube and print the result, the History Panel shows you a list of Unicode strings. You can verify this by printing the result of the polyCube command.

```
import maya.cmds;
print(maya.cmds.polyCube());
```

This example produces something like the following line of output.

```
[u'pCube1', u'polyCube1']
```

Formatting Strings

While MEL users will feel right at home simply concatenating strings, this approach can quickly become verbose and inefficient. For instance, the following example would print the string "There are 6 sides to a cube, and about 6.283185308 radians in a circle."

```
cube = 6;
pi = 3.141592654;
print(
    'There are '+str(cube)+
    ' sides to a cube, and about '+
    str(2*pi)+' radians in a circle.'
);
```

Apart from the tedium of casting your variables as strings, the value of 2π is unnecessarily verbose for human-readable output.

Fortunately, strings and Unicode strings in Python allow you to use powerful, concise formatting operations to increase efficiency, reduce verbosity, and alter the appearance of output. The basic approach is that you insert a % character in the string to initiate a formatting sequence, and then follow the string's value with another % character and a list of the arguments in order. The previous example could be rewritten in the following way.

```
cube = 6;
pi = 3.141592654;
print(
    'There are %s sides to a cube, and about %.2f radians in a
    circle'%(
        cube, 2*pi
    )
);
```

Table 2.5 Important String Formatting Patterns

Code	Meaning	Notes
d	Signed integer	Truncates decimal numbers
i	Signed integer	Truncates decimal numbers
e	Scientific notation	
f	Floating point	
g	Mixed floating point	Uses scientific notation if number is very small or very large
s	String	Same as using **str()** function with object

Using this formatting process, the result is now "There are 6 sides to a cube, and about 6.28 radians in a circle."

Section 5.6.2 of Python Standard Library provides information on more detailed options for string formatting, though we only use this basic paradigm throughout the book. The documentation also contains a list of available string formatting codes. We have listed some common patterns in Table 2.5.

The Python documentation also lists other flags that can accompany some of these codes. Though you should refer to Python's documents for more information, it is worth describing the precision modifier, as we use it occasionally.

Note that you can modify the precision that a decimal number will use by following the % character in the string with a period and number, before the formatting character. For example, the following lines create a variable pi and print it to five decimal places.

```
pi = 3.141592654;
print('%.5f'%pi);
```

More on Lists

Because lists are mutable, they have some properties not shared with other sequence types. For instance, as you have already seen, lists alone allow for individual element assignment using the index operator. However, lists have a couple of other unique properties worth briefly discussing.

del()

Just as you can alter items in a list using the index operator, you can delete items in a list using the **del()** function. For instance, the following example produces the list [0, 2, 3, 4, 5, 6, 7].

```
nums = [0,1,2,3,4,5,6,7];
del(nums[1]);
```

You also delete a slice from a list in the same way. The following example results in the list [0, 1, 4, 5, 6, 7].

```
nums = [0,1,2,3,4,5,6,7];
del(nums[2:4]);
```

Note in both cases that the original list is being modified. A new list is not being created. You can execute the following lines to confirm that the identity is intact.

```
nums = [0,1,2,3];
print('id before', id(nums));
del(nums[1:2]);
print('id after', id(nums));
```

Nested Lists

As you have seen up to this point, immutable objects, such as tuples, do not allow you to alter their values. Altering the value of a variable pointing to an object with an immutable type simply references new data altogether. However, as the index assignment and **del()** examples illustrated with lists, mutable objects can have their values modified. The consequence of this principle is that references to mutable types are retained when their values are mutated.

Consider the following example, which creates three immutable objects (numbers) and puts them inside a list.

```
a = 1;
b = 2;
c = 3;
abc = [a, b, c];
print(abc); # [1, 2, 3]
```

At this point, making further changes to the variables a, b, and c produces no change in the list abc.

```
a = 2;
b = 4;
c = 6;
print(abc); # [1, 2, 3]
```

■ **FIGURE 2.5** Variables pointing to mutable objects refer to the same data as collections containing the mutable objects.

You see no change in the list because, when you initially create the variables a, b, and c, they are all referencing immutable objects in memory. When you initialize the list using these variables, each element in the list is pointing to the same objects in memory. However, when you reassign the values of a, b, and c, they are referring to new data, while the elements in the list are still referring to the original data.

However, making changes to mutable objects, such as lists, will result in changes in other places the same objects are referenced (Figure 2.5). Consider the following example, which will print a tuple containing two lists: ([1, 3, 5, 7], [0, 2, 4, 6, 8]).

```
odds = [1, 3, 5, 7];
evens = [0, 2, 4, 6, 8];
numbers = (odds, evens);
print(numbers);
```

At this point, there are two lists, each pointing to a different, mutable location in memory. There is also a tuple, the elements of which are pointing to these same locations in memory. At this point, it is worth noting the identities of each of these variables.

```
print('odds', id(odds));
print('evens', id(evens));
print('numbers', id(numbers));
```

Now, you could make some adjustments to your lists, such as adding or removing elements. If you execute the following lines, you can see that the numbers tuple has new values when you modify the lists: ([1, 3, 5, 7, 9], [2, 4, 6, 8]).

```
odds.append(9);
del(evens[0]);
print (numbers);
```

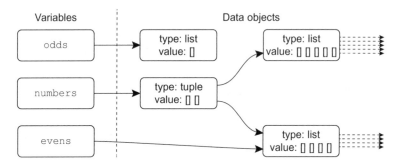

■ **FIGURE 2.6** Reassigning a variable simply points it to a new object.

Because tuples are immutable, you may be wondering how exactly you have changed the values in the tuple. Remember that the tuple contains two elements, each referencing the same location in memory as the respective lists. Because the lists are mutable, their values can be altered, and the reference is retained. If you print the variables' identities now, they should be identical to what they were before altering the lists.

```
print('odds', id(odds));
print('evens', id(evens));
print('numbers', id(numbers));
```

Note that although we demonstrated this principle by nesting lists in a tuple, it also applies to lists nested in lists. *The key feature is the mutability of lists: All other mutable types will produce the same behavior.* It is important that you understand this concept, as it becomes more important when you begin working with classes and objects in Chapter 5.

Finally, note that only mutations of mutable data, not reassignments of variables pointing to the data, affect other variables' values (Figure 2.6). The reason for this behavior is that the list outside the tuple (or list) is a reference to a data object, not to another variable (which is itself a reference to some object). The following lines illustrate that reassigning the odds list does not affect the object referred to inside the numbers tuple.

```
odds = [];
print(numbers);
```

OTHER CONTAINER TYPES

In addition to the basic sequence types, Python includes a couple of important container types. Although these types are not used with Maya commands directly, you will make frequent use of them in your own programs that use Maya commands. In this section we briefly introduce two containers: sets and dictionaries.

Sets

Section 5.7 of Python Standard Library describes sets as "an unordered collection of distinct hashable objects." While sets have many applications, the most common uses include membership testing and removing duplicates from a sequence. Note that sets are a mutable type. Python also implements a comparable type, frozenset, which is immutable.

Creating a set is as easy as using the **set()** constructor with an iterable type, such as any of the sequences we have discussed. For instance, you can create a set from a string or from a list.

```
set1 = set('adam@adammechtley.com');
set2 = set([1, 2, 3, 3, 5, 6, 7, 7, 7, 8, 9]);
```

If you were to print set2,

```
print(set2);
```

you would see the following output:

```
set([1, 2, 3, 5, 6, 7, 8, 9]);
```

As you can see, the set appears to be a version of the list that has had its duplicate elements pruned.

Operators

While sets implement many of the same operations as the sequence types we already discussed (e.g., **in** and **len()**), the fact that they are unordered means that they cannot make use of others (e.g., indexing and slicing). Table 2.6 lists important set operators.

While they fundamentally serve different purposes, sets can test membership more efficiently than ordinary sequences. Consider the following case.

```
nums = [1, 2, 3, 3, 5, 6, 7, 7, 7, 8, 9];
```

Table 2.6 Important Set Operators

Operation	Result
x **in** set	True if x is in set
x **not in** set	True if x is not in set
len(set)	Length of set
set \| other	New set with all elements from set and other
set **&** other	New set with only common elements from set and other
set − other	New set with elements in set that are absent in other
set ^ other	New set with elements in set or other, but not both

If you were writing a program that needed to test membership, you could simply use the **in** operator with the list.

```
8 in nums;
```

However, this operation effectively needs to test each of the items in the list in order. The fact that there are several duplicates in the list wastes computation time. Although this example is fairly simple, you can imagine how a very long list or a large number of membership tests might slow things down. On the other hand, you can put this list into a set.

```
numset = set(nums);
```

Testing membership on the set is much more efficient.

```
8 in numset;
```

While removing duplicates may seem like the source of the gain, the actual gain relates to the fact that the items in the set are hashable. Thinking back to our discussion of Python's data model, a hashable piece of data is one that will have a consistent identity for its lifetime—an immutable object. *While you can generate a set from a list, a list cannot be an item in a set!* The advantage to looking up items on the basis of a hash is that the cost of a lookup is independent of the size of the set.

Including an item in a set maintains an active reference to the data. Even if the object loses all of its other references, through reassignments or use of **del()**, the set maintains an active reference unless the item is specifically removed from the set using a built-in method, or the set itself is deleted.

Dictionaries

Another useful container type is the dictionary. Programmers coming from other languages will recognize the dictionary as a hash table. A dictionary is composed of a set of hashable (immutable) keys, each of which maps to an arbitrary object.

Like a set, because the keys in a dictionary are hashable, each key can only appear once, and therefore may only have one value associated with it. Moreover, the dictionary itself is a mutable object. Consequently, a dictionary cannot be a key in another dictionary, but it may be a value associated with a particular key in another dictionary.

Creating a dictionary is very simple, and is somewhat similar to lists and tuples. To create a dictionary, enclose a set of comma-delimited, colon-separated key-value pairs inside of curly braces ({ and }). For example, the following

assignment creates a dictionary with two keys—the strings "radius" and "height"—which have values of 2 and 5 associated with them, respectively.

```
cylinderAttributes = {'radius':2, 'height':5};
```

Remember that the keys may be any immutable type, and that the values may be anything. You could create a dictionary that maps numbers to their names (in German, no less).

```
numberNames = {1:'eins', 2:'zwei', 3:'drei'};
```

The keys also do not all need to be the same type. The following dictionary will map numbers to names, as well as names to numbers.

```
numberNames = {
    1:'one',2:'two',3:'three',
    'one':1,'two':2,'three':3
};
```

Operators

Section 5.8 of Python Standard Library includes operators and methods for dictionaries. We have included some of the most important ones in Table 2.7. While the first three operations should be pretty clear by this point, two of the remaining items in our table merit some discussion.

Because dictionaries are a table of hashable objects, the items in a dictionary have no order, much like a set. Consequently, there is no concept of slicing in a dictionary. However, unlike sets, dictionaries implement the square bracket operator. Instead of supplying a dictionary with an index, however, you supply it with a hashable object. For instance, the following snippet would print the name "two" associated with the number 2.

```
numberNames = {1:'one', 2:'two', 3:'three'};
print(numberNames[2]);
```

Table 2.7 Important Dictionary Operators

Operation	Result	Notes
key **in** d	True if key is in d	
key **not in** d	True if key is not in d	
len(d)	Length of dictionary	
d[key]	Value (object) corresponding to key	
d.**keys**()	List of all keys in the dictionary	
d.**setdefault**(key)	Value corresponding to key if it exists, otherwise None	Optional default value

Because dictionaries are mutable, you can use this operator not only to get an object but also to set it. The following lines assign Polish names to our number keys.

```
numberNames[1] = 'jeden';
numberNames[2] = 'dwa';
numberNames[3] = 'trzy';
```

In this respect, you can almost think of dictionaries as a table of mailing addresses: The occupant at each particular address can change, but the address will still be present. What happens then if you try to access an address that does not exist?

Conveniently, any time you set the value for a key that does not yet exist, it is simply added to the dictionary. You could execute the following line to add another item to your dictionary.

```
numberNames[4] = 'cztery';
```

However, if you try to access a key that does not yet exist, you will get a **KeyError**, as in the following line.

```
print(numberNames[5]);
```

Thus, querying a key that does not yet exist would throw an exception and stop execution of your program. Thankfully, dictionaries implement a **setdefault()** method, which, if a key exists, will return its value. If a key does not exist, the method will add the key and assign a value of None to it. Optionally, you can supply a parameter for this method that, if the key does not exist, will become its default value. The following line will add a new entry with the key 5 and value "pięć" that will be printed.

```
print(numberNames.setdefault(5, u'pi\u0119\u0107'));
```

Bardzo dobrze!

Dictionaries in Practice

Dictionaries, though perhaps initially confusing for newcomers, are powerful objects in practice, especially when working with Maya commands. To take one example, Python developers can use dictionaries to map rotation orders.

In Maya, some commands return or specify rotation order as a string, such as "xyz" or "zxy". The following example demonstrates how xform is one such command, and will print "xyz" when querying a locator's rotation order.

```
import maya.cmds;
loc = maya.cmds.spaceLocator()[0];
print(maya.cmds.xform(loc, q=True, rotateOrder=True));
```

Internally to Maya, however, rotation order is a special kind of type, called an enumerated type. While we will discuss enumerated types in greater detail when exploring the API, the basic idea is that each different rotation order sequence corresponds to an integer. Consequently, using the getAttr and setAttr commands with rotation order requires use of an integer in Python. The following example demonstrates this issue, and will print "0" when using getAttr to get a rotation order.

```
import maya.cmds;
loc = maya.cmds.spaceLocator()[0];
print(maya.cmds.getAttr('%s.rotateOrder'%loc));
```

As you can imagine, intermixing such commands can be an annoyance.

Fortunately, you can easily create dictionaries to help with this problem. One dictionary can map strings to integers, and the other can map integers to strings.[4]

```
roStrToInt = {
    'xyz':0,'yzx':1,'zxy':2,
    'xzy':3,'yxz':4,'zyx':5
};
roIntToStr = {
    0:'xyz',1:'yzx',2:'zxy',
    3:'xzy',4:'yxz',5:'zyx'
};
```

Armed with these two dictionaries, you could do something like the following example to set the rotation order of a cube and a joint to zxy.

```
import maya.cmds;
cube = maya.cmds.polyCube()[0];
maya.cmds.setAttr(
    '%s.rotateOrder'%cube,
    roStrToInt['zxy']
);
rotateOrder = maya.cmds.getAttr('%s.rotateOrder'%cube);
joint = maya.cmds.joint(
    rotationOrder=roIntToStr[rotateOrder]
);
```

[4]For a dictionary where all the values are known to be unique, a concise technique to automatically generate an inverse mapping, which we avoid here for the sake of clarity and also progress in the text, would be inverseMap = dict((val, key) for key, val in originalMap.iteritems()).

CONCLUDING REMARKS

Any useful programming task requires the use of variables. You have seen in this chapter how variables in Python differ from those in MEL and C++, and you have explored much of their underlying mechanics. You are now able to work effortlessly with many of Python's principal built-in objects, and also have a strong foundation for understanding a range of complex topics that we will explore in this text. The stage is now set to start developing programs with functions, conditional statements, loops, and more.

Writing Python Programs in Maya

BY THE END OF THIS CHAPTER, YOU WILL BE ABLE TO:

■ Describe what functions are.

■ Create Python functions using the **def** keyword.

■ Describe and leverage Python's different function argument types.

■ Use **return** statements to pass information between functions.

- Execute some common Maya commands.
- Exploit the **for** statement to create loops.
- Use the **range()** function to emulate **for** loops in MEL.
- Leverage conditional statements for branching and flow control.
- Mimic MEL ternary and **switch** statements using Python analogs.
- Create a loop using the **while** statement.
- Handle exceptions and errors in your code.
- Build the framework for a basic texture processing tool.

So far we have introduced you to some basic Maya commands and the essentials for understanding data and variables in Python. Nevertheless, you still need some more fundamentals to start creating Python programs.

In this chapter, we walk through a simple texture-processing framework for Maya as we introduce functions, the building blocks for complex programs. We begin by learning how to declare a function in Python and return data from it. We then explore different methods for controlling code execution using Python's sequence types and looping statements. Next, we demonstrate how to further control execution using Python's conditional statements and branching capabilities. We conclude our exploration of functions by learning techniques for handling exit cases, including error and exception handling and returns. Finally, we incorporate all the major topics of this chapter into a set of functions that work with Maya commands to process textures.

CREATING PYTHON FUNCTIONS

The term *function* carries specific connotations in different programming circles. *For our purposes, a function is a grouping of statements, expressions, and commands that can be accessed using a developer-defined name and that can optionally act on developer-supplied input parameters.* Functions can be thought of as the building blocks of large programs in that they can be reused in different contexts to act on different data sets. A Python function is analogous to MEL's procedures.

Anatomy of a Function Definition

Similar to how a MEL procedure is defined with the keyword **proc**, a Python function is declared using the **def** keyword, followed by a name, a set of parentheses that encloses definitions for optional input arguments, and a colon.

```
def function_name(optional, input, parameters):
    pass;
# This line is no longer part of the function
# optional, input, and parameters have no meaning here
```

As we noted in this book's introduction, Python is very particular about whitespace. The lines following the colon, inside the function block, must be indented. All lines at or below the indentation level following the **def** keyword are taken to be part of the function's body of executable statements, up until a line at the same indentation level as the **def** keyword.

In our hypothetical example, we included the **pass** keyword inside of the function's body to indicate where code would be. Normally, you would put a set of executable statements inside the function. Python offers the **pass** keyword as a placeholder where something is syntactically required (executable statements in this case). We could substitute in a line to print a message in our own function.

1. Execute the following lines in the Script Editor to define **process_all_ textures()**. This function prints a simple string. (Note that we will be altering this function throughout this chapter, so it is advisable that you highlight it and execute it using **Ctrl + Enter** so it is not cleared from the Script Editor's Input Panel.)

    ```
    def process_all_textures():
        print('Process all textures');
    ```

Since the **print()** line is encapsulated in the function definition, executing this code in the Script Editor does nothing—or at least nothing immediately obvious.

Recall the definition we offered for the term *function*. The key phrase in our definition is that a function is "accessed by a developer-defined name." When you execute a function *definition*, the definition is registered with the Python interpreter, much like a name for a variable. Python is then aware of the function, the statements contained within it, and the name by which those statements should be called.

2. Execute the following line in the Script Editor to display the type associated with the name of the function you just defined.

    ```
    type(process_all_textures);
    ```

 As you can see, the name process_all_textures is like any other name you define, but is associated with an object of type function.

    ```
    # Result: <type 'function'> #
    ```

3. Likewise, you can define another name that points to the same object, just like you can with variables. Execute the following lines in the Script Editor to bind another name to your function, and then compare the identities associated with both names.

```
processAllTextures = process_all_textures;
print('Ref 1: %s'%id(process_all_textures));
print('Ref 2: %s'%id(processAllTextures));
```

Your output should show that the identities for both references are the same.

Executing a function is referred to as *calling* a function. To instruct Python to call a function, the function name needs to be supplied to the interpreter, followed by parentheses containing values to pass to the function.

4. Execute the following lines in the Script Editor to call your function using both of the names you bound to it.

```
process_all_textures();
processAllTextures();
```

While simply using the function's name returns a reference to it (as you saw in steps 2 and 3), entering a set of parentheses after the name instructs Python to execute its statements. Consequently, you should see the following lines of output.

```
Process all textures
Process all textures
```

While functions allow you to execute any number of statements inside their bodies, including Maya commands, their real value comes from including arguments.

Function Arguments

Recall the template we offered for function definitions in the previous section.

```
def function_name(optional, input, parameters):
    pass;
```

The names optional, input, and parameters enclosed in the parentheses are called *arguments*. Arguments are used to further customize a function by allowing the developer to provide data to the function from the calling context. While a function does not require arguments in its definition, arguments are one of the first steps required to make functions reusable. They are the primary mechanism for customizing the behavior of a function.

One of the shortcomings of the current implementation of **process_all_textures()** is the fact that every time this function is called from somewhere else, otherwise known as the calling context, it will produce the same result every time. Optimally, the function should be able to be called in different contexts and act upon specified textures.

As you saw in our template, the simplest type of argument is a named parameter, declared along with the function's name as part of the **def** statement. The function can then access this parameter by name in code and exists for the duration of the function's execution. In this case, we say that the scope of the parameter name is inside of the function. As we hinted a moment ago, scope in Python is determined by indent levels, which are analogous to curly braces in MEL.

```
def a_function():
    inside_func_scope = 0;
outside_func_scope = 1;
"""
The following line would produce a NameError since
inside_func_scope does not exist outside of a_function()
"""
outside_func_scope = inside_func_scope;
```

We can add an argument to the scope of **process_all_textures()** by changing the function definition.

5. Execute the following lines to alter the function definition for **process_all_textures()**.

    ```
    def process_all_textures(texture_node):
        print('Processed %s'%texture_node);
    ```

 At this point, you could now pass an argument to this function to change its behavior. Whatever argument is passed is bound to the name `texture_node` when executing statements inside the function's body.

6. Execute the following lines of code to create a new **file** node and pass it to the **process_all_textures()** function.

    ```
    import maya.cmds;
    texture = maya.cmds.shadingNode('file', asTexture=True);
    process_all_textures(texture);
    ```

 As you can see, the function has printed the name of the new node that you passed to it, instead of a static statement.

    ```
    Processed file1
    ```

The important point is that Python maps the incoming reference to the internal name for the argument. Although the node name is assigned to

a variable called `texture` in the calling context, this variable maps to `texture_node` once execution enters the function body. However, the function now requires that an argument be passed.

7. Try to call the **process_all_textures()** function without specifying any arguments.

```
process_all_textures();
```

You can see from the output that Python has thrown an error and told you that you have specified the wrong number of arguments.

```
# Error: TypeError: file <maya console> line 1:
process_all_textures() takes exactly 1 argument
(0 given) #
```

The new declaration of **process_all_textures()** dictates that the function must now be called with an argument.

8. Note also that functions can be made to support multiple arguments by adding a comma-delimited list of names to the function definition. Execute the following lines to redefine the **process_all_textures()** function, requiring that it take two arguments.

```
def process_all_textures(texture_node, prefix):
    print('Processed %s%s'%(prefix, texture_node));
```

9. Execute the following lines to call **process_all_textures()** and pass its two arguments.

```
process_all_textures(texture, 'my_');
```

You should now see the following output.

```
Processed my_file1
```

As before, arguments defined in this manner are required to be passed with the function call. Otherwise, Python returns an error indicating the number of arguments required and the number found. However, Python provides many different approaches for declaring and passing arguments that help relax these restrictions somewhat. Arguments can be default arguments, keyword arguments, and variable-length argument lists.

Default Arguments

Default arguments are values defined along with the function's arguments, which are passed to the function if it is called without an explicit value for the argument in question.

10. Execute the following lines to assign a default value to the `prefix` argument in the **process_all_textures()** function definition.

```
def process_all_textures(texture_node, prefix='my_'):
    print('Processed %s%s'%(prefix, texture_node));
```

By assigning the value "my_" to the `prefix` argument in the function's declaration, you are ensuring that the prefix input parameter will always have a value, even if one is not supplied when the function is called.

11. Execute the following line to call the function again with its changes.

```
process_all_textures(texture);
```

This time, the output shows you that the `prefix` name used the default value "my_" inside the function body, even though you specified no prefix.

```
Processed my_file1
```

You may have noticed that it is not required that every argument carry a default value. As long as the function is called with a value for every argument that has no default value assigned, and as long as the function body can properly handle the type of incoming arguments, the function should execute properly.

As an aside, it is worth briefly noting that a default argument's value can also be None, which allows it to be called with no arguments without raising an error.

```
def a_function(arg1=None):
    pass;
a_function(); # this invocation works
```

Returning to **process_all_textures()**, it is worth mentioning that our definition now contains two different types of arguments. The first argument, `texture_node`, is called a positional argument. On the other hand, the definition you created in step 8 contained two positional arguments.

Positional input parameters are evaluated based on the order in which they are passed to the function and are absolutely required by the function to run. In the preceding definition, the first parameter passed into the function will be mapped to the `texure_nodes` name, while the second parameter will be mapped to `prefix`. As you can imagine, you could run into problems if you accidentally passed your arguments out of order. Fortunately, an input parameter can be mapped to a specific position if it is passed as a keyword argument.

Keyword Arguments

Keyword arguments are a form of input parameter that can be used when calling a function to specify the variable in the function to which the supplied data are bound.

12. Execute the following lines to redeclare the **process_all_textures()** function.

```
def process_all_textures(
    texture_node=None, prefix='my_'
):
    print('Processed %s%s'%(prefix, texture_node));
```

If the function were declared in this manner, any of the following calls would be *syntactically* valid, though the first one wouldn't produce an especially useful result.

```
# no arguments
process_all_textures();
# single positional argument
process_all_textures(texture);
# multiple positional arguments
process_all_textures(texture, 'grass_');
```

All of these examples rely on default values and positional arguments to pass data. Passing a keyword argument, on the other hand, allows you to specify a parameter in the form keyword=value. Passing an argument by keyword allows the caller to specify the name to which the argument will be bound in the function body.

13. Recall that when passing positional arguments, each argument is evaluated in the order it is passed. Execute the following call to **process_all_textures()**.

```
process_all_textures('grass_', texture);
```

Because the string intended to be used as `prefix` was passed as the argument in the first position (position 0) the function produces the wrong output.

```
Processed file1grass_
```

14. Passing each argument by keyword alleviates this problem. Execute the following line to pass keyword arguments (a syntax that should look familiar).

```
process_all_textures(
    prefix='grass_',
    texture_node=texture
);
```

While these techniques of argument passing do provide a fair bit of flexibility, there are two issues to be aware of, both of which are closely related. *The first issue is that positional arguments must come before keyword arguments, both in the function declaration and when calling the function. The second issue is that an argument can be passed by position or by keyword, but not both.*

In the current definition of **process_all_textures()**, `texture_node` is the argument at position 0 and `prefix` is the argument at position 1. Calling **process_all_textures()** with the following arguments would produce an error.

```
process_all_textures('grass_', texture_node=texture);
```

Because a positional argument is passed to **process_all_textures()** in position 0 in this situation, the variable at position 0 (`texture_node` in this case) is already bound by the time that Python attempts to map `texture` to it as a keyword argument.

Variable-Length Argument Lists with the * Operator

In addition to the cases we have examined so far, there are also situations in which you may need to implement functions that can take an unspecified number of variables. To address this situation, Python provides variable-length argument lists. Variable-length argument lists allow a developer to define a function with an arbitrary number of arguments.

15. Execute the following code to modify the **process_all_textures()** definition to support a variable-length argument list.

```
def process_all_textures(*args):
    print(args[0], args[1:]);
```

16. The function can now be called with a variety of different argument patterns. Execute the following lines to create new **file** nodes (textures) and then use different invocations for the function.

```
tx1 = maya.cmds.shadingNode('file', asTexture=True);
tx2 = maya.cmds.shadingNode('file', asTexture=True);
tx3 = maya.cmds.shadingNode('file', asTexture=True);
tx4 = maya.cmds.shadingNode('file', asTexture=True);
process_all_textures('grass_');
process_all_textures('grass_', tx1);
process_all_textures('grass_', tx2, tx3, tx4);
```

You should see the following output lines, indicating that each call was successful.

```
('grass_', ())
('grass_', (u'file2',))
('grass_', (u'file3', u'file4', u'file5'))
```

Although this particular syntax isn't terribly useful for our current case, the main issue to be aware of in this example is the use of the asterisk (*) operator in the function declaration.

```
def process_all_textures(*args):
```

This operator, when prefixed in front of an argument, instructs the Python interpreter to pack all of the arguments passed to the function into a tuple and to pass that tuple to the function, as opposed to passing each argument individually. Any name can be used to declare a variable-length argument list in a function declaration as long as the asterisk (*) operator precedes the name, though convention is to use the name `args`.

In this implementation, the function assumes that the data at position 0 correspond to a prefix, and that all further arguments in the slice from 1 onward are texture names. Consequently, the current implementation requires at least one positional argument for the function to execute.

Recall that we passed each of the **file** nodes as individual arguments in step 16. The asterisk operator can also be used in the function call to pass the arguments differently. When used in this manner, the asterisk instructs the Python interpreter to unpack a sequence type and use the result as positional arguments.

17. Execute the following lines to pack the **file** nodes you created in step 16 into a list and pass the list to the function.

```
node_list = [tx1, tx2, tx3, tx4];
process_all_textures('grass_', node_list);
```

As you can see in the output, the list itself is contained in a tuple.

```
('grass_', ([u'file2', u'file3', u'file4', u'file5'],))
```

18. Passing `node_list` using the asterisk operator fixes this problem. Execute the following line to call your function and have it unpack the list of **file** node names.

```
process_all_textures('grass_', *node_list);
```

You should see output like that in step 16, confirming that the operation was successful.

```
('grass_', (u'file2', u'file3', u'file4', u'file5'))
```

Variable-Length Keyword Argument Lists with the ** Operator

Python also allows for variable-length keyword argument lists. The syntax is almost identical to a positional variable-length list. Variable-length keyword argument lists are declared using the double asterisk (**) operator. The double asterisk operator tells the interpreters to pack all key-value pairs passed to the function into a dictionary.

19. Execute the following changes to the **process_all_textures()** definition to add a variable-length keyword argument, `kwargs`.

```
def process_all_textures(**kwargs):
    pre = kwargs.setdefault('prefix', 'my_');
    texture = kwargs.setdefault('texture_node');
    print('%s%s'%(pre, texture));
```

Recall from Chapter 2 that the **setdefault()** function is a special type of function associated with dictionary objects. This function searches the associated dictionary for the key specified in the first positional argument, returning a value of None if a second positional argument is not specified. In this case, the `pre` variable is initialized to "my_" if the `prefix` keyword is not set, while the `texture` variable is initialized to None if the `texture_node` keyword is not specified.

20. Execute the following lines to test different syntax patterns for the **process_all_textures()** function.

```
# calling with no keywords does nothing
process_all_textures();
# calling with an unhandled keyword produces no error
process_all_textures(file_name='default.jpg')
# specifying the 'texture_node' key will process file1
process_all_textures(texture_node=texture);
```

You should see the following output, confirming that each invocation worked as expected. The first two completions are from executions that did nothing, while the third prints a new name for `texture`. Keywords that you do not explicitly handle in your function are simply ignored.

```
my_None
my_None
my_file1
```

21. As with the single asterisk operator, the double asterisk can also be used to expand a dictionary and pass it to a function as a list of keyword arguments. Execute the following code to create an argument dictionary to pass to the function.

```
arg_dict = {
    'prefix':'grass_',
    'texture_node':tx1
};
process_all_textures(**arg_dict);
```

In addition to offering you a variety of options for how to construct your functions, pass arguments, and handle incoming parameters, Python's flexible syntax for working with functions also offers you many opportunities

to make your code much more readable, rather than relying on cryptic variable names being passed in an arbitrary order.

Return Values

While passing arguments to functions is a basic requirement for doing useful work, so, too, is returning data. Mutable objects, such as lists, can simply be passed as arguments to a function, and any mutations you happen to invoke inside your function are reflected in the calling context when the function has concluded. For instance, the following example creates a new empty list, mutates it inside a function, and then prints the list in the calling context to indicate that its mutations have affected the object in the calling context.

```
def mutate_list(list_arg):
    list_arg.append(1);
    list_arg.append(2);
    list_arg.append(3);
a_list = [];
mutate_list(a_list);
print(a_list);
# prints: [1, 2, 3]
```

On the other hand, immutable objects are not affected in the same way, as their values cannot be changed. Incrementing a number's value inside of a function, for example, has no result on the variable passed to the function in the calling context.

```
def increment_num(num):
    num += 1;
n = 1;
increment_num(n);
print(n);
# prints: 1
```

Moreover, in some cases, you actually want a function to perform some operation and yield a result that you wish to store in a new variable altogether. In such cases, you will want to use a **return** statement to send the function's results back to the calling context. Implementing the **return** statement in a function causes it to immediately and silently exit, sending the value specified to the right of the keyword back to the calling context.

22. Execute the following lines to modify the **process_all_textures()** function. It now renames the supplied **file** node using the `rename` command and returns the result of the operation to the calling context.

```
def process_all_textures(**kwargs):
    pre = kwargs.setdefault('prefix', 'my_');
```

```
        texture = kwargs.setdefault('texture_node');
        return maya.cmds.rename(
            texture,
            '%s%s'%(pre, texture)
        );
```

23. Execute the following lines to rename the **file** node specified by `tex-`
`ture` using the **process_all_textures()** function and store the new value
in the `texture` variable.

```
texture = process_all_textures(texture_node=texture);
print(texture);
# prints: my_file1
```

As you can see, the new version of the function in fact returns the value returned
by the `rename` command, which is the new name of the object. Return values
are an essential part of designing useful functions, particularly in cases where
you are working with immutable objects. We'll keep working on this function
throughout this chapter to introduce some further language features, but it is
worth briefly returning to Maya commands for a moment before proceeding.

MAYA COMMANDS

At this point, you have probably noticed that functions resemble the Maya
commands you have seen so far. In fact, Maya's commands are all func-
tions! (You may have already used the built-in **type()** function with some
commands' names and discovered this fact.)

Recall that we noted in Chapter 1 that MEL syntax requires command argu-
ments to follow flag arguments, while Python requires the opposite order.
At this point, it is hopefully clear why Python requires its syntax for working
with commands: In Python, command arguments are simply a variable-length
argument list, while flag arguments are variable-length keyword arguments.
For instance, in the following example, we create a sphere and then execute
the `polySphere` command in edit mode, passing it first the name of the object
and then a series of keyword arguments to set values for the command flags.

```
import maya.cmds;
sphere = maya.cmds.polySphere();
maya.cmds.polySphere(
    sphere[1], edit=True,
    radius=5, sh=16, sa=16
);
```

Remember that we pointed out that commands like `polySphere` return a
list containing a **transform** node and another node (a **polySphere** node in
this case).

```
print(maya.cmds.polySphere());
# prints: [u'pSphere2', u'polySphere2']
```

In addition to capturing this return value in a list, you can use special Python syntax to unpack each individual list item in a separate variable, just as you can for ordinary Python functions that return sequences.

```
cube_xform, cube_shape = maya.cmds.polyCube();
print(cube_xform); # prints: pCube1
print(cube_shape); # prints: polyCube1
```

Although we have introduced a number of Maya commands already, such as those for creating basic objects and working with attributes, it is worth briefly pointing out a couple more common ones that we will use throughout this book. Developers accustomed to MEL will already recognize these commands and should be fairly comfortable with their syntax.

Listing and Selecting Nodes

The basic command for retrieving a list of nodes in the scene is the `ls` command.

1. Open a new Maya scene and execute the following lines to store a list of all the nodes in the scene and print it. You should see a number of default scene nodes, including time1, sequenceManager1, renderPartition, and so on.

   ```
   import maya.cmds;
   nodes = maya.cmds.ls();
   print(nodes);
   ```

2. The `ls` command also allows you to pass a string specifying the type of objects you would like in your list. Execute the following lines to store all of the **transform** nodes in the scene in the `nodes` variable and print the list.

   ```
   nodes = maya.cmds.ls(type='transform');
   print(nodes);
   ```

 You should see a list of camera **transform** nodes.

   ```
   [u'front', u'persp', u'side', u'top']
   ```

3. You can also pass strings as positional arguments containing an optional wildcard character (*) to store all objects of which the names match the pattern (as well as any other additional filters you specify using flag arguments). Execute the following lines to store and print the list of nodes of which the names begin with "persp".

```
nodes = maya.cmds.ls('persp*');
print(nodes);
```

You should see a list containing the **transform** and **shape** nodes for the perspective camera.

```
[u'persp', u'perspShape']
```

4. Another handy, basic command is the `select` command, which allows you to populate the current global selection list. Like the `ls` command, the `select` command allows you to specify a wildcard character in its arguments. Execute the following lines to select the **transform** and **shape** nodes for the top and side cameras.

```
maya.cmds.select('side*', 'top*');
```

5. You can also use the `sl/selection` flag with the `ls` command to list the currently selected items. Execute the following line to print the current selection.

```
print(maya.cmds.ls(selection=True));
```

You should see that you have the **transform** and **shape** nodes for the top and side cameras currently selected.

```
[u'side', u'sideShape', u'top', u'topShape']
```

6. Both the `ls` and `select` commands allow you to pass either a list or any number of arguments. Execute the following line to create a list of items to select, and then select it and print the selection. You should see the same items in the `selection_list` variable in the output.

```
selection_list = ['front', 'persp', 'side', 'top'];
maya.cmds.select(selection_list);
print(maya.cmds.ls(sl=True));
```

7. You can use the `select` command in conjunction with the `ls` command to select all objects of a certain type. Execute the following lines to select all of the **shape** nodes in the scene and print the current selection.

```
maya.cmds.select(maya.cmds.ls(type='shape'));
print(maya.cmds.ls(sl=True));
```

You should see the following output, indicating you have selected all of the camera **shape** nodes.

```
[u'frontShape', u'perspShape', u'sideShape',
 u'topShape']
```

The `file` **Command**

The `file` command provides a basic interface for working with Maya scene files.[1] It uses a number of flags to alter its behavior as needed.

1. Execute the following lines to open a new Maya scene.

```
import maya.cmds;
maya.cmds.file(new=True, force=True);
```

The `force` flag allows you to bypass the dialog box that would ordinarily appear, asking if you wanted to save changes.

2. Execute the following lines to create a new cube in the scene and save it to your home folder (Documents folder in Windows) as cube.ma.

```
import os;
maya.cmds.polyCube();
maya.cmds.file(
    rename=os.path.join(
        os.getenv('HOME'),
        'cube.ma'
    )
);
maya.cmds.file(save=True);
```

As you can see, the `rename` flag allows you to set the name for the file (as if performing a Save As operation), while the `save` flag allows you to save the file to the specified location. Note that the `rename` flag must be invoked by itself.

3. Execute the following line to open a new scene.

```
maya.cmds.file(new=True, force=True);
```

4. At this point, you can specify a command argument giving the location of a file you wish to open in conjunction with the `open` flag. Execute the following line to reopen the cube.ma file you saved in step 2.

```
maya.cmds.file(
    os.path.join(
        os.getenv('HOME'),
        'cube.ma'
    ),
    open=True,
    force=True
);
```

[1]Note that Python itself provides other tools for manipulation of arbitrary files. See Chapter 7 for an example.

Adding Attributes

Although getting, setting, connecting, and disconnecting attributes are all useful tasks, it is also possible to add custom attributes to objects in Maya. Such attributes are then compatible with all of the attribute manipulation commands we discussed in Chapter 2.

1. Execute the following lines to open a new scene, create a sphere named "Earth", and add a mass attribute to its **transform** node.

```
import maya.cmds;
maya.cmds.file(new=True, f=True);
sphere_xform, sphere_shape = maya.cmds.polySphere(
    n='Earth'
);
maya.cmds.addAttr(
    sphere_xform,
    attributeType='float',
    shortName='mass',
    longName='mass',
    defaultValue = 5.9742e24
);
```

2. You can now get and set this attribute like any other. Execute the following line to print the mass of Earth.

```
print(maya.cmds.getAttr('%s.mass'%sphere_xform));
```

Note that some types of attributes do not use the `attributeType` flag, but instead use the `dataType` flag. Execute the following lines to add another attribute to Earth to store an alternate name on it.

```
maya.cmds.addAttr(
    sphere_xform,
    dataType='string',
    shortName='alt',
    longName='alternateName'
);
```

3. When setting a string attribute like this one, you must specify a `type` flag when invoking the `setAttr` command. There are some other types bound to the same requirements, and they are documented in Maya's Python Command Reference. Execute the following lines to assign a value to the new **alternateName** attribute.

```
maya.cmds.setAttr(
    '%s.alternateName'%sphere_xform,
    'Terra',
    type='string'
);
```

4. Note that you can specify and then subsequently access both long and short names for custom attributes. Execute the following line to print the alternate name for Earth using the short name for its custom attribute.

```
print(maya.cmds.getAttr('%s.alt'%sphere_xform));
# prints: Terra
```

ITERATION AND BRANCHING

Now that you understand the basics of functions and have familiarity with a range of common Maya commands, we can return to our texture-processing function to improve it. Let's look at it in its current state.

```
def process_all_textures(**kwargs):
    pre = kwargs.setdefault('prefix', 'my_');
    texture = kwargs.setdefault('texture_node');
    return maya.cmds.rename(
        texture,
        '%s%s'%(pre, texture)
    );
```

In its present form, the function isn't especially remarkable—it can rename a single **file** node and return the new name. What happens if we fail to pass it a texture_node argument, or if we want to process multiple textures? Fortunately, you can use features such as iteration and branching to add sophisticated behavior to custom functions.

The for Statement

Any developer with experience writing Maya tools in MEL is undoubtedly familiar with a common development requirement: Iterate over a set of scene objects and process each object based on a condition or set of conditions. *Iteration is a technique that allows you to execute a set of statements repeatedly.*

Much like MEL, Python implements the **for** statement, which allows developers to loop through a collection of items, such as a sequence type. The **for** statement takes the following basic form.

```
for item in collection:
    perform_task(item);
```

This block of code instructs the Python interpreter to take the following steps:

- Iterate over every element in the collection object.
- Temporarily bind the element in the current iteration of collection to the name item.

- Pass the item name into the **for** loop.
- Execute statements in the **for** loop block.

The **in** keyword is a special operator that applies only to collection types. Recall that we mentioned in Chapter 2 that this operator returns True if the given item is found in a sequence. For example, the following snippet would print True.

```
print(5 in [1, 2, 5]);
```

When creating a **for** loop, the **in** operator has a slightly different meaning. It is the mechanism for binding the current item in the iteration of the collection (on the right of the operator) to the name for the item in the current step (on the left of the operator). Consider the following example.

```
sequence = [1, 2, 3];
for item in sequence:
    print(item);
```

This loop executes the **print()** function once for each item in the sequence list. The loop first prints 1, then 2, then 3.

Python's syntax differs significantly from the MEL **for** statement, which uses the following basic form.

```
for ($lower_bound; halting_condition; $step)
{
    perform_task();
}
```

For example, the following **for** loop in MEL would print numbers 1, 2, and 3.

```
for ($i=1; $i<=3; $i++)
{
    print($i+"\n");
}
```

range()

While Python's basic **for** statement is sufficient for most (in fact, almost all) cases, the MEL **for** syntax can be emulated in Python using the **range()** function. This simple and useful function can be used to generate a numeric progression in a list. It allows you to iterate over a list of numbers without having to define a literal list for iteration. Consider the following examples.

```
# following line prints [0, 1, 2, 3, 4]
print(range(5));
# following line prints [2, 3, 4, 5]
print(range(2,6));
# following line prints [4, 6, 8, 10, 12, 14, 16, 18]
```

```
print(range(4,20,2));
# following line prints [0, 1, 2]
print(range(len(['sphere','cube','plane'])));
```

As you can see, the **range()** function allows you to pass up to three arguments (much like the sequence slicing syntax we investigated in Chapter 2). It can take the following forms.

```
# following call returns numeric progression
# from 0 to upper_limit-1
range(upper_limit);
# following call returns numeric progression
# from lower_bound to upper_limit-1
range(lower_bound, upper_limit);
# following call returns numeric progression
# from lower_bound to upper_limit-1, using step value
range(lower_bound, upper_limit, step);
```

Because the **range()** function returns a list, you can also apply a slice to reverse it if you like.

```
# following line prints [4, 3, 2, 1, 0]
print(range(0,5)[::-1]);
```

The **range()** function can be used to generate an index for every element in a given sequence type, and thereby emulate a MEL-style **for** loop, as in the following examples.

```
"""
MEL equivalent:
string $a_list[] = {"spam","eggs","sausage","spam"};
for ($i=2; $i<size($a_list); $i++)
    print($a_list[$i]+"\n");
"""
a_list = ['spam', 'eggs', 'sausage', 'spam'];
for i in range(2, len(a_list)):
    print(a_list[i]);
"""
MEL equivalent:
int $nums[] = {1,2,3,4,5};
for ($i=0;$i<size($nums);$i+=2)
    print($nums[$i]+"\n");
"""
nums = [1,2,3,4,5];
for i in range(0,len(nums),2):
    print(nums[i]);
```

In addition to using the **range()** function to generate a numeric progression with an upper bound, you can also emulate a **for** loop with a halting condition

by slicing the iterated sequence up to the desired upper bound, as in the following example.

```
"""
MEL equivalent:
int $nums[] = {1,2,3,4,5,6,7};
for ($i=0; $i<5; $i++)
    print($nums[$i]+"\n");
"""
nums = [1,2,3,4,5,6,7];
for i in nums[:5]:
    print(i);
```

Let's modify our **process_all_textures()** function to be a bit more useful.

1. Execute the following lines to redefine the **process_all_textures()** function. As you can see, it now searches for a `texture_nodes` keyword. It will iterate through all of the items in the collection specified with this keyword, rename them all, and append them to a `new_texture_names` list to return.

```
import maya.cmds;
def process_all_textures(**kwargs):
    pre = kwargs.setdefault('prefix', 'my_');
    textures = kwargs.setdefault('texture_nodes');
    new_texture_names = [];
    for texture in textures:
        new_texture_names.append(
            maya.cmds.rename(
                texture,
                '%s%s'%(pre, texture)
            )
        );
    return new_texture_names;
```

2. Execute the following lines to create a new Maya scene with a list of three **file** nodes and print the list to see their names (which will be file1, file2, and file3).

```
maya.cmds.file(new=True, f=True);
textures = [];
for i in range(3):
    textures.append(
        maya.cmds.shadingNode(
            'file',
            asTexture=True
        )
    );
print(textures);
```

3. Execute the following lines to pass the new list of textures to the **process_all_textures()** function and print the result (which should be dirt_file1, dirt_file2, and dirt_file3).

```
new_textures = process_all_textures(
    texture_nodes=textures,
    prefix='dirt_'
);
print(new_textures);
```

As you can see, using a **for** statement is a powerful and concise way to repeat a set of operations. Because of Python's unique language features, including slicing and the **range()** function, you have a number of different options available when creating a **for** loop.

Branching

While you have made some important improvements to the **process_all_textures()** function, it still has some limitations. For example, passing no texture_nodes argument will simply cause an error.

4. Execute the followings lines to try to execute the **process_all_textures()** function without specifying the texture_nodes argument.

```
process_all_textures(
    prefix='mud_',
);
```

You should see the following error message print to the console.

```
# Error: TypeError: file <maya console> line 6: 'NoneType'
object is not iterable #
```

The problem is that our current implementation assumes that the argument passed with the texture_nodes keyword is a list or tuple containing object names. If the texture_nodes argument is not specified, then it initializes to a value of None.

5. Execute the following lines to make modifications to the **process_all_textures()** function.

```
def process_all_textures(**kwargs):
    pre = kwargs.setdefault('prefix', 'my_');
    textures = kwargs.setdefault('texture_nodes');
    new_texture_names = [];
    if (isinstance(textures, list) or
        isinstance(textures, tuple)):
        for texture in textures:
            new_texture_names.append(
```

```
                maya.cmds.rename(
                    texture,
                    '%s%s'%(pre, texture)
                )
            );
        return new_texture_names;
    else:
        maya.cmds.error('No texture nodes specified');
```

6. Now attempt to execute the **process_all_textures()** function without supplying the `textures_nodes` argument.

```
new_textures[0] = process_all_textures(
    prefix='mud_'
);
```

As you can see, the function now displays a more descriptive error message.

```
# Error: RuntimeError: file <maya console> line 17: No
texture nodes specified #
```

Let's look back at the section we added.

```
if (isinstance(textures, list) or
    isinstance(textures, tuple)):
    # ...
else:
    maya.cmds.error('No texture nodes specified');
```

To inform the user there is a problem, we implemented an **if** clause. What happened in this case is that the `textures` object was initialized to a value of None, the type of which is **NoneType**. We test the type of `textures` using the **isinstance()** function, which lets us compare an item in argument position 0 to an item in argument position 1. Consequently, because the **NoneType** failed to meet our test conditions, execution jumped down to the **else** block, which executes a command to display an error message.

if, elif, and else

An **if** statement tells the Python interpreter to execute a specific code block only if specified conditions are met. This process is called *branching*. A Python **if** statement consists of three separate parts:

- An **if** clause
- An optional **elif** clause or clauses
- An optional **else** clause

An **if** statement takes the following basic form, whereby execution only enters the block if `condition` is True.

```
if condition:
    # do something
```

It can be extended to include **elif** and **else** clauses, which are evaluated sequentially. In the following case, the **elif** and **else** clauses would be ignored if `condition` is True. If `condition` were False, then `another_condition` would be tested. If no **elif** clauses evaluate True, then execution defaults to the **else** block.

```
if condition:
    # do something
elif another_condition:
    # do something else
# any number of other elif clauses
else:
    # do default action
```

Using Comparison Operations

Conditional statements are the primary situation where you will use the Boolean operations discussed in Chapter 2. For example, **do_something_else()** would be executed in this case if `node_name` were "sandwich".

```
if node_name == 'ham':
    do_something();
elif node_name == 'sandwich':
    do_something_else();
```

However, there are in fact a number of comparison operators usable by many built-in types, which return Boolean values that you can use to evaluate conditions. These operators, described in Section 5.3 of Python Standard Library, are summarized in Table 3.1.

Table 3.1 Comparison Operators

Operation	Returns
$x < y$	True if x is less than y
$x <= y$	True if x is less than or equal to y
$x > y$	True if x is greater than y
$x >= y$	True if x is greater than or equal to y
$x == y$	True if x and y have the same value
$x != y$	True if x and y have different values
x **is** y	True if x and y have the same identity
x **is not** y	True if x and y have different identities

For example, the following statements would each print True.

```
v1, v2, v3, v4 = [1,2,3,4];
print(v1 < v2);
print(v3 > v1);
print(v4 <= v4);
print(v2 == v2);
```

On the other hand, the following statements would each print False.

```
v1, v2, v3, v4 = [1,2,3,4];
print(v1 >= v2);
print(v3 <= v1);
print(v4 > v4);
print(v2 != v2);
```

Multiple conditions can be tested to compute a single condition, in which case each one is evaluated in order. Consider the following example.

```
xform_list = maya.cmds.ls(type='transform');
camera_name = 'persp';
if (isinstance(xform_list, list) and
    camera_name in xform_list):
    print('%s is in the list of transforms'%camera_name);
```

Because `xform_list` is, in fact, a list object and the value referenced by `camera_name` is a member of the list, this condition will evaluate to True and the statement in the **if** clause will be printed. However, if `xform_list` were anything other than a list (e.g., a string, tuple, or set), the condition would immediately be evaluated to False, irrespective of whether `camera_name` happened to be in the collection or not, and the **if** block would be skipped.

Moreover, the same principle applies when testing multiple statements using the **or** operator.

```
cameras = maya.cmds.ls(type='camera');
shapes = maya.cmds.ls(type='shape');
camera_shape = 'perspShape';
if camera_shape in shapes or camera_shape in cameras:
    print(
        '%s has been found in one of the lists'%
        camera_shape
    );
```

As soon as a condition is found that evaluates to True, the **if** block is entered, no matter what the other values happen to be. For instance, in this example, the node name referenced by `camera_shape` happens to be in both lists. As such, when it is found in the `shapes` list, it does not need to be further tested for membership in the `cameras` list. You can exploit this principle to minimize the number of tests you perform.

7. Make the following modifications to the **process_all_textures()** function to require that the supplied prefix contains a trailing underscore if it is specified.

```
def process_all_textures(**kwargs):
    pre = kwargs.setdefault('prefix');
    if (isinstance(pre, str) or
        isinstance(pre, unicode)):
        if not pre[-1] == '_':
            pre += '_';
    else: pre = '';
    textures = kwargs.setdefault('texture_nodes');
    new_texture_names = [];
    if (isinstance(textures, list) or
        isinstance(textures, tuple)):
        for texture in textures:
            new_texture_names.append(
                maya.cmds.rename(
                    texture,
                    '%s%s'%(pre, texture)
                )
            );
        return new_texture_names;
    else:
        maya.cmds.error('No texture nodes specified');
```

If you examine the test we implemented, you can see that it comprises a few steps. First, we test whether pre is a string or Unicode object. If this test fails, we drop to the **else** block, where pre is assigned an empty value. Otherwise, if pre is a string or Unicode object, we jump into the first **if** block and proceed to test whether the final character in pre is an underscore. If it is, then we do nothing, but if it is not, then we add an underscore.

8. Execute the following lines to create a new **file** node and then process it using a prefix without an underscore.

```
tex = [maya.cmds.shadingNode('file', asTexture=True)];
print('Before: %s'%tex);
tex = process_all_textures(
    texture_nodes=tex,
    prefix='metal'
);
print('After: %s'%tex);
```

As you can see from the output, the function now appends an underscore as needed, which other tools in your pipeline may require as part of your naming convention.

```
Before: [u'file1']
After:  [u'metal_file1']
```

Note that the **not** keyword can be used to test if an expression is not true. Consider the following test.

```
if not b:
```

If the expression represented by b evaluates to False, the statement as a whole evaluates to True. Otherwise, the statement will evaluate to False. In short, the **not** operator negates whatever follows it. The **not** operator can and should also be used to compare Boolean values to False, as in the following example.

```
# this statement
if x == False:
# can be written as
if not x:
```

Moreover, the **not** keyword is most often used to test against what is called an *implicit false*. There are certain values in Python that can be evaluated as Booleans and will return a value of False. The most common of these include "empty" values, such as 0, None, [], and ".

```
# this statement
a_list = list();
if len(a_list)==0:
    print('This list is empty');
# can be written as
if not a_list:
    print('This list is empty');
```

Finally, note that the **if** statement can also be used as part of an expression in Python 2.5 and later (e.g., Maya 2008 and later). The following example demonstrates this concept by presenting a pattern for emulating MEL's ternary operator using an **if** statement.

```
// MEL
$result = $value_1 == $value_2 ? "equal" : "not equal";
# Python
result = 'equal' if value_1 == value_2 else 'not equal';
```

Emulating Switches

As we noted previously, a component of an **if** statement is an optional **elif** clause, which is a shortened name for the "else if" pattern found in other languages. The **elif** statement is very useful, as it can appear multiple times and create multiple branches. It can be used to emulate the **switch** statement found in MEL.

```
// MEL
switch($func_test):
{
    case "A":
    {
        exec_func_A();
        break;
    }
    case "B":
    {
        exec_func_B();
        break;
    }
    default:
    {
        exec_default();
        break;
    }
}
# Python
if func_test is 'A':
    exec_func_A()
elif func_test is 'B':
    exec_func_B()
else:
    exec_default()
```

Because function names are accessible like any other name in Python, you can also use a dictionary to implement a **switch** in some cases. For example, the following dictionary-based approach is equivalent to the previous example.

```
func_dict = {
    'A':exec_funcA,
    'B':exec_funcB,
};
func_dict.setdefault(func_test, exec_default)();
```

continue and break

Along with conditional statements, Python provides a few other tools for branching specifically for use inside of loops: the **break** and **continue** statements.

The **break** statement is used to exit a loop immediately.

9. Execute the following lines to include a test in the **for** loop inside of **process_all_textures()**. If the current item is not found or is not a texture, then the loop exits immediately.

```
def process_all_textures(**kwargs):
    pre = kwargs.setdefault('prefix');
    if (isinstance(pre, str) or
        isinstance(pre, unicode)):
        if not pre[-1] == '_':
            pre += '_';
    else: pre = '';
    textures = kwargs.setdefault('texture_nodes');
    new_texture_names = [];
    if (isinstance(textures, list) or
        isinstance(textures, tuple)):
        for texture in textures:
            if not (maya.cmds.ls(texture) and
                maya.cmds.nodeType(texture)=='file'):
                break;
            new_texture_names.append(
                maya.cmds.rename(
                    texture,
                    '%s%s'%(pre, texture)
                )
            );
        return new_texture_names;
    else:
        maya.cmds.error('No texture nodes specified');
```

10. Execute the following lines to supply the **process_all_textures()** function with a list of three items, two of which are invalid, and print the result.

```
new_textures = [
    'nothing',
    'persp',
    maya.cmds.shadingNode('file', asTexture=True)
];
print('Before: %s'%new_textures);
new_textures = process_all_textures(
    texture_nodes=new_textures,
    prefix='concrete_'
);
print('After: %s'%new_textures);
```

As you can see from the results, the loop simply exited when it reached the first invalid object, causing it to return an empty list.

```
Before: ['nothing', 'persp', u'file1']
After:  []
```

In contrast, the **continue** statement is used to skip an element in a loop's sequence, and is a much more useful alternative in this case.

11. Execute the following lines to change the **break** statement you imple-
mented in step 9 into a **continue** statement. This alternative approach will
simply skip over invalid nodes, rather than exiting the loop entirely.

```
def process_all_textures(**kwargs):
    pre = kwargs.setdefault('prefix');
    if (isinstance(pre, str) or
        isinstance(pre, unicode)):
        if not pre[-1] == '_':
            pre += '_';
    else: pre = '';
    textures = kwargs.setdefault('texture_nodes');
    new_texture_names = [];
    if (isinstance(textures, list) or
        isinstance(textures, tuple)):
        for texture in textures:
            if not (maya.cmds.ls(texture) and
                maya.cmds.nodeType(texture)=='file'):
                continue;
            new_texture_names.append(
                maya.cmds.rename(
                    texture,
                    '%s%s'%(pre, texture)
                )
            );
        return new_texture_names;
    else:
        maya.cmds.error('No texture nodes specified');
```

12. Execute the following lines to supply the **process_all_textures()** func-
tion with a new list similar to the one you created in step 10, and print
the results.

```
new_textures = [
    'nothing',
    'persp',
    maya.cmds.shadingNode('file', asTexture=True)
];
print('Before: %s'%new_textures);
new_textures = process_all_textures(
    texture_nodes=new_textures,
    prefix='concrete_'
);
print('After: %s'%new_textures);
```

As you can see from the output, the item with no match in the scene
was skipped, as was the perspective camera's **transform** node. The
resulting list contains only a valid **file** node.

```
Before: ['nothing', 'persp', u'file2']
After: [u'concrete_file2']
```

List Comprehensions

One of Python's key features is simple, readable syntax. Often when dealing with loops and conditionals, code can become obfuscated. Consider the following block of code that walks through a theoretical directory of textures and builds a list of names by splitting the file name and extension.

```
textures = [];
for file_name in folder:
    if '_diff' in file_name:
        texture_list.append(name.split('.')[0]);
```

Rewriting these lines as a list comprehension both reduces the amount of code in the function and in many cases makes the code more readable. You could rewrite the preceding hypothetical block as a list comprehension as in the following line.

```
textures = [
    name.split('.')[0] for name in folder if '_diff' in name
];
```

List comprehensions take the following basic form.

```
[expression_or_element for element in sequence if condition];
```

Here are a few other examples of common Python iteration patterns that can be rewritten as list comprehensions.

```
# join a folder and a name to create a path
root_path = 'C:\\path\\';
name_list = ['name_1','name_2','name_3','name_4'];
# using a for loop
full_paths = [];
for name in name_list:
    full_paths.append(root_path+name);
# as a list comprehension
full_paths = [root_path+name for name in name_list];

# filter a list into a new list
texture_list = ['rock_diff',
                'base_diff',
                'base_spec',
                'grass_diff',
                'grass_bump'];
# using a for loop
diff_list = [];
```

```
for texture in texture_list:
    if '_diff' in texture:
        diff_list.append(texture);
# as a list comprehension
diff_list = [
    texture for texture in texture_list if '_diff' in texture
];

# mapping a function to a list
some_strings = ['one','two','three','four'];
# using a for loop
uppercased = [];
for s in some_strings:
    uppercased.append(s.upper());
# as a list comprehension
uppercase = [s.upper() for s in some_strings];
```

As you can see, list comprehensions are a unique feature that allow for clear and concise construction of new sequences using a combination of the **for** statement and conditional statements.

The while Statement

Now that you have mastered the nuances of conditional statements and understand the concepts of iteration, we can discuss another loop statement that Python offers: **while**. The **while** statement, also found in MEL, is a type of loop that evaluates as long as a particular condition is True. The following template shows the basic form of a **while** loop.

```
while (expression_is_true):
    perform_task();
    update_expression_parameter();
```

A **while** statement enacts the following steps:

- The expression to the right of the **while** keyword is evaluated.
- If the conditional expression is True, then execution enters the **while** block.
- Statements in the **while** block are executed.
- Conditional parameters are updated for the next test.
- If the condition is False, then execution moves to the next statement outside of the **while** block.

Unlike the **for** statement, the Python **while** statement is a bit closer in form to its MEL counterpart, as the following code snippet demonstrates.

```
"""
MEL equivalent:
int $ctr = 0;
while ($ctr < 4)
```

```
    {
        print("counted "+$ctr+"\n");
        $ctr += 1;
    }
    """
    ctr = 0;
    while (ctr < 4):
        print('counted %s'%ctr);
        ctr += 1;
```

Although a **for** loop is more sensible for our purposes, implementing **process_all_textures()** with a **while** statement could look like the following example.

```
def process_all_textures(**kwargs):
    pre = kwargs.setdefault('prefix');
    if (isinstance(pre, str) or
        isinstance(pre, unicode)):
        if not pre[-1] == '_':
            pre += '_';
    else: pre = '';
    textures = kwargs.setdefault('texture_nodes');
    new_texture_names = [];
    if (isinstance(textures, list) or
        isinstance(textures, tuple)):
        ctr = len(textures) -1;
        while ctr > -1:
            texture = textures[ctr];
            if (maya.cmds.ls(texture) and
                maya.cmds.nodeType(texture)=='file'):
                new_texture_names.append(
                    maya.cmds.rename(
                        texture,
                        '%s%s'%(pre, texture)
                    )
                );
            ctr -= 1;
        return new_texture_names;
    else:
        maya.cmds.error('No texture nodes specified');
```

Just like **for** statements, **while** statements are also helpful tools for iteration. In contrast, however, they make use of conditional statements to determine whether they should continue. Consequently, although **for** statements are useful tools for executing linear, repeatable steps, **while** statements may be useful in nonlinear situations. Moreover, **while** loops are helpful in situations that need to monitor other objects that may be manipulated outside the **while**

loop, or that have their values altered as a cascading effect of something that does happen in the **while** loop.

ERROR TRAPPING

When dealing with large programs, you often would like to be able to handle how errors are processed and reported back to the developer calling your function. These situations all concern a function's exit path, and Python provides several different options. Although we have already covered the **return** statement, we explore here some basic strategies for handling errors.

try, except, raise, and finally

In a perfect world, functions would perform exactly as intended on every call and our need to worry about handling flawed execution would be minimal. As this ideal is absolutely not the case, developers must be prepared not only to handle errors in code cleanly, but also to provide meaningful messages in such cases. Fortunately, Python provides some built-in features to address these situations:

- Exception and Error classes
- A **try** statement that encompasses exception handling and cleanup
- A **raise** statement that allows the developer to specify an Error class and message

Detailing Python's Exception and Error classes is beyond the scope of this chapter. It is strongly recommended that you consult Section 8 of Python Tutorial online for more detailed information on these topics.

The concept behind Exception and Error classes is that they allow a developer to halt the flow of execution and handle an unexpected or incorrect result. Triggering an exception or error is referred to as raising an exception (or error) and is done by using Python's **raise** statement.

```
raise StandardError('An Error Occurred');
# Error: StandardError: file <maya console> line 1: An Error
Occurred #
```

Raising an error in this case could also be achieved with alternative syntax.

```
raise StandardError, 'An Error Occurred';
```

1. Execute the following lines to raise a **TypeError** in **process_all_textures()** when the supplied texture_nodes argument is not a tuple or a list.

```
def process_all_textures(**kwargs):
    pre = kwargs.setdefault('prefix');
    if (isinstance(pre, str) or
```

```
            isinstance(pre, unicode)):
        if not pre[-1] == '_':
            pre += '_';
    else: pre = '';
    textures = kwargs.setdefault('texture_nodes');
    new_texture_names = [];
    if (isinstance(textures, list) or
        isinstance(textures, tuple)):
        for texture in textures:
            if not (maya.cmds.ls(texture) and
                maya.cmds.nodeType(texture)=='file'):
                continue;
            new_texture_names.append(
                maya.cmds.rename(
                    texture,
                    '%s%s'%(pre, texture)
                )
            );
        return new_texture_names;
    else:
        raise TypeError(
            'Argument passed was not a tuple or list'
        );
```

2. Execute the following line to try to pass a string to the `texture_nodes` argument when calling **process_all_textures()**.

   ```
   process_all_textures(texture_nodes='this is a string')
   ```

 Now if **process_all_textures()** is called without an argument for `texture_nodes`, a **TypeError** with the developer-supplied message is raised.

   ```
   # Error: TypeError: file <maya console> line 24: Argument
   passed was not a tuple or list #
   ```

Python supports a higher-level pattern for handling errors that allows a developer to try a block of code, handle any errors, and clean up any results. This pattern is called a **try** statement, and it consists of the following parts:

- A **try** clause that contains the code to be tested
- An optional **except** clause or clauses that handle any errors by type
- An optional **else** clause following an **except** clause, which specifies a block of code that must run if no errors occur in the **try** block
- An optional **finally** clause that must be executed when leaving the **try** block to perform any cleanup required, and that is always executed whether or not there was an error

A **try** statement must further include either an **except** clause or a **finally** clause. Either of the following code snippets is valid.

```
# example 1
try:
    # code to be tested
except:
    # raise an exception
# example 2
try:
    # code to be tested
finally:
    # clean up
```

You can also combine the two, in which case the **finally** block will execute whether or not an error occurs in the **try** block.

```
try:
    # code to be tested
except:
    # raise an exception
finally:
    # called no matter what, upon completion
```

You are also allowed to include an optional **else** clause following an **except** clause. Such an **else** clause specifies code that must run if no error occurred in the **try** block.

```
try:
    # code to be tested
except:
    # raise an exception
else:
    # called if try block is successful
```

It is also valid to use all four components if you choose.

```
try:
    # code to be tested
except:
    # raise an exception
else:
    # called if try block is successful
finally:
    # called no matter what, upon completion
```

While you have a variety of options, any errors raised by code in the **try** clause will only be handled by the **except** clause.

3. Execute the following lines to wrap an invalid call to **process_all_ textures()** in a **try-except** clause.

```
try:
    process_all_textures();
except TypeError as e:
    print(e);
```

You should see the custom **TypeError** message you defined inside the function print as a result, which is the specified action in the **except** block.

```
Argument passed was not a tuple or list
```

When an exception is raised from inside a **try** clause, the Python interpreter checks the **try** statement for a corresponding **except** clause that defines a handler for the raised error type and executes the block of code contained within the **except** clause. This process is called catching the exception.

Because **process_all_textures()** raises a **TypeError** if it is called with an incorrect argument, we needed to tell the **except** clause to handle a **TypeError** specifically. Once the exception is caught, information regarding the exception can be extracted from the variable e and manipulated in the **except** clause's expression. To better understand this concept, consider the **except** statement on its own.

```
except TypeError as e:
```

Given that a **TypeError** was raised in **process_all_textures()** with the message "Argument passed was not a tuple or list", the **except** statement is functionally equivalent to the following code.

```
e = TypeError('Argument passed was not a tuple or list');
```

In this case, e is referred to as a target, meaning that the **TypeError** was bound to it using the **as** keyword. The variable e is not a required keyword; in fact, any legal variable name can be used as a target. Targets are also optional, though excluding them prevents you from obtaining any specific information about the exception. Any of the following statements use valid **except** syntax.

```
except TypeError:
except TypeError as my_error:
except TypeError, improper_type:
```

Hopefully you can see the tremendous value in protecting the execution of your code by properly handling errors. It is strongly recommended you refer to the Python documentation for more information on working with errors, as it represents one of Python's most helpful features for tracking down problems.

DESIGNING PRACTICAL TOOLS

Now that you have a firm understanding of some core programming concepts in Python, as well as knowledge of some important Maya commands, we will walk through a set of functions that can be used to perform some

real production tasks. Any time you design a new tool, it is always useful to plan out each of the steps it will need to perform. We will be designing a simple texture-processing framework according to the following specifications:

- Query the current scene for all the **file** nodes (textures).
- Iterate over the resulting **file** nodes.
- If the given list is empty, the main function should exit with an appropriate error message.
- Design a function that validates each node and verifies that it is assigned to an object and named properly.
- Process each node's texture in a separate function based on a type determined by the naming convention:
 - ❏ Textures with the suffix "_diff" will be processed as diffuse textures.
 - ❏ Textures with the suffix "_spec" will be processed as specular textures.
 - ❏ Textures with the suffix "_bump" will be processed as bump textures.
- The individual texture processors can raise errors, but errors should be handled by the main function. Ideally, the texture processors should return a success or fail status.
- The main function should return a list of textures that processed successfully, a list of textures that produced errors, and a list of skipped textures.
- The main function should save out a new scene once the textures have been reassigned.

Up to this point, all the example functions have been for illustrative purposes. We will be implementing all the functions and patterns from scratch even though we use names that we used in prior examples.

The first step is to implement the main function, **process_all_textures**(). We would start by coding a simple skeleton for the function, as in the following example.

```python
import maya.cmds;
import os;
def process_all_textures(out_dir = os.getenv('HOME')):
    """
    A function that gets a list of textures from the current scene
    and processes each texture according to name
    """
    texture_nodes = []; # to be replaced
    processed_textures = [];
    error_textures = [];
    skipped_textures = [];
```

```python
if not texture_nodes:
    maya.cmds.warning('No textures found, exiting');
    return (
        processed_textures,
        error_textures,
        skipped_textures
    );
for name in texture_nodes:
    if is_valid_texture(name):
        print('Processing texture %s'%name);
        as_type = None;
        status = False;
        texture = None;
        if '_diff' in name:
            status, texture = process_diffuse(
                name, out_dir
            );
            if status:
                processed_textures.append(texture);
                as_type = 'diffuse';
            else:
                error_textures.append(texture);
        elif '_spec' in name:
            status, texture = process_spec(
                name, out_dir
            );
            if status:
                processed_textures.append(texture);
                as_type = 'specular';
            else:
                error_textures.append(texture);
        elif '_bump' in name:
            status, texture = process_bump(
                name, out_dir
            );
            if status:
                processed_textures.append(texture);
                as_type = 'bump';
            else:
                error_textures.append(texture);
        if status:
            print(
                'Processed %s as a %s texture'%(
                    texture, as_type
                )
            );
        else:
            print('Failed to process %s'%name);
```

```
            else:
                print('%s is not a valid texture, skipping.'%name);
                skipped_textures.append(name);
    return (
        processed_textures,
        error_textures,
        skipped_textures
    );
```

As previously noted, this function is simply a skeleton, and in fact does no actual work. Calling **process_all_textures()** at this point would return three empty lists, as it would fail the first **if** test.

The next step would be to generate a list of texture nodes. To accomplish this task, we search the scene and create a list by querying the attributes on all the file texture nodes. This task is accomplished with a simple call of the ls command, specifying that we are looking for **file** nodes.

```
    texture_nodes = maya.cmds.ls(type='file');
```

This list is really the only piece of data required by the preceding function to return a result, given properly named textures. One of the shortcomings of such an approach, however, is that it would process *every* **file** node in the scene. Recall from the original specifications that an **is_valid_texture()** function should be used to verify a **file** node for processing. A minimum specification for the **is_valid_texture()** function could be:

- Check the **file** node to determine that it is connected to an assigned shader.
- Verify that the file has one of the predefined substrings ("_diff", "_bump", or "_spec").

The following implementation of **is_valid_texture()** satisfies these conditions.

```
    def is_valid_texture(file_node):
        shaders = maya.cmds.listConnections(
            '%s.outColor'%file_node,
            destination=True
        );
        if not shaders: return False;
        for shader in shaders:
            groups = maya.cmds.listConnections(
                '%s.outColor'%shader
            );
            if not groups: return False
            for group in groups:
                meshes = maya.cmds.listConnections(
                    group,
```

```
                        type='mesh'
                );
                if meshes:
                    if '_diff' in file_node:
                        return True;
                    elif '_spec' in file_node:
                        return True;
                    elif '_bump' in file_node:
                        return True;
        return False;
```

This function employs a fairly simple pattern that most MEL developers are probably familiar with:

■ A **file** node is passed to the function.
■ The node is queried for its connections to a shader via the **outColor** attribute.
■ If any connected nodes are found, they are further searched for connections to meshes.
■ If meshes are found, the function assumes the shader is assigned and queries the given **file** node's **fileTextureName** attribute.
■ The texture name is checked for one of the predefined tokens, and if found, returns True.
■ All other cases fail and return False.

Now, rather than calling **is_valid_texture()** as part of the main **for** loop, it can instead be called as part of a list comprehension and used to generate the initial list of **file** nodes.

```
texture_nodes = [
    i for i in maya.cmds.ls(type='file')
    if is_valid_texture(i)
];
```

Using this technique to get our list of textures, we could revise **process_all_textures()** to the following form.

```
def process_all_textures(out_dir = os.getenv('HOME')):
    """
    A function that gets a list of textures from the current
    scene and processes each texture according to name
    """
    texture_nodes = [
        i for i in maya.cmds.ls(type='file')
        if is_valid_texture(i)
    ];
    processed_textures = [];
```

```python
error_textures = [];
skipped_textures = [];
if not texture_nodes:
    maya.cmds.warning('No textures found, exiting');
    return (
        processed_textures,
        error_textures,
        skipped_textures
    );
for name in texture_nodes:
    print('Processing texture %s'%name);
    as_type = None;
    status = False;
    texture = None;
    if '_diff' in name:
        status, texture = process_diffuse(
            name, out_dir
        );
        if status:
            processed_textures.append(texture);
            as_type = 'diffuse';
        else:
            error_textures.append(texture);
    elif '_spec' in name:
        status, texture = process_spec(
            name, out_dir
        );
        if status:
            processed_textures.append(texture);
            as_type = 'specular';
        else:
            error_textures.append(texture);
    elif '_bump' in name:
        status, texture = process_bump(
            name, out_dir
        );
        if status:
            processed_textures.append(texture);
            as_type = 'bump';
        else:
            error_textures.append(texture);
    if status:
        print(
            'Processed %s as a %s texture'%(
                texture, as_type
            )
        );
    else:
        print('Failed to process %s'%name);
```

```
    return (
        processed_textures,
        error_textures,
        skipped_textures
    );
```

Note that the main **for** loop has been simplified by excluding the main **else** clause, since it is no longer needed—our texture list is inherently valid since it is created using the list comprehension.

Now we can move on to the implementation of the actual texture-processing functions. For the most part, the texture-processing functions follow a similar pattern. Consequently, we will only discuss one of these functions in detail, **process_diffuse**(). To reiterate, this function should:

- Take a verified **file** node and extract the texture.
- Process the texture.
- On success:
 - A new shading network is created.
 - The new shader is assigned to the original object.
 - A status of True is returned along with the new texture name.
- On failure:
 - A warning is printed.
 - The original texture name is returned.

Given this design specification, **process_diffuse**() could be implemented as follows. Note that this implementation makes use of the maya.mel module, which allows you to execute statements in MEL to simplify the creation and setup of the new file texture node, as well as a set of nested calls for retrieving the shader's assigned object. We will examine the maya.mel module in further detail in coming chapters.

```python
import maya.mel;
def process_diffuse(file_node, out_dir):
    """
    Process a file node's texture, reassign the new texture
    and return a status and texture name
    """
    status = False;
    texture = None;
    file_name = maya.cmds.getAttr('%s.ftn'%file_node);
    meshes = [];
    shaders = maya.cmds.listConnections(
        '%s.outColor'%'file1',
        destination=True,
    );
```

```python
if shaders:
    for s in shaders:
        groups = maya.cmds.listConnections(
            '%s.outColor'%s
        );
        if groups:
            for g in groups:
                m = maya.cmds.listConnections(
                    g, type='mesh'
                );
                if m: meshes += m;
try:
    # processing code would be here
    new_file_name = file_name
    # new_file_name is the processed texture
    shader = maya.cmds.shadingNode(
        'blinn',
        asShader=True
    );
    shading_group = maya.cmds.sets(
        renderable=True,
        noSurfaceShader=True,
        empty=True
    );
    maya.cmds.connectAttr(
        '%s.outColor'%shader,
        '%s.surfaceShader'%shading_group
    );
    texture = maya.mel.eval(
        'createRenderNodeCB -as2DTexture "" file "";'
    );
    maya.cmds.setAttr(
        '%s.ftn'%file_node,
        new_file_name,
        type='string'
    );
    maya.cmds.connectAttr(
        '%s.outColor'%texture, '%s.color'%shader
    );
    for mesh in meshes:
        maya.cmds.sets(
            mesh,
            edit=True,
            forceElement=shading_group
        );
    status = True;
except:
    texture = file_node;
```

```
            status = False;
     return (status, texture);
```

With this function in place, the texture framework is almost complete. The final step is to generate a new scene name and save the new file. To keep things simple, **process_all_textures**() will take the new file name and an output directory as arguments. Below is the listing for the final version of **process_all_textures**().

```
def process_all_textures(
    out_dir = os.getenv('HOME'),
    new_file='processed.ma'
):
    """
    A function that gets a list of textures from the current scene
    and processes each texture according to name
    """
    texture_nodes = [
        i for i in maya.cmds.ls(type='file')
        if is_valid_texture(i)
    ];
    processed_textures = [];
    error_textures = [];
    skipped_textures = [];
    if not texture_nodes:
        maya.cmds.warning('No textures found, exiting');
        return (
            processed_textures,
            error_textures,
            skipped_textures
        );
    for name in texture_nodes:
        print('Processing texture %s'%name);
        as_type = None;
        status = False;
        texture = None;
        if '_diff' in name:
            status, texture = process_diffuse(
                name, out_dir
            );
            if status:
                processed_textures.append(texture);
                as_type = 'diffuse';
            else:
                error_textures.append(texture);
        elif '_spec' in name:
            status, texture = process_spec(
```

```
                        name, out_dir
                    );
                    if status:
                        processed_textures.append(texture);
                        as_type = 'specular';
                    else:
                        error_textures.append(texture);
                elif '_bump' in name:
                    status, texture = process_bump(
                        name, out_dir
                    );
                    if status:
                        processed_textures.append(texture);
                        as_type = 'bump';
                    else:
                        error_textures.append(texture);
                if status:
                    print(
                        'Processed %s as a %s texture'%(
                            texture, as_type
                        )
                    );
                else:
                    print('Failed to process %s'%name);
        try:
            maya.cmds.file(
                rename=os.path.join(
                    out_dir, new_file
                )
            );
            maya.cmds.file(save=True);
        except:
            print('Error saving file, %s not saved.'%new_file);
        finally:
            return (
                processed_textures,
                error_textures,
                skipped_textures
            );
```

While this framework is somewhat naïve in implementation, it does present working examples of everything covered in this chapter, including function declarations, arguments, iteration, conditionals, error handling, **return** statements, and the use of Maya commands. This texture-processing framework could be made production-ready, and we encourage you to take this code and rework it for your own use or study.

CONCLUDING REMARKS

You now have a firm grasp of many of the fundamentals of programming with Python, including the ins and outs of functions, loops, branching, and error handling. While we covered a number of examples in this chapter, you are still only scratching the surface of Python in Maya. The functions we implemented barely make use of any advanced Python Standard Library functionality or language-specific features.

This chapter has introduced enough basic concepts that you should be able to work through all of the examples in further chapters in this book. Nevertheless, we encourage any developers interested in furthering their knowledge of Python and its capabilities to browse the online documentation, or to consult any of the other excellent Python-specific books available. Because you are now capable of creating Python programs, the next step is to organize them into modules, which we examine in Chapter 4.

Modules

Concluding Remarks 145

BY THE END OF THIS CHAPTER, YOU WILL BE ABLE TO:

- Describe what a module is.

- Explain how scope relates to modules.

- Differentiate global and local symbol tables.

- Define what attributes are in Python.

- Create your own module.

- Describe the default attributes of any module.

- Use comments to document your modules for use with the **help()** function.

- Compare and contrast packages and ordinary modules.

- Create your own packages to organize your tools.

- Compare and contrast **import** and **reload()**.

- Compare and contrast Python's **import** keyword and MEL's `source` directive.

- Use the **as** keyword to assign names to imported modules.

- Use the **from** keyword to import attributes into the current namespace.

- Temporarily modify Python's search path using the **sys.path** attribute.

- Create a userSetup script to automatically configure your environment.

- Configure the PYTHONPATH environment variable in Maya.env.

- Create complex deployments using systemwide environment variables.

- Describe the advantages of using a Python IDE for module development.

- Locate and install a Python IDE.

Thus far, we have used Maya's Script Editor to do all our work. The Script Editor is perfectly fine for testing ideas, but once your script is functional, you will want to save it as a module for later use. Although you have been *using* modules all along, this chapter will discuss everything you need to start *creating* modules.

We begin by discussing what exactly a module is and how modules manage and protect data in a Python environment. We then discuss how to

create modules as well as how to organize modules into packages. Next, we focus on exactly what happens when a module is imported and examine different options for importing modules. We then dive into a multitude of ways to configure your environment and deploy the Python tools to your studio. Finally, we examine a few different options you have for doing advanced, rapid Python development.

WHAT IS A MODULE?

A *module* is a standalone Python file containing a sequence of definitions and executable statements. Modules can contain as few or as many lines of code as are required, and often focus on specific tasks. Modules can also import other modules, allowing you to organize your code by functionality and reuse functionality across tools. While modules allow you to easily reuse code in this way, they are also designed to protect your code.

Modules are simply text documents with the .py extension. When you import a module for the first time, a corresponding .pyc file will be generated on-the-fly, which is a compiled module. A compiled module consists of what is called bytecode, rather than source code. While source code is human readable, bytecode has been converted into a compact format that is more efficient for the Python interpreter to execute. As such, you can deploy your modules as either .py or .pyc files. Many modules that ship with Maya's Python interpreter exist only as bytecode to protect their contents from accidental manipulation.

Python itself ships with a large library of default modules. There are all kinds of modules for various tasks, including doing math, working with emails, and interfacing with your operating system. Although we use several of these standard modules throughout this book, you will want to check out the online Python documentation at some point to view a full list of built-in modules and descriptions of their functions. Often, a module already exists that solves some problem you may be encountering!

In addition to these built-in modules, there are many useful modules available in the Python community at large. For example, the numpy package contains useful modules for scientific computing and linear algebra, while packages such as pymel offer powerful tools specifically designed to extend Maya's built-in cmds and API modules.

In the remainder of this chapter we will focus on creating custom modules. Before you create your first modules, however, it is worth reviewing the role of scope in modules.

MODULES AND SCOPE

We have briefly discussed the concept of scope when learning about functions. Scope is also important when working with modules. When you execute a line of code in the Script Editor, you are working in a particular scope. Consider the following example.

1. Enter the following line in the Script Editor to create a new variable.

   ```
   character = 'Bob';
   ```

2. Python has two built-in functions, **globals()** and **locals()**, that allow you to see what objects exist in the current global and local scope, respectively. Execute the following line in the Script Editor to see the current global symbol table.

   ```
   print(globals());
   ```

 If you just started a new Maya session, you should see a fairly short dictionary like that shown in the following output. If you have been executing other Python scripts in the Script Editor though, your output may be significantly longer.

   ```
   {'__builtins__': <module '__builtin__' (built-in)>,
   '__package__': None, '__name__': '__main__', '__doc__':
   None, 'character': 'Bob'}
   ```

 In the dictionary, you can see the character variable you just defined, as well as its current value. However, a variable with such a name is quite generic. It is likely that you or another programmer will create another variable with the same name. If your program were to rely on this variable, then you may have a problem.

3. Assign a new value to the character variable and print the global symbol table again.

   ```
   character = 1;
   print(globals());
   ```

 As you can see in the output, Bob is no more, and the character variable now has a number value.

   ```
   {'__builtins__': <module '__builtin__' (built-in)>,
   '__package__': None, '__name__': '__main__', '__doc__':
   None, 'character': 1}
   ```

If every script we created were storing variables in this scope, it would be very difficult to keep track of data. For example, if you were to execute two scripts one after the other, and if they contain variables with the same names, you may have conflicts. This problem can easily arise when working in MEL, necessitating that you devise exotic naming conventions for

variables. When using Python modules, however, you can avoid many such conflicts.

In contrast to the global symbol table, the local symbol table, accessible with the **locals()** function, lists the names of all symbols defined in the current scope, whatever that may be. If you simply execute **locals()** in the same way you have **globals()**, the difference may not be obvious, as the symbol tables are identical at the top level. However, the local scope may be inside a function.

4. Execute the following lines in the Script Editor.

```
def localExample():
    foo = '1';
    print(locals());
localExample();
```

As you can see, the local symbol table in the function contains only the variable that has been defined in its scope.

```
{'foo': '1'}
```

It is recommended that you consult Section 9.2 of the Python Tutorial online for more information on scope and how names are located.

Module Encapsulation and Attributes

Modules are designed to encapsulate data in their own symbol tables, eliminating the concern that you may overwrite data accidentally. *Each module has its own global symbol table*, which, as you have seen, you can access using the **globals()** function. By default, importing another module adds it to the current global symbol table, but its variables and other data are only accessible using the name assigned to it in the current namespace. Consider the following short sample.

```
import math;
print(math.pi);
```

The math module contains several such variables. *Variables and functions that are part of a module are called attributes.* (Unfortunately, Maya also uses the term *attributes* to describe properties of nodes, but you can hopefully follow.) To access an attribute in the math module—**pi** in this case—we supplied the name that was assigned to the imported module, a period, and then the name of the attribute. Follow the same pattern when accessing functions or other data in a module. As you have seen in previous chapters, the maya. cmds module contains a variety of functions for executing Maya commands.

In this case, the **pi** attribute is said to exist in the namespace of the math module. This concept ensures that any reference to the **pi** attribute must

be qualified by specifying its namespace, guarding against unintentional changes to its value. For example, you can create a new variable pi and it will not interfere with the one in the math namespace.

```
pi = 'apple';
print('our pi: %s'%pi);
print('math pi: %.5f'%math.pi);
```

The output clearly shows that the variables are referencing different data.

```
our pi: apple
math pi: 3.14159
```

In this example, we have a pi variable defined in the global symbol table, and the math module continues to have the correct value for its **pi** attribute in its global symbol table.

Since Python encapsulates the data in a module, we can safely import a module into another module. However, it is important to note that module attributes are not private in the sense used in other languages. It is possible to modify attribute values externally. Consider the following example.

```
pitemp = math.pi;
math.pi = 'custard';
print('override: %s'%math.pi);
math.pi = pitemp;
print('reassigned: %.5f'%math.pi);
```

As you can see from the output, it is possible to override the value of the **pi** attribute in the math module.

```
override: custard
reassigned: 3.14159
```

This aspect of Python is actually incredibly useful in some cases, as it allows you to override any attributes, including functions! For instance, you can override string output when printing API objects to the console, a trick of which the value will be clearer as you start working with the API. However, with great power comes great responsibility. In this case, we effectively "checked out" the existing value to another variable and "checked it back in" when we were done. It is often important to exercise good citizenship in this way, as other modules may rely on default values and behavior.

The __main__ Module

It is now worth pointing out that the Maya Script Editor is creating your data in a module as well. This module is called __main__. Every module has a few default attributes and one of these is called **__name__**, which you probably saw when you printed the global symbol table earlier. If

you print the __**name**__ attribute in the Script Editor you will see the name
of the current module.

```
print(__name__);
```

As you can see, the current module that you are in has the name of __main__.
The Maya Script Editor is the root module and all other modules branch out
from it. This concept is illustrated in Figure 4.1. In Maya, our scripts cannot
be the __main__ module, as Maya is acting as the __main__ module.

It is worth briefly noting that any Python script executed as a shelf button
(as we demonstrated in Chapter 1) is executed in the __main__ module,
just as if it were executed in the Script Editor.

1. Type the following code in the Script Editor but do not execute it.

    ```
    character = ('Nathan', 'Chloe', 'Elena');
    ```

2. Highlight the code you just entered in the Script Editor and **MMB** drag
 the line to the Shelf. If you are using a version of Maya that asks, make
 sure you specify the code is written in Python.
3. Press the new custom button and you should see the new assignment
 output appear in the Script Editor's History Panel.
4. Execute the following line to print the global symbol table for
 __main__.

    ```
    print(globals());
    ```

 You should see from the output that the value of `character` has chan-
 ged once more.

    ```
    {'__builtins__': <module '__builtin__' (built-in)>,
    '__package__': None, '__name__': '__main__', '__doc__':
    None, 'math': <module 'math' from '/Applications/
    Autodesk/maya2013/Maya.app/Contents/Frameworks/Python.
    framework/Versions/Current/lib/python2.6/lib-dynload/
    math.so'>, 'character': ('Nathan', 'Chloe', 'Elena')}
    ```

Scope is an essential concept not only of modules but also of Python more
generally. We'll examine a few more aspects of scope throughout this text,

■ **FIGURE 4.1** Example hierarchy of three imported modules.

but it is always a good idea to consult the Python documentation for more information. At this point, we've covered enough basic information for you to start creating your own modules.

CREATING A MODULE

Creating your own module is simple, and only requires that you create your script in any text editor and save it with the .py extension. You can also save a script that you have entered in Maya's Script Editor directly from its menu. We will start by using the Script Editor to create our first module: spike. This module contains a function to add spikes to a polygon object, and will create a spiky ball model as shown in Figure 4.2.

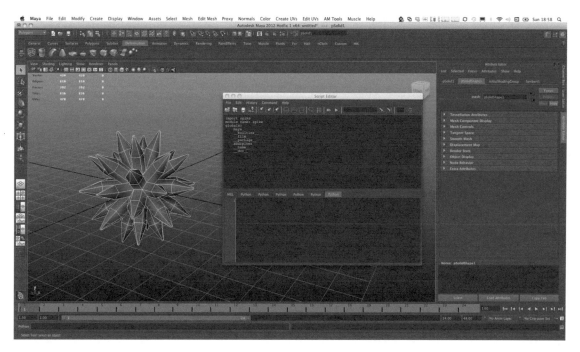

■ **FIGURE 4.2** The results of the spike module.

The spike Module

```
"""This script prints some information and creates a spike
ball."""
import maya.cmds;
def addSpikes(obj):
    """This function adds spikes to a polygon object."""
    try: polycount = maya.cmds.polyEvaluate(obj, face=True);
```

```
    except: raise;
    for i in range(0, polycount):
        face = '%s.f[%s]'%(obj, i);
        maya.cmds.polyExtrudeFacet(face, ltz=1, ch=0);
        maya.cmds.polyExtrudeFacet(
            face, ltz=1, ch=0,
            ls=[0.1, 0.1, 0.1]
        );
    maya.cmds.polySoftEdge(obj, a=180, ch=0);
    maya.cmds.select(obj);
print('module name: %s'%__name__);
print('globals:');
for k in globals().keys(): print('\t%s'%k);
addSpikes(maya.cmds.polyPrimitive(ch=0)[0]);
```

1. Download the spike.py module from the companion web site or copy the preceding text into the Script Editor. If you have downloaded the script, then open it in Maya by selecting **File → Load Script** from the Script Editor window. The contents of the module should now appear in the Input Panel. Do not execute them.

2. Select **File → Save Script** from the Script Editor window. Name the script spike.py and save it to a location in your Python path based on your operating system:
 - ❑ **Windows:** C:\Documents and Settings\user\My Documents\maya\ <version>\scripts\
 - ❑ **OS X:** ~/Library/Preferences/Autodesk/maya/<version>/scripts/
 - ❑ **Linux:** ~/maya/<version>/scripts/

3. In an empty Python tab, import the spike module and you should see some output in your History Panel.

   ```
   import spike;
   ```

When you first imported the spike module, its contents were executed. If you look at the module's source, you can see that it defines a function for adding spikes to a polygon model, then prints some information about the module and executes the **addSpikes()** function, passing in a basic polygon ball. We included the printout information to provide a better picture of what is going on in the module.

```
module name: spike
globals:
    maya
    __builtins__
    __file__
    __package__
    addSpikes
    __name__
    __doc__
```

In addition to printing the name of the module, we printed its global symbol table using the **globals()** function. As you can see, this module's global symbol table differs from that of the __main__ module, which we investigated earlier. These names are all those existing in the module's namespace. As such, its data are separate from those defined in the __main__ module's namespace, which we investigated earlier. This example clearly demonstrates the encapsulation principle.

Default Attributes and help()

Looking at the global names in the spike module, you can see five attributes that have a double underscore at the beginning and end of the names. These five attributes will always be included with any module, even if they are not explicitly defined. We have already discussed __**name**__.

The __**builtins**__ attribute points to a module that contains all of Python's built-in functions such as **print()** and **globals()**, and objects such as int and dict. This module is always automatically loaded, and does not require that you access its attributes using a namespace.

The __**file**__ attribute of a module is simply a string indicating the absolute path to the module's .py file on the operating system.

The __**package**__ attribute of a module returns the name of the package to which the module belongs. Because the spike module is not part of a package, this attribute returns a value of None. We will talk more about packages later in this chapter.

The __**doc**__ attribute is very useful when used correctly. Python assumes the first comment in a module is its docstring. Likewise, each function has its own __**doc**__ attribute, also presumed to be the first comment in its definition. If you properly add comments to a module in these locations, you can use the built-in Python **help()** function to get information.

```
help(spike);
```

We added comments in the spike module specifically to demonstrate this feature. Though many of our examples in this book exclude comments to save space, it is good practice to always include docstrings for your modules and functions.

```
Help on module spike:

NAME
    spike - This script prints some information and creates a
    spike ball.
```

```
FILE
    c:\documents and settings\ryan trowbridge\my documents
    \maya\2011\scripts\spike.py

FUNCTIONS
    addSpikes()

        This function adds spikes to a polygon object.

DATA
    k = '__doc__'
```

The output under the NAME heading shows the name of the module, which is identical to the value stored in its __**name**__ attribute. The name of the module is followed by the comment at the beginning of the module, which specifies what the module is for. Similarly, the FILE section shows the path to the module's source file by using the value in the __**file**__ attribute.

The FUNCTIONS section shows a list of all of the functions in the file, as well as their docstrings if they have them. Remember that function docstrings are specified just like module docstrings by using a literal string comment right at the beginning of the definition.

The final section, DATA, shows the noninternal attributes contained in the module. This section lists any module attributes that are not prefixed with underscores. In this example, we see the final value that was in the **k** attribute in our iterator to print the spike module's global symbol table.

Conveniently, you can also use the **help()** function with individual functions, which is useful with large modules like math. Consider the following example.

```
import math;
help(math.atan);
```

You should see output describing the **atan()** function.

```
Help on built-in function atan in module math:

atan(...)
    atan(x)

        Return the arc tangent (measured in radians) of x.
```

Packages

In addition to ordinary, individual modules, Python allows you to organize your modules into special hierarchical structures called *packages*. You can think of a package as essentially a folder that is treated as a module.

Packages allow you to cleanly deploy suites of tools, rather than requiring that end users fill up one folder with a bunch of modules, or that you create extraordinarily long modules. Packages provide both organization and technical advantages over ordinary modules. First, you are able to bypass naming conflicts by nesting modules inside of packages (or even packages inside of packages), reducing the likelihood of butting heads with other tools. Second, modules contained within a package do not need to have their disk locations explicitly added to your Python search path. Because the package folder itself is treated as a module, you can access modules in the package without having to append their specific locations to the search path. We talk more about the Python search path in the next section.

Packages are easy to create. The basic requirement is that you add a file, __init__.py, into a folder that is to be treated as a package (or a subpackage). That's it! After that point, you can then import the folder as though it were a module, or import any modules in the folder by using the dot delimiter. We'll walk through a brief example to demonstrate a couple of the features of packages.

1. Return to the location where you saved the spike.py module in the previous example and create a new folder called primitives. As an alternative to steps 1–3, you can also download the primitives package from the companion web site and unzip it here.
2. Create two files in this new folder called create.py and math.py and copy the contents from the examples shown here. The create module wraps some default Maya commands for creating polygon primitives, returning the **shape** nodes from the creation calls. The math module contains two simple utility functions for accessing attributes on primitives that have **radius** and **height** attributes.

create.py

```
import maya.cmds;
def cone(**kwargs):
    try: return maya.cmds.polyCone(**kwargs)[1];
    except: raise;
def cube(**kwargs):
    try: return maya.cmds.polyCube(**kwargs)[1];
    except: raise;
def cylinder(**kwargs):
    try: return maya.cmds.polyCylinder(**kwargs)[1];
    except: raise;
def plane(**kwargs):
    try: return maya.cmds.polyPlane(**kwargs)[1];
    except: raise;
```

```
def sphere(**kwargs):
    try: return maya.cmds.polySphere(**kwargs)[1];
    except: raise;
def torus(**kwargs):
    try: return maya.cmds.polyTorus(**kwargs)[1];
    except: raise;
```

math.py

```
import maya.cmds;
pi = 3.1415926535897931;
def getCircumference(obj):
    try: return maya.cmds.getAttr('%s.radius'%obj) * 2.0 * pi;
    except: raise;
def getHeight(obj):
    try: return maya.cmds.getAttr('%s.height'%obj);
    except: raise;
```

3. Add another file in this new folder called __init__.py. This file turns the folder into a package. Copy the contents from our example here into this file. This file will simply import two modules in the package. You should now have a directory structure like that shown in Figure 4.3.

■ **FIGURE 4.3** Organization of the primitives package.

__init__.py

```
import create, math;
```

4. In Maya, you can now import the primitives package and use it to create objects and access information about the objects you create. Execute the following lines.

```
import primitives;
cyl = primitives.create.cylinder(r=0.25);
print(
    'Circumference is %.3f'%
    primitives.math.getCircumference(cyl)
);
```

You should see the circumference printed to three decimal places.

```
Circumference is 1.571
```

The first interesting point about this example is, as you noticed, we created a module called math. Because this module is nested in a package, its name can conflict with the built-in math module without our having to worry that we will affect other tools.

That being said, however, the second interesting point is that our custom math module *does* conflict in any of the namespaces in the primitives package. For instance, we had to add our own attribute **pi** to the math module, and could not import the **pi** attribute associated with the built-in math module. The same rule goes for importing the math module from __init__.py.

This point leads nicely to the third, which concerns how we imported the package's modules in the __init__.py file. We only need to supply the module names as they exist in the package, and do not need to reference them by nesting them, as in the following line.

```
import primitives.create;
```

When importing modules inside a package, modules in the package are considered to be in the search path, and will take precedence if there are any conflicts.

Finally, note that it is not necessary that the __init__.py file actually contain any code. This file simply indicates that the folder is a package. Adding these import calls, however, allows the modules in the package to be accessed as attributes without requiring their own separate imports. For example, by importing the package's modules in __init__, we are immediately able to access them as attributes of primitives in __main__. Without these import calls, we would need to separately import primitives .create and primitives.math in __main__.

Hopefully, the value of packages is clear from this simple example, as you will use them frequently in production. In practice, you will use packages to organize complex tools on a functionality basis. For example, you may put all of your project's tools into one package and have subpackages inside of it for animation, effects, modeling, rigging, utilities, and so on. While you are unlikely to be so flippant as to create modules of which the names conflict with those of built-in modules, packages do allow you a good deal of assurance that your tools are not likely to conflict with other tools your team members may install, provided you are sufficiently creative with your package names. For more information on packages, consult Section 6.4 of the Python Tutorial online.

As you can see, creating modules and packages is rather straightforward. After creating a module you can import it any time you need to use it.

IMPORTING MODULES

Now that you know how to create modules, we can talk a little more about what actually happens during the importation process. As you have seen up to this point, the basic mechanism for loading a module is the **import** keyword. As you start working on your own modules, however, it is important to have a clearer understanding of exactly what happens when you import a module. In this section we briefly discuss the mechanics of the **import** keyword, as well as some special syntax that allows you finer control over your modules' namespaces.

import versus reload()

As we discussed earlier, the first time you import a module, a corresponding .pyc file will be generated. This .pyc file consists of bytecode that the interpreter actually reads at execution time. One important consequence of this implementation is that all subsequent importations of the module during a single session—from __main__ or any other module—will reference the compiled bytecode if it exists.

While this ensures that subsequent importations of the module into other namespaces are much faster than they might otherwise be, it also means that executable statements in the module are not repeated, and that any changes you make to the .py source file are not ready for use.

To handle these situations, you must use the **reload()** function. This function will recompile the bytecode for the module you pass as an argument (though it will not automatically recompile any modules that your module imports). Consequently, using **reload()** will not only repeat any executable

statements in the module, but will also update any attributes in the module to reflect any changes you may have made to its source code.

Note also that calling **reload**() in one namespace will not affect existing instances of the module in other namespaces. Because of how Python manages memory, other names will still point to old data (the module before it was reloaded). Moreover, reloading a package will not automatically reload all of its subpackages. Consult the description of **reload**() in Section 2 of Python Standard Library for more information.

It is important that MEL users contrast Python's **reload**() function and the MEL source directive. While **reload**() will both recompile and reexecute the specified module, the MEL source directive will only reexecute the contents of a supplied MEL script, but will not recompile it.[1]

The as Keyword

Sometimes a module is embedded deep within a package, or it has an inconveniently long (albeit descriptive) name. In addition to the package we created earlier, you have already seen one example of a module embedded within a package many times: maya.cmds. Unfortunately, prefixing every command with maya.cmds can quickly become tedious. The **as** keyword allows you to assign a custom name to the module when it is added to the global symbol table during importation. As you can see in the following code, this pattern can help you substantially reduce the amount of typing (and reading) you have to do, while still retaining the benefits of encapsulation.

```
import maya.cmds as cmds;
cmds.polySphere();
```

The from Keyword

Python also provides special syntax to import specific attributes from a module into the global symbol table. For example, the math module contains some useful trigonometric functions, such as **acos**().

```
print(math.degrees(math.acos(0.5)));
```

If the module in which you are working does not have any conflicts in its namespace, you may find it helpful to just import these attributes directly into the global symbol table to access them without a prefix. Python allows

[1]It is possible to use the eval MEL command in conjunction with the source directive to trigger recompilation of a MEL script. Consult the MEL Command Reference document for more information.

you to accomplish this task using the **from** keyword. This pattern allows you to specify individual, comma-delimited attributes to import.

```
from math import degrees, acos;
print(degrees(acos(0.5)));
```

Python also allows you to import all attributes from a module into the current namespace using the asterisk character (*).

```
from math import *;
print(degrees(asin(0.5)));
```

Remember to be cautious when you use such patterns! Python's system of namespaces is offered as a convenience and a safeguard, so do not dismiss it as a menace. Namespaces can protect you from any unforeseen conflicts, especially when you are working on large projects with other developers. For example, you may be importing all of a module's attributes into your global symbol table, and someone working on the other module may later add an attribute that conflicts with one in your own module. In many cases, if verbosity is causing problems, it is often safest to use the **as** keyword and assign a short name to the module you are importing.

Attribute Naming Conventions and the from Keyword

Before moving on to create our own modules, it is worth pointing out the naming convention of some of the attributes we have seen so far. Recall that we mentioned that attributes in Python are not private, as the concept exists in other languages such as C++. We can still mutate modules while inside some other module.

In Python, many attributes are prefixed with underscores, indicating that they are "internal" symbols. In addition to essentially being a suggestion that you treat them as though they were private (by rendering them inconvenient to type, if nothing else), this convention also ensures that the attributes are not imported into the global symbol table when using the syntax to import all of a module's attributes with the **from** keyword and the asterisk. You certainly wouldn't want to overwrite the __**name**__ attribute of the __main__ module with the name of another module you were importing!

PYTHON PATH

In MEL, you are able to call the source directive and pass a path to a script located anywhere on your computer to load it, even if it is not in your MEL script path. Importing in Python has no analogous option. When you attempt to import a module, Python searches all of the directories that have been specified in your Python path. In Python, all modules must be located in one of

these directories, or inside of a package in one of these directories, and you have a variety of options available for appending directories to your Python path. In this section we will look more closely at different ways you can manipulate your Python search path.

sys.path

One handy mechanism for working with your Python path is the **path** attribute in the sys module. This attribute contains a list of all directories that Python will search, and you can interactively work with it like any other list, including appending to it.

```
import sys;
for p in sys.path: print(p);
```

If you import the sys module and print the elements in **path**, you may see something like the following example (in Windows).

```
C:\Program Files\Autodesk\Maya2012\bin
C:\Program Files\Autodesk\Maya2012\bin\python26.zip
C:\Program Files\Autodesk\Maya2012\Python\DLLs
C:\Program Files\Autodesk\Maya2012\Python\lib
C:\Program Files\Autodesk\Maya2012\Python\lib\plat-win
C:\Program Files\Autodesk\Maya2012\Python\lib\lib-tk
C:\Program Files\Autodesk\Maya2012\bin
C:\Program Files\Autodesk\Maya2012\Python
C:\Program Files\Autodesk\Maya2012\Python\lib\site-packages
C:\Program Files\Autodesk\Maya2012\bin\python26.zip\lib-tk
C:/Users/Adam/Documents/maya/2012/prefs/scripts
C:/Users/Adam/Documents/maya/2012/scripts
C:/Users/Adam/Documents/maya/scripts
```

The first several of these directories are built-in paths for Maya's Python interpreter, and they are all parallel to Maya's Python install location. Depending on your platform, these are:

- **Windows:** C:\Program Files\Autodesk\Maya<version>\...
- **OS X:** /Applications/Autodesk/maya<version>/Maya.app/Frameworks/ .../lib/...
- **Linux:** /usr/autodesk/maya/lib/...

If you run a separate Python interpreter on your machine, you would see similar directories if you were to print this same example. These directories are all made available as soon as your Python session has begun. The final directories in the list are specific to Maya. Depending on your platform, they will be something like the following:

- **Windows:** C:\Users\<username>\Documents\maya\...

- **OS X:** /Users/<username>/Library/Preferences/Autodesk/maya/…
- **Linux:** /home/<username>/maya/…

These final directories are appended to the Python path when Maya is initialized.[2] It is important to know how the Python path is altered during the launch process in some cases. For example, if you launch Maya's interpreter, mayapy, on its own to use Maya without a GUI, this second group of paths is only accessible after you have imported the maya.standalone module and called its **initialize()** function. This order of operations is also important if you want to deploy a sitecustomize module, which we will discuss shortly. For now, we turn our attention to the most basic way to add directories to your search path.

Temporarily Adding a Path

1. As we mentioned earlier, because the **path** attribute is simply a list, you can easily append to it just as you can any other list. You can take advantage of this functionality to temporarily add a directory to your Python path during a Maya session. We'll show a quick example to add a module to your desktop and then add your desktop to your Python search path to import the module. Download the lightplane.py module from the companion web site and save it to your desktop. The module creates a red light and a plane in your scene.

2. Now append your desktop to the **sys.path** attribute by executing the following lines in the Script Editor.

```
import os, sys;
home = os.getenv('HOME');
user = os.getenv('USER');
sys.path.append(
    os.path.join(
        home[:home.find(user)],
        user, 'Desktop'
    )
);
```

In this case, we were able to take advantage of a useful built-in module, os, to help build the path. The first two calls return the value of environment variables with the specified keys, the first providing a path to the user's home folder and the second returning the name of the user.

The os module has a path extension module with a **join()** function, which concatenates multiple strings using whatever directory delimiter your operating system uses (forward slash on OS X and Linux, backslash on

[2]Note that directories in your **sys.path** attribute are supplied as absolute paths, and do not include the tilde (~) character for OS X and Linux as a shortcut for the user's home directory.

■ **FIGURE 4.4** The results of the lightplane module.

Windows).[3] Unfortunately, in this example we also have to do some slicing on the home directory, as it points to My Documents in Windows rather than to the user's folder. If you like, you can print the entries in the **sys.path** attribute to see the result for your platform at the end of the output.

3. Now that you have added your desktop to your path, you can import the lightplane module, after which you should see something like Figure 4.4 if you enable lighting (press **5** on the keyboard to switch to shaded view, and then **7** on the keyboard to enable lighting).

```
import lightplane;
```

If you simply append a location to the **sys.path** attribute, it will only be in effect until Maya closes. While this may be handy if you need to add a location from within some other module, or if you need to test something that you haven't yet buried away in your Python path, you will often want some directories to be consistently added to your Python path.

[3]Note that newer versions of Windows use both delimiters fairly interchangeably. Python can handle them both just fine, but it's always safest to use the os.path module to build paths.

While you have a variety of options for automatically configuring your Python search path across all your sessions, we cover three of the most common options here: creating a userSetup script, creating a sitecustomize module, and configuring an environment variable. In some cases, you may find that a combination of these approaches meets your particular needs based on how your studio deploys tools.

userSetup Scripts

A useful feature of Maya is the ability to create a userSetup script. A user-Setup script simply needs to be in a proper location on your computer, and Maya will execute any instructions in it when it starts. Depending on your operating system, you can add such a script to the specified default directory:

■ **Windows:** C:\Documents and Settings\user\My Documents\maya\ <version>\scripts\
■ **OS X:** ~/Library/Preferences/Autodesk/maya/<version>/scripts/
■ **Linux:** ~/maya/<version>/scripts/

Note that you may only have one userSetup script and it must be either a Python or a MEL script—you cannot have both a userSetup.mel and a userSetup.py script. A MEL script will take precedence if both exist.

In the following brief example, you will alter your userSetup script to automatically append your desktop to the Python search path and import the lightplane module that you created in the previous example (which should still be on your desktop).

1. If you do not have a userSetup script, create either a userSetup.mel or a userSetup.py script in the appropriate directory for your operating system. Copy the contents of the appropriate following example into your script.

userSetup.py

```
import os, sys;
home = os.getenv('HOME');
user = os.getenv('USER');
sys.path.append(
    os.path.join(
        home[:home.find(user)],
        user, 'Desktop'
    )
);
import lightplane;
```

userSetup.mel

```
python("import os, sys");
python("home = os.getenv('HOME')");
```

```
python("user = os.getenv('USER')");
python("sys.path.append(os.path.join(home[:home.find
(user)], user, 'Desktop'))");
python("import lightplane");
```

2. Close Maya and reopen it to start a new session.

Contrary to what you may have expected, the scene does not in fact contain the plane and red light! What happened? In essence, Maya imported your module before the Maya scene was prepared. Nonetheless, you can confirm that your userSetup script was properly executed by printing your global symbol table.

```
for k in globals().keys(): print(k);
```

You should see os, sys, and lightplane among the names.

```
__builtins__
__package__
sys
user
home
lightplane
__name__
os
__doc__
```

It is interesting to note that a userSetup script is not fully encapsulated like an ordinary module. All of its statements are executed in the __main__ module using the built-in **execfile()** function, so any modules you import from userSetup are automatically available in __main__ when Maya is initialized, as are any attributes you define.[4]

3. Return to your userSetup script and replace the lines you entered in step 1 with the following (we assume MEL users can translate easily enough).

```
import maya.utils, os, sys;
home = os.getenv('HOME');
user = os.getenv('USER');
sys.path.append(
    os.path.join(
        home[:home.find(user)],
        user, 'Desktop'
    )
);
maya.utils.executeDeferred('import lightplane');
```

[4]If you want to know more, you can investigate the modules that are part of Maya's installation. The userSetup script is executed in site-packages/maya/app/startup/basic.py.

As you can see, the only real change we made was to wrap the importation of the lightplane module in a call to the **executeDeferred()** function in the maya.utils module. This function allows you to queue up operations to be executed as soon as Maya is idle, which will be after the scene is initialized in this case.

4. Close Maya and reopen it. You should now see the red light and polygon plane in your scene.

While the userSetup script is a convenient way to automatically perform some operations, many Maya users are also accustomed to using it for their own purposes. You could wind up with complications if you require your artists to configure their path in their userSetup scripts, as opposed to simply importing your studio's tool modules. As such, a userSetup script is not always the best way to set up your path. Fortunately, it is also not the only option you have available.

sitecustomize Module

A built-in feature in Python is support for a sitecustomize module. A sitecustomize module is always executed when your Python session begins. Similar to a userSetup script, this module allows you to import modules, append to **sys.path**, and execute statements. *However, unlike a userSetup script, a sitecustomize module encapsulates its attributes like any other module, and so any modules you import in it are not automatically in the global symbol table for __main__.* We will see this issue in the next example.

The principle advantage of using a sitecustomize module is that it offers you an opportunity to set up the Python path without interfering with a userSetup script. Consequently, you could deploy a studiowide sitecustomize module to configure users' paths to point to network directories and so on. At the same time, your artists would still be able to set up their own individual userSetup scripts, as either MEL or Python depending on their needs and comfort levels. Artists would only need to import one package for your tools, and would be free to load other tools they may have downloaded from the Internet. You can offer them the flexibility to configure their environments individually, while also reducing the likelihood that they will inadvertently affect their search paths.

Recall earlier when we printed the directories in **sys.path** that there were essentially two groups of folders: those belonging to Maya's Python interpreter, and those that are added during Maya's initialization process. *Your sitecustomize module is imported before Maya's directories are added to the search path.* Consequently, convention dictates that you should put your sitecustomize module in your site-packages directory, which is in your

Python path by default. (In practice, you are free to include it in any directory that is part of your search path prior to Maya's initialization.) In this brief example, you will simply recreate the path manipulation functionality of the userSetup script that you created in the previous example.

1. Navigate back to the folder where you put your userSetup script, and remove the lines from it that you added in the previous example, or delete it altogether.

sitecustomize.py

```
import os, sys;
home = os.getenv('HOME');
user = os.getenv('USER');
sys.path.append(
    os.path.join(
        home[:home.find(user)],
        user, 'Desktop'
    )
);
```

2. Create a new module called sitecustomize.py and copy the contents of our example printed here into it. Save it in your site-packages directory in Maya's installation location. Note that to reach this location in OS X, you must press **Cmd-Shift-G** from a Save dialog to type in the path (you can also right-click on Maya.app and select Show Contents to drag a file into this location in Finder). Windows users may have to supply administrative privileges to write to this folder. The location of this folder varies based on your operating system:
 - **Windows:** C:\Program Files\Autodesk\Maya<version>\Python\lib\site-packages
 - **OS X:** Applications/Autodesk/maya<version>/Maya.app/Contents/Frameworks/Python.framework/Versions/Current/lib/python<version>/site-packages
 - **Linux:** /usr/autodesk/maya/lib/python<version>/site-packages
3. Close and reopen Maya to start a new session.
4. If you print the contents of your **sys.path** attribute, you will see that your desktop has been added to the search path immediately after the site-packages folder.

```
import sys;
for p in sys.path: print(p);
```

For example, a Windows user may see the following output.

```
C:\Program Files\Autodesk\Maya2012\bin
C:\Program Files\Autodesk\Maya2012\bin\python26.zip
```

```
C:\Program Files\Autodesk\Maya2012\Python\DLLs
C:\Program Files\Autodesk\Maya2012\Python\lib
C:\Program Files\Autodesk\Maya2012\Python\lib\plat-win
C:\Program Files\Autodesk\Maya2012\Python\lib\lib-tk
C:\Program Files\Autodesk\Maya2012\bin
C:\Program Files\Autodesk\Maya2012\Python
C:\Program Files\Autodesk\Maya2012\Python\lib\site-packages
C:/Users/Adam\Desktop
C:\Program Files\Autodesk\Maya2012\bin\python26.zip\lib-tk
C:/Users/Adam/Documents/maya/2012/prefs/scripts
C:/Users/Adam/Documents/maya/2012/scripts
C:/Users/Adam/Documents/maya/scripts
```

At this point, you could import the lightplane module if you like. However, there are a couple of important points worth discussing here. First, notice that the path to your desktop immediately follows the site-packages folder, indicating that the adjustments made in sitecustomize.py become immediately available—before Maya has initialized. Consequently, you cannot issue Maya commands from a sitecustomize module. Although you would be able to import the cmds module without errors (since it is accessible from the site-packages directory), it is effectively a dummy at this point in the initialization process, containing only placeholders for Maya commands. The maya.utils module suffers from the same limitation in this case.

Second, unlike the userSetup script, sitecustomize operates as an ordinary module, and therefore encapsulates its data. Consequently, if you were to print the global symbol table for the __main__ module at this point, you would not see any of the modules you imported or other variables you defined from within sitecustomize.py, such as os or the home or user variables.

While using a sitecustomize module is handy, you may find it inconvenient to write to a folder in Maya's install location, especially if you need to update the module occasionally. Another tool at your disposal for configuring your Python path, which can work in conjunction with a sitecustomize module and/or a userSetup script, is to set up an environment variable.

Setting Up a PYTHONPATH Environment Variable

Setting up an environment variable allows you to specify directories in your Python path that will be available before Maya has initialized, thus eliminating the need to append to **sys.path**. You can set up an environment variable specifically for Maya, or you can set up one that is systemwide. Either way, because directories you add via an environment variable are part of the search path before Maya has initialized, you can also put your sitecustomize module in a folder that you have specified using an environment variable, if you so choose.

Maya-Specific Environment Variables with Maya.env

The easiest way to configure an environment variable is to set up one that is exclusive to Maya. Maya has a file, Maya.env, available in a writable location, which allows you to configure a host of environment variables. You can add an environment variable, PYTHONPATH, to this file, and set its value to a collection of directories you want to include in the search path.

1. Delete the sitecustomize.py file that you created in the previous example if you still have it.
2. Open the Maya.env file in a text editor. Depending on your operating system, you can find this file in one of the following locations:
 - **Windows:** C:\Documents and Settings\user\My Documents\maya\ <version>
 - **OS X:** ~/Library/Preferences/Autodesk/maya/<version>
 - **Linux:** ~/maya/<version>
3. By default, your Maya.env file will be blank. This file allows you to specify environment variables and their values. Set a value for the PYTHONPATH variable to point to your desktop, where you saved the lightplane module. The syntax is similar for all platforms; just ensure you set the value appropriately based on your operating system. For example, if you are a Windows user, you may enter the following line.

   ```
   PYTHONPATH = C:\Users\Adam\Desktop
   ```

 If you already have a value set for PYTHONPATH, or if you want to add more directories, simply add your operating system's delimiter between them (Windows uses a semicolon, Linux and OS X use a colon). For example, a Windows user could enter the following.

   ```
   PYTHONPATH = C:\Users\Adam\Desktop;C:\mypythonfiles
   ```

4. Save your changes to the Maya.env file.
5. Close and reopen Maya to start a new session.
6. Open the Script Editor and print the **sys.path** attribute.

   ```
   import sys;
   for p in sys.path: print(p);
   ```

 As you can see, your desktop is now part of the Python search path—even before many of the default directories.

   ```
   C:\Program Files\Autodesk\Maya2012\bin
   C:\Users\Adam\Desktop
   C:\Program Files\Autodesk\Maya2012\bin\python26.zip
   C:\Program Files\Autodesk\Maya2012\Python\DLLs
   C:\Program Files\Autodesk\Maya2012\Python\lib
   ```

```
C:\Program Files\Autodesk\Maya2012\Python\lib\plat-win
C:\Program Files\Autodesk\Maya2012\Python\lib\lib-tk
C:\Program Files\Autodesk\Maya2012\bin
C:\Program Files\Autodesk\Maya2012\Python
C:\Program Files\Autodesk\Maya2012\Python\lib\
site-packages
C:\Program Files\Autodesk\Maya2012\bin\python26.zip\
lib-tk
C:/Users/Adam/Documents/maya/2012/prefs/scripts
C:/Users/Adam/Documents/maya/2012/scripts
C:/Users/Adam/Documents/maya/scripts
```

At this point, you could again import the lightplane module without having to alter the **sys.path** attribute.

Modifying the Maya.env file is one of the easiest and most reliable ways to configure your Python search path with minimal effects on other users. In a majority of cases, using some combination of the techniques we have discussed thus far is perfectly sufficient. However, you can also create a systemwide PYTHONPATH variable.

Systemwide Environment Variables and Advanced Setups

Your operating system allows you to define many custom environment variables that are shared across all applications. Because setting a systemwide environment variable will override your settings in Maya.env, and because it will apply to all applications that make use of it, it can be dangerous to use one, but also quite powerful if you know what you are doing. Systemwide environment variables simply offer you one more option for deploying common code across a range of applications.

For example, in addition to your Maya tools, you may have some shared libraries (e.g., numpy, PyQt4, and some Python utilities) that you use across a range of applications (e.g., Maya, MotionBuilder, and so on). To avoid deploying these modules to individual users, you may put them on a network drive, along with your tools for each specific application.

One option for solving this problem is to modify application-specific environment variables for each interpreter to point to individual sitecustomize modules in network directories (one directory/sitecustomize for each version of each application). In this scenario, each application has its own PYTHONPATH variable pointing to a network directory where you can easily deploy and update a sitecustomize module that appends new directories to the path (Figure 4.5). Each sitecustomize module could append further network directories relevant to the application's Python version and so on.

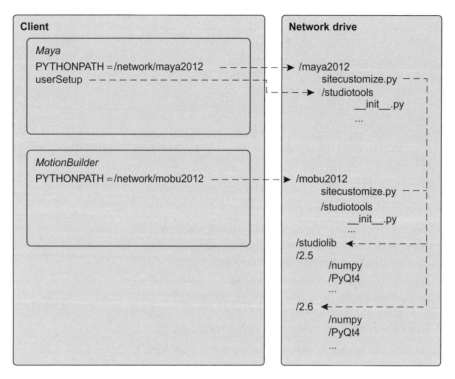

■ **FIGURE 4.5** One way to deploy systemwide modules with separate sitecustomize modules.

However, you may find it troublesome to add new software to your pipeline, or to upgrade existing software. For example, if you upgrade to a new version of Maya with a new version of Python, you would need to make sure you were pointing to a new version of PyQt and so on.

You could also set up a sitecustomize module on a network folder that is specified via a systemwide environment variable (Figure 4.6). Using a setup with systemwide environment variables would also enable you to set values for MAYA_SCRIPT_PATH, which is used to locate MEL scripts. Such a configuration would allow you to take advantage of the search path's construction order to use global userSetup scripts for your artists. Using a global userSetup script, you could automatically import your tools and then search for an individual user's userSetup script to execute it as well, which would allow your artists complete freedom over their own userSetup scripts without you having to worry that they import your tools.

In this setup, your global sitecustomize module could use attributes in the sys module to find out what application is importing it (**sys.executable**)

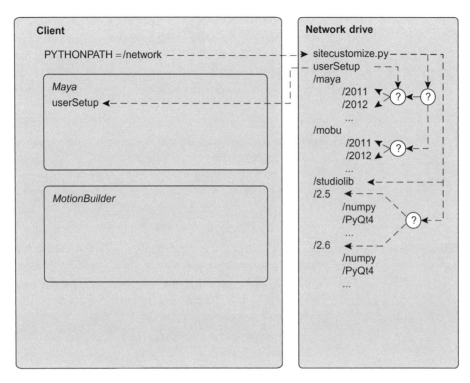

■ **FIGURE 4.6** One way to deploy systemwide modules with a systemwide environment variable.

and what version of Python it is running (**sys.version**). It could then use this information to append directories to the search path as needed. In this setup, any time you add a new piece of software to your pipeline, it can access your shared libraries right away. Keeping the sitecustomize module in one place where you can write to it makes it easy to update your whole team's toolset immediately. Just don't take that kind of power lightly! (If you are feeling really creative—or cavalier—you can also import __builtin__ in your sitecustomize module and add attributes to it for modules you know you will consistently want available right away, such as math, sys, os, or re.)

You can find more information about systemwide environment variables on the Internet, but we offer a few quick pointers here to get you started if you are interested.

Windows

To create a systemwide environment variable, open your System Properties dialog from the Control Panel. In the Advanced tab, there is an Environment Variables button at the bottom of the dialog. Clicking this button opens

a dialog that lets you create new variables that apply to the current user as well as variables that apply to the system. Simply create a variable called PYTHONPATH in the User section and supply it with semicolon-delimited directories just as you did in Maya.env. When you press OK, the new variable is ready to go and in place for all Python interpreters you run.

OS X

Apple's official technical documentation tells users to add environment variables to an environment.plist file and put it in the ~/.MacOSX directory. The problem with setting up an environment variable in this way is that it will only apply to applications with particular parent processes. For example, if you were to configure PYTHONPATH in this way and launch Maya from Spotlight rather than Finder, it would not be in effect.

To create an environment variable in OS X that will apply to applications with any parent process, you need to modify the configuration file for the launchd daemon. If you do not have one, you can create one at /etc/launchd.conf. Inside this text file, you can add a line like the following example with colon-delimited directories to specify your Python path.

```
setenv PYTHONPATH /users/Shared/Python:/users/Shared/
MorePythonStuff
```

USING A PYTHON IDE

As you start creating more modules and complex packages, the ability to work efficiently becomes more critical. While text editors and the Maya Script Editor are fine tools for quickly experimenting with code, they're not optimal environments for dealing with complex projects, version control systems, and so on. A better option is to use a Python IDE.

An IDE, or integrated development environment, is a tool for programming in large projects efficiently. Some major Python IDEs include features such as text editors with syntax highlighting and automatic code completion, debuggers, project navigation views, in-editor version control support for tools like SVN and Git, integrated interpreters, and more. In short, if you plan on writing more than one short Python script per year, you probably stand to gain a great deal by using a Python IDE.

Downloading an IDE

While you have many options available for coding in Python, we will only discuss two popular options here: Wing IDE and Eclipse. We only cover basics to save space, but you can consult the companion web site for links

and more information on how to set up these tools. Our main goal here is simply to help you find both of the tools and briefly examine some of their advantages and disadvantages. Knowing the strengths and weaknesses of each tool can help you find which is most comfortable for you, or even use them effectively in concert with one another!

Wing IDE

Wing IDE is a commercial product developed by Wingware, and is available at *http://wingware.com/*. As a commercial product, Wingware benefits from being a fairly straightforward tool to install, configure, and use. Moreover, Wingware offers a personal version, as well as a student version of Wing IDE, each of which is available at a lower price point than the professional version, yet which omit some features. Consequently, many users often find that Wing IDE is the easiest entry point when they begin working.

Wingware offers a handy online guide to setting up Wing IDE for use with Maya, which includes information on configuring its debugger, code completion, and sending commands to Maya (Wing uses its own interpreter by default).

Eclipse

Eclipse is an open-source product, and is available at *http://www.eclipse.org/downloads/*. Like many open-source products, Eclipse may seem daunting at first to those who are generally only familiar with commercial software. For starters, going to the download page offers a range of options, as the community has customized many configurations for common uses. (Note that Eclipse originated primarily as a Java development platform.) In our case, we are interested in Eclipse Classic. Once you have installed Eclipse, you need to download and install the Pydev plug-in, which can be done directly from the Eclipse GUI.

While Eclipse can perhaps be more complicated to configure, it does have some benefits. The most obvious benefit is of course that it is free. Moreover, Eclipse allows you to fully configure a variety of interpreters and select which interpreter each project is using. Furthermore, because the Eclipse community has developed a range of free plug-ins, you can easily download and install additional tools from within the application.

Basic IDE Configuration

Once you have downloaded and installed one or more IDEs to try out, you will need to go through a few steps to configure your environment. While we leave the specific details for the companion web site, we have selected a

few high-level points to discuss here so you have a better idea of what is going on under the hood.

Views

Whatever IDE you are using will be made up of multiple views, which can usually be customized into a layout that works for you. Figures 4.7 and 4.8 show some of the basic panels in Eclipse and Wing IDE, respectively. The largest panel is the text editor, where you actually input code (center-left in both of the screenshots).

Each IDE also contains project views, which display all of the modules and packages in your project. In our screenshots, Wing IDE's source browser is occluding the project view (right), but you can see the tab to expose it. Eclipse's project browser, on the other hand (far right), displays several projects, each expanded to show their contents. Moreover, each project also displays what interpreter it is using.

Another helpful feature in many IDEs is a source browser or module outliner (right in both). These views show you a collapsible outline of the current module, including its classes and other attributes. In both Wing IDE

■ **FIGURE 4.7** Eclipse.

FIGURE 4.8 Wing IDE.

and Eclipse, selecting an item from the outliner allows you to quickly jump to its definition, as well as see its scope. Moreover, Eclipse has a handy built-in feature to highlight all occurrences of the selected object, which not only highlights it in the text editor view but also highlights markers on the text editor's scrollbar to see where other occurrences are.

Each editor has a number of other views (which we will not detail here), including panels for debugging, interactively using an interpreter, reviewing project errors, console output, version control history, and much more.

Selecting an Interpreter

Most Python IDEs integrate an interpreter that you can use for executing code, debugging, and so forth. Wing IDE is bundled with its own interpreter, but Eclipse allows you to configure as many as you like, using interpreters already existing on your machine. Because Wing IDE ships with its own interpreter, you cannot directly use Maya's modules in its interactive terminal to test them.

An advantage to configuring multiple interpreters is that you may deploy to different versions of Python across the different products you are

supporting, whether they are different versions of Maya or other applications like MotionBuilder. As such, you can ensure that your projects are properly implementing supported language features for the end user's environment, for example. Moreover, you can individually configure the search path for each interpreter you configure. In Eclipse, you can configure interpreters from the **Preferences** menu, where you can select **Interpreter – Python** in the Pydev dropdown menu. You can consult the companion web site for more information on configuring an interpreter for Maya in Eclipse.

Automatic Code Completion

Most advanced Python development environments will support some mechanism for autocompletion of code. The basic idea is that the IDE is aware of the contents of modules you import, and so it can begin to offer completion suggestions while you type. As you can imagine, this feature can be a huge time saver and can reduce typos.

While most IDEs can offer interactive completion by analyzing the contents of the module in which you are working, as well as other modules in your project, this mode of autocompletion may be sluggish. As such, IDEs such as Eclipse and Wing IDE allow you to use what are called stubs to generate autocompletion results for modules. In short, the stubs are special, concise files with either a .py or .pi extension, which contain dummies for some actual module, allowing them to be parsed for autocompletion more quickly. Fortunately, there are handy tools for automatically generating these stubs from Maya's modules. You can find more information about this process on the companion web site.

Projects

The key mode of organization in a Python IDE is to create projects. Projects are typically small description files that contain information about a collection of modules (e.g., their location on disk), the interpreter to be used, version control settings, and so on. Consequently, project files do not usually store any of your actual data, but rather allow you to easily locate and organize your files. Many IDEs also offer special tools for performing projectwide searches, replacements, and so on.

Connecting to Maya

Both Wing IDE and Eclipse offer functionality for advanced users to connect the IDE directly to Maya. The basic process is that you can call the `commandPort` command in your userSetup script to automatically listen

for input from a port on which the IDE will send commands to Maya. Using this feature enables you to execute a whole module (or individual lines of code that you select) and send them to Maya's __main__ module, just like using the Script Editor. You can refer to the companion web site for more information on tools for connecting to Maya.

Debugging

The final important feature we want to note is that many IDEs, such as both Wing IDE and Eclipse, offer tools for debugging modules. Using an integrated debugger allows you to set break points in your module before you execute it, so you can interactively monitor the values of different variables during execution. You can refer to the companion web site for links to information on the debuggers for Wing IDE and Eclipse.

CONCLUDING REMARKS

You now have a solid grasp of modules and packages, as well as how to optimize your development and deployment practices. Although we introduced some of Python's built-in modules in this chapter, such as math, os, and sys, there are many more that you will find useful when working in Maya. We encourage you to consult Python's online documentation and familiarize yourself with some of the most common modules, as they have often already solved problems you may otherwise toil over! Likewise, there are many useful modules in the Python community at large that you can use in Maya.

Although the power of modules should be clear, particularly compared to traditional MEL scripts, they are still only the tip of the iceberg for what you can accomplish using Python in Maya. Now that you are better acquainted with concepts such as scope and encapsulation, you are ready to start working with one of Python's greatest advantages over MEL: the ability to do object-oriented programming.

Object-Oriented Programming in Maya

BY THE END OF THIS CHAPTER, YOU WILL BE ABLE TO:

- Compare and contrast object-oriented and procedural programming.

- Describe what objects are.

- Create your own custom class.

- Define attributes.

- Distinguish data attributes and methods.

- Compare and contrast instance attributes and class attributes.

- Distinguish the @staticmethod and @classmethod decorators.

- Describe and implement inheritance.

- Locate more information about object-oriented programming.

- Compare and contrast the pymel and cmds modules.

- Explain the underlying mechanics of the pymel module.

- Describe the benefits and disadvantages of the pymel module.

- Install the pymel module if needed.

- Locate online documentation for the pymel module.

- Use pymel methods to take advantage of OOP in your daily work.

As you have seen up to this point, Python's basic language features can work in conjunction with Maya commands to build a variety of useful functions and tools. Nevertheless, because this approach to Python programming differs little from MEL, the advantages of Python may not yet be immediately clear.

In Chapter 4, we introduced the concept of modules, and examined the many ways in which they are more powerful than ordinary MEL scripts. Part of the reason modules are so useful is because they allow you to encapsulate functions and variables, called attributes, into namespaces. Although we did not explicitly point out the relationship, modules are objects, just like any other piece of data in Python (including integers, strings, lists, dictionaries, and even functions themselves). In fact, Python is a fully object-oriented language, and most of its built-in types have attributes and functions that you can access much like those in modules.

In this chapter, we take a high-level look at the two programming paradigms available when using Python with Maya: object-oriented programming and procedural programming. After discussing these concepts, we will thoroughly examine the heart of object-oriented programming: objects. To better understand objects, we will create a custom Python class and use it to explore many of the basic components of classes, including data attributes, class attributes, and methods. We then introduce the concept of inheritance by creating a new class derived from our first one. Thereafter, we turn back to Maya to compare and contrast the maya.cmds module with an alternative, object-oriented suite: pymel. We conclude with some basic examples to introduce the pymel module and illustrate its unique features.

OBJECT-ORIENTED VERSUS PROCEDURAL PROGRAMMING

While MEL developers may be new to the concept, many programmers have at least heard of object-oriented programming (OOP). To some, it simply means programming with "classes." But what does that actually

mean, and what are the benefits of these "classes" and "objects"? To answer these questions, we need to compare and contrast OOP with procedural programming, another widely used programming paradigm.

For the sake of this discussion, think of a program as a means of operating on a data set to produce some result. In procedural programming, a program is made up of variables and functions designed to operate on data structures. Most Maya developers are probably familiar with the concepts behind procedural programming from MEL, as in the following hypothetical code snippet.

```
// convert a string to uppercase in MEL
string $yourName = "AnnieCat";
string $newName = `toupper($yourName)`;
print($newName);
// prints ANNIECAT //
```

This example perfectly illustrates the main tenet of procedural programming: *Data and the code that processes the data are kept separate*. The variables $yourName and $newName are simply collections of data, with no inherent features or functionality available to developers. Processing the data requires functions and procedures external to the strings, in this case, the MEL function **toupper()**.

A clue as to the nature of OOP is contained in the words "object-oriented." OOP refers to a programming paradigm that relies on objects as opposed to procedures. To understand this principle, consider the previous MEL example translated into Python.

```
# convert a string to uppercase in Python
your_name = 'Harper';
new_name = your_name.upper();
print(new_name);
# prints HARPER
```

Here you can see that the uppercasing function **upper()** is associated with the variable your_name. While we pointed out in Chapter 2 that variables in Python are objects with a value, type, and identity, we didn't really explore this principle further. *An object can be thought of as an encapsulation of both data and the functionality required to act on them*.

So if a procedural program is defined as a collection of variables and functions that operate on a data set, an object-oriented program can be defined as a collection of classes that contain both data and functionality. The term *object* refers to a unique occurrence of a class, an instance. While everything in Python is represented internally as an object, we will explore how you can define your own types of objects.

Basics of Class Implementation in Python

In addition to the set of built-in objects, Python also allows developers to create their own objects by defining *classes*. The basic mechanism to do so is the **class** keyword, followed by the name of the class being defined. Proper coding convention dictates that a class name should be capital case (e.g., **SpaceMarine**, **DarkEldar**).

1. Execute the following lines to define a class called **NewClass**.

```
class NewClass:
    pass;
```

2. If you use the **dir()** function on this class, you can see that it has some attributes by default, which should be familiar.

```
dir(NewClass);
# Result: ['__doc__', '__module__'] #
```

Although this basic syntax is the minimum requirement for defining a class, it is referred to as an old-style or classic class. Up until Python 2.2, this syntax was the only one available. Python 2.2 introduced an alternate class declaration, which allows you to specify a parent from which the class should derive. It is preferable to derive a class from the built-in object type.

3. Execute the following lines to redefine the **NewClass** class.

```
class NewClass(object):
    pass;
```

4. If you use the **dir()** function now, you can see that the class inherits a number of other attributes.

```
dir(NewClass);
# Result: ['__class__', '__delattr__', '__dict__',
'__doc__', '__format__', '__getattribute__', '__hash__',
'__init__', '__module__', '__new__', '__reduce__',
'__reduce_ex__', '__repr__', '__setattr__',
'__sizeof__', '__str__', '__subclasshook__',
'__weakref__'] #
```

Although it is not required to define a basic class by deriving from the object type, it is strongly recommended. We will talk more about the importance of inheritance later in this chapter.

Instantiation

Once you have defined a class, you can create an instance of that class by calling the class (using function notation) and binding its return value to a variable.

5. Execute the following lines to create three **NewClass** instances.

```
instance1 = NewClass();
instance2 = NewClass();
instance3 = NewClass();
```

These creation calls each return a valid, unique **NewClass** instance. Each instance is a separate immutable object. Recall that immutability means only that the value of the underlying data cannot change. As such, each instance is guaranteed to have a consistent identity over the course of its existence as well (and hence could be used as a key in a dictionary). However, using OOP, you can effectively mutate instances by using attributes.

ATTRIBUTES

Like modules, classes have attributes. However, attributes in classes are much more nuanced. An attribute may be a piece of data or a function, and it may belong to the class or to an instance of the class. The basic paradigm for creating an attribute is to define it in the class definition, as in the following example.

```
class NewClass():
    data_attribute = None;
    def function_attribute(*args): pass;
```

At this point, you could pass **NewClass** to the **dir()** function and see its attributes (note that we do not inherit from the object type, simply to have a shorter list of attributes for this example).

```
print(dir(NewClass));
"""
prints:
['__doc__', '__module__', 'data_attribute',
'function_attribute']
"""
```

However, Python also allows you to add attributes to a class on-the-fly, after you have defined the class. You could now execute the following lines to add another data attribute to the class and see the results.

```
NewClass.another_data_attribute = None;
print(dir(NewClass));
"""
prints:
['__doc__', '__module__', 'another_data_attribute',
'data_attribute', 'function_attribute']
"""
```

You can also add attributes to individual instances after creating them, which will not affect other instances of the class. The following example illustrates this process.

```
instance1 = NewClass();
instance1.instance_attribute = None;
instance2 = NewClass();
# only instance1 has instance_attribute
print('Instance 1:', dir(instance1));
print('Instance 2:', dir(instance2));
```

Remember that attributes can be functions. Consequently, you can assign the name of any function to an attribute. A function that is an attribute of a class is referred to as a *method*.

```
def foo(*args): print('foo');
NewClass.another_function_attribute = foo;
instance1.another_function_attribute();
instance2.another_function_attribute();
```

While attributes you add to an instance become available to that instance immediately, adding attributes to the class itself makes the attributes immediately available to all current and further instances of the same class.

Finally, it is worth noting that reexecuting a class definition will not affect existing instances of the class. Because of how Python's data model works, old instances are still associated with an object type somewhere else in memory.

```
class NewClass():
    just_one_attribute = None;
new_instance = NewClass();
print('New:', dir(new_instance));
"""
prints: ('New:', ['__doc__', '__module__',
'just_one_attribute'])
"""

print('Old:', dir(instance1));
"""
prints: ('Old:', ['__doc__', '__module__',
'another_data_attribute', 'another_function_attribute',
'data_attribute', 'function_attribute',
'instance_attribute'])
"""
```

In the following sections, we will explore some of the special distinctions between instance attributes and class attributes.

Data Attributes

While you can add data attributes in a number of ways, a common mechanism for defining them is to do so in the __init__() method, which is called when an instance is first created. Because Python automatically searches for this function as soon as an instance is created, attributes that are created in this way are instance attributes, and require that you access them from an instance.

1. Execute the following lines to define a **Human** class with an __init__() method, which initializes some basic data attributes based on input arguments.

    ```python
    class Human(object):
        def __init__(self, *args, **kwargs):
            self.first_name = kwargs.setdefault('first');
            self.last_name = kwargs.setdefault('last');
            self.height = kwargs.setdefault('height');
            self.weight = kwargs.setdefault('weight');
    ```

2. Now you can pass arguments to the class when you create an instance, and their values will be bound accordingly. Execute the following code to create three new **Human** instances, passing each one different keyword arguments.

    ```python
    me = Human(first='Seth', last='Gibson');
    mom = Human(first='Jean', last='Gibson');
    dad = Human(first='David', last='Gibson');
    ```

3. Execute the following lines to confirm that each instance's data attributes have been properly initialized.

    ```python
    print('me: ', me.first_name);
    print('mom:', mom.first_name);
    print('dad:', dad.first_name);
    ```

While developers coming from other languages may be tempted to refer to __init__() as a constructor function, it is in fact quite different from one. Though its parameter list specifies the syntax requirements for instantiation, the instance has already been constructed by the time __init__() is called. Arguments passed to the constructor call are passed directly to __init__(). Note that the parameters you specify for __init__() restrict the constructor to all of its syntactic requirements, including any constraints it may impose on positional arguments. Refer to Chapter 3 for a refresher on the myriad options for passing arguments to functions.

As you can see, the first argument passed to this method is called self, while the remaining arguments are those that are passed to the constructor

when the instance was created. The self name is used as a convention, and refers to the instance object calling this function. This argument is always passed to methods on objects. Consequently, all ordinary methods will pass the owning instance as the first argument, though we will examine some exceptions later when discussing class attributes.

4. Execute the following lines to print the results of the **dir()** function for the **Human** class and for an instance, me.

```
print('Class:    ', dir(Human));
print('Instance:', dir(me));
```

You should see at the end of the output list that an instance allows you to access attributes that do not exist as part of the class definition itself. Remember that you can define attributes in the class definition as well. While data attributes defined both ways may have unique values for any particular instance, those that exist in the class definition can be accessed without an instance of the class, as in the following hypothetical example.

```
import sys;
class NewClass():
    # exists in class definition
    data_attribute1 = 1;
    def __init__(self):
        # added to instance upon instantiation
        self.data_attribute2 = 2;
print(NewClass.data_attribute1);
try:
    print(NewClass.data_attribute2);
except AttributeError:
    print(sys.exc_info()[0]);
instance = NewClass();
print(instance.data_attribute1);
print(instance.data_attribute2);
```

We will discuss the importance of this difference later as we examine class attributes.

As you have seen, you can access attributes by using the dot (**.**) operator. You can both reassign and read an attribute's value by accessing the attribute on the instance.

5. Execute the following lines to print the **first_name** attribute on the me instance, and then reassign it and print the new value.

```
print(me.first_name);
me.first_name = 'S';
print(me.first_name);
```

While you are free to modify data on your instances using this paradigm, another, more useful technique is to use methods.

Methods

A method is a function existing in a class. Ordinarily its first argument is always the instance itself (for which we conventionally use the `self` name). Methods are also a type of attribute. For example, while **len()** is simply a built-in function that you can use with strings, **upper()** is a method that is accessible on string objects themselves. You can add further methods to your class definition by remembering that the first argument will be the instance of the class.

6. Execute the following lines to add a **bmi()** method to the **Human** class, which returns the instance's body mass index using metric computation.

```
def bmi(self):
    return self.weight / float(self.height)**2;
Human.bmi = bmi;
```

Assuming we are working in the metric system, you could now create an instance and call the **bmi()** method on it to retrieve the body mass index if `height` and `weight` are defined.

7. Execute the following lines to create a new **Human** instance and print its BMI. The result should be 22.79.

```
adam_mechtley = Human(
    first='Adam',
    last='Mechtley',
    height=1.85,
    weight=78
);
print('%.2f'%adam_mechtley.bmi());
```

As we indicated earlier in this chapter, methods are one of the primary tools that differentiate OOP from procedural programming. They allow developers to retrieve transformed data or alter data on an instance in sophisticated ways. Apart from the syntactic requirement that the first argument in a method definition be the instance owning the method, you are free to use any other argument syntax as you like, including positional arguments, keyword arguments, and so on.

__str__()

It is also possible to override inherited methods to achieve different functionality. For example, printing the current instance isn't especially helpful.

8. Execute the following line.

```
print(adam_mechtley);
```

The results simply show you the namespace in which the class is defined, the name of the class, and a memory address. Sample output may look something like the following line.

```
<__main__.Human object at 0x130108dd0>
```

In Python, when printing an object or passing it to the **str()** function, the object's __**str**__() method is invoked. You can override this inherited method to display more useful information.

9. Execute the following lines to override the __**str**__() method to print the first and last name of the **Human**.

```
def human_str(self):
    return '%s %s'%(
        self.first_name,
        self.last_name
    );
Human.__str__ = human_str;
```

10. Print one of the instances you previously created and you should see its first and last name.

```
print(mom);
# prints: Jean Gibson
```

As we described in Chapter 4 when discussing modules, Python does not really have the concept of privacy. Just as with modules, Python uses the double-underscore convention to suggest that certain attributes or methods, such as __**str**__(), be treated as internal. Nevertheless, you can reassign internal methods from any context by reassigning another function to the method name.

Note that when you override a method like __**str**__(), all instances will reflect the change. The reason for this behavior concerns the type of the __**str**__() method in the base class.

11. Execute the following line to view the type of the __**str**__() method in the object class.

```
print(type(object.__str__));
# prints: <type 'wrapper_descriptor'>
```

As you can see from the result, the type is given as wrapper_descriptor. The basic idea is that when __**str**__() is invoked, it is not calling a particular implementation on the instance itself, but the implementation defined in the class. For example, reassigning this method on an instance object has no effect.

12. Execute the following lines to try to reassign **__str__**() on the adam_
mechtley instance. As you can see, there is no effect.

```
def foo(): return 'just some dude';
adam_mechtley.__str__ = foo;
print(adam_mechtley);
# prints: Adam Mechtley
```

On the other hand, overriding ordinary instancemethods will only affect the particular instance that gets the new assignment.

13. Execute the following line to print the type of the **bmi**() method on adam_mechtley. You should see the result instancemethod.

```
print(type(adam_mechtley.bmi));
```

14. Execute the following lines to create a new **Human** instance and define a new function that returns a witty string.

```
matt_mechtley = Human(
    first='Matt',
    last='Mechtley',
    height=1.73,
    weight=78
);
msg = 'Studies have shown that BMI is not indicative of
health.';
def wellActually(): return msg;
```

15. Execute the following lines to store the **bmi**() method on adam_mechtley in a variable, reassign the **bmi**() name on the adam_mechtley instance, and then print the results of **bmi**() for both instance objects.

```
old_bmi = adam_mechtley.bmi;
adam_mechtley.bmi = wellActually;
print(str(matt_mechtley), matt_mechtley.bmi());
print(str(adam_mechtley), adam_mechtley.bmi());
```

You can see from the results that the matt_mechtley instance properly returns a BMI value, while the adam_mechtley instance returns the value of the **wellActually**() function.

16. Execute the following lines to reassign the **bmi**() instance-method on matt_mechtley to that on adam_mechtley.

```
adam_mechtley.bmi = matt_mechtley.bmi
print(adam_mechtley.bmi());
```

As you can see, adam_mechtley is not in fact printing its own BMI (about 22.8), but is printing the BMI associated with matt_mechtley (about 26.06)! The reason is because the method name on the

adam_mechtley instance is pointing to the method on the matt_mechtley instance, and so the name self refers to that instance in the method body.

17. Execute the following line to reassign the original instancemethod to the adam_mechtley instance. As you can see from the output, the result is about 22.8, as it should be.

```
adam_mechtley.bmi = old_bmi;
print(adam_mechtley.bmi());
```

You may sometimes want to temporarily override the functionality of methods in your own work. In such cases, you would want to use this pattern to maintain a reference to the original method so you can replace it when you are done. If you fail to replace a method that you are manipulating for some reason (e.g., overriding __str__() on someone else's class for debugging purposes), you should always replace the original when you are done, as other code may rely on the original functionality.

__repr__()

You may have noticed in step 15 that we wrapped the names of the instances in a call to the **str()** function. The reason for doing so is that when a call is made to **print()** with multiple arguments, the __str__() method on the object is not actually called.

18. Execute the following line to create two new **Human** instances and try to print their names.

```
sis = Human(first='Ruth', last='Gibson');
baby_sis =Human(first='Emily', last='Gibson');
print(sis, baby_sis);
```

Unfortunately, the results that you see closely resemble the output you saw in step 8, before you overrode the __str__() method. Some parts of Python do not invoke the __str__() method for output, but instead use the __repr__() method. Convention dictates that this method should return a string that would allow the object to be reconstructed if passed to the **eval()** function, for example.

19. Execute the following lines to add a __repr__() method to the **Human** class.

```
def human_rep(self):
    return """Human(%s='%s', %s='%s', %s=%s,
    %s=%s)"""%(
        'first', self.first_name,
        'last', self.last_name,
        'height', self.height,
```

```
            'weight', self.weight
        );
    Human.__repr__ = human_rep;
```

20. Execute the following line to try to print the instances you created in step 18 again.

```
print(sis, baby_sis);
```

You should see something like the following output, indicating that the **__repr__**() method has been invoked.

```
(Human(first='Ruth', last='Gibson', height=None,
weight=None), Human(first='Emily', last='Gibson',
height=None, weight=None))
```

21. Because we have followed convention, **__repr__**() returns a statement that could be evaluated. You could leverage this functionality to create a duplicate. Execute the following lines to create a duplicate of `baby_sis`. Note that each of these objects has a unique identity.

```
twin = eval(baby_sis.__repr__());
print(baby_sis, twin);
print(id(baby_sis), id(twin));
```

There are many more built-in methods you can override. Consult Section 3.4 of Python Language Reference for a full listing.

Properties

Properties are special types of methods that can be accessed as though they were ordinary data attributes, and hence do not require function syntax (e.g., `print(instance.property_name)`). When you add a property in a class definition itself, you can add the appropriate decorator to the line prior to the method's definition. A *decorator* is a special, recognized word, prefixed with the @ symbol.

```
# for a read-only property
@property
def property_name(self):
    # return something here
```

Note that Python 2.6 and later (Maya 2010 and later) allows you to also use a decorator to specify that a property can be set by simply passing a value to it like a data attribute (e.g., `instance.property_name = value`).

```
# make the property settable
@property_name.setter
def property_name(self, value):
    # set some values here
```

Another option, compatible with all versions of Maya, is to use the **property()** function in conjunction with new style class syntax, which lets you specify a getter and a setter (as well as some further optional parameters). At minimum a property must have a getter, but other aspects are optional.

```
def getter(self):
    # return something here
def setter(self, value):
    # set some values here
Class.property_name = property(getter, setter);
```

22. Add a `full_name` property to the **Human** class as shown in the following lines.

```
def fn_getter(self):
    return '%s %s'%(self.first_name, self.last_name);
def fn_setter(self, val):
    self.first_name, self.last_name = val.split();
Human.full_name = property(fn_getter, fn_setter);
```

Note the special assignment syntax we use in the **fn_setter()** method to assign multiple variables at the same time, based on items in the sequence returned from the **split()** method.

23. Execute the following lines to create a new **Human** and use its property to get and set the first and last names using the `full_name` property.

```
big_sis = Human(first='Amanda', last='Gordon');
# notice that property is not invoked with parentheses
print(big_sis.full_name);
# prints: Amanda Gordon
# set a new value
big_sis.full_name = 'Amanda Gibson';
print(big_sis.full_name);
# prints: Amanda Gibson
```

Class Attributes

In addition to instance attributes, Python contains support for class attributes. *A class attribute can be accessed by using the class name, and does not require that you create an instance.* Class attributes can be useful for adding data or methods to a class that may be of interest to other functions or classes when you may not have a need to create an instance of the class. You can access them by using the dot operator with the name of the class.

As we pointed out earlier, class data attributes behave exactly like instance attributes on instances: changing the value on one instance has no effect on other instances. However, because they can be accessed without an

instance, you may use them in cases where you have no instance (e.g., when you are creating a new instance).

24. Execute the following lines to add two basic unit-conversion attributes to the **Human** class.

```
Human.kPoundsToKg = 0.4536;
Human.kFeetToMeters = 0.3048;
```

25. Execute the following lines to reconstruct a new **Human** instance using these class attributes to help construct it from American units (feet and pounds, respectively).

```
imperial_height = 6.083;
imperial_weight = 172;
adam_mechtley = Human(
    first='Adam',
    last='Mechtley',
    height=imperial_height*Human.kFeetToMeters,
    weight=imperial_weight*Human.kPoundsToKg
);
print('Height:', adam_mechtley.height);
print('Weight:', adam_mechtley.weight);
```

Because of Python's system of modules, you may find it unnecessary to store such values as part of a class definition, instead preferring to store them as attributes of a module, outside of the class definition. However, when you have several classes defined in a single module, as you often will when working with the Maya API, it can be helpful to further nest such attributes inside of classes, especially if their names might conflict. You will see this practice used frequently starting in Chapter 10 as we introduce plug-in development.

Static Methods and Class Methods

Python also includes support for some special types of methods known as static methods and class methods. *Static methods and class methods allow you to call a method associated with the class without requiring an instance of the class.* You can add these types of methods to your class definition using decorators on the line before a definition. They take the following basic forms.

```
class ClassName(object):
    @staticmethod
    some_static_method():
        # insert awesome code here
        pass;
    @classmethod
```

```
some_class_method(cls):
    # insert awesome code here
    pass;
```

At this point, you could call either of these functions using the following identical forms.

```
ClassName.some_static_method();
ClassName.some_class_method();
```

Note that the only difference between these two options is that a class method implicitly passes the class itself as the first argument, which allows you shorthand access to any class attributes (by allowing you to access them using `cls.attribute_name` rather than `ClassName.attribute_name` inside the method). It is also worth pointing out that, because these types of methods are called using the name of the class rather than on an instance, they do not pass an instance (`self`) as an argument. Otherwise, you are free to add whatever other arguments to them you like.

26. Execute the following lines to add a static method to the **Human** class that returns the taller person.

```
@staticmethod
def get_taller_person(human1, human2):
    if (human1.height > human2.height):
        return human1;
    else: return human2;
Human.get_taller_person = get_taller_person;
```

27. Execute the following lines to print the taller person.

```
taller = Human.get_taller_person(
    adam_mechtley, matt_mechtley
);
print(taller);
```

Class methods can be used to implement alternate creation methods for a class or in other situations where access to class data is required separate from an instance.

28. Execute the following lines to add a class method that creates a **Human** with some specified default parameters.

```
@classmethod
def create(cls):
    return cls(
        first='Adam',
        last='Mechtley',
        height=6.083*cls.kFeetToMeters,
        weight=172*cls.kPoundsToKg
    );
```

```
Human.create_adam = create;
dopplegaenger = Human.create_adam();
print(dopplegaenger);
```

As with ordinary class attributes, the value of such methods is in those situations when you want to expose some functionality without an instance. While you can exploit a class method to create alternate constructors, they are also handy in cases when you want to access class data attributes.

Human Class

For your benefit, we have printed the entire code for the **Human** class example below, as it would appear if you were to define it all at once.

```python
class Human(object):
    kPoundsToKg = 0.4536;
    kFeetToMeters = 0.3048;
    def __init__(self, *args, **kwargs):
        self.first_name = kwargs.setdefault('first');
        self.last_name = kwargs.setdefault('last');
        self.height = kwargs.setdefault('height');
        self.weight = kwargs.setdefault('weight');
    def bmi(self):
        return self.weight / float(self.height)**2;
    @staticmethod
    def get_taller_person(human1, human2):
        if (human1.height > human2.height):
            return human1;
        else: return human2;
    @classmethod
    def create_adam(cls):
        return cls(
            first='Adam',
            last='Mechtley',
            height=6.083*cls.kFeetToMeters,
            weight=172*cls.kPoundsToKg
        );
    # Begin properties
    def fn_getter(self):
        return '%s %s'%(self.first_name, self.last_name)
    def fn_setter(self, val):
        self.first_name, self.last_name = val.split()
    full_name = property(fn_getter, fn_setter)
    # End properties
    # Alternate property defs for Maya 2010+
    """

    @property
```

```
    def full_name(self):
        return '%s %s'%(self.first_name, self.last_name);
    @full_name.setter
    def full_name(self, val):
        self.first_name, self.last_name = val.split();
    """
    def __str__(self):
        return self.full_name;
    def __repr__(self):
        return """Human(%s='%s', %s='%s', %s=%s,
        %s=%s)"""%(
            'first', self.first_name,
            'last', self.last_name,
            'height', self.height,
            'weight', self.weight
        );
```

INHERITANCE

Another critical concept in OOP is inheritance. Although we made some use of it in the previous example, we did not explore it in detail. At the high level, inheritance allows a new class to be derived from a parent class, allowing it to automatically inherit all of its parent's attributes. As we demonstrated briefly in the previous section, this concept also allows you to override functionality as needed in a descendant class.

For example, suppose you have implemented a class like **Human** and decide that you need a similar class, but only with marginal changes. One option might be to just add the additional required functionality to the original class, but the new functionality may be substantially different, or may be something that not all instances require.

With inheritance, rather than having to copy or reimplement features from the original class, you can simply tell Python to create a new class based on an existing class that preserves all the functionality of the original, while allowing new functionality to be introduced.

1. Ensure that you have the **Human** class defined in your current name-space. See the end of the previous section for details.
2. Execute the following code to implement a class called **MyKid** that inherits from the **Human** class presented in the previous section.

```
class MyKid(Human):
    def __init__(self, *args, **kwargs):
        Human.__init__(self, *args, **kwargs);
        self.mom = kwargs.setdefault('mom');
```

```
            self.dad = kwargs.setdefault('dad');
            self.siblings = [];
            if kwargs.setdefault('sibs') is not None:
                self.siblings.extend(
                    kwargs.setdefault('sibs')
                );
    def get_parents(self):
        return '%s, %s'%(
            self.mom.full_name,
            self.dad.full_name
        );
    def set_parents(self, value):
        self.mom, self.dad = value;
    parents = property(get_parents, set_parents);
```

There are two main points related to class derivation that merit discussion. The first point concerns the class declaration statement.

```
class MyKid(Human):
```

Rather than using the built-in object class, **MyKid** uses **Human** as the parent or base class. This syntax is the first step for ensuring that the child/derived class **MyKid** retains the functionality implemented in **Human**.

The second point to take note of is the class initializer for **MyKid**. This situation is one of the few instances where a class's **__init__**() method needs to be called directly.

```
def __init__(self, *args, **kwargs):
    Human.__init__(self, *args, **kwargs);
    self.mom = kwargs.setdefault('mom');
    self.dad = kwargs.setdefault('dad');
    self.siblings = [];
    if kwargs.setdefault('sibs') is not None:
        self.siblings.extend(
            kwargs.setdefault('sibs')
        );
```

If the base class's initializer is not called, the derived class's functionality may be a bit unpredictable. For example, a derived class will inherit its parent class's methods (as we saw in the previous section when inheriting from **object**). If these methods are not specifically implemented (overridden) in the child class, some of them may require the presence of an instance data attribute that is created in the base class's **__init__**() method, rather than in the base class's definition.

When any method is executed, inherited or otherwise, it is executed in the scope of the derived class. If an inherited method references specific data

attributes and the base class's initializer hasn't also been run in the scope of the derived class, the derived class will not be able to access those data attributes since they do not exist. As a matter of practice, it is always wise to first call the base class's **__init__**() method in the derived class's **__init__**() method, and then override any data attributes or methods as needed.

3. Execute the following line to confirm all of the attributes in the **MyKid** class. As you can see from the output, the class has inherited all of the attributes you defined in the **Human** class earlier, as well as all of the attributes it inherited from **object**.

```
print(dir(MyKid));
"""
prints: ['__class__', '__delattr__', '__dict__',
'__doc__', '__format__', '__getattribute__', '__hash__',
'__init__', '__module__', '__new__', '__reduce__',
'__reduce_ex__', '__repr__', '__setattr__',
'__sizeof__', '__str__', '__subclasshook__',
'__weakref__', 'bmi', 'create_adam', 'full_name',
'get_parents', 'get_taller_person', 'kFeetToMeters',
'kPoundsToKg', 'parents', 'set_parents']
"""
```

4. Execute the following lines to create two **Human** instances to pass as arguments to a new **MyKid** instance, and then create the new **MyKid** instance.

```
mom = Human(first='Jean', last='Gibson');
dad = Human(first='David', last='Gibson');
me = MyKid(
    first='Seth', last='Gibson',
    mom=mom, dad=dad
);
```

5. Print the **MyKid** instance and note that the base class handles the **__str__**() implementation.

```
print(me);
# prints: Seth Gibson
```

Although we do not do so here for the sake of economy, you will always want to override **__repr__**() in child classes to ensure they will properly return values that would allow them to be reconstructed as instances of the derived class.

Note also that the **siblings** attribute could store further instances of the **MyKid** class.

6. Execute the following code to use a list comprehension to populate the **siblings** attribute on the me instance with further **MyKid** instances.

```
me.siblings.extend(
    [MyKid(
        first=n,
        last='Gibson',
        mom=mom,
        dad=dad
    ) for n in ['Amanda', 'Ruth', 'Emily']]
);
```

7. Execute the following line to print each of the siblings and confirm they were properly created.

```
for s in me.siblings: print(s);
"""
prints:
Amanda Gibson
Ruth Gibson
Emily Gibson
"""
```

Another advantage of inheritance is that you could easily create another derived class with its own separate functionality, which may be completely unimportant for other classes.

8. Execute the following code to create another derived class, **SpaceMarine**.

```
class SpaceMarine(Human):
    def __init__(self):
        Human.__init__(self);
        self.weapon_skill = 4;
        self.ballistic_skill = 4;
        self.strength = 4;
        self.toughness = 4;
        self.wounds = 1;
        self.initiative = 4;
        self.attacks = 1;
        self.leadership = 8;
```

Deriving classes is a powerful yet flexible way to both reuse code and keep codebases organized. Developers interested in learning more on this topic are advised to read both the Python Language Reference, which includes information on both Python's data and execution models, and the FAQs included on Python's design, which give insight into many of the design decisions behind Python.

Armed with a working knowledge of classes in Python, we can now take a look at how you can use some of these paradigms in Maya using an alternate Python implementation to maya.cmds.

PROCEDURAL VERSUS OBJECT-ORIENTED PROGRAMMING IN MAYA

One of the shortcomings of maya.cmds identified by many developers is that maya.cmds does not present a properly object-oriented equivalent to MEL as was originally hoped for. Fortunately, a developer at Luma Pictures named Chad Dombrova, along with other developers from Luma, ImageMovers Digital, and a few other studios, created a set of tools called PyMEL, which seek to address this issue.

Since its initial public release, PyMEL has found its way into many game and film productions, including *Thor*, *True Grit*, *Halo*, *PlanetSide 2*, and *League of Legends*. In this section, we will take a look at how it works, learn basic use techniques and syntax, and compare and contrast the pymel and maya.cmds modules. In the final section of this chapter, we will finish by developing a small tool using the pymel module.

Installing PyMEL

The pymel package ships with versions of Maya from 2011 forward. Earlier versions require a separate install, which can be accomplished a couple of different ways:

- The zip archive can be downloaded from *http://code.google.com/p/pymel/downloads/list*.
- GitHub users can pull source files from *https://github.com/LumaPictures/pymel*.

If you needed to download pymel for your version of Maya, you can install it according to the documentation found at *http://www.luma-pictures.com/tools/pymel/docs/1.0/install.html*.

The most recent documentation can always be found on the Luma Pictures web site, *http://www.luma-pictures.com/tools/pymel/docs/1.0/index.html*.

Introduction to PyMEL

While there are some functions in the pymel package that act the same as their maya.cmds counterparts, its real advantages come from using proper object-oriented paradigms. To get started with the pymel package once it has been installed in your Python search path, it simply needs to be

imported. The core extension module is the primary gateway to working with PyMEL.

1. Open a new Maya scene and execute the following line to import the pymel.core module. It may take a moment to initialize.

```
import pymel.core as pm;
```

2. Querying the scene is done in a similar manner to maya.cmds. Execute the following line to get all of the transforms in the scene.

```
scene_nodes = pm.ls(type='transform');
```

3. If you inspect this list, however, you see the first major difference between maya.cmds and pymel. Execute the following line to print all of the items in the scene_nodes list.

```
print(scene_nodes)
"""

prints:
[nt.Transform(u'front'), nt.Transform(u'persp'), nt.
Transform(u'side'), nt.Transform(u'top')]
"""
```

4. Compare this result with the standard maya.cmds approach by executing the following lines.

```
import maya.cmds as cmds;
print(cmds.ls(type='transform'));
"""

prints:
[u'front', u'persp', u'side', u'top']
"""
```

PyNodes

While the `ls` command in the cmds module returns a list of Unicode strings, the PyMEL invocation returns a list of a custom class type, which encapsulates data related to a Maya **transform** node.

5. Execute the following line to print the type of the first item in the scene_nodes list.

```
print(type(scene_nodes[0]));
# prints <class 'pymel.core.nodetypes.Transform'>
```

This aspect is one of PyMEL's key features: the **PyNode** class. All commands in the pymel.core module that mimic maya.cmds syntax return **PyNode** objects instead of strings. The reason for this approach is that commands accessible in the pymel.core module, even those that are

syntactically equivalent to maya.cmds calls, are not simply wrapped. Most of these calls are derived upon importation or are wrapped manually. This technique allows for greater functionality; API integration (or as the developers call it, hybridization); increased ease of access; occasional refactoring of large commands into smaller, logical chunks as needed (such as the `file` command); and even function calls unique to PyMEL. We will demonstrate a few of these features at the end of the chapter in our PyMEL tool.

PyNode objects in and of themselves are an interesting development and could easily have a whole section devoted to them. In simplest terms, a **PyNode** object is a Python class wrapper for an underlying API object of the given scene object it represents. Each type of node in the scene is represented in the Maya API, and so the **PyNode** class is able to simplify interfaces to many API methods. This approach provides developers with some interesting functionality.

- Code can be written more pythonically, as **PyNode** attributes are accessed through proper attribute references, as opposed to external queries.
- **PyNode** objects incorporate API-wrapped methods that can sometimes be a bit faster than their maya.cmds counterparts.
- Because **PyNode** objects have unique identities, tracking them in code becomes much simpler and more reliable than when working with object names. If the name of an object represented by a **PyNode** changes in the scene, the **PyNode** object's identity remains intact.
- API-based operations tend to be faster than string-processing operations, which in some cases can speed up node and attribute comparisons.

PyMEL Features

Let's take a look at a few more examples of interacting with PyMEL. The following lines illustrate how it handles the creation and manipulation of objects. As you can see, the **PyNode** class allows you to modify attribute values on nodes in the scene using methods rather than getAttr and setAttr commands.

```
import pymel.core as pm;
# create a sphere and wrap it in a PyNode
my_sphere = pm.polySphere()[0];
# set an attribute
my_sphere.translateX.set(10);
my_sphere.scaleY.set(6);
# get an attribute
translate_x = my_sphere.translateX.get();
scale_y = my_sphere.scaleY.get();
```

```
# get a transform's shape
sphere_shape = my_sphere.getShape();
# connect attributes
my_cube = pm.polyCube()[0];
my_cube.translateX.connect(my_sphere.rotateY);
```

As you can see, PyMEL natively embraces many of the OOP paradigms we have covered in this chapter to perform common operations. You can also work with files quite easily. The PyMEL implementation breaks the `file` command into a few different functions instead of using a single command with numerous flags.

```
pm.newFile(force=True);
pm.saveAs('newSceneName.ma', force=True);
pm.openFile('oldSceneName.ma', force=True);
```

Although we will not talk about building a GUI with Maya commands until Chapter 7, it is worth noting that PyMEL can help simplify GUI creation, as it implements GUI commands as Python contexts using the **with** keyword.

```
with pm.window() as w:
    with pm.columnLayout():
        with pm.horizontalLayout() as h:
            pm.button()
            pm.button()
            pm.button()
            h.redistribute(1,5,2)
        with pm.horizontalLayout() as h2:
            pm.button()
            pm.button()
            pm.button()
            h2.redistribute(1,3,7)
    """horizontalLayout is a custom pymel ui widget derived from
    frameLayout"""
```

These examples are merely the tip of the iceberg. To get a better idea of how PyMEL really works, we recommend porting a script from either MEL or maya.cmds to PyMEL as an example of not only how different the two are syntactically, but also as an example of how PyMEL offers different design possibilities with its object-oriented approach to Maya.

Advantages and Disadvantages

PyMEL definitely offers some advantages over maya.cmds, which may make it a worthwhile investment for projects of any size. Some advantages include:

- Experienced Python programmers may have a much easier time learning PyMEL due to its object-oriented nature.
- PyMEL syntax tends to be a bit cleaner and creates neater code.

- Speed is greater in some cases due to API hybridization.
- The pymel package is open source, meaning studios can pull their own branch and add their own features and fixes.

That said, PyMEL does present a few disadvantages compared to maya.cmds:

- PyMEL's object-oriented nature can present a learning curve to MEL programmers. Switching from MEL to Python and learning a new programming paradigm at the same time can be daunting.
- PyMEL is not very widely adopted yet. A small community does mean that sometimes getting questions answered is difficult. Nevertheless, the development team is always eager to answer questions online.
- In some cases, speed can be degraded. Processing large numbers of components, for instance, can be much slower using PyMEL depending on the specific operation.
- Autodesk's long-term roadmap for PyMEL is unclear.
- Because the pymel package is open source, it is possible (though rare) to get into a situation where a custom branch is quite divergent from the main one.

Overall, we encourage developers to give pymel at least a cursory evaluation. Because PyMEL comes preinstalled with versions of Maya from 2011 and later, you may have to do little more than import pymel.core if you are up-to-date. In the final section of this chapter, we will observe PyMEL in action by developing a small tool to manage scene objects based on attributes.

A PyMEL Example

The following example demonstrates how you might implement a tool that manages the level of detail tagging for a game using PyMEL. The basic premise is that objects can be selected and have an attribute applied to them that determines the level of detail. Once this tag has been applied, objects can be selected and shown or hidden.

1. Download the lodwindow.py module from the companion web site and save it somewhere in your Python search path. The lodwindow.py module contains a class, **LODWindow**, which has a **create()** method for drawing the window.
2. Execute the following lines to import the **LODWindow** class, create an instance of it, and then draw it using the **create()** method.

   ```
   from lodwindow import LODWindow;
   win = LODWindow();
   win.create();
   ```

■ **FIGURE 5.1** The LOD window.

You should now see a window appear like that shown in Figure 5.1. The window has a dropdown menu for selecting a level of detail to apply to the currently selected objects using the Set LOD button. There is also a group of buttons that allows you to select all objects with a given level of detail, and show/hide all objects with a given level of detail.

3. Execute the following lines to create a grid of cylinders with different numbers of subdivisions.

```
import pymel.core as pm;
for res in range(4)[1:]:
    for i in range(3):
        cyl = pm.polyCylinder(sa=res*6, n='barrel1');
        cyl[0].tx.set(i*cyl[1].radius.get()*2);
        cyl[0].tz.set((res-1)*cyl[1].radius.get()*2);
```

4. Select all of the low-resolution cylinders in the back row, select the Low option from the LOD window dropdown menu, and press the Set LOD button. Repeat the same steps for the corresponding medium- and high-resolution cylinders.

5. Press the Select All button in the Medium row of the LOD window and notice that it selects all of the cylinders in the middle row (those with 12 subdivisions).

6. Press the Toggle Visibility button for the High row in the LOD window. Notice that all of the high-resolution cylinders disappear. Play around with the other buttons to your liking.

For the most part, the GUI's implementation is pretty straightforward. Because we have not yet covered all of the nuances of how GUIs work in Maya, however, we will only highlight a few of the key PyMEL features

at work in the module. After you have read Chapters 7 and 8, you may want to revisit this example to better appreciate its advantages.

The first item of note is the use of the **horizontalLayout()** function.

```
with pm.horizontalLayout():
    pm.text(label='Resolution')
    with pm.optionMenu() as self.res_menu:
        pm.menuItem(l='Low');
        pm.menuItem(l='Med');
        pm.menuItem(l='Hi');
    # ...
```

As we noted earlier, **horizontalLayout()** returns a custom PyMEL GUI widget derived from a form layout, which allows for advanced positioning of GUI controls. In this case, we have to do very little to get controls to display nicely.

Second, this example makes use of **CallBack()**, which is a function wrapper that provides a simple way of passing a callback and arguments to a GUI control.

```
set_res_btn = pm.button(
    label='Set LOD',
    command=pm.Callback(self.on_set_res_btn)
);
```

Third, this example makes use of the **setText()** method to manage the status_line text field, as opposed to using the textField command in edit mode.

```
if selected:
    self.tag_nodes(selected, res);
    self.status_line.setText(
        'Set selection to resolution %s'%res
    );
else:
    self.status_line.setText('No selection processed.');
```

Finally, this example makes use of node types for building object lists rather than passing in a string corresponding to the name of the type. Using this approach, developers can minimize errors due to typos, as an IDE can offer automatic code completion for these types.

```
poly_meshes = [
    i for i in pm.ls(
        type=pm.nt.Transform
    ) if type(i.getShape())==pm.nt.Mesh
];
```

While these PyMEL examples are relatively simple, we hope they have whet your appetite for some of the more complex possibilities available with PyMEL. We want to reiterate that if you are using Maya 2011 or later, because PyMEL is built in, evaluating it for your workflow is as simple as importing a module. Experiment, have fun, and consult the companion web site for information on places to communicate with other developers about this powerful tool.

CONCLUDING REMARKS

In this chapter, we summarized one of the final main advantages of the Python language itself by introducing object-oriented programming. You have seen that creating classes with a range of different types of attributes is simple, powerful, and incredibly flexible. You have also seen how the concept of inheritance can help you design an organized hierarchy of classes. Finally, you have seen how PyMEL offers a fully object-oriented alternative to Maya's built-in cmds module, enabling you to harness the power of OOP in your daily work. We hope you have been intrigued and give it a shot!

In all the chapters that follow, we make heavy use of classes to define GUIs, design Maya tools, and create API plug-ins, so it is essential that you feel comfortable with the basics presented in this chapter. Nevertheless, we will return to some high-level OOP concepts in Chapter 9 when we introduce the Maya API, so working through the examples in the intervening chapters will help give you more practice. Hopefully, because you have been taking advantage of some OOP features by using Python already, many of these concepts are already clear. You now have all the prerequisites to start building all kinds of great Maya tools, so it is time we start looking into some!

Designing Maya Tools with Python

Principles of Maya Tool Design

BY THE END OF THIS CHAPTER, YOU WILL BE ABLE TO:

- Distinguish form and function in tools.

- Implement some basic strategies for user-centered development.

- Describe the role that selection plays in Maya's tools.

- Create custom marking menus.

- Identify common patterns across marking menus.

- Enumerate some common elements in many Maya GUIs.

Up to this point, we have discussed a number of basic language features of Python, the mechanics of how they actually interact with Maya, and how to create simple programs that execute different operations in Maya. With these basics covered, we can now turn our attention toward the more practical matter of designing Maya tools.

Generally speaking, any tool consists of two fundamental parts. The first part of any tool, on which we have hitherto focused, is the tool's *function*. Function concerns what the tool actually does, the sequence of operations it carries out to produce some desired end result. For instance, a tool may

perform some computation on a selected object and then alter it in a systematic way. This aspect of tool creation is frequently the easiest for many programmers, as it is the focus of much of their professional training, and is often the most exhilarating part of any tool creation task. At bottom, crafting a tool's function is a technical problem-solving exercise.

The second part of every tool is its *form*. The form of a tool is the part that faces the user, whether it is complex and configurable, remarkably simplified, or completely invisible. For example, a tool may take the form of a command that a user invokes via script, it may be a GUI with complex visual controls, or it may be a background process that is silently invoked when some ordinary action is taken, such as saving a file. Thus, the primary purpose of a tool's form is to gather input from the user in some way to pass the data on to the tool's functionality. Therefore, the form of a tool entails not only providing interfaces for gathering all of these data, but also, in most cases, validating the input and providing feedback to the user.

Designing good user interfaces is often the most difficult task for many programmers, as it can often be a psychological problem-solving exercise. It is a delicate art that is very situated in context: The most sensible approach for any particular tool can vary widely depending on its function, how it fits into a larger suite of tools, the person actually using it, and so on. Because of this complexity, and because many good books and articles have already been written on the topic, we won't stray too far into the territory of user interface design generally. However, before we get carried away creating tools and GUIs all willy-nilly, we do want to impress upon you the importance of focusing on your users, especially because the majority of users are rarely developers themselves.

In this chapter, we will briefly discuss some general tips to help get you started thinking about your users and then look at some existing tools in Maya to locate common tool paradigms. This chapter should help serve as a springboard for you to better understand the tools that we cover in the following chapters, as well to develop your own custom tools.

TIPS WHEN DESIGNING FOR USERS

Without attempting to dictate a single vision for tool design, we want to cover a couple of items briefly, particularly for the benefit of programmers who are just beginning their journey of Maya tool design. There are some general strategies that may help you orient your own development efforts toward your users.

Communication and Observation

One of the most important skills for any tools programmer is communication. Identifying and communicating with your customers during your tool development process is a central task. Whether you are soliciting a tool idea, seeking feedback during development, or reviewing old tools, you always want to involve some of your users to keep yourself from working in a black box and ultimately missing their expectations.

Equally important as communication is observation. Observing your users, either directly or indirectly, can sometimes be more illuminating than an email or even a meeting. Observation can often reveal workflow problems, of which your users may not be aware. Users may be accustomed to a workaround for a broken process, or may be inured to the fact that they have to make several mouse clicks for a single repetitive task.

Observation can also help you clarify communication. Some users may communicate a problem to you that they want solved, yet may be describing a symptom of a larger problem rather than the source problem itself. Users, in fact, don't always necessarily know what they want! For example, suppose an artist requests a tool that validates the naming convention of objects in a scene. You could simply create the tool as requested, but by observing and talking with the artist, you may discover that the artist is using an internal naming convention to sort objects in the scene while working. Thus, the problem concerns sorting and searching for objects, rather than the naming of objects necessarily. In this case, an alternate solution, such as a tagging system, may be more robust and easier to work with. By observing your users directly, you can often help them uncover better solutions to a problem than they originally thought they wanted.

Another useful strategy may be to indirectly observe your users by automatically tracking their input or capturing information when a tool fails that you can submit to a database. While the implementation of such techniques is beyond the scope of this text, it is a relatively trivial task in Maya given the power and flexibility of Python.

Ready, Set, Plan!

Communication and observation are essential for establishing the goals of any tool. However, there is often production pressure to jump right in and start coding once the problem has been established. Although these forces can be difficult to resist, a tool that is developed without sufficient planning can very quickly turn into a mess. Tool developers can follow the same

processes involved in previsualization by planning everything out before beginning work. Thinking through all of the required components and making large changes before any code has been written can save much time and money. Frequently, taking the time to plan can also help developers see how built-in nodes and commands can be leveraged, where existing functionality may otherwise be needlessly recreated.

As you plan, remember to stay focused on the problem! It can often be tempting to expand the feature set of your tools well beyond their original problem spaces, or to overengineer using advanced programming techniques or language features, simply because the joy of solving technical problems becomes so engrossing. Apart from the obvious constraints imposed by production deadlines, wild overengineering can run the risk of resulting in needlessly complex interfaces to negotiate a glut of features. Generally speaking, your central duty is to make the jobs of users easier, not to make your own job more interesting!

At the same time, while the most important task is always solving the problem at hand, you are often required to think ahead. While you have a limited ability to think about the needs of your next project, you may have some perspective that allows you to see problems that will arise on the current project in the coming months. Although it is often wise to avoid overengineering, you can still stay ingratiated to your future self by taking some simple precautions to architect intelligently.

In general, the most important decision you can make in this respect is to separate your form from your functionality in your code. By keeping your user interface separated from the nuts and bolts of your tool, you can more easily alter the interface at a later point. This practice can also make it easier to reuse parts of your code in other places, such as creating additional interfaces for a single tool, or creating common functions that you can share across all of your interfaces. One of the most basic advantages to separating out these elements is that you can more easily access the functionality of your tool via script later, which may help you automate an application of the tool to a large number of files or objects. Fortunately, because of how Maya was architected, you should not need to explicitly create special scripting interfaces for plug-ins, and you only need to organize your scripts intelligently to keep their functions open to other tools later.

In short, although you must always get your job done quickly, a few simple but thoughtful decisions can make your code much more pleasant to work with in the future.

Simplify and Educate

The central task of a tools programmer is to simplify the lives of others—you are often required to transform a painful and tedious task into something fun and streamlined, or to eliminate it altogether. Your users will often not be as technical as a tools developer, and are unlikely to have much awareness of a tool's internals. In this respect, you need to maintain heightened awareness of the parts of your tool that face your users. A classic example of this problem concerns the labels that you give your GUI controls. While you may internally use terms like "vector," "interpolate," or "initialize," words such as "direction," "blend," and "start" are almost certain to be clearer to a larger number of your users. However, it is equally important to educate your users while still simplifying their work.

Just as many developers overcomplicate their tools, it is easy to fall into the trap of oversimplifying. You may often work hard to hide complex information from the user and either do work behind the scenes or guess at the user's intentions based on input. While this is useful for streamlining tasks, it can also risk closing off a little too much. You may frequently have to strike a balance between making a tool easy to use while also leaving it open for users to apply in corner cases or even possibly extend for special uses.

Thus, it can also be helpful to educate your users while simultaneously simplifying their work. Creative work in digital art forms, such as films and games, is fundamentally still a technical process. To help your team members grow, you can educate them about some of the technical things that may be going on behind the scenes. Consequently, education can help your users offer clearer and more intelligent feedback for future tools. Your users will become better at expressing their needs and requesting useful ways to manually override certain functionality when needed.

Remember also that someone will break your tools at some point, no matter how airtight you attempt to make them. While raising an exception in the console suffices for most of your work, your artists may rarely look at the Command Line output to figure out what they did wrong. Although our examples in this text are fairly limited due to space requirements, you should always try to find useful and friendly ways to communicate input problems to your users.

TOOLS IN MAYA

Now that we have discussed some of the higher-level considerations you may want to make when developing tools, we can start looking at some example tools in Maya. While Maya's tools and interfaces are by no means

the gold standard in all cases, there are some important patterns that can be valuable to follow in many cases.

A good starting point to design for your users, then, is to consider following some of these patterns so that your tools operate predictably. Developing in this manner can save you a good deal of trouble when documenting your tools, since users should generally already know how to use them. In other cases, you may want to break from convention where you can improve an interface, but familiarizing yourself with some of Maya's tools can nonetheless be helpful.

Selection

A good starting point for examining Maya's tools is to investigate the role that selection plays in the execution of a tool. The most basic observation is of course that operations are applied to currently selected objects. Although this may seem incredibly obvious, it is important to contrast it with other applications where you might enter a tool mode and then start clicking on objects, or where tools exist as part of the objects themselves. The following example illustrates this concept clearly:

1. Open Maya and create a new scene.
2. Create a new polygon cube (**Create → Polygon Primitives → Cube**).
3. Enter the Polygons menu set by selecting **Polygons** from the dropdown menu in the upper left of the main application window.
4. With the cube still selected, enter the Sculpt Geometry Tool (**Mesh → Sculpt Geometry Tool**). You can now see the red Artisan brush move over the surface as you move your cursor over the cube. If you click when this red gizmo appears, then you will apply some deformation to the cube's vertices depending on the brush's current mode.
5. Deselect the cube (**Edit → Deselect**).
6. Reenter the Sculpt Geometry Tool (the default hotkey for previous tool is **Y**). You will notice that moving your mouse cursor over the cube no longer displays the red Artisan brush. Likewise, clicking on the cube does nothing.

As you can see, the tool is designed to operate on the current selection, rather than to operate in isolation. Most other tools, such as the Paint Skin Weights Tool, all follow the same principle. Following from this point, however, is the more important issue of how Maya's built-in tools work when multiple objects are concerned. There are many tools that require multiple objects to be selected, and they generally follow a common pattern, as the next example demonstrates.

1. Create a new scene.
2. Enter wireframe display mode by pressing the number **4** or by selecting **Shading → Wireframe** from the menu at the top of your viewport.
3. Create a new polygon cube (**Create → Polygon Primitives → Cube**).
4. Create a new polygon sphere (**Create → Polygon Primitives → Sphere**).
5. Create a new polygon cone (**Create → Polygon Primitives → Cone**).
6. With the cone still selected, hold **Shift** and left-click the sphere and then the cube to add them to your selection. The cube's wireframe should highlight green, while the wireframes for the cone and sphere are white. This color scheme indicates that the cube is the last object that was selected.
7. With the objects still selected, open the Script Editor and execute the following short script in a Python tab.

   ```
   import maya.cmds as cmds;
   print(cmds.ls(sl=True));
   ```

 As you can see, order matters! The list that was printed has ordered the items based on the order in which they were selected.

   ```
   [u'pCone1', u'pSphere1', u'pCube1']
   ```

8. With the objects still selected, use the `parent` command. If you have default hotkeys, you can press the **P** key. If not, you can select the menu item (**Edit → Parent**), or enter it into the Script Editor manually. At this point, the cube is deselected, and only the sphere and cone are selected. If you select the cube, you can see that the sphere and cone are now its children, and will follow it around if you move it.

The important point here is that *the last object in the selection list is semantically important: It corresponds to what the tool is doing.* Specifically, the tool's name, Parent, indicates what happens to the final object selected: It becomes the parent of any other objects that are also selected.

Imagine that the tool had a more ambiguous name, such as Link. A name like Link tells you absolutely nothing about what the result will be: The cube might be "linked" to the sphere, but what does that mean? Which one is the parent and which is the child? Is the tool implying that they both affect one another? Parent is a much more useful name as it clearly indicates the direction of the operation.

This same pattern is followed in all of Maya's built-in tools that require multiple selections, whether objects, geometry components, or something else: *The last object in the selection list corresponds to the action indicated by the tool's name.*

9. Select only the cube.
10. **Shift-LMB** click the sphere to add it to the selection list.
11. Open the options window for the Transfer Attributes tool, by selecting the small square icon next to its menu item (**Mesh → Transfer Attributes □**).
12. In the Transfer Attributes Options window, select **Edit → Reset Settings** from its menu.
13. In the Transfer Attributes Options window, turn the Vertex Position radio button to **On** and press **Apply**. You can now see that the sphere's vertices are effectively snapped to the surface of the cube. Because the sphere was the last object selected, it is the object to which the tool's settings were applied.

As indicated, you could go through a number of other tools, such as Copy Skin Weights, and you would see the same pattern: The final object selected has the operation applied to it. Whether or not this pattern is objectively the "best" design option, it is important to be aware of it (though it is certainly much easier for users to change what object is the last in their selection lists than to change which object is first, particularly if the selection list is long). In most cases, you will want to try to follow a similar paradigm in any selection-based tools you may create, and should probably have a very good reason for deviating from it lest you risk confusing your users.

Marking Menus

One of the most unique and important workflow features of Maya's user interface is marking menus, which you saw briefly in the Script Editor in Chapter 1. Marking menus are not only an incredible interface that can outpace hotkeys and standard context-sensitive menus for many users, but are also a valuable example for designing consistency into your tools to leverage a user's muscle memory or spatial understanding. A few brief examples should demonstrate some of the key points regarding marking menus that you may find helpful.

1. Create a new scene.
2. Create a new polygon cube (**Create → Polygon Primitives → Cube**).
3. With the cube selected, move your cursor over the cube and hold the **RMB**. You will see a menu appear, where there is a compass under your cursor and a variety of menu items farther below (Figure 6.1). While holding the **RMB**, if you move your cursor over the Vertex item in the marking menu's west location (left of the compass center) and release, then you will switch to working on the object in vertex mode.

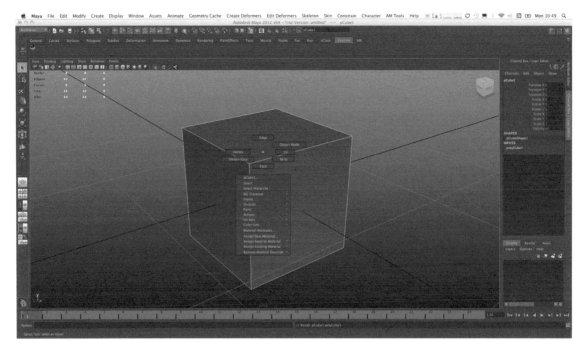

■ **FIGURE 6.1** Basic polygon marking menu.

4. While in vertex mode, move your cursor over the cube. Press and hold the **RMB** and quickly flick the cursor downward, releasing the **RMB** immediately after your downward flick. Performing this action will change the cube to face mode. As you can see, marking menu compasses accommodate flicking as well as a traditional deliberate usage common of right-click context menus.
5. While in face mode, select a face on the cube.
6. While your cursor is over the cube, hold the **Shift** key and **RMB**. **Shift** is the shortcut for performing tool operations in the current selection mode. As you can see, the south item on the compass invokes the Extrude Face tool.
7. With the face still selected, move your cursor over the cube and hold the **Ctrl** key and **RMB**. **Ctrl** is the shortcut for converting one selection to another type. As you can see, in this marking menu, the west item converts the selection to vertices, while the south item converts the selection to faces. If you compare this to the standard **RMB** menu, you will see that the compass items correspond to each component type. In both cases, south corresponds to faces, west to vertices, and so on. In this respect, two different marking menus follow a similar pattern, which can help users

establish muscle memory for the marking menu rather than having to hold the **RMB** and read all of the options individually for a given menu, as is common in many other applications.

8. Using the **Ctrl + RMB** marking menu, convert the selected face to vertices.

9. Hold **Shift** and **RMB** to look at the tool marking menu for vertices. Just as the Extrude Face tool was south in face mode, the Extrude Vertex tool is south in vertex mode. While not all modes have the same corresponding tool types, each direction on the marking menu compass generally tries to correspond to some equivalent for the other modes where it makes sense.

The key takeaway from this example is the value in establishing a convention to help users predict different actions. Marking menus allow users to work fast not only because they support quick gestures, but also because they provide a means for establishing a visual-spatial relationship with an operation. While you can certainly apply similar principles concerning consistency in other types of GUIs, you can also use this knowledge to help create your own marking menus. The following short example will show you how to create your own simple marking menu.

1. Create a new scene.

2. In the main application window, open the marking menu editor by selecting **Window → Settings/Preferences → Marking Menu Editor**.

3. In the Marking Menus window, click the Create Marking Menu button.

4. In the Create Marking Menu window, the top displays a group of icons representing the different locations in the Marking Menu: north, south, east, west, etc. (Figure 6.2). **RMB** click the icon for the east item and select Edit Menu Item from the context menu.

5. Enter the following lines in the Command(s) input field. Unfortunately, the commands to execute for a marking menu item must be issued in MEL. As you can see, we simply use MEL's `python` command to execute two simple lines of Python code. This particular marking menu item will move the currently selected UVs to the right by one unit.

```
python("import maya.cmds as cmds");
python("cmds.polyEditUV(u=1.0, v=0.0)");
```

6. In the Label field, enter the word "Right" and press the Save and Close button.

7. In the Create Marking Menu window, edit the west menu item to have the following command input. Similar to the command you created in step 5, this marking menu item will move the currently selected UVs one unit to the left.

■ **FIGURE 6.2** Testing a custom marking menu in the marking menu editor.

```
python("import maya.cmds as cmds");
python("cmds.polyEditUV(u=-1.0, v=0.0)");
```

8. In the Label field, enter the word "Left" and press the Save and Close button.
9. Keeping the Create Marking Menu window open, create a cube and enter UV editing mode (**RMB + east**).
10. Open the UV Texture Editor window (**Windows → UV Texture Editor**). You should see the default UV layout for the cube.
11. Select all the cube's UVs.
12. In the Create Marking Menu window, use the **LMB** in the test area (lower left) to try out your new marking menu on the cube's UVs (Figure 6.2).

The important aspect of what you have done, besides simply creating a marking menu, is leverage the marking menu's spatial layout to create a gestural control of which the form and function correspond: flicking to the right moves the UVs to the right, while flicking to the left moves them left. As you can see, creating custom marking menus can be a powerful tool for grouping and organizing similar operations. In addition to their speed,

they can also either take advantage of a user's spatial understanding to make controls that are immediately understood, or also create new patterns to reinforce a user's muscle memory. In the case of the default marking menus, for instance, there is nothing inherent about the direction west/left that corresponds with a user's understanding of vertices, but Autodesk has nonetheless created a consistent pattern so users can develop that relationship in the context of Maya.

At this point, you could give your custom marking menu a name, save it, and assign it to a Hotbox quadrant or to a hotkey in the Hotkey Editor (see the dropdown menu in the Marking Menus window labeled "Use marking menu in:"). When you save a marking menu here, it exists as a .mel file in a user's preferences directory. You can leverage this fact to easily share custom marking menus with your users.

Options Windows

The final aspect of Maya's interface worth discussing at this point is its options windows. As we have reiterated throughout the text, Maya's GUI is, fundamentally, just an interface between the user and the command engine. A majority of the menu items in Maya are simply mechanisms for executing commands.

The idea behind this principle is that form and function are almost wholly separated: The functionality of a tool exists in the command, while the form is a GUI control created via script. In many of your own tools, you can simply include your form and functionality in the same module, but will almost certainly want to separate them into different functions at the least. Thus, options windows in Maya are simply interfaces for exposing different command flags to the user to set up arguments.

Just as with marking menus, Maya has set up some conventions that are generally worth following for most simple tools. Take a look at some different options windows in the following example.

1. Enter the Polygons menu set (**F3**).
2. Select the small square icon to the right of the Extract tool in the main application menu (**Mesh → Extract** □). Looking at the options window that appears, there are a few items worth noting. First, the title of the window is "Extract Options." Second, the window menu has an Edit submenu and Help submenu. Take a moment to look at the contents of each submenu. The central part of the window exists in a group entitled "Settings." Finally, the bottom of the window has three buttons. From left to right they are Extract, Apply, and Close. The Extract button has the effect

of performing the operation and closing the window simultaneously, while the Apply button simply performs the operation.

3. Select the small square icon to the right of the Smooth tool in the main application menu (**Mesh → Smooth □**). Looking at the options window that appears, you should see the exact same core parts that you saw in the Extract tool, plus additional groups of related items in the center of the window (Figure 6.3).

At this point, you could continue looking through a number of the tools in the main application window and see the same pattern repeated. Apart from simply establishing a consistent pattern across all windows, there are a couple of other important things happening here. First, each window has a menu option to reset it to its default settings, as well as a way to get help. Second, each tool has a button to apply the operation without closing the window (middle), as well as an option to apply the operation and close the window (far left). If you are creating a tool that performs an operation in this way, it can be helpful to provide your user with both options. Moreover, as we will see in the following chapters, some simple organization can allow you to easily reuse code when you implement this or any other common options window patterns. This sort of problem is the perfect example of something that is worth the trouble of architecting well, since you can be reasonably sure you will want to create many different windows with the same menu items and button layouts.

■ **FIGURE 6.3** Options window for the Extract tool.

CONCLUDING REMARKS

Having discussed the higher-level topics related to the creation of tools, such as how to get in the habit of focusing on your users and where to look for starting ideas, we can now move into lower-level topics concerning how to actually create some different interfaces. In the remaining chapters of this part of the book we will create a variety of user interfaces.

Basic Tools with Maya Commands

BY THE END OF THIS CHAPTER, YOU WILL BE ABLE TO:

- Describe Maya's GUI management system.

- Create a basic window using Maya commands.

- Design a base class for tool option windows.

- Implement menus, layouts, and controls in windows.

- Compare and contrast different ways to link commands to GUI controls.

- Extend a base window class to quickly create new option windows.
- Design reusable functions that are separate from your GUI.
- Work with files from a GUI.
- Serialize object data with the cPickle module.

As you delve into the design of custom tools and GUIs, you have a variety of options available. One of the most basic approaches to designing GUIs in Maya is to use the functionality available in the cmds module. Because the cmds module is interacting with Maya's Command Engine, this approach should be immediately familiar. However, because the Command Engine was originally designed with MEL in mind, using commands to create a GUI can be a little cumbersome.

Thankfully, Python's support for object-oriented programming allows you to develop GUIs in ways that would be impossible with MEL. Taking advantage of Python classes in conjunction with basic Maya commands is the easiest way to build and deploy GUI windows. Moreover, working with the cmds module introduces many of the underlying mechanics of Maya's GUI system.

In this chapter, we will first discuss some core technical concepts related to Maya's GUI and then develop a base class for tool option windows. We then explore some of Maya's built-in GUI controls and demonstrate how you can easily extend this class to quickly create new tools. Finally, we discuss some advanced topics related to tool creation, such as serializing data and working with files, by examining a simple pose manager tool.

MAYA COMMANDS AND THE MAYA GUI

We have pointed out many times that the Command Engine is the primary interface for working with Maya. In addition to those commands that manipulate Maya scene objects and operate on files, some commands allow for the creation and manipulation of GUI objects, such as windows and buttons. These commands do not interface with the Maya application directly, but rather communicate with a GUI toolkit (Figure 7.1).

Fundamentally, the Maya GUI consists of a set of controls and windows created using MEL commands. Much like nodes in the Dependency Graph, GUI elements in Maya are accessible via unique string names, which can often become incredibly verbose. The following example illustrates this general concept.

1. In the Script Editor window, select the menu option **History → Echo All Commands**.

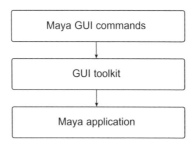

■ **FIGURE 7.1** Maya GUI commands interact with a GUI toolkit, which in turn interacts with the Maya application (to display graphics or execute other commands).

2. Click in one of the menus in Maya's main menu bar to open it and then move your cursor left and right to cause other menus to open and close in turn.

3. Look at the output in the Script Editor. You should see a variety of statements executed, the arguments for which show a path to the open menu. For instance, when scrolling over menus in the Polygons menu set, you may see something like the following lines in the History Panel.

```
editMenuUpdate MayaWindow|mainEditMenu;
checkMainFileMenu;
editMenuUpdate("MayaWindow|mainEditMenu");
ModObjectsMenu MayaWindow|mainModifyMenu;
PolygonsSelectMenu MayaWindow|mainPolygonsSelectMenu;
PolygonsNormalsMenu MayaWindow|mainPolygonsNormalsMenu;
PolygonsColorMenu MayaWindow|mainPolygonsColorMenu;
```

Notice that the names of these menu items look similar to **transform** nodes in a hierarchy: they are given unique, pipe-delimited paths. In fact, the menus in Maya are constructed in a similar way. In each of these examples, the MayaWindow GUI object is the parent of some menu item, as indicated by the vertical pipe character separating them. In MEL, the "MayaWindow" string is also stored in the global variable $gMainWindow.

Just like **transform** nodes in your scene, full GUI object names must be globally unique. Consequently, the names of GUI controls can sometimes be a little unwieldy to maintain uniqueness. Nested controls can be even more frightening to look at. In some versions of Maya, for instance, clearing history in the Script Editor (**Edit → Clear History**) displays something like the following line in the Script Editor's History Panel.

```
// Result: scriptEditorPanel1Window|TearOffPane|
scriptEditorPanel1|formLayout37|formLayout39|paneLayout1|
cmdScrollFieldReporter1 //
```

As you can see, the selected menu option is a child at the end of a very long sequence of GUI objects. Fortunately, when you design GUIs in a module using cmds, the commands you execute will return these names, so you will hopefully never have to concern yourself with them directly. It is important, however, to understand that because these GUI object names must be unique, you should ensure that your own GUIs do not have conflicting names at their top levels.

4. Before proceeding, it is advisable that you disable full command echoing (**History → Echo All Commands**) in the Script Editor, as it can degrade performance.

BASIC GUI COMMANDS

When creating GUI controls with Maya commands, we unfortunately have no visual editor available for creating interfaces. Instead, we must create everything entirely programmatically. Although this process can be a little tedious for complex GUIs, it is easy to test out a new user interface element quickly, since commands respond immediately. That being said, however, Maya GUIs operate in retained mode (in contrast to the immediate mode that many videogames use, for example). The primary consequence as far as we need to be concerned is that our custom GUIs will not update unless we explicitly rerender them somehow. As such, the basic steps you must take are to first define a window and then explicitly render it.

Windows

One of the most common GUI objects is a window, which can house other controls as children. You can create a GUI window using the `window` command, but must execute the `showWindow` command to display it.

1. Execute the following lines in the Script Editor to create a window with the handle "ar_optionsWindow" and then show it. You should see an empty window like that shown in Figure 7.2.

```
import maya.cmds as cmds;
win = cmds.window(
    'ar_optionsWindow',
    title='My First Window',
    widthHeight=(546,350)
);
cmds.showWindow(win);
```

This example first creates a window with a specified (hopefully unique) handle, a title bar string, and a size equal to that of most of Maya's standard

■ **FIGURE 7.2** An empty window.

tools (546 pixels wide by 350 pixels high).[1] After the window is created, it is shown.

Note the handle we assigned to our window: "ar_optionsWindow". One way that many Maya programmers attempt to avoid naming conflicts is to prefix their GUI elements' names with their initials or the initials of their studios. At this point, you can use the window's unique handle to access it further.

2. With your window still up, try to change the title of your window by executing the following code.

```
win = cmds.window(
    'ar_optionsWindow',
    title='My Second Window',
    widthHeight=(546,350)
);
```

You should see an error in the History Panel informing you that the name is already in use.

```
# Error: RuntimeError: file <maya console> line 4: Object's
name 'ar_optionsWindow' is not unique. #
```

To make changes to a GUI, you must destroy it, make your change, and then show it again. You can destroy your window by pressing the close button in its corner or using the deleteUI command.

[1]To spare ourselves explanation of how we came up with different dimensions, button sizes, spacing, and so forth, it is worth noting that we refer to the getOptionBox.mel script that ships with Maya. You can find this script in the <Maya application directory>/scripts/others/ folder if you would like more details.

3. Execute the following code to delete the UI, assign a new title, and then show it again.

```
cmds.deleteUI(win, window=True);
win = cmds.window(
    'ar_optionsWindow',
    title='My Second Window',
    widthHeight=(546,350)
);
cmds.showWindow(win);
```

Because of this requirement—as well as a number of other reasons—it is often more convenient to organize your windows into classes.

BUILDING A BASE WINDOW CLASS

While you can simply execute GUI commands in the Script Editor or in a module, as in the previous example, this approach can quickly become tedious. Designing new windows from scratch isn't always fun, especially if you know you will want some basic parts in all of your windows. Fortunately, Python's support for object-oriented programming offers solutions that surpass any organizational strategies available in MEL. In this section, we will make our basic window a class and add a set of controls to create a template that resembles Maya's built-in tool option windows.

1. Execute the following lines to create the **AR_OptionsWindow** class. From this point forward if you are using the Script Editor you will find it useful to highlight all of your code before executing it with **Ctrl + Enter** so it is not cleared from the Input Panel.

```
class AR_OptionsWindow(object):
    def __init__(self):
        self.window = 'ar_optionsWindow';
        self.title = 'Options Window';
        self.size = (546, 350);
    def create(self):
        if cmds.window(self.window, exists=True):
            cmds.deleteUI(self.window, window=True);
        self.window = cmds.window(
            self.window,
            title=self.title,
            widthHeight=self.size
        );
        cmds.showWindow();
```

In the **AR_OptionsWindow** class, the **__init__**() method initializes some data attributes for the window's handle, title, and size. The **create**() method actually (re)draws the window.

2. Execute the following lines in a new Python tab in the Script Editor to create a new instance of the **AR_OptionsWindow** class and call its **create()** method.

```
testWindow = AR_OptionsWindow();
testWindow.create();
```

With our window properly sized and organized in a class, we will want to add a menu and some controls to be more useful. If you are using the Script Editor as opposed to an external IDE, leave the **AR_OptionsWindow** class up in a working Python tab, as we will modify it throughout the rest of this example.

Menus and Menu Items

Adding menus to windows is quite simple. You must enable support for menus by passing a value of True with the `menuBar` flag when you call the `window` command. After that point, you can add menus using the `menu` command, and add children to them using `menuItem` and related commands.

3. Add a new data attribute called `supportsToolAction` in the **__init__()** method and assign a default value of False to it. This data attribute will be used to disable certain menu items by default.

```
def __init__(self):
    self.window = 'ar_optionsWindow';
    self.title = 'Options Window';
    self.size = (546, 350);
    self.supportsToolAction = False;
```

4. Add a new method to the **AR_OptionsWindow** class called **commonMenu()** with the following contents. This method will add common menu items shared across all of Maya's tools.

```
def commonMenu(self):
    self.editMenu = cmds.menu(label='Edit');
    self.editMenuSave = cmds.menuItem(
        label='Save Settings'
    );
    self.editMenuReset = cmds.menuItem(
        label='Reset Settings'
    );
    self.editMenuDiv = cmds.menuItem(d=True);
    self.editMenuRadio = cmds.radioMenuItemCollection();
    self.editMenuTool = cmds.menuItem(
        label='As Tool',
        radioButton=True,
        enable=self.supportsToolAction
    );
```

```
self.editMenuAction = cmds.menuItem(
    label='As Action',
    radioButton=True,
    enable=self.supportsToolAction
);
self.helpMenu = cmds.menu(label='Help');
self.helpMenuItem = cmds.menuItem(
    label='Help on %s'%self.title
);
```

The **commonMenu()** method first creates a menu with the label "Edit" and adds Maya's ordinary menu items to it: Save Settings, Reset Settings, a divider, and then two radio buttons to use the window as a tool or as an action.[2]

Note that we call the `radioMenuItemCollection` command to initiate a sequence of items in a radio button group. The subsequent `menuItem` calls then enable the `radioButton` flag to make them members of this group. We also disable these items by default using the `supportsToolAction` data attribute, which we added in the **setupWindowAttributes()** method in the previous step.

We follow these commands with another call to the `menu` command to create the help menu with one item ("Help on Options Window"). As you can see, each successive call to the `menu` command establishes the most recently created menu as the default parent for successive `menuItem` calls.

5. In the **create()** method, add the `menuBar` flag to the `window` call, and then add a call to the **commonMenu()** method before showing the window.

```
def create(self):
    if cmds.window(self.window, exists=True):
        cmds.deleteUI(self.window, window=True);
    self.window = cmds.window(
        self.window,
        title=self.title,
        widthHeight=self.size,
        menuBar=True
    );
    self.commonMenu();
    cmds.showWindow();
```

[2]Although we tend to use the term *tool* fairly loosely in this text, Maya distinguishes tools and actions in its GUI. A *tool* is something that works continuously by clicking, such as any of the Artisan tools (e.g., Paint Skin Weights, Paint Vertex Colors) or the basic transform tools (e.g., Move, Rotate, Scale). An *action* is a "one-shot" operation, like most of the menu items. Most windows you will create with our template in this chapter will be actions, though some menu items, such as those in the Edit NURBS menu, support both modes. For more information, browse the Maya help in **User Guide → General → Basics → Preferences and customization → Customize how Maya works → Switch operations between actions and tools**.

■ **FIGURE 7.3** A basic window with a menu.

6. If you are working in the Script Editor, execute the **AR_Options Window** class's code again to update it. Remember to highlight all of it before pressing **Ctrl + Enter** so you do not clear the Input Panel.

7. Create a new **AR_OptionsWindow** instance and call its **create()** method. The modifications you made in the previous steps add a menu bar that resembles Maya's default menus for tool options, as shown in Figure 7.3.

```
testWindow = AR_OptionsWindow();
testWindow.create();
```

Although our menu looks pretty good by Autodesk's standards, none of its menu items actually do anything yet. At this point, we should look into adding some commands.

Executing Commands with GUI Objects

Many GUI commands, including menuItem, implement a command flag, which allows you to specify what happens when the GUI control is used.

Recall that when Maya was first created, the only scripting language available in it was MEL, and that MEL is not object-oriented. Consequently, when using MEL to create a GUI, this flag's argument value contains a string of statements to execute either commands or a MEL procedure. As a Python user, you can pass this flag a pointer to a function or a string of statements to execute.

Passing a Function Pointer

A common and safe approach for menu commands is to pass a function pointer to a method in your class.

8. Add a **helpMenuCmd()** method to the **AR_OptionsWindow** class with the following contents. This method will load the companion web site in a browser.

```
def helpMenuCmd(self, *args):
    cmds.launch(web='http://maya-python.com');
```

9. Change the assignment of the helpMenuItem attribute in **commonMenu()** and pass it a pointer to the **helpMenuCmd()** method.

```
self.helpMenuItem = cmds.menuItem(
    label='Help on %s'%self.title,
    command=self.helpMenuCmd
);
```

If you execute your class definition again to update it in __main__, instantiate the class, and then call its **create()** method, the help menu item will now launch the companion web site. (Try to avoid tormenting your coworkers by sending their help requests to *http://lmgtfy.com/.*)

```
testWindow = AR_OptionsWindow();
testWindow.create();
```

Although this approach is clean, straightforward, and safe, it suffers at least one important limitation. Namely, it does not allow you to pass arguments to the function specified with the command flag. If you were to print args inside the **helpMenuCmd()** method, you would see that the method is implicitly passed a tuple argument with one item.

```
(False,)
```

While you can largely bypass this problem by putting your GUI into a class and reading data attributes inside the method you call, this issue prevents you from specifying a pointer to any commands in the cmds module (since they will expect different object lists) or from passing a value that you may not have defined as a data attribute (and hence would like to pass as a key-word argument).

Passing a String

Another option you have for issuing commands is to pass a string of statements. Much like Python's built-in **eval()** function, this technique allows you to simply use string formatting operations to pass in arguments, as in the following hypothetical snippet, which creates a personalized polygon sphere.

```
import os;
import maya.cmds as cmds;
class SphereWindow(object):
    def __init__(self):
        self.win = 'arSphereSample';
        if cmds.window(self.win, exists=True):
            cmds.deleteUI(self.win);
        self.win = cmds.window(
            self.win,
            widthHeight=(100,100),
            menuBar=True
        );
        self.menu = cmds.menu(
            label='Create'
        );
        cmds.menuItem(
            label='Personalized Sphere',
            command='import maya.cmds;' +
                'maya.cmds.polySphere(n="%s")'%
                os.getenv('USER')
        );
        cmds.showWindow();
win = SphereWindow();
```

Apart from being an annoyance, this technique also has a big problem associated with it. Namely, the string you pass is executed in __main__. Consequently, you may have problems when trying to access functions in modules. As you saw, because you cannot make assumptions about what modules have been imported into __main__, you may need to include **import** statements if you want to execute Maya commands.

You may find it tedious to include **import** statements for all of your controls to simply ensure that modules you require exist. One technique to combat this problem is to use the **eval()** function in the maya.mel module to invoke the python command, allowing you to execute an **import** statement in __main__. The following code snippet illustrates this approach.

```
import os;
import maya.cmds as cmds;
import maya.mel as mel;
mel.eval('python("import maya.cmds");');
class SphereWindow(object):
    def __init__(self):
        self.win = 'arSphereSample';
        if cmds.window(self.win, exists=True):
            cmds.deleteUI(self.win);
        self.win = cmds.window(
            self.win,
```

```
                    widthHeight=(100,100),
                    menuBar=True
                );
                self.menu = cmds.menu(
                    label='Create'
                );
                cmds.menuItem(
                    label='Personalized Cube',
                    command='maya.cmds.polyCube(n="%s")'%
                        os.getenv('USER')
                );
                cmds.menuItem(
                    label='Personalized Sphere',
                    command='maya.cmds.polySphere(n="%s")'%
                        os.getenv('USER')
                );
                cmds.showWindow();
        win = SphereWindow();
```

While this approach may be tempting, it is also dangerous and ignores the point of module scope. Thankfully, there is an ideal approach available for most versions of Maya with Python support.

Using the functools Module

Python 2.5 introduced a module called functools, which provides a range of operations for working with higher-order functions. Because it is a complex module we only cover a basic application here. Refer to Section 9.8 of Python Standard Library for more information on the functools module at large.

If you are working in Maya 2008 or later (i.e., not 8.5), you can use the **partial()** function in the functools module to pass a function with arguments to the command flag. This technique is documented in the Maya help (**User Guide → Scripting → Python → Tips and tricks for scripters new to Python**). As such, we show only a short hypothetical example here. The following code creates a small window with menu options to create one, two, three, four, or five evenly spaced locators along the *x*-axis.

```
from functools import partial;
import maya.cmds as cmds;
class LocatorWindow(object):
    def __init__(self):
        self.win = cmds.window(
            'ar_locSample',
            widthHeight=(100,100),
            menuBar=True
        );
```

```
        self.menu = cmds.menu(
            label='Make Locators'
        );
        for i in range(5):
            cmds.menuItem(
                l='Make %i'%(i+1),
                command=partial(self.makeLocCmd, i+1)
            );
        cmds.showWindow();
    def makeLocCmd(self, numLocators, *args):
        locs = []
        for i in range(numLocators):
            locs.append(
                cmds.spaceLocator(
                    p=[-(numLocators+1)*0.5+i+1,0,0]
                )[0]
            );
        cmds.select(locs);
win = LocatorWindow();
```

As you can see inside the **for** loop in the **__init__()** method, the **partial()** function lets us pass not only a pointer to a function, but also any number of arguments to correspond to its parameter list. Fortunately, our present menu items are relatively simple, but this trick is essential for creating a more involved GUI.

10. Return to the **AR_OptionsWindow** class and add four placeholder methods for child classes to override: **editMenuSaveCmd()**, **edit MenuResetCmd()**, **editMenuToolCmd()**, and **editMenuActionCmd()**. Remember to also specify these methods for their respective controls. Your complete class should currently look like the following example.

```
class AR_OptionsWindow(object):
    def __init__(self):
        self.window = 'ar_optionsWindow';
        self.title = 'Options Window';
        self.size = (546, 350);
        self.supportsToolAction = False;
    def create(self):
        if cmds.window(self.window, exists=True):
            cmds.deleteUI(self.window, window=True);
        self.window = cmds.window(
            self.window,
            title=self.title,
            widthHeight=self.size,
            menuBar=True
        );
```

```
            self.commonMenu();
            cmds.showWindow();
        def commonMenu(self):
            self.editMenu = cmds.menu(label='Edit');
            self.editMenuSave = cmds.menuItem(
                label='Save Settings',
                command=self.editMenuSaveCmd
            );
            self.editMenuReset = cmds.menuItem(
                label='Reset Settings',
                command=self.editMenuResetCmd
            );
            self.editMenuDiv = cmds.menuItem(d=True);
            self.editMenuRadio = cmds.
            radioMenuItemCollection();
            self.editMenuTool = cmds.menuItem(
                label='As Tool',
                radioButton=True,
                enable=self.supportsToolAction,
                command=self.editMenuToolCmd
            );
            self.editMenuAction = cmds.menuItem(
                label='As Action',
                radioButton=True,
                enable=self.supportsToolAction,
                command=self.editMenuActionCmd
            );
            self.helpMenu = cmds.menu(label='Help');
            self.helpMenuItem = cmds.menuItem(
                label='Help on %s'%self.title,
                command=self.helpMenuCmd
            );
        def helpMenuCmd(self, *args):
            cmds.launch(web='http://maya-python.com');
        def editMenuSaveCmd(self, *args): pass
        def editMenuResetCmd(self, *args): pass
        def editMenuToolCmd(self, *args): pass
        def editMenuActionCmd(self, *args): pass
```

Our base class is now almost wrapped up! We will finally add some buttons and then it is ready to go.

Layouts and Controls

In a GUI hierarchy, a window cannot have controls like buttons as its immediate children. Rather, the window must have one or more layouts as children, which may have controls or other layouts as their children. A layout specifies how its children are to be arranged. In the next few steps,

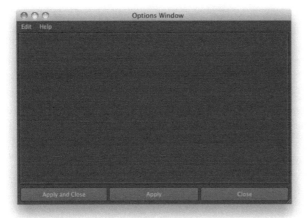

■ **FIGURE 7.4** A basic window with a menu and three buttons.

we will add a layout to the **AR_OptionsWindow** class to create a row of buttons, as shown in Figure 7.4.

Basic Layouts and Buttons

Recall in Chapter 6 that we showed how most actions in the Maya GUI consist of a basic three-button layout. The first button performs the window's action and closes it, the second only performs the action, and the third only closes the window.

11. Add a new data attribute, `actionName`, in the **__init__**() method for the **AR_OptionsWindow** class to set the name that will display on the window's action button. Most windows in Maya default to something like Apply and Close.

```
def __init__(self):
    self.window = 'ar_optionsWindow';
    self.title = 'Options Window';
    self.size = (546, 350);
    self.supportsToolAction = False;
    self.actionName = 'Apply and Close';
```

12. Add methods to the **AR_OptionsWindow** class for the common buttons: **actionBtnCmd**(), **applyBtnCmd**(), and **closeBtnCmd**().

```
def actionBtnCmd(self, *args):
    self.applyBtnCmd();
    self.closeBtnCmd();
def applyBtnCmd(self, *args): pass
```

```
def closeBtnCmd(self, *args):
    cmds.deleteUI(self.window, window=True);
```

These methods will be called when the corresponding buttons are pressed. Because of how we have written these methods, the only one that subclasses will need to override is the **applyBtnCmd()** method. The **closeBtnCmd()** method simply closes the window, and the **actionBtnCmd()** method invokes the Apply behavior and then the Close behavior.

13. Add the following **commonButtons()** method to the **AR_Options Window** class right before the **helpMenuCmd()** definition. We will refer back to this method momentarily after some additional changes, so you will be able to compare the code with the visual result.

```
def commonButtons(self):
    self.commonBtnSize = ((self.size[0]-18)/3, 26);
    self.commonBtnLayout = cmds.rowLayout(
        numberOfColumns=3,
        cw3=(
            self.commonBtnSize[0]+3,
            self.commonBtnSize[0]+3,
            self.commonBtnSize[0]+3
        ),
        ct3=('both','both','both'),
        co3=(2,0,2),
        cl3=('center','center','center')
    );
    self.actionBtn = cmds.button(
        label=self.actionName,
        height=self.commonBtnSize[1],
        command=self.actionBtnCmd
    );
    self.applyBtn = cmds.button(
        label='Apply',
        height=self.commonBtnSize[1],
        command=self.applyBtnCmd
    );
    self.closeBtn = cmds.button(
        label='Close',
        height=self.commonBtnSize[1],
        command=self.closeBtnCmd
    );
```

14. Add a call to **commonButtons()** in the **create()** method right after the call to **commonMenu()**.

```
def create(self):
    if cmds.window(self.window, exists=True):
        cmds.deleteUI(self.window, window=True);
```

```
        self.window = cmds.window(
            self.window,
            title=self.title,
            widthHeight=self.size,
            menuBar=True
        );
        self.commonMenu();
        self.commonButtons();
        cmds.showWindow();
```

15. Evaluate all of your updates to the **AR_OptionsWindow** class and then create a new **AR_OptionsWindow** instance. If you are working in the Script Editor, remember to highlight your class definition and press **Ctrl + Enter**.

```
win = AR_OptionsWindow();
win.create();
```

You should now see a window like that shown in Figure 7.5. If you press the buttons, the "Apply and Close" and "Close" buttons simply close the window, and the "Apply" button does nothing yet. Let's look back at the **commonButtons()** method to compare the code with our results. We first specify a size for our buttons as a tuple, `commonBtnSize`, which stores a (width, height) pair.

```
self.commonBtnSize = ((self.size[0]-18)/3, 26);
```

The basic idea for computing the width is that we want 5 pixels of padding on the left and right, and 4 pixels of padding in between the buttons ($5 + 4 + 4 + 5 = 18$). Hence, we subtract a total of 18 from the window's width before dividing by 3. The height is 26 pixels.

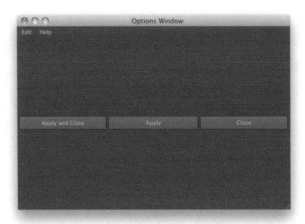

■ **FIGURE 7.5** The intermediate results of the **AR_OptionsWindow** class using a row layout.

Next, we create a row layout, `commonBtnLayout`, which will serve as the parent for our buttons. Remember that controls like buttons must have a layout parent of some kind.

```
self.commonBtnLayout = cmds.rowLayout(
    numberOfColumns=3,
    cw3=(
        self.commonBtnSize[0]+3,
        self.commonBtnSize[0]+3,
        self.commonBtnSize[0]+3
    ),
    ct3=('both','both','both'),
    co3=(2.5,0,2.5),
    cl3=('center','center','center')
);
```

When invoking the `rowLayout` command, we specify that the layout should have three columns and then set properties for column width, attachment, offset, and text alignment. Attachment specifies how the offset values should be interpreted (as being relative to the left, right, or both sides). These flags offer us about as much refinement as we will get from a row layout. The alignment flag, `cl3`, is not strictly necessary for Maya 2011 and later in this case, as all buttons in newer versions of Maya default to centered text.

Finally, we added three buttons with the proper names, using our specified height, pointing to the proper methods that they should invoke.

```
self.actionBtn = cmds.button(
    label=self.actionName,
    height=self.commonBtnSize[1],
    command=self.actionBtnCmd
);
self.applyBtn = cmds.button(
    label='Apply',
    height=self.commonBtnSize[1],
    command=self.applyBtnCmd
);
self.closeBtn = cmds.button(
    label='Close',
    height=self.commonBtnSize[1],
    command=self.closeBtnCmd
);
```

As was the case with the menus, when we create any layout or control, Maya assumes that the most recently created layout is to be the parent. As such, we do not need to manually specify a parent control using the `parent` flag.

You have obviously noticed that although the buttons are sized correctly and appear to function as expected, they are also not at the correct vertical alignment. (Users of Maya 2010 and earlier will see their buttons at the top of the window, rather than centered.) The problem is that `commonBtnLayout` is an immediate child of `window`, and so it is located in the default position under `window`. Figure 7.6 illustrates the current hierarchy for our GUI window.

■ **FIGURE 7.6** The hierarchy of a window created by the **AR_OptionsWindow** class.

Equally as problematic, the controls do not scale when we adjust the size of the window. Scaling in the width of the window simply clips the buttons on the right side. To fix these problems, we need a more advanced layout.

Form Layouts

Although there are a variety of built-in layout commands that can generate quick results, many of them do not offer a great deal of flexibility. The form layout, accessible via the `formLayout` command, allows for a range of precise positioning options, as well as support for interactively scaling controls. In the next few steps we will retool the **AR_OptionsWindow** class to use a hierarchy of form layouts.

16. Add the following line to the **create()** method, right after the call to the `window` command and before the call to **commonMenu()**.

```
self.mainForm = cmds.formLayout(nd=100);
```

If you evaluate the class definition and create a new **AR_OptionsWindow** instance now, the buttons should be at the top of the window, no matter what version of Maya you are using. The `mainForm` attribute will be the parent for the next layout defined in the window (the row layout), which will be positioned at the top left of the form by default.

The `nd` (or `numberOfDivisions`) flag that we passed to the `formLayout` command allows us to use relative coordinates when specifying attachment positions of controls, as we will see soon. The value of 100 that we passed means that a position of (0, 0) refers to the window's upper left corner, and a position of (100, 100) refers to the window's lower right corner.

17. In the **commonButtons()** method, remove the `commonBtnLayout` assignment (`rowLayout` call), and add the following lines after the assignment of `closeBtn`.

```
cmds.formLayout(
    self.mainForm, e=True,
    attachForm=(
        [self.actionBtn,'left',5],
        [self.actionBtn,'bottom',5],
        [self.applyBtn,'bottom',5],
        [self.closeBtn,'bottom',5],
        [self.closeBtn,'right',5]
    ),
    attachPosition=(
        [self.actionBtn,'right',1,33],
        [self.closeBtn,'left',0,67]
    ),
```

```
        attachControl=(
            [self.applyBtn,'left',4,self.actionBtn],
            [self.applyBtn,'right',4,self.closeBtn]
        ),
        attachNone=(
            [self.actionBtn,'top'],
            [self.applyBtn,'top'],
            [self.closeBtn,'top']
        )
    );
```

As you can see, we call the `formLayout` command in edit mode to configure how the buttons need to be attached in `mainForm`. We pass four different (multiuse) flag arguments to accomplish this task.

Attaching a control specifies how it should scale when the form's dimensions are updated (when the user scales the window).[3] The basic pattern for each flag is that we pass lists that specify a control, an edge on the control, and then the values associated with the edge.

- The `attachForm` flag specifies edges on controls that we want to pin to the bounds of the form we passed to the command. In this case, we pin the action button to the left, the close button to the right, and all the buttons to the bottom of the form. We apply an offset of five pixels on each attachment to pad the buttons in from the edge of the window.
- The `attachPosition` flag specifies edges that we want to pin to points in our relative coordinate grid that we defined using the `nd` flag when we first created `mainForm`. The final numbers in each list, 33 for `actionBtn` and 67 for `closeBtn`, correspond to points approximately one-third and approximately two-thirds of the form's width (33/100 and 67/100, respectively). The penultimate number in each list represents a pixel offset for the attachment.
- The `attachControl` flag specifies edges on a control that we want to attach to another control, with an optional offset. In this case, because we pinned the inner edges of the outermost buttons (`actionBtn` and `closeBtn`) using `attachPosition`, we can attach both the left and right edges of the center button (`applyBtn`) to these outer buttons.

[3]Note that if you scale this window it will save its preferences, and thus subsequent calls to **create()** will use the old dimensions. While we won't go into the details of window preferences here, you can consult the companion web site for more information. In the meantime, you can assign a different handle to your class, or call the `window` command in edit mode after the call to `showWindow` to force its size.

■ The `attachNone` flag specifies edges on controls that should not attach to anything, and hence should not scale. Because we specified that the bottom edges of our buttons attached to `mainForm`, setting the top edges as none means they will retain the fixed height specified when we called the `button` command to create them, while the buttons remain pinned to the bottom of the window.

At this point, if you evaluate and then instantiate the **AR_OptionsWindow** class, you can see that you are almost done. We have only a few minor adjustments to make this class ready for other classes to inherit from it.

18. Add a placeholder method to the **AR_OptionsWindow** class for **displayOptions()**. This method will be overridden in child classes to actually display the contents in the main part of the options window.

```
def displayOptions(self): pass
```

19. Add the following lines in the **create()** method right after the call to **commonButtons()** and before the call to the `showWindow` command. These lines add a central pane to the window and then call the **displayOptions()** method you just created.

```
self.optionsBorder = cmds.tabLayout(
    scrollable=True,
    tabsVisible=False,
    height=1
);
cmds.formLayout(
    self.mainForm, e=True,
    attachForm=(
        [self.optionsBorder,'top',0],
        [self.optionsBorder,'left',2],
        [self.optionsBorder,'right',2]
    ),
    attachControl=(
        [self.optionsBorder,'bottom',5,self.applyBtn]
    )
);
self.optionsForm = cmds.formLayout(nd=100);
self.displayOptions();
```

As you can see, we do not simply nest our form layout, `optionsForm`, in `mainForm`. Rather, we nest it in a tab layout, `optionsBorder`, which itself is nested in `mainForm`. Although Autodesk has specific reasons for implementing this pattern, the only effect as far as we need to be concerned is that nesting the form layout in the tab layout displays a nice little border for the

options area in Maya 2011 and later.[4] Now, if you evaluate your changes and create an instance of the **AR_OptionsWindow** class, you should see the result we previewed in Figure 7.4.

At this point, you should save the **AR_OptionsWindow** class into a module, optwin.py, as we will use it in further examples in this chapter. Alternatively, you can download the optwin.py module from the companion web site. For your convenience, we have printed the final contents of the **AR_OptionsWindow** class here for you to compare your results. Note that we have also added a class method, **showUI()**, which provides a shortcut for creating and displaying a new window instance. The module on the companion web site additionally contains comments.

Complete AR_OptionsWindow Class

```
class AR_OptionsWindow(object):
    @classmethod
    def showUI(cls):
        win = cls();
        win.create();
        return win;
    def __init__(self):
        self.window = 'ar_optionsWindow';
        self.title = 'Options Window';
        self.size = (546, 350);
        self.supportsToolAction = False;
        self.actionName = 'Apply and Close';
    def create(self):
        if cmds.window(self.window, exists=True):
            cmds.deleteUI(self.window, window=True);
        self.window = cmds.window(
            self.window,
            title=self.title,
            widthHeight=self.size,
            menuBar=True
        );
        self.mainForm = cmds.formLayout(nd=100);
        self.commonMenu();
        self.commonButtons();
        self.optionsBorder = cmds.tabLayout(
            scrollable=True,
```

[4]Autodesk uses this pattern to reduce flickering when changing from one option window to another. For more information, see the comments in the **createOptionBox()** procedure in getOptionBox.mel. See note 1 for more information.

```
                tabsVisible=False,
                height=1
        );
        cmds.formLayout(
            self.mainForm, e=True,
            attachForm=(
                [self.optionsBorder,'top',0],
                [self.optionsBorder,'left',2],
                [self.optionsBorder,'right',2]
            ),
            attachControl=(
                [self.optionsBorder,'bottom',5,
                self.applyBtn]
            )
        );
        self.optionsForm = cmds.formLayout(nd=100);
        self.displayOptions();
        cmds.showWindow();
    def commonMenu(self):
        self.editMenu = cmds.menu(label='Edit');
        self.editMenuSave = cmds.menuItem(
            label='Save Settings',
            command=self.editMenuSaveCmd
        );
        self.editMenuReset = cmds.menuItem(
            label='Reset Settings',
            command=self.editMenuResetCmd
        );
        self.editMenuDiv = cmds.menuItem(d=True);
        self.editMenuRadio = cmds.radioMenuItemCollection();
        self.editMenuTool = cmds.menuItem(
            label='As Tool',
            radioButton=True,
            enable=self.supportsToolAction,
            command=self.editMenuToolCmd
        );
        self.editMenuAction = cmds.menuItem(
            label='As Action',
            radioButton=True,
            enable=self.supportsToolAction,
            command=self.editMenuActionCmd
        );
        self.helpMenu = cmds.menu(label='Help');
        self.helpMenuItem = cmds.menuItem(
            label='Help on %s'%self.title,
            command=self.helpMenuCmd
        );
```

```python
def helpMenuCmd(self, *args):
    cmds.launch(web='http://maya-python.com');
def editMenuSaveCmd(self, *args): pass
def editMenuResetCmd(self, *args): pass
def editMenuToolCmd(self, *args): pass
def editMenuActionCmd(self, *args): pass
def actionBtnCmd(self, *args):
    self.applyBtnCmd();
    self.closeBtnCmd();
def applyBtnCmd(self, *args): pass
def closeBtnCmd(self, *args):
    cmds.deleteUI(self.window, window=True);
def commonButtons(self):
    self.commonBtnSize = ((self.size[0]-18)/3, 26);
    self.actionBtn = cmds.button(
        label=self.actionName,
        height=self.commonBtnSize[1],
        command=self.actionBtnCmd
    );
    self.applyBtn = cmds.button(
        label='Apply',
        height=self.commonBtnSize[1],
        command=self.applyBtnCmd
    );
    self.closeBtn = cmds.button(
        label='Close',
        height=self.commonBtnSize[1],
        command=self.closeBtnCmd
    );
    cmds.formLayout(
        self.mainForm, e=True,
        attachForm=(
            [self.actionBtn,'left',5],
            [self.actionBtn,'bottom',5],
            [self.applyBtn,'bottom',5],
            [self.closeBtn,'bottom',5],
            [self.closeBtn,'right',5]
        ),
        attachPosition=(
            [self.actionBtn,'right',1,33],
            [self.closeBtn,'left',0,67]
        ),
        attachControl=(
            [self.applyBtn,'left',4,self.actionBtn],
            [self.applyBtn,'right',4,self.closeBtn]
        ),
```

```
                    attachNone=(
                        [self.actionBtn,'top'],
                        [self.applyBtn,'top'],
                        [self.closeBtn,'top']
                    )
                );
        def displayOptions(self): pass
```

EXTENDING GUI CLASSES

Now that you have a complete base class for a basic, familiar-looking GUI window, you can easily extend it for use in a variety of scenarios. Maya contains a great many GUI commands, and so we cannot cover them all here, but we can briefly look at an example that implements some common, useful controls by extending the **AR_OptionsWindow** class.

For the example in this section, we assume that you have saved the **AR_OptionsWindow** class in a module called optwin.py, or that you have downloaded the optwin.py module from the companion web site. We will use **AR_OptionsWindow** as a base class for a simple window with some polygon creation options.

1. Execute the following lines to create a subclass of **AR_OptionsWindow** called **AR_PolyOptionsWindow**. If you are working in the Script Editor, highlight this text before pressing **Ctrl + Enter** to execute it, as we will be working on this class through the next several steps.

```python
import maya.cmds as cmds
from optwin import AR_OptionsWindow;
class AR_PolyOptionsWindow(AR_OptionsWindow):
    def __init__(self):
        AR_OptionsWindow.__init__(self);
        self.title = 'Polygon Creation Options';
        self.actionName = 'Create';
AR_PolyOptionsWindow.showUI();
```

Planning has clearly paid off! As you can see, it is a trivial matter to start creating a new window right away by using a class. Calling the base class **__init__**() method and then reassigning some of its attributes produces a window with a new title and a new action button label.

Note that we did not override the window's unique handle, window, in **__init__**(). While you certainly could do so if you prefer, we have chosen not to in order to give our window similar behavior to Maya's option windows. Namely, when you instantiate a new window derived from this class, it will first clear other windows derived from the same class (unless you overwrite the window attribute in **__init__**()).

Although we will not override all of the empty methods in **AR_Options-Window**, we will work through enough to explore a few more GUI commands.

Radio Button Groups

2. Override the **displayOptions()** method by adding the following code to the **AR_PolyOptionsWindow** class. This method adds a radio button selector with four different basic polygon object types.

```
def displayOptions(self):
    self.objType = cmds.radioButtonGrp(
        label='Object Type: ',
        labelArray4=[
            'Cube',
            'Cone',
            'Cylinder',
            'Sphere'
        ],
        numberOfRadioButtons=4,
        select=1
    );
```

Note that we set the default selected item to 1. Radio button groups in the GUI use 1-based, rather than 0-based indices. Consequently, if you evaluate your changes and then call the inherited **showUI()** class method, you will see that the Cube option is selected by default.

3. Override the **applyBtnCmd()** method by adding the following code to the **AR_PolyOptionsWindow** class. This method will execute an appropriate command based on the current selection.

```
def applyBtnCmd(self, *args):
    self.objIndAsCmd = {
        1:cmds.polyCube,
        2:cmds.polyCone,
        3:cmds.polyCylinder,
        4:cmds.polySphere
    };
    objIndex = cmds.radioButtonGrp(
        self.objType, q=True,
        select=True
    );
    newObject = self.objIndAsCmd[objIndex]();
```

As you can see, we create a dictionary to map the radio indices to different function pointers. We then query the objType radio button group and use

the dictionary to execute the command that corresponds to the currently selected index.

At this point, you should take a look at the following code, which shows the entire **AR_PolyOptionsWindow** class, to make sure yours looks the same as ours.

```
class AR_PolyOptionsWindow(AR_OptionsWindow):
    def __init__(self):
        AR_OptionsWindow.__init__(self);
        self.title = 'Polygon Creation Options';
        self.actionName = 'Create';
    def displayOptions(self):
        self.objType = cmds.radioButtonGrp(
            label='Object Type: ',
            labelArray4=[
                'Cube',
                'Cone',
                'Cylinder',
                'Sphere'
            ],
            numberOfRadioButtons=4,
            select=1
        );
    def applyBtnCmd(self, *args):
        self.objIndAsCmd = {
            1:cmds.polyCube,
            2:cmds.polyCone,
            3:cmds.polyCylinder,
            4:cmds.polySphere
        };
        objIndex = cmds.radioButtonGrp(
            self.objType, q=True,
            select=True
        );
        newObject = self.objIndAsCmd[objIndex]();
```

If you call the **showUI()** class method, you can use the Create and Apply buttons to create different polygon primitives.

```
AR_PolyOptionsWindow.showUI();
```

Frame Layouts and Float Field Groups

4. Add the following lines to the bottom of the **displayOptions()** method to add a group for entering default transformations.

```
self.xformGrp = cmds.frameLayout(
    label='Transformations',
```

```
        collapsable=True
);
cmds.formLayout(
    self.optionsForm, e=True,
    attachControl=(
        [self.xformGrp,'top',2,self.objType]
    ),
    attachForm=(
        [self.xformGrp,'left',0],
        [self.xformGrp,'right',0]
    )
);
self.xformCol = cmds.columnLayout();
self.position = cmds.floatFieldGrp(
    label='Position: ',
    numberOfFields=3
);
self.rotation = cmds.floatFieldGrp(
    label='Rotation (XYZ): ',
    numberOfFields=3
);
self.scale = cmds.floatFieldGrp(
    label='Scale: ',
    numberOfFields=3,
    value=[1.0,1.0,1.0,1.0]
);
cmds.setParent(self.optionsForm);
```

The first command creates a frame layout and stores it in the `xformGrp` attribute. Frame layouts are a type of layout that can collect a series of controls in a group with a label and an optional button to collapse and expand the group. We then issue a call to `formLayout` to attach `xformGrp` to the `objType` selector and to the sides of `optionsForm`. As earlier, issuing a new layout command sets the newly created layout as the default parent for subsequent calls to control commands.

Although Maya 2011 and later would allow us to simply proceed to add controls to `xformGrp`, earlier versions of Maya throw an exception because we would be trying to add too many children to the frame layout. Consequently, to support earlier versions of Maya, we have further nested the controls in a column layout, `xformCol`. The next three controls we add all have the column layout as their parent.

The next three calls are to `floatFieldGrp`, which creates a group of floating-point number input fields. We have created a group for each of the basic transformations: translation, rotation, and scale. Note that when we

initialize the value for the scale field we must pass it four values, since the command does not know by default if it will consist of one, two, three, or four fields.

Finally, we issue a call to the setParent command to make optionsForm the current parent again. Without making this call, subsequent controls would be grouped under the xformCol column layout, as opposed to being children of the optionsForm layout. You may find this pattern more convenient than manually specifying the parent argument for each new control or layout you create.

5. Now that you have added your new controls, add the following lines to the **applyBtnCmd()** method to apply the transformations to the newly created object's **transform** node.

```
pos = cmds.floatFieldGrp(
    self.position, q=True,
    value=True
);
rot = cmds.floatFieldGrp(
    self.rotation, q=True,
    value=True
);
scale = cmds.floatFieldGrp(
    self.scale, q=True,
    value=True
);
cmds.xform(newObject[0], t=pos, ro=rot, s=scale);
```

If you call the **showUI()** class method again, you can now enter default translation, rotation, and scale values for the primitive you create.

Color Pickers

We will wrap up this example by adding a color picker to assign default vertex colors to the object.

6. Add the following lines to the end of the **displayOptions()** method to add a color picker control.

```
self.color = cmds.colorSliderGrp(
    label='Vertex Colors: '
);
cmds.formLayout(
    self.optionsForm, e=True,
    attachControl=(
        [self.color,'top',0,self.xformGrp]
    ),
```

```
        attachForm=(
            [self.color,'left',0],
        )
    );
```

The `colorSliderGrp` command creates a color picker with a luminance slider next to it.

7. Add the following lines to the end of the **applyBtnCmd()** method, after the call to the `xform` command, to apply the selected color to the new model's vertices.

```
    col = cmds.colorSliderGrp(
        self.color, q=True,
        rgbValue=True
    );
    cmds.polyColorPerVertex(
        newObject[0],
        colorRGB=col,
        colorDisplayOption=True
    );
```

8. Call the **showUI()** class method again and you should see an example like that shown in Figure 7.7. If you are having difficulties, consult

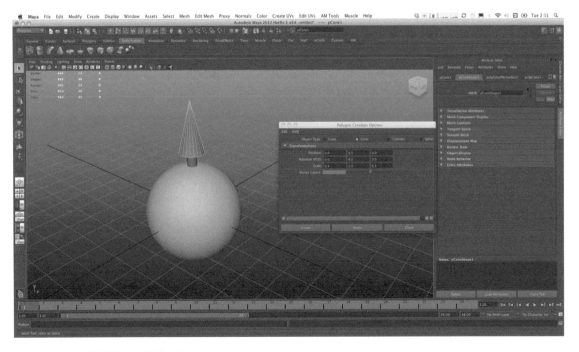

■ **FIGURE 7.7** The AR_PolyOptionsWindow class in action.

the complete example in the polywin.py module available on the companion web site.

While we could continue augmenting this tool with a variety of interesting controls, there are far too many in the cmds module to cover here! This example has hopefully given you enough exposure to the basics that you should be comfortable exploring a variety of other common GUI controls as you extend the **AR_OptionsWindow** class for your own tools.

CREATING MORE ADVANCED TOOLS

Before concluding this chapter, we want to touch upon a few more topics to help you develop more complex tools on your own. While these topics are not strictly related to Maya's GUI commands, you will no doubt find them helpful in many custom tools you develop. In this section, we examine the posemgr.py module from the companion web site to explore tool structure, data serialization, and working with files.

Pose Manager Window

The posemgr.py module contains a simple tool that enables you to copy and paste a character's pose, as well as save poses to a file. Although the window in this module is very basic to simplify the points we want to make, we have designed the module in a way that you could easily extend it if you wanted to use it in production.

1. Download the posemgr1.ma file from the companion web site and open it. The file contains a basic character with some animation applied. Play the animation to see how it loops.
2. Download the posemgr.py module from the companion web site and save it somewhere in your Python search path.
3. Execute the following lines in Maya to launch the Pose Manager GUI.

```
from posemgr import AR_PoseManagerWindow;
AR_PoseManagerWindow.showUI();
```

You should see a very barebones GUI window like that shown in Figure 7.8. The window contains a control group for copying and pasting poses, as well as a control group for saving and loading poses.

4. Move the time slider to the first frame, select the character's pelvis joint (CenterRoot), and press the Copy Pose button in the Pose Manager window. The Pose Manager tool works by copying the values for all of the keyable attributes on **transform** nodes in the hierarchy under

■ **FIGURE 7.8** The Pose Manager window contains a few simple controls.

the nodes you have selected. In this case, it is copying the transformation values for all of the joints in the character's hierarchy.

5. Scroll to the final frame on the time slider and then press the Paste Pose button. The character should now be in the same pose it was in when at the start of the animation.

6. With the CenterRoot joint still selected, select the character's whole hierarchy using the **Edit → Select Hierarchy** menu option and set a key on all of its joints (**Animate → Set Key** in the Animation menu set or default hotkey **S**).

If you play the animation now, the start and end frames should match. While this application of the pose manager is handy, it is not especially revolutionary.

7. Scrub to the first frame of the animation, select the CenterRoot joint, and then press the Save Pose button in the Pose Manager window. Save the pose as idle.pse in a location you will remember.

8. Open the file posemgr2.ma and view its animation. You should see the same character with a different motion applied. Unfortunately, its initial pose doesn't quite match the other animation well enough to produce a good blend for a game.

9. Scrub the time slider to the first frame in the animation.

10. Press the Load Pose button in the Pose Manager to pull up a file dialog. Browse to the idle.pse file that you just saved and open it.[5] The character's pose should now match the one you saved.

[5]If you cannot find the file you just saved, and are running Maya 2008 or earlier on OS X, try browsing one folder up your directory tree. See note 7 for more information.

11. Select the character's hierarchy again and set a key as in step 6. The character's motion now begins in the same pose as the other animation, and would be able to produce a much better blend if they were dropped into a game together.

While this tool does not appear to be overly glamorous, it does make use of some important techniques worth discussing. Open the posemgr.py file and examine its source code. The file contains some imports, an attribute, a class, and some assorted functions. While you are free to examine the module's contents in greater detail on your own, we highlight some key points here.

Separating Form and Function

The first point worth discussing is how the module is organized overall. Our previous examples separated form and functionality by implementing different methods in a single class: Each button had a command method associated with it, which could be easily overridden in a child class. This pattern was sufficient for the **AR_PolyOptionsWindow** class, as its actions were not likely to be of interest to other tools.

In comparison, the Pose Manager window incorporates some functionality that may be of interest to other tools or other classes. Consequently, we have defined some attributes in the module outside of the **AR_PoseManagerWindow** class. These include the **kPoseFileExtension** variable (a three-letter file extension for our custom pose files), as well as some functions for doing the core work of the tool, including **exportPose()**, **saveHierarchy()**, and **importPose()**. By making these items available without an **AR_PoseManagerWindow** instance, we would enable other developers to hook into them in other GUIs or even when running in headless mode via mayapy, for example.

Serializing Data with the cPickle Module

The **exportPose()** function takes two arguments: a path to a file and a collection with the names of root nodes.

```
def exportPose(filePath, rootNodes):
    try: f = open(filePath, 'w');
    except:
        cmds.confirmDialog(t='Error', b=['OK'],
            m='Unable to write file: %s'%filePath
        );
        raise;
    data = saveHiearchy(rootNodes, []);
    cPickle.dump(data, f);
    f.close();
```

The first step in this function is to create a file object, f, using Python's built-in **open**() function. This function allows you to specify a path to a file and a flag to indicate if you would like read or write permissions for the file. When working in write mode, if no file exists at the specified path, Python will automatically create one. The return value is a built-in type, file, which contains a number of useful methods. We recommend consulting Section 5.9 of Python Standard Library online for more information on working with file objects.

If there is a problem, we create a notification dialog to inform users of the error before raising an exception. An artist who uses a tool that invokes this method won't have to hunt around the console, but a developer using Maya in headless mode would still get an exception and a stack trace.

We then call the **saveHierarchy**() function (which we will examine in a moment), and use the cPickle module to serialize the data it returns. The cPickle module is a built-in module that allows you to serialize and deserialize Python objects effortlessly. Python also includes an analogous built-in module, pickle, which is almost identical. The difference between the two modules is that cPickle is written in C, and so can work up to a thousand times faster than the standard pickle module. The only key downside is that pickle implements two classes (**Pickler** and **Unpickler**) that can be overridden, while cPickle implements them as functions. Because we do not need to override their functionality, we can use the cPickle module here and harness its greater speed.

The most common usage of these modules is to call the **dump**() function (as we do here) to write serialized data to a file, and the **load**() function to read it back in and deserialize it. Because we cannot explore them in greater depth here, you should consult Sections 11.1 and 11.2 of Python Standard Library for more information on the pickle and cPickle modules, as you will find them invaluable in a number of situations.

After writing the file's contents with the **dump**() function, we close the file. Remember that you must always close files when you are done with them![6]

The **saveHierarchy**() function creates the data that we dump into the pose file. As you can see, it has two parameters: rootNodes and data.

[6]Python 2.5 added special syntax in the form of the **with** keyword, which allows you to open a file and operate on it in a block, after which it is automatically closed. Consult Section 7.5 of Python Language Reference online for more information on its features and usage.

```
def saveHiearchy(rootNodes, data):
    for node in rootNodes:
        nodeType = cmds.nodeType(node);
        if not (nodeType=='transform' or
            nodeType=='joint'): continue;
        keyableAttrs = cmds.listAttr(node, keyable=True);
        if keyableAttrs is not None:
            for attr in keyableAttrs:
                data.append(['%s.%s'%(node,attr),
                    cmds.getAttr('%s.%s'%(node,attr))]
                );
        children = cmds.listRelatives(node, children=True);
        if children is not None: saveHiearchy(children,
data);
    return data;
```

This function is recursive, meaning it calls itself in its body. Recall that when we invoke this function from **exportPose()**, we pass it an empty list for the data parameter.

```
data = saveHiearchy(rootNodes, []);
```

The **saveHierachy()** function iterates through all of the **transform** nodes passed in the rootNodes argument, skipping over objects that are not **transform** or **joint** nodes. (You could support any object types you like, but we keep it simple here.) For each valid node, it gathers all of the object's keyable attributes and then appends an [object.attribute, value] pair to the data list. Once all of these pairs have been appended, it sees if the current node has any children.

If there are any children, the function calls itself, passing in the children list as well as the current state of the data list. Because lists are mutable, this recursive invocation does not need to capture the result in a return value, as data will be mutated in-place. Once the iteration has finished, the function returns. When the function has returned out to the original invocation, where it was called from the **exportPose()** context, and it has completed the last node, the data list is returned and then assigned to a variable in **exportPose()**.

When we read a pose back in, we use the **importPose()** function, which takes a path to a pose file as its argument.

```
def importPose(filePath):
    try: f = open(filePath, 'r');
    except:
        cmds.confirmDialog(t='Error', b=['OK'],
            m='Unable to open file: %s'%filePath
        );
        raise;
```

```
pose = cPickle.load(f);
f.close();
errAttrs = [];
for attrValue in pose:
    try: cmds.setAttr(attrValue[0], attrValue[1]);
    except:
        try: errAttrs.append(attrValue[0]);
        except: errAttrs.append(attrValue);
if len(errAttrs) > 0:
    importErrorWindow(errAttrs);
    sys.stderr.write(
        'Not all attributes could be loaded.'
    );
```

This function is very straightforward. It begins by trying to open the supplied file in read mode, again displaying a dialog box if there is some kind of problem. If the file opens successfully, we then call the **load()** function in the cPickle module to deserialize the file's contents into the pose list and close the file.

The function then iterates through the items in the pose list. It tries to set the specified attribute to the specified value in the deserialized [object.attribute, value] pairs. If the scene does not contain the node, or cannot set the specified attribute for some other reason, then it appends the attribute name to a list of error attributes (errAttrs) to be able to inform the user of which attributes were by necessity ignored. Because the **importErrorWindow()** function does not introduce anything novel, we leave it to interested readers to inspect its contents in the source code if so desired.

Working with File Dialogs

Although we separated out the Pose Manager's important functions from the window class to enable other tools to hook into them, we needed to implement a mechanism in our sample GUI to provide file paths when invoking these functions. In the **AR_PoseManagerWindow** class you can find four methods—**copyBtnCmd()**, **pasteBtnCmd()**, **saveBtnCmd()**, and **loadBtnCmd()**—which correspond to the Copy Pose, Paste Pose, Save Pose, and Load Pose buttons, respectively.

The **copyBtnCmd()** and **pasteBtnCmd()** methods are fairly straightforward, and so we do not discuss their contents in detail here. Though they implement some minor validation and user feedback, which you can view in the source code, the important point is that they call the **exportPose()** and **importPose()** functions, respectively, passing a tempFile attribute as the filePath parameter. This attribute is created in the **__init__()** method.

```
self.tempFile = os.path.join(
    os.path.expanduser('~'),
    'temp_pose.%s'%kPoseFileExtension
);
```

This attribute simply initializes a string to provide a path to a file, temp_pose.pse, in the user's home folder, since this location is guaranteed to be writable. Using this technique allows us to easily invoke the same functions as the other button command methods.

The **saveBtnCmd()** and **loadBtnCmd()** methods obtain a file path using a file dialog, and then pass this value to the **exportPose()** and **importPose()** functions, respectively. Although these methods do not merit a detailed discussion, they implement a similar pattern worth noting. First examine the **saveBtnCmd()** method.

```
def saveBtnCmd(self, *args):
    rootNodes = self.getSelection();
    if rootNodes is None: return;
    filePath = '';
    try: filePath = cmds.fileDialog2(
        ff=self.fileFilter, fileMode=0
    );
    except: filePath = cmds.fileDialog(
        dm='*.%s'%kPoseFileExtension, mode=1
    );
    if filePath is None or len(filePath) < 1: return;
    if isinstance(filePath, list): filePath = filePath[0];
    exportPose(
        filePath,
        cmds.ls(sl=True, type='transform')
    );
```

The method begins with some simple selection validation, and then proceeds to a **try-except** clause. Though not strictly necessary, we implement this pattern to support all versions of Maya with Python support. Maya 2011 added the `fileDialog2` command, so we prefer it if it is available. If it does not exist, however, we fall back on the `fileDialog` command, which is available in earlier versions of Maya, to retrieve `filePath`.

The next lines perform some validation on the results retrieved from the file dialog. We can return early if `filePath` is None or has length 0 (e.g., if the user canceled or dismissed the file dialog). The next test, to see if `filePath` is a list, is again just to support all versions of Maya. While `fileDialog` simply returns a string, the `fileDialog2` command returns a list of paths, as it supports the ability to allow users to select

multiple files. Thereafter, the method can simply call the **exportPose()** function using the supplied path. The **loadBtnCmd()** method implements a similar process.

```
def loadBtnCmd(self, *args):
    filePath = '';
    try: filePath = cmds.fileDialog2(
        ff=self.fileFilter, fileMode=1
    );
    except: filePath = cmds.fileDialog(
        dm='*.%s'%kPoseFileExtension, mode=0
    );
    if filePath is None or len(filePath) < 1: return;
    if isinstance(filePath, list): filePath = filePath[0]
    importPose(filePath);
```

Apart from not requiring selection validation (or selection at all), the only major difference in this method concerns the argument values that are passed to the fileDialog2 and fileDialog commands.

The mode flag on the fileDialog command specifies whether the dialog is in read or write mode. While we specified a value of 0 here for read, the **saveBtnCmd()** method passed a value of 1 for write.[7]

On the other hand, the fileDialog2 command implements a more flexible fileMode flag. Although the arguments we passed are the opposite from those we passed to the fileDialog command's mode flag (we pass 1 when loading, and 0 when saving), the fileMode flag has a very different meaning from the mode flag on the fileDialog command. The basic idea is that file dialogs don't really need to know whether you plan to read or write: you handle all of that functionality separately. *Rather, it needs to know what you want to allow the user to be able to see and select*. This flag allows you to specify what the file dialog will display, and what the command can return. Although its different argument values are covered in the Python Command Reference, we summarize the different argument values for this flag in Table 7.1.

[7]In Maya 2008 and earlier versions, on some versions of OS X, using fileDialog in write mode (mode=1) may return a string value with no path separator between the directory and file names. For example, instead of returning "/users/adammechtley/Desktop/untitled.pse", the command would return "/users/adammechtley/Desktopuntitled.pse". If you are running this example on such a version of Maya and are having difficulty finding poses you save, then try looking one folder up from where you expect it to be.

Table 7.1 Possible Argument Values and Their Meanings for the `fileMode` Flag Used with the `fileDialog2` Command

Argument Value	Meaning
0	Any file, whether it exists or not (e.g., when saving a new, nonexistent file)
1	A single existing file (e.g., when loading a file)
2	A directory name (both directories and files appear in the dialog)
3	A directory name (only directories appear in the dialog)
4	The names of one or more existing files (e.g., when loading several files)

CONCLUDING REMARKS

In addition to having mastered some basic GUI commands, you have another hands-on example of some of the benefits of object-oriented programming in Maya using Python. By creating basic classes for common tool GUIs, you can introduce new tools into your studio's suite much more easily than if you were restricted to MEL or if you were manually creating new windows for every new tool. Moreover, you have learned best practices for executing commands with your GUI controls, organizing your GUI windows, and architecting your GUI code in a larger code base. Finally, you have been introduced to the basics of data serialization and working with files in Python. You now have all the foundations necessary to create a range of useful tools, though Python still has much more to offer!

Advanced Graphical User Interfaces with Qt

BY THE END OF THIS CHAPTER, YOU WILL BE ABLE TO:

- Describe what Qt is and how it is integrated into modern versions of Maya.

- Dock built-in and custom windows in the Maya GUI.

- Locate, download, and install Qt libraries and tools.

- Define widgets, signals, and slots.

- Identify Qt widgets that correspond to native Maya GUI commands.

- Create a basic user interface with Qt Designer.

- Add Maya functionality to controls in a Qt user interface.
- Load a Qt interface in Maya 2011 and later.
- Use signals and slots to implement advanced GUI controls.
- Describe how PyQt works and what it enables you to do.
- Locate helpful resources for working with Qt.

In Chapter 7, we examined Maya's built-in tools for creating basic windows using the cmds module. While the cmds module provides a very natural and native mechanism for creating GUIs in Maya, you can probably imagine that creating more involved windows, controls, and layouts using commands could be an arduous programming task. Fortunately, Maya 2011 and later have introduced an alternative user interface approach that not only provides more options, but also offers a set of tools that can substantially expedite the creation of a custom GUI. Specifically, Maya 2011 and later have fully integrated the Qt graphics libraries.

In this chapter, we briefly examine what Qt is and how it has been integrated into Maya. We then discuss how you can install Qt libraries and tools. Next, we discuss the basics of using Qt Designer to rapidly create GUIs and use them in Maya. Finally, we provide a brief overview of PyQt.

Qt AND MAYA

To facilitate GUI flexibility and customization, Maya 2011 and later incorporate a graphics library called Qt (pronounced "cute") as the GUI toolkit. This third-party technology is not developed or owned by Autodesk, but is nevertheless tightly integrated into Maya.

The main benefit of the Qt toolkit is that it is a cross-platform C++ application framework. Recall that Maya ships on three platforms: Windows, OS X, and Linux. As you can imagine, it requires a lot of resources to maintain three separate GUI toolkits across these platforms. In addition to its platform diversity, Qt excels at creating compact, high-performance tools.

The philosophy around Qt is to focus on innovative coding, not infrastructure coding. The idea is that you should spend most of your time making an elegant window, rather than trying to place one button in the middle of the interface. Qt's tools have been designed to facilitate this workflow, which makes it an interesting alternative to using native Maya commands.

Don't worry! Maya's user interface commands are not being phased out. All of your existing GUIs created with Maya commands will still work. GUI creation with Qt is purely an addition to the Maya environment, and

no functionality has been removed or lost. To help understand how Qt fits into modern versions of Maya, refer to Figure 8.1.

Imagine the Qt GUI toolkit as an abstraction layer sitting on top of the Maya application. This illustration closely resembles that shown in Chapter 7. The key point, however, is that all target platforms can now make use of the same GUI toolkit. Prior to Maya 2011, the GUI layer was platform-specific (e.g., Carbon on OS X, Motif on Linux). Now, because all platforms use the same GUI library, there is much greater consistency across operating systems. On top of the Qt layer, the native Maya GUI commands remain unchanged. Behind the scenes, Autodesk has connected the existing GUI commands to the new Qt layer, which allows you to seamlessly transition into Maya 2011 and later.

For Maya 2011 and later, the standard Maya user interface is still built using Maya GUI commands. However, now that the Maya GUI commands are driven by Qt in the background, you will see that there is much more functionality available when customizing the Maya interface (Figure 8.2).

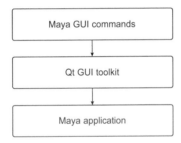

■ **FIGURE 8.1** The Qt GUI toolkit exists as another abstraction layer outside the Maya application, yet can work on all platforms that Maya targets.

■ **FIGURE 8.2** The Maya 2011 GUI is a big step up from the Maya 2010 GUI.

In addition to featuring a striking dark color scheme, Maya's Qt-based GUI permits much better window organization and customization by enabling features like docking, which allows you to insert windows adjacent to other items in the main GUI window. Another helpful feature is the inclusion of drag-and-drop functionality when adding and moving windows around in your layout.

Docking Windows

The easiest way to discover the flexibility of Qt is to take a look at an example that demonstrates some of the new functionality. If you are using Maya 2010 or earlier, you will unfortunately just have to use your imagination. Let's first examine the `dockControl` command, new in Maya 2011, and use it to dock a Graph Editor into the current interface layout.

1. Open the Script Editor and execute the following short script in a Python tab.

```
import maya.cmds as cmds;
layout = cmds.paneLayout(configuration='single');
dock = cmds.dockControl(
    label='Docked Graph Editor',
    height=200,
    allowedArea='all',
    area='bottom',
    floating=False,
    content=layout
);
ge = cmds.scriptedPanel(
    type='graphEditor',
    parent='layout'
);
```

The previous script created a pane layout, `layout`, for the Graph Editor to sit in and then created a dock control, `dock`, to house the pane layout at the bottom of the Maya interface (using its `content` flag). It finally created an instance of the Graph Editor and made it a child of `layout`.

Similarly, you can use the `dockControl` command to dock your own custom windows created using the cmds module. For instance, you can use it to dock the Pose Manager window we discussed in Chapter 7.

2. Ensure that you have downloaded the posemgr.py module from the companion web site and have saved it somewhere in your Python search path.
3. Open the Script Editor and enter the following script in a Python tab.

```
import maya.cmds as cmds;
import posemgr
```

```
pwin = posemgr.AR_PoseManagerWindow();
pwin.create();
cmds.toggleWindowVisibility(pwin.window);
layout = cmds.paneLayout(configuration='single');
dock = cmds.dockControl(
    label=pwin.title,
    width=pwin.size[0],
    allowedArea='all',
    area='right',
    floating=False,
    content=layout
);
cmds.control(pwin.window, e=True, p=layout);
```

As you can see, the process is very similar to that when docking built-in windows. In this case, right after we create the window, we toggle its visibility off, since the **create()** method shows the window by default. Without this toggle, the window would display both floating in the Maya UI and docked on the right side, as the `dockControl` command automatically displays its contents. Note also that closing a dock control does not delete the dock, but simply hides it. You can access closed dock controls by clicking the **RMB** over any dock's title.

INSTALLING Qt TOOLS

The native Maya GUI commands that we introduced in Chapter 7 are sufficient for most users. However, you may find you require more access to the underlying Qt toolkit. Maya does not ship with all of the Qt libraries, but rather only those it requires to run. To work with the additional Qt header files and libraries, you must download the correct source files, and then install and build them. Keep in mind the additional Qt toolkit is optional, and is aimed at developers who wish to create more demanding interfaces through such tools as PyQt and PySide.

The Qt SDK

In this section we will talk briefly about how to obtain and install the Qt Software Development Kit (SDK). The Qt SDK contains additional libraries and development tools, one of which is Qt Designer. Qt Designer is a visual GUI editing application, which allows you to drag and drop controls into a canvas as opposed to manually coding them. *Although Qt Designer is part of the SDK, you do not need to install the SDK to obtain it*. If you are only interested in using Qt Designer, you can skip to the next section of this chapter, as we discuss an alternative method to install it

Table 8.1 Links for the Qt SDK for Maya 2011 and 2012

Maya Version	Operating System	Link
2011	Windows	ftp://ftp.qt.nokia.com/qt/source/qt-win-opensource-4.5.3-mingw.exe
2011	OS X	ftp://ftp.qt.nokia.com/qt/source/qt-mac-cocoa-opensource-4.5.3.dmg
2011	Linux	ftp://ftp.qt.nokia.com/qt/source/qt-all-opensource-src-4.5.3.tar.gz
2012	Windows	http://get.qt.nokia.com/qtsdk/qt-sdk-win-opensource-2010.05.exe
2012	OS X	http://get.qt.nokia.com/qtsdk/qt-sdk-mac-opensource-2010.05.dmg
2012	Linux	http://get.qt.nokia.com/qtsdk/qt-sdk-linux-x86_64-opensource-2010.05.bin

without all of the other tools and libraries, many of which you may never use. If you are still interested, however, read on!

Each version of Maya is built with a specific version of Qt. Before downloading any files, you must first examine the Autodesk Maya API Guide and Reference documentation, and determine which version of Qt you need to download. You can find this information in Maya's help on the page **API Guide → Setting up your build environment → Configuring Qt for use in Maya plug-ins**. For example, Maya 2011 uses version 4.5.3, while Maya 2012 uses 4.7.1. The Qt version is likely to change with every major release of Maya, so it is your responsibility to always check when setting up your Qt environment what version the new Maya release uses.

Once you have verified the Qt version required for your version of Maya, navigate to the Official Qt SDK download site at *http://get.qt.nokia.com/qtsdk/* where you can locate and download the required source package for your version.[1] Table 8.1 lists example links for each platform for Maya 2011 and 2012.

Once you have successfully downloaded the required Qt source package, you may now install it by double clicking the .exe file on Windows or the .dmg file on OS X. For Windows and OS X operating systems, we recommend that you follow the installation wizard using default installation settings. On Linux there is no installation wizard—you are required to

[1] In addition to offering several version options, there are two available license options: the LGPL (Lesser General Public License) free software license and the GPL (General Public License) commercial software license. Determine which license type best suits your needs by consulting the licensing terms and conditions.

configure the source packages yourself. For more detailed installation instructions and steps, consult the docs/html folder that is part of the Qt SDK download. Look for the appropriate Installing Qt page based on your operating system.

After a successful installation, you now have access to a range of Qt tools:

- *Qt Designer* is an application for designing and building GUIs from Qt components.
- *Qt Linguist* is an application to translate applications into local languages.
- *Qt Creator* is a cross-platform integrated development environment (IDE).
- *Qt Assistant* is a help browser featuring comprehensive documentation to work with the Qt tools.
- Other tools and examples such as plugins, frameworks, libraries, and Qt Command Prompt.

Qt DESIGNER

Thus far we have designed our GUIs by using Maya commands. An alternative approach available to modern versions of Maya is to use Qt Designer (Figure 8.3). Qt Designer is an application for designing and building GUIs from Qt components. You can compose and customize your GUIs in a visual drag-and-drop environment. Qt Designer is referred to as a WYSIWYG (what-you-see-is-what-you-get) tool.

In Maya 2011 and later, your WYSIWYG GUIs can be imported directly into Maya, allowing for easy interface building. Moreover, you can embed Maya commands into your GUI by creating dynamic properties, which provide you with an additional level of interface control and complexity. In addition to enabling rapid prototyping to ensure your designs are usable, Qt Designer also facilitates easy layout changes without altering the underlying code of your GUI.

With Qt Designer you can create three types of forms: main windows, custom widgets, and dialogs.

- *Main windows* are generally used to create a window with menu bars, dockable widgets, toolbars, and status bars.
- *Custom widgets* are similar to a main window, except that they are not embedded in a parent widget and thus do not provide the various toolbars as part of the window.
- *Dialogs* are used to provide users with an options window.

Main windows and custom widgets are the most commonly used forms within Maya. Dialogs tend not to be used in Maya because there is no

■ **FIGURE 8.3** The Qt Designer application.

equivalent Maya command for the button box that is provided with the default dialog templates. However, you could easily emulate the dialog functionality with a custom widget using two buttons.

Widgets

All the components that are used within forms are called widgets. A *widget* is any type of control in the interface, such as a button, label, or even the window itself. To be able to query a Qt widget inside of Maya, Maya must have an equivalent representation of the widget available in the Maya commands. Unfortunately, not all widgets in Qt Designer are available in Maya. To access the list of available widget types and their associated Maya commands, use the `listTypes` flag on the `loadUI` command.

```
import maya.cmds as cmds;
for t in cmds.loadUI(listTypes=True):
    print(t);
```

If you print the items in the list, you will see something like the following results.

```
CharacterizationTool:characterizationToolUICmd
QCheckBox:checkBox
QComboBox:optionMenu
QDialog:window
QLabel:text
QLineEdit:textField
QListWidget:textScrollList
QMainWindow:window
QMenu:menu
QProgressBar:progressBar
QPushButton:button
QRadioButton:radioButton
QSlider:intSlider
QTextEdit:scrollField
QWidget:control
TopLevelQWidget:window
```

If you require a widget that is not available, you must manually map the Qt widget to something that is accessible to Maya. Qt provides a built-in mapping mechanism referred to as signals and slots.

Signals and Slots

Signals and slots are central to Qt and help it stand out from other GUI toolkits. *Signals* and *slots* are used to allow objects to communicate with each other and to easily assign behaviors to widgets. In short, GUI events emit certain signals, which are linked to different functions (slots). In essence, the mechanism is a more secure alternative to simply passing function pointers as we do when using Maya commands. There are great resources on the Web to ensure you understand this mechanism, so it is certainly worth referring to the Qt documentation. We will later examine an example demonstrating the use of signals and slots to enable controls that are not automatically supported.

Qt Designer Hands On

To discuss some of the theory behind GUI design and the workflows that are involved in creating a window in Qt Designer that will interact with Maya, it is worth walking through a brief, hands-on example. Note that if you elected not to install the entire Qt SDK, you will need to download and install the Qt Creator application from the Official Qt web site (*http://qt.nokia.com/products*). Qt Creator is an IDE that embeds the Qt Designer application, among other tools.

In this section, we'll work through a basic GUI to create a cone that points in a direction specified using a control in the window.

1. Open Qt Designer (or Qt Creator if you are using it). You can find it at one of the following locations based on your operating system:
 - **Windows:** Start → Programs → Qt SDK → Tools → …
 - **OS X:** /Developers/Applications/Qt/…
 - **Linux:** Start → Programming → … or Start → Development → …
2. If you are using Qt Creator, select **File** → **New File or Project** from the main menu. In the menu that appears, select **Qt** from the Files and Classes group on the left, and **Qt Designer Form** in the group on the right. Press the **Choose** button.
3. Whichever application you are using, you should now see a dialog where you can select what type of widget you would like to create. (If using Qt Designer, you should have seen a default pop-up menu when you launched the application. If you did not, you can simply navigate to **File** → **New**.) Select the **Main Window** widget from this dialog and **Default Size** from the Screen Size dropdown menu and proceed.
4. If you are using Qt Creator, you must now specify a file name and location. Name the file cone.ui and set its location to your home directory. Skip past the next page in the project wizard, which allows you to specify if you want to use version control.

Whichever application you are using, you should now be in the main application interface, which is very similar in both cases. Although we will not go into all of its details, we will cover what you need to start creating a custom Maya GUI. The main interface is roughly divided into thirds (Figure 8.4). The drag-and-drop widgets/controls are on the left (A), the work area is in the middle, and the editors section is on the right. The Property Editor (B) on the right is one of the most important panes.

As you start designing a custom GUI in the following steps, it may be helpful to think of the main window as a canvas, like those found in two-dimensional image editing packages. Let's start by adding some properties to the main window.

The Property Editor is dynamic and changes based on whatever object is selected in the work area. To ensure you always have the object you want selected, it helps to use the Object Inspector window in the upper right corner. If you are working in Qt Designer and cannot see the Object Inspector window, it may be occluded by another window. Toggle its visibility from the **View** menu so you can see it.

■ **FIGURE 8.4** The Qt Creator interface.

5. Select the `MainWindow` object from the Object Inspector window. You should see information for the `MainWindow` object in the Property Editor.

The Property Editor displays all of the properties associated with the currently selected object. Though it contains many properties, we will only discuss some basics. The first property in the list is called **objectName**. This property contains the name that will be given to your window in Maya, if you need to access it via commands, for instance.

6. Set the value for **objectName** to ar_conePtrWindow.
7. Scroll down in the Property Editor list to find the property **windowTitle**. Set its value to Create Cone Pointer.
8. Adjust the size of the main window to your liking by clicking on the bottom right corner of the window and dragging it in and out. Note that the **geometry** property updates in the Property Editor in real time. You can also expand this property and manually enter a height and width to your liking—a value like 300×200 is appropriate for this example.

9. Locate the Widget Box on the left side of the interface. This box allows you to create all of the basic types of widgets built in to Qt. Add a button to the window by dragging the **Push Button** item from the Buttons group into your main window in the canvas (Figure 8.5).

10. Change the label appearing on the button by double clicking on it. Set the text to Create Cone Pointer. Note that the **text** property in the **QAbstractButton** section of the Property Editor shares this value. Adjust the size of the button as needed.

Note how the sections in the Property Editor are organized. Each section represents different properties associated with the selected widget at different abstraction levels. Because all widgets inherit from a **QWidget** class, they all have the same common properties in the **QWidget** section. You can use this organization to help you browse the Qt documentation if you need to know about any particular properties.

11. To make your button interact with Maya, you need to add a dynamic string property to the button. Press the large green **+** button in the Property Editor and select the Option **String**… (Figure 8.6).

12. You should now see a Create Dynamic Property dialog box. To link your button to a Python command in Maya, you must set the Property Name on this new property to be "+command" and then click OK.

As you probably noticed, adding a dynamic property to your button created an entry for it in the bottom of the Property Editor. The **+command** property corresponds to the command flag available when creating GUI controls using Maya commands. You can prefix any dynamic property with a **+** symbol to indicate that it maps to a flag of the same name on the

■ FIGURE 8.5 A **Push Button** widget.

■ **FIGURE 8.6** Adding a dynamic string property in the Property Editor.

corresponding Maya command. Consequently, the string value you assign to this property inherits the same problems we discussed in Chapter 7. Namely, the value you pass to this command is either a string to be executed in __main__ (in which case you must enclose the value you enter in quotation marks) or it may be a function pointer.

Because of the issues associated with executing a string of statements in __main__, you may desire to pass the flag a function pointer as we did in Chapter 7, where we passed names of methods on an instance object by accessing attributes using the self name. *While you can still pass the name of a function, it must be a valid name in __main__: You cannot call methods on self.* The reason for this requirement is that when Maya builds this user interface, even when it is loaded from inside a class, its controls are not constructed in the context of an instance object, where the self name exists, but in __main__.

Consequently, we want to make as few assumptions about __main__ as possible, so we do not want to point to a method on a particular instance

name for the GUI like `win`. Although there are numerous ways of handling this issue depending on your production environment and tool deployment,[2] we will make the assumption that the class name for the GUI (which we will code in a few steps) will exist in __main__. If we assume that the class name exists, we can safely access any class attribute associated with it. The mechanics of this process will be clearer in a few steps when we design our class, **AR_QtConePtrWindow**, for this GUI in Python.

13. In the Property Editor, assign the value AR_QtConePtrWindow.use. createBtnCmd to the **+command** property.
14. Drag a **Label** widget into your window and change its display text to "Y-Rotation:".
15. Drag in a **Line Edit** widget next to the label and assign the value inputRotation to its **objectName** attribute. This widget corresponds to Maya's text field control.
16. Double click on the inputRotation widget and enter a default value of 0.0.
17. Save your .ui file as cone.ui in your home folder (Documents folder on Windows). All Qt forms are stored in files with the .ui extension. This file contains XML code that makes up all the properties and widgets inside of your UI.

LOADING A Qt GUI IN MAYA

At this point we can investigate how to load the .ui file that you created in Qt Designer into Maya 2011 and later. To load your custom Qt Designer interface files, you need to use the `loadUI` command. We will issue this command from within a custom class, much as we called the `window` and `showWindow` commands in Chapter 7. We assume that you still have the cone.ui file from the previous example in your home directory.

1. Execute the following code in a Python tab in the Script Editor to create a new class, **AR_QtConePtrWindow**, and then instantiate it and call its **create()** method to display your window.

```
import maya.cmds as cmds;
import os;
```

[2]For example, when you deploy your class in a package of tools, you could include an **import** statement that will execute in __main__ when userSetup is run, using the `eval` function in maya.mel: `maya.mel.eval('python("from moduleName import ClassName");')`.

```python
class AR_QtConePtrWindow(object):
    use = None;
    @classmethod
    def showUI(cls, uiFile):
        win = cls(uiFile);
        win.create();
        return win;
    def __init__(self, filePath):
        AR_QtConePtrWindow.use = self;
        self.window = 'ar_conePtrWindow';
        self.rotField = 'inputRotation';
        self.uiFile = filePath;
    def create(self, verbose=False):
        if cmds.window(self.window, exists=True):
            cmds.deleteUI(self.window);
        self.window = cmds.loadUI(
            uiFile=self.uiFile,
            verbose=verbose
        );
        cmds.showWindow(self.window);
    def createBtnCmd(self, *args):
        rotation = None;
        try:
            ctrlPath = '|'.join([
                self.window,
                'centralwidget',
                self.rotField]
            );
            rotation = float(
                cmds.textField(
                    ctrlPath,
                    q=True, text=True
                )
            );
        except: raise;
        cone = cmds.polyCone();
        cmds.setAttr('%s.rx'%cone[0], 90);
        cmds.rotate(0, rotation, 0,
            cone[0],
            relative=True
        );
win = AR_QtConePtrWindow(
    os.path.join(
        os.getenv('HOME'),
        'cone.ui'
    )
);
win.create(verbose=True);
```

Your window should now appear in Maya. One of the first things you may notice is that your Qt Designer interface is integrated seamlessly into Maya. Specifically, the interface automatically takes on the look of Maya's GUI skin. This integration prevents you from having to set all the colors in your custom GUI to match those of the Maya GUI. Your GUI should create a cone when you press its button. Changing the value for the rotation input field changes the cone's default heading when it is created.

Although it bears some similarities to those we created in Chapter 7, this GUI class is more complex and merits some discussion. The first item defined is a class attribute **use**, which you may recognize from the value we assigned the **+command** attribute in Qt Designer.

```
use = None;
```

This attribute, which is initialized to None in the class definition, will temporarily store the instance being created when its **__init__**() method is called.

```
def __init__(self, filePath):
    AR_QtConePtrWindow.use = self;
    self.window = 'ar_conePtrWindow';
    self.rotField = 'inputRotation';
    self.uiFile = filePath;
```

The rationale behind this pattern is that when the **create()** method is called (which we will investigate next), this attribute will be pointing to the most recently created instance. Consequently, when the button command's callback method is bound by referencing this class attribute, it will be pointing to the function associated with the instance on which **create()** is called (assuming you call **create()** after each instantiation, if you were to create duplicates of this window).

You could easily achieve a similar result using a variety of techniques, so your decision really boils down to how your tool suite deploys modules and classes. It is stylistically fairly common to import individual classes using the **from-import** syntax, so it would not be unusual to do so in __main__ via a userSetup script, for example. Feel free to disagree though and do what works for you with your own tools.

After initializing this "cache" variable, we set up some attributes to match the names we assigned to the window and to the input field in Qt Designer. Note that we also necessitate that the constructor be passed a `filePath` argument, which will specify the location of the .ui file on disk.

The `loadUI` command

The **create()** method looks very similar to those in Chapter 7, yet it makes use of a special command, `loadUI`, to load the .ui file.

```
def create(self, verbose=False):
    self.window = cmds.loadUI(
        uiFile=self.uiFile,
        verbose=verbose
    );
    cmds.showWindow(self.window);
```

The `loadUI` command will translate the .ui file into controls recognized by
Maya, as though the interface were created with Maya's native GUI com-
mands. Note that we also pass the command the `verbose` flag, which is
an optional argument for the **create()** method. This flag will output detailed
information on which widgets in the GUI will be functional. Recall that not
all Qt widgets have corresponding Maya commands, so although they will
be visible, they may not be accessible by other Maya commands. It is pos-
sible to access values of unsupported controls indirectly using signals and
slots, which we examine shortly. When you called the **create()** method on
the instance at the end of the last step, you passed the `verbose` flag, so
you may have seen output like the following example in the History Panel.

```
# Creating a QWidget named "centralwidget". #
# Creating a QPushButton named "pushButton". #
# Creating a QmayaLabel named "label". #
# Creating a QmayaField named "inputRotation". #
# Creating a QDial named "dial". #
# Creating a QMenuBar named "menubar". #
# Creating a QStatusBar named "statusbar". #
# There is no Maya command for objects of type
QMainWindowLayout. #
# Executing: import maya.cmds as cmds;cmds.button
('MayaWindow|ar_conePtrWindow|centralwidget|pushButton',
e=True,command=AR_QtConePtrWindow.use.createBtnCmd) #
# There is no Maya command for objects of type Taction. #
# There is no Maya command for objects of type QmayaDragManager. #
# There is no Maya command for objects of type QHBoxLayout. #
# Result: MayaWindow|ar_conePtrWindow|centralwidget|
pushButton #
```

Note also that it is not a requirement to test for the existence of the window
and delete it with the `deleteUI` command. Unlike the `window` command,
the `loadUI` command will automatically increment the created window's
name if there is a conflict, much like naming **transform** nodes.

Another interesting option for loading a Qt interface into Maya is to set the
`uiString` flag instead of the `uiFile` flag when calling the `loadUI` com-
mand. The `uiString` flag allows you to embed the XML code contained
in a .ui file directly into a Maya script as a string. This feature allows
you to eliminate the requirement of deploying additional .ui files in your

pipeline. Nevertheless, you should always keep your .ui files around some-where in case you want to make changes later! If you opened your .ui file in a text editor and copied its contents, you could paste them into a `loadUI` call like the following alternative example.

```
self.window = cmds.loadUI(
    uiString= \
r''' # Paste your XML code here
''',
    verbose=verbose
);
```

Since the XML code will be too long to store in one variable, you need to use the correct syntax for wrapping text in Python. To wrap text, use the triple-double-quotation-mark syntax. Note also that we have used the **r** pre-fix to indicate that this variable stores a raw string. Refer to Chapter 2 if you need a refresher on this syntax.

Before proceeding, it is worth reiterating that our cache, **use**, only needs to be initialized before the `loadUI` command is called, as its invocation will trigger the button's association with the method immediately. Thereafter, we need not be concerned with the fact that **use** will be reassigned if another instance of the GUI were loaded. Recall our discussion on Python's data model in Chapter 2. The pointer to the button's callback method for the first instance of the GUI class will still be pointing to the same item in memory (the method on the first instance), rather than to the method on the item to which the cache happens to be pointing when the control's command is invoked. Consequently, multiple instances of this window will not interfere with one another, since each will point to its own method when it is created.

Accessing Values on Controls

Finally, let's look at the method that is actually called when you press the button.

```
def createBtnCmd(self, *args):
    rotation = None;
    try:
        ctrlPath = '|'.join([
            self.window,
            'centralwidget',
            self.rotField]
        );
        rotation = float(
            cmds.textField(
```

```
            ctrlPath,
            q=True, text=True
        )
    );
except: raise;
cone = cmds.polyCone();
cmds.setAttr('%s.rx'%cone[0], 90);
cmds.rotate(0, rotation, 0,
    cone[0],
    relative=True
);
```

The first step is to try to get the rotation value entered in the text field as a float. We accomplish this task by constructing the full path to the text field and querying its value. If you examine the Object Inspector in Qt Designer (upper right corner), you can see the hierarchy of widget names as they will come into Maya, which lets us know that there is a widget called centralWidget between the main window and the text field. The rest of the method simply calls appropriate commands to create and rotate the cone.

2. If you would like to dock your new custom interface, execute the following code.

```
dock = cmds.dockControl(
    allowedArea='all',
    height=cmds.window(win.window, q=True, h=True),
    area='top',
    floating=False,
    label='Docked Cone Pointer Window',
    content=win.window
);
```

While your new GUI fits nicely into Maya, it's also not quite as good as it could be. The text input field is a somewhat clunky way for manipulating this GUI, so another control, such as a dial, may be a more interesting way to manipulate the default rotation value. Unfortunately, the dial is not a built-in Maya type, and so it cannot be directly accessed via commands to read its value. Fortunately, as we noted earlier, Qt provides a mechanism for solving this problem: signals and slots.

Mapping Widgets with Signals and Slots

While it is worth reading the Qt documentation to fully understand the concept of signals and slots, we cover a basic example here. Recall that we earlier described the process of mapping signals and slots as effectively a more sophisticated callback system. Consequently, we can use this mechanism to pipe the results of controls that are not supported in Maya into ones that

are, which allows us to indirectly query their values with Maya commands in our GUI class's button callback.

3. Return to Qt Designer and drag a **Dial** control into your window next to the **Line Edit** widget. You can find the **Dial** in the Input Widgets section.
4. Set the **objectName** property for the dial to "dialRotation" and set its maximum value to 360 in the **QAbstractSlider** section.
5. Enter Signal/Slot mode by selecting **Edit → Edit Signals/Slots** from the main menu. In this mode, you can no longer move your widgets around on the canvas.
6. Click and drag your dial to the line input and you should see a red arrow appear (as shown in Figure 8.7), as well as a mapping dialog.

In the mapping dialog that appears, the items on the left are different signals that the driving control emits, and the items on the right are the slots to which the signal can connect.

Although we want to map the **valueChanged(int)** signal on the left to a slot that will set the text value of the line edit, there is unfortunately not a slot on the **Line Edit** widget that accepts an integer. We would only be able to perform actions like selecting or clearing the text when the dial rotates, which isn't especially useful. In contrast to using ordinary function pointers with Maya GUI commands, Qt's signal/slot mechanism is type safe, meaning that it will only allow us to link up signals and slots that are sending and receiving the correct types of arguments. Consequently, to pipe an integer into the line edit, we unfortunately need to route the dial through another control.

7. Return to widget mode (**Edit → Edit Widgets**) and add a **Spin Box** widget to your canvas. Set its **maximum** property in the **QSpinBox** section to 360 as well.

■ **FIGURE 8.7** Connecting a dial control to a line input in Qt Designer.

8. Return to Signal/Slot mode (**Edit → Edit Signals/Slots**) and drag the dial onto the spin box. Select the **valueChanged(int)** signal on the dial, and the **setValue(int)** slot on the spin box, and press OK. Now the dial will update the spin box.

9. Drag the spin box onto the **Line Edit** widget. Select **valueChanged (QString)** on the spin box as the signal, and **setText(QString)** on the line edit as the slot, and press OK. Now, when the value of the spin box is changed, it will be passed to the **Line Edit** widget as a string.

10. Because the spin box is simply there to perform a conversion for you, you probably do not want it cluttering up your GUI. Scale it to a small size and move it over your dial so it fits entirely within the dial. Right-click and select **Send To Back** from the context menu to hide the spin box behind the dial.

11. Return to Maya and execute the following code to create a new instance of your window.

```
win = AR_QtConePtrWindow(
    os.path.join(
        os.getenv('HOME'),
        'cone.ui'
    )
);
win.create(verbose=True);
```

You can now manipulate the dial control to alter the *y*-rotation value in your GUI, which you may find more intuitive. Using signals and slots, you have also ensured that when a user manipulates the dial control, the value passed to the text field will contain a numeric value (Figure 8.8).

■ **FIGURE 8.8** Using signals and slots allows you to integrate nonstandard GUI controls, such as dials, into Qt-based interfaces.

You could probably envision more useful applications of controls such as these to interactively manipulate character or vehicle rigs. Feel free to experiment and get creative with your GUIs as you explore the other widgets available in Qt!

PyQt

Up to this point we have focused on Maya 2011 and later, as Qt is seamlessly integrated into its GUI. However, since the `loadUI` command is not available in earlier versions of Maya, developers need another mechanism if they wish to support Qt-based GUIs in earlier versions of Maya. Fortunately, there is a command-line utility called pyuic4 that allows you to convert Qt Designer files into Python code that you can access in any Python interpreter. To access this tool, however, you must build a set of bindings, such as PyQt or PySide.

As the name suggests, PyQt is a combination of the Python Language and the Qt GUI toolkit. More specifically, PyQt is a set of Python bindings for the Qt GUI toolkit. Because it is built using Qt, PyQt is cross-platform, so your PyQt scripts will successfully run on Windows, OS X, and Linux. PyQt combines all the advantages of Qt and Python, and allows you to leverage all of the knowledge you have gained using Python in Maya.

Installing PyQt

The first step for building PyQt is to download all of the Qt header files as we described when installing the Qt SDK. Thereafter, you can download source code for the PyQt bindings online at *http://www.riverbankcomputing.co.uk/software*.

Once you have these required files, installing and building PyQt is a two-step process. First, you must download, install, and build the sip module. The sip module allows you to create bindings to items in the Qt C++ library. It creates what are called *wrappers*, which allow you to map Python functions and classes to corresponding items in the compiled C++ libraries. The Maya API is automatically available via a similar utility called SWIG, which we will discuss in Chapter 9. Second, you must download, install, and build the PyQt module. The PyQt module allows you to access all the classes and functions for creating Qt windows. When you have acquired the sip and PyQt modules, place them in your appropriate site-packages directory based on your operating system:

- **Windows:** C:\Program Files\Autodesk\Maya<version>\Python\lib\site-packages

- **OS X:** /Applications/Autodesk/maya<version>/Maya.app/Contents/
 Frameworks/Python.framework/Versions/Current/lib/python<version>/
 site-packages
- **Linux:** /usr/autodesk/maya/lib/python<version>/site-packages

For Maya, you will be using the Python bindings PyQt4, which are compatible with version 4.x of the Qt GUI toolkit. Unfortunately, you must build PyQt yourself. Because there are different platform installation and build instructions, you should refer to the companion web site to get the most up-to-date information. Note that PyQt is not licensed under LGPL, so these built-in modules cannot be freely distributed. PySide offers parallel functionality and different licensing terms, so you may investigate it if you require the added flexibility.

The PyQt bindings that you build are provided as a set of modules, which contain almost 700 classes and over 6,000 functions and methods that map nicely to the Qt GUI toolkit. Anything that can be done in the Qt GUI toolkit can be accomplished in PyQt.

Using PyQt in Maya 2011+

In addition to enabling the use of Qt in your Python tools, Maya 2011 and later contain support for Qt in the Maya API. Although we discuss the API in more detail starting in Chapter 9, it is worth covering a brief example here.

There are two main modules in PyQt that you need to import when implementing it in your own scripts: QtCore and QtGui. The QtCore module allows you to access the core, non-GUI-related Qt classes, such as Qt's signal and slot mechanism and the event loop. The second module, QtGui, contains most of the GUI classes. Additionally, you must import two other modules: sip and OpenMayaUI. You will be familiar with sip from the build process of PyQt: This module is required to map C++ objects to Python objects. You must also import the OpenMayaUI module, which is an API module for working with the Maya GUI. We will be covering the Maya API generally in all of the following chapters of this book. Your **import** statements should contain the following lines when creating PyQt scripts.

```
from PyQt4 import QtCore;
from PyQt4 import QtGui;
import sip;
import maya.OpenMayaUI as omui;
```

Now we can take a look at some PyQt code to create a window inside of Maya. Autodesk recommends that the safest way to work with Qt from within Maya

is to create your own PyQt windows rather than manipulating the existing Maya interface, which can leave Maya unstable. Following this guideline, we offer code here for a window that will act as a template for creating any GUIs inside of Maya. You can reuse this code over and over again to create custom PyQt windows inside of Maya. Based on our window class example in Chapter 7, it should be clear how you could use this template.

```python
def getMayaMainWindow():
    accessMainWindow = omui.MQtUtil.mainWindow();
    return sip.wrapinstance(
        long(accessMainWindow),
        QtCore.QObject
    );
class PyQtMayaWindow(QtGui.QMainWindow):
    def __init__(
        self,
        parent=getMayaMainWindow(),
        uniqueHandle='PyQtWindow'
    ):
        QtGui.QMainWindow.__init__(self, parent);
        self.setWindowTitle('PyQt Window');
        self.setObjectName(uniqueHandle);
        self.resize(400, 200);
        self.setWindow();
    def setWindow(self):
        # add PyQt window controls here in inherited classes
        pass;
```

In Maya 2011 and later, there is an API class called **MQtUtil**, which is a utility class to work with Qt inside of Maya. This class has some helpful functions to access the Qt layer underneath the Maya GUI commands layer. We use this class inside of our helper function, **getMayaMainWindow()**, to get a handle to the Maya main window using the **mainWindow()** method. Because you will learn more about working with the Maya API in later chapters, you can merely think of this call as a required step for the time being. We then use the sip module's **wrapinstance()** function to return the reference to the main window as a **QObject**, which is Qt's core object type.

We define our custom window in a **PyQtMayaWindow** class, which inherits from Qt's **QMainWindow** class. In our **PyQtWindow** class's __**init**__() method, we use our helper function to set the main Maya window as the default parent when calling __**init**__() on the base class. We want to make PyQt windows children of the main Maya window because we do not want them to be separate from Maya (and thus be treated by the operating

system as though they were separate application windows). We then set the window's title and size and call the **setWindow()** method, which subclasses can override to display any desired controls, or to change the default window title, object name, and size.

When inheriting from this class and overriding the **setWindow()** method, it is advisable to plan the GUI on paper to save time positioning controls, because the window will be defined programmatically. Refer to the PyQt Class Reference Documentation for the specific classes and functions needed to create your widgets and controls, or use the pyuic4 tool in conjunction with Qt Designer to rapidly create your GUI and get right into adding functionality to it.

To create the window specified in this class, simply create an instance of it.

```
pyQtWindow = PyQtMayaWindow();
pyQtWindow.show();
```

Using PyQt in Earlier Versions of Maya

If you are not working in Maya 2011 or later, but are still very interested in the potential of what PyQt scripts can add to your existing tools, you are still able to run your PyQt scripts in an earlier version even though it lacks the Qt-related classes in the API. Although we cannot go into all of the specifics, Autodesk fortunately provides PDF documents with instructions in the following locations to take advantage of PyQt technology in earlier versions of Maya:

- **Windows:** Program Files\Autodesk\Maya<version>\devkit\other\PyQt Scripts
- **OS X:** /Applications/Autodesk/maya<version>/devkit/devkit/other/PyQt Scripts/
- **Linux:** /usr/autodesk/maya<version>/devkit/other/PyQtScripts/

CONCLUDING REMARKS

Equipped with a better understanding of Qt and Maya, as well as some Qt tools and PyQt, you now have the skill set to take GUI design to the next level. Qt does a nice job of catering to a variety of users. Depending on your preferences, you may like the additional level of control that code provides, making PyQt a great fit for you. On the other hand, if you excel when working with visual tools, then Qt Designer will be your tool of choice.

Information on Qt and GUI design could occupy many volumes worth of knowledge, which is why we have covered only the crucial concepts required to work with Qt in Maya. If this chapter has piqued your interest in Qt, we recommend picking up some additional resources to continue on your learning path. The companion web site offers links to books and web sites where you can find information on working with Qt, designing GUIs in general, and working with Qt Designer and Maya.

Part 3

Maya Python API Fundamentals

Understanding C++ and the API Documentation

BY THE END OF THIS CHAPTER, YOU WILL BE ABLE TO:

- Define what the Maya API is.

- Explain how the Maya API uses virtual functions and polymorphism.

- Describe the organization of the Maya API.

- Understand the difference between data objects and function sets.

- Define what SWIG is.

- Navigate the Maya API documentation.

■ Identify what API functionality is accessible to Python.

■ Compare and contrast Python and C++ in the API.

Armed with an understanding of Python and familiarity with the cmds module, you have many new doors open to you. In addition to being able to access all of the functionality available in MEL, you can also architect completely new classes to create complex behaviors. However, these new tools only scratch the tip of a much larger iceberg. In addition to the basic modules examined so far, Maya also implements a set of modules that allow developers to utilize the Maya API via Python.[1] These modules include:

■ OpenMaya.py
■ OpenMayaAnim.py
■ OpenMayaRender.py
■ OpenMayaFX.py
■ OpenMayaUI.py
■ OpenMayaMPx.py
■ OpenMayaCloth.py[2]

The specifics of some of these modules are discussed in greater detail throughout the following chapters. For now, let's take a step back and discuss what the Maya API is more generally before using it in Python. If you are relatively new to software and tools development, you might be wondering what exactly the Maya API is in the first place.

The Maya API (short for application programming interface) is an abstract layer that allows software developers to communicate with the core

[1]Note that Maya 2012 Hotfix 1 introduced the Python API 2.0 in the maya.api module. This module contains a mostly parallel structure of extension modules (e.g., maya.api. OpenMaya, maya.api.OpenMayaAnim, and so on). The advantage of the Python API 2.0 is that it is often faster, eliminates some of the complexities of working with the API, and allows use of Pythonic features with API objects, such as slicing on API objects. While the new and old API can be used alongside each other, their objects cannot be intermixed (you cannot pass an old API object to a new API function). Nevertheless, they have the same classes and so learning with the old API is not disadvantageous. Because the new Python API is still in progress, and because it is only supported in the latest versions of Maya, all of our API examples in this book are written using the ordinary API modules. Refer to the Python API 2.0 documentation or the companion web site for more information on the Python API 2.0.

[2]The OpenMayaCloth.py module is for working with classic Maya cloth, and has become deprecated in favor of the newer nCloth system (introduced in Maya 8.5). The nCloth system is part of Maya Nucleus, which is accessed by means of the OpenMayaFX.py module. Consequently, you will generally not use the OpenMayaCloth.py module unless you are supporting legacy technology that has been built around the classic Maya cloth system.

functionality of Maya using a limited set of interfaces. In other words, the API is a communication pathway between a software developer and Maya's core. What exactly does this mean, though? How does the API differ from the scripting interfaces we have discussed so far?

Although Python scripts for Maya are very powerful, they still only interface with the program at a very superficial level when not using the API. If you recall the architecture we discussed in Chapter 1, the Command Engine is the user's principal gateway into Maya for most operations. Thus, Python scripts that only use the cmds module essentially allow us to replicate or automate user behavior that can otherwise be achieved by manually manipulating controls in Maya's GUI. However, programming with the API directly enables the creation of entirely new functionality that is either unavailable or too computationally intensive for ordinary scripts using only cmds. Using the API modules, you can create your own commands, DG nodes, deformers, manipulators, and a host of other useful features (Figure 9.1).

The trouble for Python developers, however, is that the API is written in C++. Although you don't have to be a C++ programmer to use the API, it is still important to have some understanding of the language to effectively read the API documentation. In this chapter, we will first revisit some concepts of object-oriented programming to examine the structure of the Maya API and understand how Python communicates with it. Thereafter, we will take a short tour of the API documentation. The chapter concludes with a brief section detailing some important differences between Python and C++ with respect to the Maya API.

■ **FIGURE 9.1** Using Python to access the Maya API offers richer interfaces with Maya's application core.

ADVANCED TOPICS IN OBJECT-ORIENTED PROGRAMMING

Before delving too deeply into Maya's API structure, we must briefly discuss a couple of advanced topics in OOP that we did not detail in Chapter 5. Because the Maya API is written in C++, a statically typed language, it makes use of some features that may not be immediately obvious to programmers whose OOP experiences are limited to Python.

Inheritance

As we discussed in Chapter 5, OOP fundamentally consists of complex objects that contain both data and functionality, and that may inherit some or all of these properties from each other. For instance, a program may have a base class called **Character** with some common properties and functionality necessary for all characters (Figure 9.2). These properties may include **health** and **speed**, as well as a **move()** method. Because there may be a variety of different types of characters—**Human**, **Dragon**, and **Toad**—each of these characters will likely require its own further properties or its own special methods not shared with the others. The **Human** may have a **useTool()** method, the **Dragon** a **breatheFire()** method, and the **Toad** a **ribbit()** method. Moreover, each of these classes

■ **FIGURE 9.2** An example object hierarchy.

may have further descendant classes (e.g., **Human** may break down into **Programmer**, **Mechanic**, and **Doctor**).

Virtual Functions and Polymorphism

In a language like C++, the **Character** class in our present example contains what is referred to as a virtual function for **move()**. As far as Python developers need to be concerned, a *virtual function* is basically a default behavior for all objects of a certain basic type, which is intended to be overridden in child classes with more specific types. While a language like Python inherently incorporates this principle, C++ must explicitly specify that a method is virtual. Considering this concept in the present example, the **move()** method would be overridden in each descendent class, such that it may contain logic for walking for a **Human**, while a **Dragon** character's **move()** method may implement logic for flying.

Thus, using virtual functions in this fashion allows a programmer to operate with a single object as multiple different types based on the abstraction level at which it is being manipulated. The technique is referred to as *polymorphism*. Again, while Python permits this technique with relative ease, it is something that a language like C++ must manually specify. The ultimate consequence, however, is that a function can be made to work with different types of objects, and can be invoked at different abstraction levels. A hypothetical Python example can help illustrate this point.

```
# create some characters
kratos = Character();
nathan = Human();
smaug = Dragon();
kermit = Toad();
# add the characters to a list
characters = [kratos, nathan, smaug, kermit];
# make all of the characters move
for character in characters: character.move();
```

Although each of the objects in the characters list is constructed as a different specific type, we can treat them all as equals inside of the iterator when calling the **move()** method. As you will soon see, understanding this technique is especially important when using the Maya API.

STRUCTURE OF THE MAYA API

While the Maya API makes use of techniques like polymorphism, it also generally adheres to an important design philosophy. Recalling Maya's program architecture (see Figure 9.1), the Maya API fundamentally consists of a

set of classes that allow developers to *indirectly* interface with Maya's core data. It is important to emphasize that the API does *NOT* permit direct access to these data existing in the core framework. *Maya maintains control over its core data at all times.*[3] Therefore, Autodesk engineers developing Maya can theoretically make dramatic changes to the application's core from one version to the next without worrying too much about whether any custom tools will still comply.

Because developers interface only with the API, which changes comparatively little and communicates with the core on their behalf, they do not need to worry about the core's structure. Likewise, they are protected from errors that may cause critical dysfunction, as the API acts as a communication filter. However, these particular facts lend themselves to an API class hierarchy that may not be immediately intuitive. Specifically, developers are generally only given access to a primary API base class: **MObject**.

Introducing Maya's Core Object Class: MObject

While we could directly interact with objects in descendant classes in the previous hypothetical examples, Maya only allows developers to interact with an **MObject** when working with complex data.[4] The **MObject** class knows about the whole data hierarchy inside of Maya's core, and so it is able to locate the proper functionality when developers ask an object to do something.

It is important to note, however, that **MObject** is not an actual data object within Maya's core. You are not allowed direct access to those objects! Rather, **MObject** is simply a pointer to some object in the core. Creating or deleting an **MObject**, then, leaves the actual data object inside the core untouched. Following this paradigm, internal data such as attributes, DG nodes, meshes, and so on are accessed by means of an **MObject**.

At this point in our discussion, a new question naturally arises. Namely, if developers only have access to a single base class, how can they access functionality in descendent classes?

[3]Technically speaking, there are some cases where the Maya API does in fact provide direct access to data in the core, typically only where needed to improve performance and only when there is no risk of adversely affecting them. However, these cases are not documented for developers and are not important to know as a practical matter. Consequently, the philosophy of the API still holds as a general rule as far as developers need to be concerned.

[4]Some basic types are directly accessible in the API, such as **MAngle**, **MDataHandle**, **MTime**, etc.

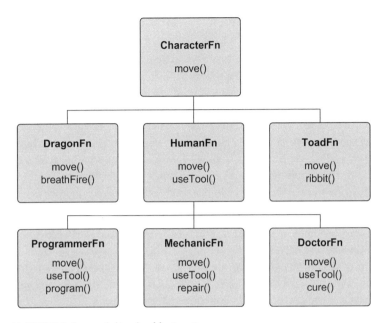

■ **FIGURE 9.3** An example hierarchy of function sets.

Manipulating MObjects Using Function Sets

Following its overarching design philosophy, the Maya API implements separate classes for data objects and their corresponding function sets. While a *data object* contains all of an object's properties, a *function set* is a special type of class that acts as an interface for calling methods associated with particular types of objects.

If we were to apply this paradigm to the previous hypothetical example, there would be not only a **Character** class, but also an associated class, **CharacterFn**, containing a **move()** method. This class would have further descendants implementing the children's functionality—**HumanFn**, **DragonFn**, and **ToadFn**. (See Figure 9.3.)

Because the Maya API makes use of polymorphism, these function sets can operate on different types of data. Consider the following hypothetical example using our character scenario.

```
# create a human
human = Human();
# instantiate the CharacterFn function set
charFn = CharacterFn();
# tell the instance of the function set to operate on the human
charFn.setObject(human);
```

```
# tell the human to move
charFn.move();
```

In this instance, polymorphism allows a **CharacterFn** object to interact with any objects in descendant classes, such as a **Human** in this case. *The key here is to remember that we are not directly accessing the data!* Because of the programming features that the Maya API has implemented, what we are really doing is asking the human object to perform its implementation of **move()** itself, rather than some implementation within **CharacterFn**. Because **move()** is a virtual function defined in **Character**, its behavior has been overridden in the **Human** class, which is the behavior that will ultimately be invoked in this case due to the type specified when the human object was created.

Thus, Maya implements classes such as **MFnAttribute**, **MFnDependency Node**, and **MFnMesh** to operate on attributes, DG nodes, and meshes, respectively. Although each of these types of objects is opaque to developers, you can supply any of these function sets with an **MObject** and call functionality as needed at the appropriate abstraction level.

Now that we have discussed the basics of how the API is structured, we can move on to another important question. Namely, if the Maya API is written in C++, how can we use it with Python?

HOW PYTHON COMMUNICATES WITH THE MAYA API

As noted earlier in this chapter, the Maya API is architected in C++. Because of this, we need some means of interacting with the API using Python.

To solve this problem, Autodesk has used a technology called Simplified Wrapper and Interface Generator, or simply SWIG for short.[5] SWIG is able to automatically generate bindings directly to the C++ code if it is written in a certain way. In essence, when Autodesk introduced Python formally in Maya 8.5, a central task to create the OpenMaya modules was to simply restructure the C++ API header files to allow SWIG to work. The advantage of this approach is that the Python modules will automatically benefit from improvements in the C++ API with each new version and require minimal additional investment to produce. The disadvantage to this approach—at least at the time of this writing—is that not all of the C++

[5]Python API 2.0 is not generated via SWIG, and many of its methods have been reworked from the ground up to return data differently, which is why it eliminates the use of **MScriptUtil**. See note 1.

API functionality is accessible to Python. Fortunately, however, it is fairly clear what you can and cannot do in Python, as we will examine in further detail in the next section.

If you're in Maya, try entering the following example into your Script Editor window to see SWIG in action.

```
import maya.OpenMaya as om;
vec = om.MVector();
print(vec);
```

You can see from the output that the vector is a special type, and not simply a tuple or list.

```
"<maya.OpenMaya.MVector; proxy of <Swig Object of type
'MVector *' at [some memory address]> >"
```

It is important to emphasize here that using API functionality in Python is simply calling an equivalent C++ API method. As a general rule, this process tends to be relatively fast for most simple operations, but can induce a substantial performance penalty in situations that involve complex or numerous API calls. Each time an API call is made, Python's parameters must be converted into something that C++ can understand, and the C++ result must respectively be translated back into something that Python understands.

The fact that Python is interpreted also introduces a minimal speed penalty, but the communication between Python and C++ ultimately tends to be the largest contributor to performance problems in complex tools.[6] As such, there are some methods included in the API (with more being constantly added) that allow large amounts of data to be obtained from C++ or given back to C++ with a minimal function call overhead.[7] In such cases, especially when working on meshes, there is less overhead to pull all of the data at once, operate on it in Python, and then give it all back to C++ afterward. Consequently, C++ may still ultimately be the best option for extremely computationally intensive tasks or simulations, though Python will almost certainly always be the fastest means of prototyping in the API.

The fact that the API is written in C++ has one further consequence as far as Python developers are concerned: The API documentation is in C++.

[6]Edmonds, D. (2008). Advanced Maya Python. Presented at Autodesk Maya Developer's Conference, 2008, Scottsdale, AZ.
[7]This issue is why the example in this book's Introduction chapter used the **MItGeometry. setAllPositions()** method, for example.

As a result, you need to know a little bit of C++ to clearly understand how to use API functionality with Python.

HOW TO READ THE API DOCUMENTATION

When you need to know how to do something with the Maya API, the documentation is always the most important source of information. Being able to navigate the Maya API documents will allow you to work far more efficiently. Although this text does not attempt to teach C++ in great detail, we will identify and define some common terms that appear in the API documents to help reduce confusion.

To find API documentation, there are two basic options. The first option is to open Maya's HTML help documents, either from Maya's menu (**Help → Maya Help**) or on the Web.[8] The second option is to navigate to the actual C++ header files manually. Each file corresponds to a class in the API (e.g., MVector.h contains definitions for the **MVector** class). You can find these files in the following locations based on your operating system:

■ **Windows:** Program Files\Autodesk\Maya<version>\include\maya\
■ **OS X:** /Applications/Autodesk/maya<version>/devkit/include/maya/
■ **Linux:** /usr/autodesk/maya<version>-x64/include/maya

In most cases, the HTML documentation will be the easiest method of finding help, as it is more thoroughly commented, easy to browse, and does not require the depth of C++ knowledge necessary to make sense of the header files. Unfortunately, however, depending on your version of Maya, the HTML help documents may not always be 100% accurate or complete. Many times, if you come across something that does not appear to be working as it should, a good first step in troubleshooting is to look at the actual header file in question and make sure it reflects what you see in the HTML documentation.[9] This test is useful because the header files are exactly what the C++ API uses. For now, however, we will focus on the HTML documentation, as it is generally the best source of information overall.

If you open the HTML help and scroll to the bottom of the table of contents in the left menu, depending on what version of Maya you are using, there is

[8]Visit the Autodesk web site at *http://www.autodesk.com* to find these documents.
[9]Autodesk used a technology called doxygen to generate the newer versions of the documentation. Because doxygen requires that code be specially formatted to be correctly parsed, some API methods may seem to have disappeared in version 2009. Checking the actual header files confirms, however, that they still exist, and were simply not parsed out correctly. See, for instance, **MFnMesh::getUVShellsIds()**.

either an "API" link or a "Technical Documentation" section containing an "API reference" link. The pages for Maya 8.5 and 2008 share many commonalities, while 2009 was completely reformatted. The structures of each version are slightly different and worth briefly reviewing.

In Maya 8.5 and 2008, by default, there is a list of all of the API classes (Figure 9.4). At the top, you can click a link to browse by hierarchy or stay in the view containing all classes. In this view, everything is sorted alphabetically, with options in the header to search by first letter in the top right or by substring just underneath and to the left. The alphabetical search list is further split by category, with all M classes on top and MFn (function set) classes underneath.

In the main view of the page are links to each individual class. Each link also has a basic description of what the class is, as well as a parenthetical notation of which Python module allows access to the class. If you click on a link to a class, you are given a list of all of its members (data attributes) and methods, as well as descriptions of what they do.

The documentation for versions of Maya 2009 and later contains tabs in the header for navigating (Figure 9.5). As there is both a "Modules" tab

■ **FIGURE 9.4** The API documentation for Maya 2008.

■ **FIGURE 9.5** The API documentation for Maya 2009.

and a "Classes" tab, you can navigate for information using either option. Clicking the "Modules" tab displays a list of all the Maya Python API modules. Clicking the name of one of these modules brings up a list of all API classes that are wrapped in it with a partial description of the class.

Clicking the "Classes" tab displays a browser that is more similar to the documentation in Maya 8.5 and 2008. At the top is a list of tabs that allow you to view the classes as an unannotated alphabetical list ("Alphabetical List"), an annotated alphabetical list ("Class List"), a hierarchically sorted alphabetical list ("Class Hierarchy"), or to see an alphabetical list of all class members with links to the classes in which they exist ("Class Members"). The "Class Members" section lets you further narrow your search by filtering on the basis of only variables, only functions, and so on. Now that we have discussed how to find the API classes, let's walk through an example to see some common terminology.

Whichever version of the Maya documentation you are using, navigate to the **MVector** class and click its link to open its page (Figure 9.6). At the top, you will see a brief description telling you what the **MVector** class

■ **FIGURE 9.6** The API documentation for the **MVector** class.

does: "A vector math class for vectors of doubles." Immediately below this description is a list of public types and public members.

The first item in this list is an enumerator called **Axis**. The **Axis** enumerator has four possible values: **kXAxis**, **kYAxis**, **kZAxis**, and **kWAxis**. Enumerators such as these are typically included in basic classes and are often required as arguments for some versions of methods (more on this later). Enumerated types preceded with the letter **k** in this fashion typically represent static constants (and are thus accessed similar to class attributes in Python). Execute the following code in a Python tab in the Script Editor.

```
import maya.OpenMaya as om;
print('X-Axis: %s'%om.MVector.kXaxis);
print('Y-Axis: %s'%om.MVector.kYaxis);
print('Z-Axis: %s'%om.MVector.kZaxis);
print('W-Axis: %s'%om.MVector.kWaxis);
```

As you can see, the value of each of these enumerators is an integer representing the axis in question, rather than an actual vector value.

```
X-Axis: 0
Y-Axis: 1
```

```
Z-Axis: 2
W-Axis: 3
```

Consequently, you are also able to test and set enumerator values in code using an integer rather than the name for the enumerator. Such shorthand is typically not recommended, however, as it makes the code harder to read later than does simply using logical names.

After this enumerator, the next several functions are constructors. These functions are all called **MVector()** and take a variety of arguments (see Figure 9.6). In C++, a function with a single name can be overloaded to work with different types of data or values as well as with different numbers of arguments. **MVector** has seven different constructor options, depending on what type of data you want to give it. The first constructor, **MVector()**, is the default constructor taking no arguments. This will initialize the members of the **MVector** object to their default values.

The second, third, fourth, and fifth constructors—**MVector (const MVector &)**, **MVector (const MFloatPoint &)**, **MVector (const MFloatVector &)**, and **MVector (const MPoint &)**—all follow a common pattern. Namely, they create a new **MVector** object and initialize its *x*, *y*, *z*, and *w* values from some other object's corresponding members. In our effort to understand C++, we should note two common features of these constructors: first, each argument is prefixed by the keyword **const**, and second, each argument is suffixed by an ampersand (**&**).

The **&** symbol means that the object is passed by reference; you can think of the **&** symbol as standing for "address of" something. This symbol is given because C++ programmers have the option to pass parameters by value or by reference. Passing an item by reference means that the caller and the method share the same copy of the data in memory. Passing by reference reduces runtime and memory overhead for complex types by eliminating the need to copy the data before passing it to the method. It also means that changes made to the data by the method will be visible to the caller (like mutable objects in Python).

The keyword **const** is short for "constant." It indicates that the method will only read the value and not modify it. If a parameter that is passed by reference is also marked as **const,** it is effectively the same as if the parameter were being passed by value, except that it is more efficient because the data are not copied.

Although Python does not use the same terminology, class types in Python are effectively passed by reference, while simple types are passed by value. Therefore, if a Maya API method specifies a parameter of a class type, such

as **MVector**, you can simply pass the value normally, as you would to any other Python method. It does not matter whether the method wants the parameter to be passed by reference or has it marked as **const**; the SWIG interface layer will take care of getting it to the API method correctly.

As we will soon see, however, the situation is a bit more complicated when working with simple, mutable data types. If an API method requests that a parameter of a simple type be passed by value (i.e., the parameter does not have the **&** qualifier), then you can just pass the value normally since Python natively passes simple types by value. Similarly, as noted earlier, a parameter that is both **const** and passed by reference is effectively the same as passing by value, so once again you can simply pass an item normally in such cases.

A problem arises, however, when an API method indicates that it wants a parameter of a simple type to be passed by reference but does not mark it as **const**. Such methods intend to change the value of that parameter and want the new value to also be reflected in the calling context. The SWIG interface layer unfortunately cannot work around this situation automatically because there is no mechanism built into Python for doing so. Instead, the Maya API provides a special class called **MScriptUtil** to work around these situations. We will soon see examples of this class in action.

The sixth constructor, **MVector (double xx, double yy, double zz = 0.0)**, creates a new **MVector** object with initial x, y, and z values corresponding to the three doubles passed in. The **double** data type in C++ is a decimal number with double precision. While a standard floating-point number (**float** type) requires 32 bits in memory, a double requires twice as much: 64 bits.[10] The equals sign (=) after the **zz** parameter indicates that this argument is optional and will assume the default value shown if nothing is supplied (just like a keyword argument in a Python definition). In this way, an **MVector** can be initialized with only two doubles using this constructor, which will be its initial x and y values, while its z will be the default 0.0.

The seventh and final constructor, **MVector (const double d[3])**, creates a new **MVector** object and initializes its x, y, and z values to the elements in

[10]Compare the **MFloatVector** class to the **MVector** class, for example. **MFloatVector** has essentially the same functionality, yet is composed of floats rather than doubles. Because floats allocate less memory, they are therefore suited to tasks where performance is more critical than precision. Floats are the most common decimal format used in real-time videogame applications.

the double array being passed in. The square brackets ([]) indicate that the data are an array with the length given inside of them. This parameter is not suffixed with the **&** symbol, which means that the array itself is not passed by reference. However, the *elements* of an array parameter in C++ are always effectively passed by reference. As we mentioned earlier, a parameter of a simple type that is passed by reference requires special handling, unless it is also marked as **const**. We have **const** in this case, so you may assume that should allow us to just pass in a Python list containing three decimal values.

```
import maya.OpenMaya as om;
doubleList = [1.0, 2.0, 3.0];
vec = om.MVector(doubleList);
```

Unfortunately, this approach results in an error message.

```
# Error: NotImplementedError: Wrong number of arguments for
overloaded function 'new_MVector'.
Possible C/C++ prototypes are:
MVector()
MVector(MVector const &)
MVector(MFloatPoint const &)
MVector(MFloatVector const &)
MVector(MPoint const &)
MVector(double,double,double)
MVector(double const [3]) #
```

Depending on what version of Maya you are using, you may see an error message like the following output instead.

```
# Error: TypeError: in method 'new_MVector', argument 1 of type
'double const [3]' #
```

Although our logic was sound in this case, the API's SWIG layer is not smart enough (as of Maya 2012) to make the conversion where arrays are concerned. This situation thus requires Maya's special **MScriptUtil** class, as in the following example.

```
import maya.OpenMaya as om;
# create a double array dummy object
doubleArray = om.MScriptUtil();
# populate the dummy with data from a list
doubleArray.createFromList([1.0, 2.0, 3.0], 3);
# create the vector by passing a pointer to the dummy
vec = om.MVector(doubleArray.asDoublePtr());
print('(%s, %s, %s)'%(vec.x, vec.y, vec.z));
```

You should see the value (1.0, 2.0, 3.0) printed to confirm that the vector was correctly created.

The **MScriptUtil** class is a handy, but somewhat confusing, way of interfacing with the API where it requires special representations of data that Python does not implement. Specifically, because Python always passes simple data types by value, a special tool is needed when the API requires arrays, pointers, or references of simple types like integers and decimals. The **MScriptUtil** class is briefly explained in more detail in the final section of this chapter, and explored in-depth on the companion web site.

At the end of the **MVector** class's list of constructors is also a destructor, prefixed with the tilde character (~). C++ uses functions like this one to deallocate memory when an object is deleted (just like the built-in **__del__**() method for class objects in Python). As mentioned in Chapter 2, however, Python handles memory management and garbage collection on its own. Consequently, manual deallocation is not strictly necessary, and may often only be beneficial in situations for which C++ is better suited than Python anyway.

Next, you should see a set of 18 items prefixed with **operator** followed by some symbol. These are operator overloads for the **MVector** class. Many of these symbols are normally reserved for working with basic data types like numbers and lists. However, they have been overridden for this class, meaning that they are available for shorthand use. Consider the following example.

```python
import maya.OpenMaya as om;
vec1 = om.MVector(1.0, 0.0, 0.0);
vec2 = om.MVector(0.0, 1.0, 0.0);
# without operator overloading, you would have to add manually
vec3 = om.MVector(vec1.x + vec2.x, vec1.y + vec2.y, vec1.z +
vec2.z);
# with operator overloading, you can add the objects themselves
vec4 = vec1 + vec2;
# confirm that the results are the same
print('vec3: (%s, %s, %s)'%(vec3.x, vec3.y, vec3.z));
print('vec4: (%s, %s, %s)'%(vec4.x, vec4.y, vec4.z));
```

You should see from the output that both addition approaches produce the same result, but the overloaded operator is obviously preferable.

Operator overloading can also offer the advantage of bypassing the requirement of typing out method names for common operations. For instance, note that there are overloads for **operator^ (const MVector & right) const** and **operator* (const MVector & right) const**, which allow for quickly computing the cross-product and dot-product, respectively. A number of these overloads are also suffixed with the **const** keyword. When **const** appears at the end of a function declaration, it indicates that the function will not change any of the object's members. Note, in contrast, that the

in-place operators (e.g., **+=**, **-=**, ***=**, **/=**) do not have the trailing **const** keyword, as they will in fact alter the object's members. (Note that Python also allows a similar technique, as discussed in section 3.4.8 of the Python Language Reference.)

The next items in the **MVector** class are five different versions of the **rotateBy()** method, which rotates a vector by some angle and returns the rotated vector. Note that you can see the return type (**MVector**) to the left of the function's name. In the detailed description lower in the document, you can also see a double colon preceded by the class name (**MVector:: rotateBy()**). This notation simply indicates that **rotateBy()** is an instance method. The following example illustrates an invocation of the first version, **rotateBy (double x, double y, double z, double w) const**, which rotates the vector by a quaternion given as four doubles.

```
import math;
import maya.OpenMaya as om;
vector = om.MVector(0.0, 0.0, 1.0);
# rotate the vector 90 degrees around the x-axis
halfSin = math.sin(math.radians(90*0.5));
halfCos = math.cos(math.radians(90*0.5));
rotatedVector = vector.rotateBy(halfSin, 0.0, 0.0, halfCos);
# confirm rotated vector is approximately (0.0, -1.0, 0.0)
print(
    '(%s, %s, %s)'%(
        rotatedVector.x,
        rotatedVector.y,
        rotatedVector.z
    )
);
```

As you can see, you simply need to call the **rotatedBy()** method on an instance of an **MVector** object, and the resulting rotated vector will be returned. The second version, **rotateBy (const double rotXYZ[3], MTransformationMatrix::RotationOrder order) const**, rotates the vector using three Euler angles with a given rotation order. The first parameter in this case is a double array, while the second is an enumerator defined in the **MTransformationMatrix** class. Clicking on the enumerator link, you can see that this enumerator can have eight different values: **kInvalid**, **kXYZ**, **kYZX**, **kZXY**, **kXZY**, **kYXZ**, **kZYX**, **kLast**. These enumerators are accessed just like the **Axis** enumerator within the **MVector** class.

```
import maya.OpenMaya as om;
print(om.MTransformationMatrix.kXYZ); # prints 1
```

The third version of the method, **rotateBy (MVector::Axis axis, const double angle) const**, rotates the vector using the axis angle technique.

The first parameter is one of the enumerated axes from the **MVector** class (**kXaxis**, **kYaxis**, or **kZaxis**), and the second parameter is the angle in radians by which to rotate around this axis.

The fourth and fifth versions of this method, **rotateBy (const MQuaternion &) const** and **rotateBy (const MEulerRotation &) const**, rotate the vector using Maya's special objects for storing rotation as either a quaternion or Euler angles, respectively.

The next function in the list is **rotateTo (const MVector &) const**. In contrast to the **rotateBy()** methods, **rotateTo()** returns a quaternion rather than a vector, as indicated by the return type of **MQuaternion**. This quaternion is the angle between the **MVector** calling the method and the **MVector** passed in as an argument.

The **get()** method transfers the *x*, *y*, and *z* components of the **MVector** into a double array. Again, because Python can only pass simple types by value, you must use the **MScriptUtil** class to utilize this method, as in the following example.

```
import maya.OpenMaya as om;
# create a double array big enough to hold at least 3 values
doubleArray = om.MScriptUtil();
doubleArray.createFromDouble(0.0, 0.0, 0.0);
# get a pointer to the array
doubleArrayPtr = doubleArray.asDoublePtr();
# create the vector
vec = om.MVector(1.0, 2.0, 3.0);
# use the get() method to transfer the components into the array
# there is no MStatus in Python, so try-except must be used
instead
try: vec.get(doubleArrayPtr);
except: raise;
# confirm that the values (1.0, 2.0, 3.0) were retrieved
print('(%s, %s, %s)'%(
    doubleArray.getDoubleArrayItem(doubleArrayPtr,0),
    doubleArray.getDoubleArrayItem(doubleArrayPtr,1),
    doubleArray.getDoubleArrayItem(doubleArrayPtr,2)
));
```

As you can see, this method acts on the double-array pointer in-place, rather than returning an array. Instead, the method returns a code from the **MStatus** class. This class, used throughout the API, allows C++ programmers to trap errors. For example, if this call created a problem, it would return the code **kFailure** defined in the **MStatus** class. However, because Python has strong error-trapping built in with **try-except** clauses, the Python API does not implement the **MStatus** class at all. Therefore,

Python programmers must use **try-except** clauses instead of **MStatus** to handle exceptions.

The next method, **length()**, simply returns a decimal number that is the magnitude of the **MVector** object.

The following two methods, **normal()** and **normalize()**, are similar, albeit slightly different. The first, **normal()**, returns an **MVector** that is a normalized copy of the vector on which it is called. The **normalize()** method, on the other hand, returns an **MStatus** code in C++ because it operates on the **MVector** object in-place. Again, nothing in Python actually returns an **MStatus** code since the class is not implemented.

The **angle()** method provides a shortcut for computing the angle (in radians) between the **MVector** from which it is called and another **MVector** supplied as an argument.

The next two methods, **isEquivalent()** and **isParallel()**, provide shortcuts for performing comparison operations between the **MVector** from which they are called and another supplied as an argument within a specified threshold. The former tests both the magnitude and direction of the vectors, while the second compares only the direction. Each method returns a Boolean value, making them useful in comparison operations.

The final method accessible to Python is **transformAsNormal()**, which returns an **MVector** object. While the details in the documentation provide an elegant technical explanation, it suffices to say that the **MVector** this method returns is equivalent to a vector transformed by the nontranslation components (e.g., only rotation, scale, and shear) of the **MMatrix** argument supplied.

The final two items listed are operator overloads for the parenthesis () and square brackets [] characters. You will notice that, in contrast to the similar operators listed earlier, these two operators are listed as having NO SCRIPT SUPPORT. The reason is because, as you can see, each of these two specific operator overloads returns a reference to a decimal number, **& double**, while the two corresponding operators that *are* supported in Python (listed with the math operators) return values. Consequently, the lack of script support does not mean that you cannot use these two symbol sequences at all, but rather that *you cannot use them to acquire a reference to a decimal number*. As discussed earlier, Python always passes simple types by value. Consequently, it has no support for references to simple types. For the purposes of Python programming, you can effectively ignore their lack of compatibility in this case.

KEY DIFFERENCES BETWEEN THE PYTHON AND C++ APIS

As our brief tour of the **MVector** class has shown, there are some various differences between the Python and C++ APIs. Although the Maya documentation provides a list of these items (**Developer Resources → API Guide → Maya Python API → Differences between the C++ Maya API and Maya Python API**), it is worth enumerating them here for the sake of convenience.

MString and MStringArray

The C++ API contains the **MString** and **MStringArray** classes for returning and working with strings. Python's far more robust string implementation and extensive string utilities render this class useless for Python programmers working with the Maya API. As such, anywhere in the API that indicates one of these types is necessary in fact accepts standard Python strings and lists of strings in their places. Because tuples are immutable, however, a tuple of strings may only be used where the **MStringArray** is passed by value or as a **const** reference.

MStatus

As indicated in our discussion of the **MVector** class, the **MStatus** class exists in the C++ API to confirm the success of many operations by returning a status code either as the return value of a function or as one of its parameters. Whereas Python natively incorporates robust exception handling via the **try-except** clause, the **MStatus** class has not been implemented in the Python API at all. Consequently, Python programmers must use **try-except** clauses instead of **MStatus**. Trying to use Python to extract a value from functions that return **MStatus** may actually crash some versions of Maya!

Void* Pointers

The C++ API makes use of void* pointers in various places including messages. Such pointers essentially point to raw memory of an unspecified type, making them ideal for handling different data types if a programmer knows precisely what to expect. Because these pointers are unspecified in C++, any Python object can be passed where a void* pointer is required.

Proxy Classes and Object Ownership

Some scripted objects like custom commands and nodes require the creation of proxy classes (with the MPx prefix). However, these classes must

give control to Maya when they are created to ensure that Python does not accidentally garbage collect an object to which Maya is actively pointing. This process is described in greater detail in Chapters 10 and 12.

Commands with Arguments

As we showed in the first part of the book, Maya commands can accept a variety of arguments. When creating custom commands that support flags and arguments, programmers have a variety of options in the API, such as **MArgList** objects. However, you must use an **MSyntax** object for parsing a command's arguments for its flags to work properly when invoked from the cmds module. *The same is true whether the command is programmed in C++ or Python; flags passed to the command will be lost when an **MArgList** object is used, if the command is invoked from Python.* A command containing no flags can still use an **MArgList** object, as can a command that will only be invoked from MEL. Therefore, it behooves both C++ and Python programmers to avoid **MArgList** if their command has flags and they want it to work from Python. The process of designing a command with custom syntax is described in greater detail in Chapter 10.

Undo

Because Python allows programmers to use the Maya API directly within a script, it is worth noting that doing so is not compatible with Maya's undo mechanism. As such, any scripts that modify the Dependency Graph in any way must be implemented within a scripted command to support undo functionality. Maya's undo and redo mechanisms are described in greater detail in Chapter 10.

MScriptUtil

As mentioned in the discussion of the **MVector** class, Python does not support references to simple types, such as integers and decimals. Imagined through the lens of a language like C++, Python technically passes all parameters by value. While the value of a class object in Python can be imagined as being equivalent to a reference, the same does not apply for simple types, of which the value corresponds to an actual number.

Because simple types are always passed by value as far as SWIG is concerned, it needs a way to extract a reference from these values. This process is accomplished by effectively collecting the data for the simple type(s) as an attribute (or several attributes) on a class object, which SWIG can then manipulate as a reference.

As such, functions that require numeric array parameters require the invocation of an **MScriptUtil** object to act as a pointer. The **MScriptUtil** class contains methods for converting Python objects into a variety of different pointer and array types required throughout the C++ API. Using the **MScriptUtil** class can be fairly cumbersome at times, but it is unfortunately the only means of accessing many functions in the C++ API. See the companion web site for more information on using **MScriptUtil**.

CONCLUDING REMARKS

Maya's C++ API contains many classes and function sets that are accessible through various Python modules. These modules use SWIG to automatically convert Python parameters into data for C++, as well as to bring the data back into Python. Because of this intermediate layer, as well as a lack of perfect correspondence between C++ and Python, programmers working with the Python API must have some basic understanding of C++ to read the documentation, understand some limitations they will face, and better grasp classes like **MScriptUtil**. Though it is somewhat different from ordinary Python scripting in Maya, the Maya Python API provides an accessible way to rapidly develop powerful tools for Maya. The remainder of the book focuses on various uses of the Maya Python API.

Programming a Command

BY THE END OF THIS CHAPTER, YOU WILL BE ABLE TO:

- Load and unload scripted plug-ins.
- Understand how Maya uses proxy classes to establish object ownership.
- Describe and implement the basic parts of scripted commands.
- Load a scripted command into Maya.
- Add a custom syntax to a scripted command using **MSyntax.**
- Describe how Maya's undo/redo mechanisms work.
- Explain what the `flushUndo` command does.
- Implement undo and redo functionality into a scripted command.
- Add support for create, edit, and query command modes.
- Use the **MDGModifier** class to simplify undo/redo.

The ability to use Maya API methods dramatically broadens the spectrum of possibilities available to Python programmers. The API allows you to implement complex features into scripts that would be extremely difficult or even impossible if you limited yourself to the cmds module. However, as noted in Chapter 9, scripts that implement API methods that alter the scene are not undoable. As such, they are limited to operations such as rendering or querying information.

While scripts suffer from this inherent limitation, scripted commands do not. Just like the C++ API, the Python API allows developers to create Maya command objects that can support undoing and redoing like those found in the cmds module. In fact, scripted commands are automatically added to the Command Engine and therefore to the cmds module! Scripted commands, while perhaps less straightforward than standard Python scripts, allow developers to implement far more robust functionality into custom tools.

In this chapter, we explore the features of custom commands. We start with an introduction to the Plug-in Manager to load a devkit example. We then examine the anatomy of a scripted command using a basic command that prints to the console. Thereafter, we will discuss how to add custom syntax in an example command to obtain detailed transform information about a selected object. Finally, we discuss how Maya's undo/redo mechanism works and then examine how to support undo and redo functionality, as well as multiple command modes, by expanding upon the previous example.

LOADING SCRIPTED PLUG-INS

The simplest way to start developing commands is to look at the simplest possible example. The Maya devkit folder contains several example commands. You can find this folder in one of the following locations depending on your operating system:

- Windows: C:\Program Files\Autodesk\Maya<version>\devkit\plug-ins\ scripted
- OS X: /Applications/Autodesk/maya<version>/devkit/plug-ins/scripted
- Linux: /usr/autodesk/maya<version>-x64/devkit/plug-ins/scripted

The Maya devkit includes a very basic plug-in, helloWorldCmd.py, which prints the string "Hello World!" to the console. Because this command is the simplest possible example to illustrate the necessary components of a command, it is a good starting point for familiarizing yourself with the structure of a scripted command. To run this command, you must first load it into Maya.

Unlike ordinary Python modules, those created as scripted plug-ins are not loaded into Maya using the **import** keyword. Rather, a scripted plug-in must be saved in a folder in Maya's plug-in path and explicitly loaded into Maya using the Plug-in Manager (**Windows → Settings/Preferences → Plug-in Manager**) or the `loadPlugin` command. Maya's plug-in path is specified in the MAYA_PLUG_IN_PATH environment variable (see Chapter 4 for a refresher on environment variables). Once a plug-in command is loaded in Maya, it is immediately added to the cmds module for Python users. In the following example, you will load the helloWorldCmd.py plug-in from the devkit examples into Maya and execute the command that it contains.

1. Open the Plug-in Manager by selecting the **Windows → Settings/ Preferences → Plug-in Manager** item from Maya's main menu. You should see a window appear like that shown in Figure 10.1. The Plug-in Manager displays every valid plug-in it can find within the directories specified in your plug-in path.
2. In the Plug-in Manager window, click the Browse button. Using the Browse option in the Plug-in Manager allows you to locate plug-ins that are not in your plug-in path.
3. In the dialog box that appears, navigate to the location of the helloWorldCmd.py file in the devkit examples using the appropriate location for your operating system and Maya version. Select the helloWorldCmd.py file and press Open.
4. If you scroll to the bottom of the Plug-in Manager window, you should see helloWorldCmd.py with some checkboxes and an icon with the

■ **FIGURE 10.1** The Plug-in Manager window.

lowercase letter **i** next to it. This icon is the information button. Click the information button next to the entry for helloWorldCmd.py.

The dialog that appears reveals information about the plug-in's contents. If a plug-in contains multiple command definitions or any dependency nodes, they will all be listed in the Plug-in Features portion of this dialog box. In this particular case, you can see that this plug-in contains a command called spHelloWorld.

On the line for helloWorldCmd.py in the Plug-in Manager window, the Loaded checkbox indicates that the plug-in is loaded into Maya and that its contents are ready for use. When a plug-in is in your plug-in path (i.e., you do not have to browse for it), you must click this checkbox to load the plug-in for the first time.

On the other hand, the Auto load checkbox tells Maya to automatically load the plug-in every time the application launches. However, the Auto load checkbox is only compatible with plug-ins located in your plug-in path.

It is also worth noting that any changes you make in the Plug-in Manager, like many other settings in Maya, are not automatically saved to your preferences. If a plug-in crashes Maya before the workspace preferences are saved (by successfully closing Maya, for instance), the plug-in settings must be reconfigured the next time Maya is opened.

5. Open the Script Editor window and go to a MEL tab. In the MEL tab, execute the command `spHelloWorld`. You should see the greeting appear in the Script Editor's History Panel: "Hello World!"

    ```
    spHelloWorld;
    ```

6. In the Script Editor window, go to a Python tab and execute the command from the cmds module. You should see the same result.

    ```
    import maya.cmds as cmds;
    cmds.spHelloWorld();
    ```

As you can see, loading the plug-in made the new command immediately available both to MEL and the Python cmds module. When a scripted command plug-in is loaded into Maya, there is no need to reload the cmds module. Rather, if you make changes to a scripted plug-in in an external text editor, you must reload the plug-in either using the Plug-in Manager or the `unloadPlugin` and `loadPlugin` commands. Now that you understand the basics of loading and executing a plug-in and have seen the results of the helloWorld.py plug-in, we can look at code for a basic scripted command.

ANATOMY OF A SCRIPTED COMMAND

The Maya devkit contains several useful examples from which to learn. If you are ever stumped, it can be useful to search the devkit examples for a script that makes use of a class or method you are trying to troubleshoot. However, at the time of this writing many of the devkit examples unfortunately do not conform to stylistic or Pythonic best practices. As such, rather than examine Autodesk's spHelloWorldCmd.py plug-in, we have created our own alternative, AR_HelloWorldCmd.py, which is functionally similar but stylistically preferable. You can find our plug-in on the companion web site. If you load it, you will see that it prints the string "Hello, world." We will walk through the source code for our command one part at a time to discuss its constituents and then move into more complicated topics with another example.

OpenMayaMPx Module

The first part of the command simply imports a set of modules. While we have already discussed the OpenMaya module in previous chapters, you will see one new module at the end of the list: OpenMayaMPx.

```
import maya.OpenMaya as om;
import maya.OpenMayaMPx as ommpx;
```

This module allows access to Maya proxy classes, which belong to a special category of API objects that includes commands and nodes. We will soon see examples of proxy classes in this command.

Command Class Definition

The next portion of the script contains the actual command class definition.

```
class AR_HelloWorldCmd(ommpx.MPxCommand):
    kPluginCmdName = 'ar_helloWorld';
    def __init__(self):
        ommpx.MPxCommand.__init__(self);
```

The first thing to notice is that the command inherits from the **MPxCommand** class in the OpenMayaMPx module. Most custom commands you write will inherit from this class. However, the OpenMayaMPx module also contains a variety of more specific command types with built-in functionality that all inherit from **MPxCommand** (e.g., **MPxConstraintCommand**, **MPxModel EditorCommand**, **MPxToolCommand**). Because of the specific nature of such command classes, we will not belabor their details here, though you can find more information in the API documentation.

The class definition contains a class attribute, **kPluginName**. The value of this string is the actual name users will enter in Maya to invoke the command. The reason for defining the string as a class variable is to avoid using string literals in the code where the name of the command is required elsewhere. This practice makes changing the name of the command at a later point a much easier exercise. In this particular instance, users call ar_helloWorld to invoke the command.

The next item in the class is an explicit __init__() method. In this particular case, all that happens when the class is instantiated is that the __init__() method of the base class, **MPxCommand**, is called, which initializes all of the base class attributes. In your own custom commands, you might use this opportunity to initialize any data attributes for your command as well, especially including those that will be set by flags. You will see an application of this process later in our sample scripts dealing with custom syntax and undo/redo.

doIt()

The next item in the class definition is the most important part of a scripted command: the **doIt()** definition.

```
def doIt(self, args):
    print('Hello, world.');
```

This method is called when a plug-in command is actually invoked by the Command Engine. Every command must have a **doIt()** method that, as per the example, expects two arguments. While the `self` argument should be self-explanatory by now, the `args` argument is a placeholder for a special type of argument that commands require. Namely, it corresponds to an **MArgList** object, which contains any flags or objects specified when a command is called by MEL or the Python cmds module. Because this particular command does not require any custom syntax, nothing is done with the `args` argument; it simply prints a string to the console when it is called. We will see how to create custom syntax and parse command arguments in the next example in this chapter.

Command Creator

The next item in this scripted command plug-in is the command creator definition.

```
@classmethod
def cmdCreator(cls):
    return ommpx.asMPxPtr(cls());
```

This method is invoked when the command is instantiated by Maya's Command Engine. By marking it with Python's **classmethod** decorator, in contrast to the **staticmethod** property, we're able to pass the class itself as an argument to simplify the call to the **asMPxPtr()** method. The important thing to notice, however, is that the creator method does not return an instance of the class previously defined. Rather, it returns an **MPxPtr**, a type of object with which developers cannot directly work in Python.

As discussed briefly at the end of Chapter 9, this paradigm represents one difference between C++ and Python. This call transfers ownership of the command object to Maya itself from Python. Without this call, the command would be managed in memory by Python's garbage collector. As a matter of practice, it is not important that developers understand the technical processes entailed here, but rather that they understand they *must always call this method when creating MPx objects in scripted plug-ins*. In practice, you will probably start from a boilerplate script that will already include this call.

Initialization and Uninitialization

The next definition in the script is the function to initialize the plug-in.

```
def initializePlugin(obj):
    plugin = ommpx.MFnPlugin(
        obj,
        'Adam Mechtley & Ryan Trowbridge',
        '1.0', 'Any'
    );
    try:
        plugin.registerCommand(
            AR_HelloWorldCmd.kPluginCmdName,
            AR_HelloWorldCmd.cmdCreator
        );
    except:
        raise Exception(
            'Failed to register command: %s'%
            AR_HelloWorldCmd.kPluginCmdName
        );
```

This function is called when the plug-in is loaded into Maya. The format for the **initializePlugin()** definition is fairly standard across most plug-ins, though we will see some minor differences when we implement a custom syntax later in this chapter, as well as when we create custom nodes in Chapter 12.

The first thing done in this function is that a function set, plugin, of type **MFnPlugin**, is instantiated with its object set to the incoming **MObject** (the custom plug-in). The function then attempts to register the command with Maya by calling **registerCommand()** on the function set and supplying the plug-in's name and its creator method as arguments. If the registration fails for some reason, then an exception is raised and an error message is printed to the console.

Similarly, the final definition in the script is the **uninitializePlugin()** function.

```
def uninitializePlugin(obj):
    plugin = ommpx.MFnPlugin(obj);
    try:
        plugin.deregisterCommand(
            AR_HelloWorldCmd.kPluginCmdName
        );
    except:
        raise Exception(
            'Failed to unregister command: %s'%
            AR_HelloWorldCmd.kPluginCmdName
        );
```

Whereas the **initializePlugin()** function is called when the plug-in is loaded into Maya, the **uninitializePlugin()** function is called when the plug-in is unloaded. This can happen either by unchecking the Loaded checkbox in the Plug-in Manager or by invoking the `unloadPlugin` command. Overall, the definition is very similar to **initializePlugin()**, and instead simply calls the **deregisterCommand()** method on an **MFnPlugin** function set, passing in only the name of the command.

It is critical to note again that *you must unload and then reload a plug-in to see changes that you are making in an external text editor become active in Maya.*[1] Doing so calls the **uninitializePlugin()** function and then the **initializePlugin()** function again.

Now that we have reviewed the essential parts for every scripted command—its name, its class definition (including the **doIt()** method), and its creator method, as well as the plug-in's initialization and uninitialization functions—we can add more advanced features, the most important of which is the ability to handle custom syntax.

ADDING CUSTOM SYNTAX

Although every command consists of the same basic parts outlined so far, most commands need to support additional functionality to do anything useful. One of the most important features for custom commands is support for flag arguments, command arguments, and objects.

As noted in Chapter 1, flag arguments are optional parameters that can provide a command with information to alter its behavior. In practice, flags work like keyword arguments in ordinary Python functions, though Maya's Command Engine supports some built-in syntax checking that keeps developers from having to manually implement a great deal of input validation.[2]

[1]If your command supports undo and instances of it are still in the undo queue, you will also have to call the `flushUndo` command before reloading a plug-in. Maya should warn you about unloading a plug-in that still exists in another scene state, but remember to generally flush the undo queue before attempting to unload and reload.

[2]Although Maya generally handles a great deal of syntax validation, there are a couple of notes and fringe cases worth mentioning. As of this writing (i.e., up through Maya 2012), Maya only prints descriptive error messages to the Command Line when the command is invoked from MEL. If invalid syntax is found when invoking the command from Python, the command will properly trap the error, but will not provide the user with a detailed message explaining what is wrong with the syntax. The other important note is that Maya's syntax validation will not handle errors with object parsing when using the API's built-in support for edit and query modes. As discussed in the final example in this chapter, adding support for these modes requires that the object list be manually validated.

Command arguments and object arguments are both passed to the command without a flag keyword. As noted in Chapter 3, these types of arguments correspond to variable-length argument lists in Python. Consequently, command arguments and objects are mutually exclusive, and cannot be combined in a syntax definition. Command arguments may be of any of the various types supported in the **MArgType** enumeration in the **MSyntax** class (including Booleans, decimals, selection items, and so on). A basic example of a command with nonobject arguments is the `move` command, which requires a sequence of numbers to represent movement along particular axes.

Objects, on the other hand, can be individual objects or lists of objects, such as DG nodes, DAG nodes, plugs, or keyframes. A key advantage to using command objects as opposed to simply implementing command arguments of type **MArgType.kSelectionItem** is that the **MSyntax** class contains some helpful methods that simplify object validation. As you will see in the following example, you can easily set minimum and maximum selection list sizes, and optionally automatically use the current global selection list as the command objects.

In this section, we will work from the first version of the `ar_transform` command (available on the companion web site as AR_TransformCmd1.py), which simply provides requested transform information about a selected object. Before we examine the code, you should load the plug-in and see what it does.

1. Download the AR_TransformCmd1.py script from the companion web site and save it in a directory within your plug-in path.
2. In Maya, open the Plug-in Manager window (**Windows → Settings/ Preferences → Plug-in Manager**).
3. In the Plug-in Manager window, click the **Refresh** button if you do not see AR_TransformCmd1.py listed in the directory where you saved it. Alternatively, if you saved it in a directory outside of your plug-in path, then use the **Browse** button to locate it.
4. Click the Loaded checkbox next to AR_TransformCmd1.py in the Plug-in Manager window to make the command active in Maya.
5. Open a Python tab in the Script Editor and execute the following lines of code to create a locator and print some of its attribute values.

```
import maya.cmds as cmds;
locl = cmds.spaceLocator()[0];
cmds.setAttr('%s.translate'%locl, 1, 2, 3);
cmds.setAttr('%s.rotate'%locl, 45, 45, 45);
print(
    'translate: %s'%
```

```
        cmds.getAttr('%s.translate'%loc1)
    );
    print(
        'rotate: %s'%
        cmds.getAttr('%s.rotate'%loc1)
    );
```

As you can see, the script you executed created a new locator, applied some transformations with the setAttr command, and then queried and printed the values of the locator's translation and rotation using the getAttr command.

```
translate: [(1.0, 2.0, 3.0)]
rotate: [(45.0, 45.0, 45.0)]
```

6. Without deleting anything or changing scenes, now execute the following code, which prints some information using the ar_transform command.

```
    print(
        'translate: %s'%
        cmds.ar_transform(
            loc1, translation=True
        )
    );
    print(
        'rotate (xyz): %s'%
        cmds.ar_transform(
            loc1, rotation=True
        )
    );
    print(
        'rotate (zyx): %s'%
        cmds.ar_transform(
            loc1, rotation=True,
            rotateOrder='zyx'
        )
    );
```

In this case, the ar_transform command allows us to query transformation information similar to using the getAttr command. However, the result is returned as a list instead of as a tuple inside of a list, and the command also allows us to manually specify a custom Euler rotation order for the result as opposed to only getting information using the **transform** node's **rotateOrder** attribute.

```
translate:    [1.0, 2.0, 3.0]
rotate (xyz): [45.0, 45.0, 45.0]
rotate (zyx): [16.324949936895237, 58.600285190080967,
16.324949936895237]
```

7. Staying in the same scene, execute the following short script. This script will create two additional locators, one parented to the other, and will print both world-space and local-space information for the child.

```
loc2 = cmds.spaceLocator()[0];
cmds.setAttr('%s.translate'%loc2, 2, 2, 2);
cmds.setAttr('%s.rotate'%loc2, 45, 0, 0);
loc3 = cmds.spaceLocator()[0];
cmds.setAttr('%s.translate'%loc3, 1, 1, 1);
cmds.setAttr('%s.rotate'%loc3, -45, 0, 0);
cmds.parent(loc2, loc3);
print(
    'local translate: %s'%
    cmds.ar_transform(loc2, t=True)
);
print(
    'world translate: %s'%
    cmds.ar_transform(loc2, t=True, ws=True)
);
print(
    'local rotate: %s'%
    cmds.ar_transform(loc2, r=True)
);
print(
    'world rotate: %s'%
    cmds.ar_transform(loc2, r=True, ws=True)
);
```

As you can see, the ar_transform command returns local-space values by default (just like the getAttr command), but also allows you to optionally specify that you would like the results in world space.

```
local translate: [1.0, -1.1102230246251565e-16,
1.4142135623730949]
world translate: [2.0, 2.0, 2.0]
local rotate:    [90.000000000000014, -0.0, 0.0]
world rotate:    [45.000000000000007, -0.0, 0.0]
```

In the following pages, we will examine the source code for the ar_transform command to discuss how to implement custom syntax as well as how to use some basic API classes for working with **transform** nodes to implement these command features.

Mapping Rotation Orders

The plug-in starts off similarly to the AR_HelloWorldCmd.py example by importing some required modules. However, this plug-in also contains a dictionary for rotation orders.

```
kRotateOrderMapping = {
    'xyz' : om.MEulerRotation.kXYZ,
    'yzx' : om.MEulerRotation.kYZX,
    'zxy' : om.MEulerRotation.kZXY,
    'xzy' : om.MEulerRotation.kXZY,
    'yxz' : om.MEulerRotation.kYXZ,
    'zyx' : om.MEulerRotation.kZYX,
    '0' : om.MEulerRotation.kXYZ,
    '1' : om.MEulerRotation.kYZX,
    '2' : om.MEulerRotation.kZXY,
    '3' : om.MEulerRotation.kXZY,
    '4' : om.MEulerRotation.kYXZ,
    '5' : om.MEulerRotation.kZYX
};
```

As we will see later in the command, this mapping allows users to supply
either a string or a number as an argument for the `rotateOrder` flag. We
have chosen to create this mapping because, as discussed in Chapter 2,
Maya represents rotation order differently in different places. For example,
using the `getAttr` or `setAttr` command to query or set a rotation order
uses an integer in the range of 0 to 5 corresponding to an enumerator value,
while the `joint` and `xform` commands use a three-letter sequence corre-
sponding to the enumerator labels. Because we cannot be certain how or
where users might use this command in another script, we want them to
be able to supply this argument with either type of value to play nicely with
other commands and nodes in Maya.

Class Definition

The next portion of the plug-in defines the command class, **AR_Transform
Cmd**, which of course inherits from **MPxCommand**. In addition to a string
specifying the command's name, there are five pairs of class attribute strings
corresponding to short and long versions of flag names.

```
kPluginCmdName = 'ar_transform';
kWorldSpaceFlag = '-ws';
kWorldSpaceLongFlag = '-worldSpace';
kTranslationFlag = '-t';
kTranslationLongFlag = '-translation';
kRotationFlag = '-r';
kRotationLongFlag = '-rotation';
kRotateOrderFlag = '-ro';
kRotateOrderLongFlag = '-rotateOrder';
kQuaternionFlag = '-rq';
kQuaternionLongFlag = '-rotationQuaternion';
```

While the naming convention and the verbosity of the individual flags are
up to the plug-in developer, the important point is that each flag has two

forms. All of the commands in the cmds module follow this pattern as well, as you have seen throughout this book. Although it is not necessary to pre-fix each flag with the hyphen symbol, we have chosen to do so to reflect what you will find throughout the devkit examples. Whether or not a hyphen is included at the beginning of a flag, MEL users will still have to prefix each flag with a hyphen when invoking it in Maya, while Python users will not.

In the **__init__**() method, in addition to calling **__init__**() on the base class, we also initialize various data attributes.

```
def __init__(self):
    ommpx.MPxCommand.__init__(self);
    self.__transformPath = om.MDagPath();
    self.__transformFn = om.MFnTransform();
    self.__space = om.MSpace.kTransform;
    self.__rotateOrder = om.MEulerRotation.kXYZ;
    self.__translationArg = False;
    self.__rotationArg = False;
    self.__quaternionArg = False;
```

The first two data attributes, `__transformPath` and `__transformFn`, are, respectively, for storing the incoming object argument and obtaining data from it as needed. The remaining data attributes are for storing the arguments passed in via their corresponding flags. The `__space` variable determines the coordi-nate space in which data will be obtained (the default value of **MSpace. kTransform** corresponds to local space) and the `__rotateOrder` variable determines the rotation order to use for an Euler rotation query. The remaining variables—`__translationArg`, `__rotationArg`, and `__quaternionArg`—are simply Boolean values to designate whether their respective flags have been set.

Syntax Creator

At this point, we will briefly skip ahead, saving an explanation of the **doIt**() method for last. After the definition for the **cmdCreator**() method, which is identical to that in the previous example, is a definition for a new class method called **syntaxCreator**(). This method creates and returns an **MSyntax** object with information about all of the command's flags, and serves two key pur-poses. First, it makes the command's syntax known to Maya so that the `help` command can display it. Second, and most important, it allows the **MArgParser** and **MArgDatabase** classes to be used to simplify parsing of the command's arguments. Although it is not strictly necessary, using a syntax creator method in conjunction with one of these classes is generally advisable.

```
@classmethod
def syntaxCreator(cls):
    syntax = om.MSyntax();
    # ...
    return syntax;
```

Flag Arguments

After the **MSyntax** object is defined in this method, there is a call to **addFlag()** for each flag pair. Looking at its definition in the API documentation, you can see that the first two arguments for this method are the **shortName** and **longName** for the flag. Immediately following these parameters is an enumerated type, **MArgType**, which describes the argument type the flag requires.

```
syntax.addFlag(
    cls.kWorldSpaceFlag,
    cls.kWorldSpaceLongFlag,
    om.MSyntax.kNoArg
);
syntax.addFlag(
    cls.kTranslationFlag,
    cls.kTranslationLongFlag,
    om.MSyntax.kNoArg
);
syntax.addFlag(
    cls.kRotationFlag,
    cls.kRotationLongFlag,
    om.MSyntax.kNoArg
);
syntax.addFlag(
    cls.kRotateOrderFlag,
    cls.kRotateOrderLongFlag,
    om.MSyntax.kString
);
syntax.addFlag(
    cls.kQuaternionFlag,
    cls.kQuaternionLongFlag,
    om.MSyntax.kNoArg
);
```

A flag can support multiple arguments with varying types. The purpose of specifying the argument type is that Maya's Command Engine can automatically provide users with intelligent feedback and error-trapping if they supply the wrong kind of argument, all without any extra effort on the developer's part.

The first flag in this example allows users to specify that they would like the command to return the results in world space. If this flag is not set, the command presumes the user wants local-space information, in which case it will generally behave like the getAttr command. This flag has specified a type of **kNoArg**, which means that the flag only has to be present when the command is called and requires no argument to follow. This pattern prevents MEL users from having to supply a value after the flag, as in the following line.

```
ar_transform -ws;
```

However, Python users must still set this flag with a value of True.

```
cmds.ar_transform(ws=True);
```

Of the remaining flags, three follow the same pattern, including one to request translation, one to request Euler rotation, and one to request quaternion rotation. However, there is a flag with a type of **kString** that allows users to specify a rotation order in which they would like the Euler angles to be given. Using the dictionary we defined at the outset of the plug-in, we can then map either a three-letter sequence or a string containing a number from 0 to 5 to a rotation order in the API. We will see how this process works when we examine the **doIt()** method.

Command Objects

The final two items before the **syntaxCreator()** class method returns concern how the command should deal with objects. In addition to supporting flag arguments (as keyword arguments in Python), many commands support providing an object or series of objects (as a variable-length argument list in Python). Typically, the Maya paradigm is that such objects are the ones on which the command is operating. In our case, the object is the **transform** node for which the command will print information.

```
syntax.useSelectionAsDefault(True);
```

The first of these two calls is to **useSelectionAsDefault()** with a value of True passed in. The purpose of this call is simply to mimic the behavior of a variety of other Maya commands. If users have selected objects when the command is invoked, then this selection should be considered as the object argument if no selection list is manually specified. To take an example, users could select an object (e.g., **locator1**) and call the command by itself.

```
cmds.ar_transform();
```

Users could also call the command with an explicit selection list and would get the same result.

```
cmds.ar_transform('locator1');
```

The final call in the syntax creator is to **setObjectType()**. The first argument is an enumerated type, **MObjectFormat**, while the second is an integer specifying the minimum number of objects required to invoke the command, and the third is an integer specifying a maximum. Because our command requires exactly one object, the Command Engine will prevent its execution if no object or more than one object is specified.

```
syntax.setObjectType(om.MSyntax.kSelectionList, 1, 1);
```

Similar to the **MArgType** enumerated type, the **MObjectFormat** enumerated type tells Maya what type of object argument to expect. Because we are operating on objects in the DAG, our command specifies that it expects a type of **kSelectionList**, which can include DAG nodes, dependency nodes, plugs, or keys. In this particular case, **kStringObjects** would not be the preferred format.

The principal advantage of using **kSelectionList** is that the Command Engine will immediately verify whether or not the supplied objects exist. The **kStringObjects** format, on the other hand, permits an object list to contain any valid string, which may include characters that cannot exist in object names (e.g., < or @), or names of objects that do not exist. Generally speaking, therefore, you should not use the **kStringObjects** format if your object list is only going to contain actual DG nodes, as it saves you a great deal of manual validation. This format should instead be reserved for situations where you might simply need one or more arbitrary strings (e.g., a command that just adds text information to the current file).

Initialization of Syntax

The final new concept worth discussing before investigating the **doIt()** method is that the **initializePlugin()** definition is also slightly different in this command. Specifically, the call to **registerCommand()** has one new argument to include the syntax creator method.

```
def initializePlugin(obj):
    plugin = ommpx.MFnPlugin(
        obj,
        'Adam Mechtley & Ryan Trowbridge'
        '1.0', 'Any'
    );
    try:
        plugin.registerCommand(
            AR_TransformCmd.kPluginCmdName,
```

```
                    AR_TransformCmd.cmdCreator,
                    AR_TransformCmd.syntaxCreator
            );
    except:
        raise Exception(
            'Failed to register command: %s'%
            AR_TransformCmd.kPluginCmdName
        );
```

As you can see from the API documentation (and in light of the previous example), this argument for the syntax creator method is optional; it only needs to be included when the command contains support for syntax. The **initializePlugin()** function is otherwise identical to that in the previous example. The **uninitializePlugin()** function, on the other hand, is sufficiently identical to that in the AR_HelloWorld.py example, and so merits no individual discussion.

doIt()

Having examined the class definition and the command's custom syntax, we can turn to the **doIt()** method. The first step in the **doIt()** method is to parse the arguments.

```
def doIt(self, args):
    try: argData = om.MArgDatabase(self.syntax(), args);
    except: pass;
    else:
        # ...
```

We can simply put a **pass** statement in the **except** clause, as Maya's Command Engine will properly trap errors if it fails to load the argument data for any reason (e.g., if an argument is invalid or an incorrect type, if the flag/argument/object order is incorrect, and so on).[3] As you can see, the arguments are parsed by creating an **MArgDatabase** object rather than calling methods on the **MArgList** object (args) itself. As noted in Chapter 9, we must use an **MArgDatabase** object to find out which arguments have been entered. Although, strictly speaking, an **MArgList** object could be used for commands without flag arguments, commands that use flag arguments will only work in the cmds module if they use **MArgParser** or **MArgDatabase** to parse the flags. We want to again emphasize that this restriction applies equally to commands written in C++. Moreover, parsing an **MArgList** manually would forego the convenience of automatic argument validation.

[3]See note 2. A **pass** is preferable to a **raise** in this situation, since the exception raised can be extremely verbose and not very descriptive (e.g., (kFailure): Unexpected Internal Failure).

In short, you should generally avoid manual argument processing with **MArgList**.

The remainder of the command's **doIt()** method is wrapped inside an **else** clause following this test.

Object Validation

The next part of the script validates the type of the incoming object argument. The first few steps of this process create a new selection list object, store the incoming object argument in the selection list, and then create a selection iterator with a filter type of **kTransform**. Using this filter, the iterator will ignore objects in the selection list that are not **transform** nodes.

```
sList = om.MSelectionList();
argData.getObjects(sList);
iter = om.MItSelectionList(sList, om.MFn.kTransform);
if (iter.isDone() or
    not iter.itemType==
    om.MItSelectionList.kDagSelectionItem):
    selectionStrings = [];
    sList.getSelectionStrings(selectionStrings);
    raise Exception(
        '%s is not a valid transform node.'%
        selectionStrings[0]
    );
```

Consequently, since we limited this command to a single object, we can test **isDone()** on the iterator to see if the object is in fact a **transform** node. If the selection passes through this filter (i.e., the iterator is not done), the command also tests the selection item type of the object. A careful reader might wonder why this process is strictly necessary. If we already applied a filter to the iterator of type **kTransform**, then the current item in the iterator should be a DAG node. In this case, why do we not simply skip the intermediate steps and just make a call to **getDagPath()** on the `iter` object?

*The trouble is that plugs on **transform** nodes can also pass through the **kTransform** filter.* Thus, a user could inadvertently pass in a plug, as in the following invocation.

```
cmds.ar_transform('locator1.tx', t=True);
```

After this point, attempting to call **getDagPath()** would unfortunately yield a cryptic error message (e.g., (kFailure): Unexpected Internal Failure). Validating in this way allows the command to work predictably and more gracefully handle different input scenarios.

If everything is fine and no exception is raised, the command stores the DAG path of the object in its appropriate data attribute and initializes the function set data attribute.

```
iter.getDagPath(self.__transformPath);
self.__transformFn.setObject(self.__transformPath);
```

The reason we must initialize the function set with an **MDagPath** *as opposed to an* **MObject** *is because we need to support querying transform data in world space.* Without a DAG path, a particular DAG node could have multiple different world-space positions if it were instanced.[4]

Storing Flag Arguments

Once the object has been validated, the command performs a series of tests to set its data attributes using any remaining arguments. The first of these tests simply changes the __space data attribute to **MSpace.kWorld** if the worldSpace flag has been supplied.

```
if argData.isFlagSet(AR_TransformCmd.kWorldSpaceFlag):
    self.__space = om.MSpace.kWorld;
```

As you can see, we only need to test the short form of the flag. The **MArgDatabase** object, argData, knows how to map the long forms accordingly, since we supplied the **MSyntax** object generated from the syntax creator in its initialization.

The next set of tests determines what rotation order to use for Euler angles.

```
rotation = om.MEulerRotation();
self.__transformFn.getRotation(rotation);
self.__rotateOrder = rotation.order;
if argData.isFlagSet(AR_TransformCmd.kRotateOrderFlag):
    rotateOrderStr = argData.flagArgumentString(
        AR_TransformCmd.kRotateOrderFlag, 0
    );
    try:
        self.__rotateOrder = kRotateOrderMapping[
            rotateOrderStr.lower()
        ];
    except:
        self.displayWarning(
            '%s is not a valid rotate order. Rotate order of %s is
            being used instead.'%(
                rotateOrderStr,
```

[4]Consult the detailed description for the **MSpace** and **MFnDagNode** classes in the API documentation for more information.

```
            self.__transformPath.partialPathName()
        )
    );
```

By default, the command will use the rotation order of the supplied object as its
__rotateOrder value.[5] If the rotateOrder flag is set, however, then the com-
mand attempts to locate a rotation order value in the kRotateOrderMapping
dictionary that corresponds to the user's input. Because we call the **lower()**
method on the argument string, users can provide input as a sequence of all
uppercase or all lowercase letters and still have the command accept their
input. If no key is found in the dictionary that matches their input, however,
a warning message is printed to the console (using an inherited method) to
notify them that the object's rotation order is being used instead.

Finally, the remaining Boolean data attributes are set based on whether or
not their respective flags are present, and then the **doItQuery()** method is
called to output the requested information.

```
self.__translationArg = argData.isFlagSet(
    AR_TransformCmd.kTranslationFlag
);
self.__rotationArg = argData.isFlagSet(
    AR_TransformCmd.kRotationFlag
);
self.__quaternionArg = argData.isFlagSet(
    AR_TransformCmd.kQuaternionFlag
);
self.doItQuery();
```

doItQuery()

As you can see by looking at the API documentation, **doItQuery()** is not a
method that actually exists in the **MPxCommand** class. Strictly speaking,
it is not necessary to move this functionality off to another method. Query-
ing could all be done inside **doIt()** in this case. However, we prefer to sepa-
rate it out into another method in this example primarily because it helps
make our expansion of this command in the next example much smoother.
You will also encounter this paradigm in other devkit examples.

```
def doItQuery(self):
    doubleArray = om.MScriptUtil();
    if not (self.__translationArg^
        self.__rotationArg^
        self.__quaternionArg):
```

[5]Note that the **RotationOrder** enumerations in **MEulerRotation** are different from those
in **MTransformationMatrix**.

```python
            raise Exception(
                'Query mode only supports one property at a time.'
            );
        elif self.__translationArg:
            translation = self.__transformFn.getTranslation(
                self.__space
            );
            doubleArray.createFromDouble(
                translation.x,
                translation.y,
                translation.z
            );
            self.setResult(
                om.MDoubleArray(
                    doubleArray.asDoublePtr(), 3
                )
            );
        elif self.__rotationArg:
            euler = om.MEulerRotation();
            self.__transformFn.getRotation(euler);
            if (not (euler.order==self.__rotateOrder) or
                self.__space==om.MSpace.kWorld):
                rotation = om.MQuaternion();
                self.__transformFn.getRotation(
                    rotation,
                    self.__space
                );
                euler = rotation.asEulerRotation();
                euler.reorderIt(self.__rotateOrder);
            doubleArray.createFromDouble(
                math.degrees(euler.x),
                math.degrees(euler.y),
                math.degrees(euler.z)
            );
            self.setResult(
                om.MDoubleArray(
                    doubleArray.asDoublePtr(), 3
                )
            );
        elif self.__quaternionArg:
            rotation = om.MQuaternion();
            self.__transformFn.getRotation(
                rotation,
                self.__space
            );
            doubleArray.createFromDouble(
                rotation.x,
```

```
            rotation.y,
            rotation.z,
            rotation.w
    );
    self.setResult(
        om.MDoubleArray(
            doubleArray.asDoublePtr(), 4
        )
    );
```

The basic paradigm in the **doItQuery()** method is to issue a single call to **setResult()**, which outputs the command's result in a way that MEL or Python can capture and store in a variable, as with any of the built-in commands. Because each of the calls in our case outputs a list of decimal numbers, the method requires a double array, hence the creation of our **MScriptUtil** object, `doubleArray`.

In general, Maya only allows users to set a single flag argument when querying data (as in query mode). With built-in commands, supplying multiple flags when querying data often gives preference to one of the flags over the others. Without this behavior, users might simply get an undifferentiated list of various kinds of data and would have no idea what any entries in the list were supposed to represent. This order of precedence varies from one command to another, and is not documented. Moreover, because **MArgParser** and **MArgDatabase** have no means of conveying the order in which flags were supplied, your only options are to arbitrarily determine which flags take precedence, or to disallow setting multiple flags. In contrast to Maya's built-in commands, we have opted to raise an exception if more than one flag is set, which makes debugging substantially easier and is generally more useful behavior.

While it is reasonably clear what each block is doing, the block for obtaining Euler rotation merits a little discussion.

```
euler = om.MEulerRotation();
self.__transformFn.getRotation(euler);
if not (euler.order==self.__rotateOrder) or
    self.__space==om.MSpace.kWorld:
    rotation = om.MQuaternion();
    self.__transformFn.getRotation(
        rotation,
        self.__space
    );
    euler = rotation.asEulerRotation();
    euler.reorderIt(self.__rotateOrder);
doubleArray.createFromDouble(
    math.degrees(euler.x),
```

```
        math.degrees(euler.y),
        math.degrees(euler.z)
    );
```

The basic idea is that if the requested rotation order is different from that on the object, or if the object's world-space orientation is requested, then the object's orientation is obtained as a quaternion, the quaternion is converted to Euler angles, and the Euler angles are finally reordered for output. The first two steps are necessary because there is no method in the **MFnTransform** class that allows us to obtain an Euler rotation in a specific **MSpace**, so we would not be able to query the rotation in world space.

Now that we have discussed the basics of implementing custom syntax, you can create commands with a variety of complex and adjustable behaviors. However, custom syntax still does not allow us to move substantially beyond ordinary Python scripting unless we can also support undoing and redoing. In the next section, we will build upon this example command by adding support for multiple command modes (create, edit, query) as well as support for undoing and redoing.

MAYA'S UNDO/REDO MECHANISM

As we noted in Chapter 9, Python alone can communicate directly with the API and give information back to users in real time. The problem, however, is that this pathway does not support undo functionality, because Maya's undo/redo mechanism can only store *command objects*.[6] To support undo and redo, you must use the API to create custom command plug-ins.

The key to remember is that *command objects are the only type of objects that Maya's undo/redo queue can store directly*. Such objects include **MPxCommand** and its descendants. Developers can only store noncommand API objects as data attributes of a command object (e.g., **MVector**, **MQuaternion**, **MDagPath**, **MTransformationMatrix**) to save information about a previous state. Moreover, the undo queue will only store command objects that explicitly support undoing. If a command does not

[6]Executing any script (either Python or MEL) that uses commands essentially opens a chunk in the undo queue into which all of the undoable commands from the script are added. When the script completes, the chunk is closed. If the chunk contains no undoable commands, then it is discarded. If it contains undoable commands, then the chunk is added to the queue as though it were a single command. Using the undoInfo command with the printQueue flag reveals that several lines of Python (or MEL) are all lumped into a single item in the queue. On the other hand, a script using no undoable commands (e.g., a Python script using only API code) is not added to the queue.

support undoing, then no instance of it is ever added to the queue. A brief example can help illustrate how Maya's undo queue works.

First, let's assume we create a cube (**Create → Polygon Primitives → Cube**), select its top face, extrude the face (**Edit Mesh → Extrude**), convert the selection to edges (**Select → Convert Selection → To Edges**), and then bevel the selected edges (**Edit Mesh → Bevel**). Our scene would look something like that shown in Figure 10.2.

Because each of these operations supports undoing, each created an instance of some particular command object in Maya's undo queue. Figure 10.3 illustrates how these commands are added to the undo queue in the order they were invoked.

At a glance, the undo queue seems similar to a construction history, such as that shown in the channel box on the right side of the Maya GUI (e.g., see Figure 10.2). It is important to not confuse these two concepts, however. The key difference is that the objects in the construction history are actually DG nodes, but the objects in the undo queue are command objects.

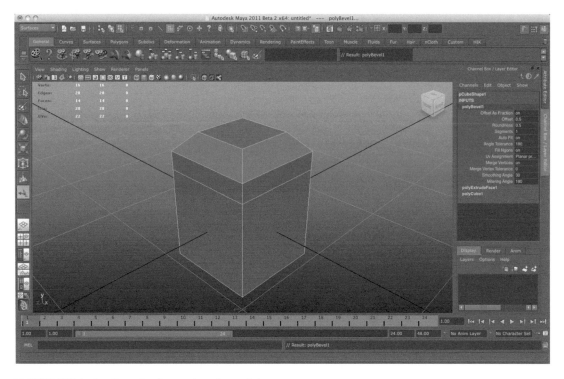

■ **FIGURE 10.2** A cube with a series of command operations applied.

■ **FIGURE 10.3** An example undo queue.

While nodes can be selected, edited, and altered at any time during their existence, command objects can only be pushed through the queue by performing operations in the Maya scene—you cannot directly destroy or alter individual command objects after the fact (although you can delete all of them at once using the `flushUndo` command). Consequently, the undo queue often contains some commands that do not create DG nodes, such as the `select` command.

The number of commands that Maya can store in its undo queue can be set in the Undo subsection of the Maya Preferences (**Window → Settings/ Preferences → Preferences**) or by using the `undoInfo` command. Once the undo queue has filled, Maya simply discards older commands (at the bottom, in Figure 10.3) to make room for new ones at the head of the queue (at the top, in Figure 10.3). In the current example we have issued five commands, so the undo queue must be a size greater than or equal to 5 if we want to be able to undo all of the commands.

If we were to change the undo queue to the size of 3, the first two commands executed in our sequence would simply be deleted from the queue. Figure 10.4 shows a side-by-side comparison of two undo queues with different sizes after executing the same series of operations. In the example on the right, we would only be able to revert to the state right before the face was extruded, while the example on the left would allow us to undo to the scene state before the cube was even created. Although Maya allows for an infinitely large undo queue, users will theoretically want to limit the queue size to keep the memory overhead low when working in a scene for a

prolonged period of time. As indicated previously, you can also invoke the `flushUndo` command to delete all commands in the queue.

On the other hand, when users undo commands in Maya using **Edit →**
Undo, the Command Engine does not actually delete any command objects. Rather, Maya updates the scene to reflect an earlier state in the command queue. In the present example, for instance, undoing twice would update the scene and move to the point in the queue when the last command was `polyExtrudeFace` (see Figure 10.5, left). The reason Maya maintains commands ahead of the last command is to support redoing.

■ **FIGURE 10.4** An undo queue with a size of 5 (left) and 3 (right).

■ **FIGURE 10.5** An example command queue after two undos (left) and one redo (right).

Redoing simply advances through the queue until the head is reached again. The right side of Figure 10.5 illustrates this concept.

In addition to the flushUndo command and a full command queue, one other situation that will delete command objects is when the command history changes. Because Maya can only support a single command history path, undoing to some earlier state and then performing a command other than undo or redo will destroy all of the command objects ahead of the last command to start a new sequence. Figure 10.6 illustrates this concept if we were to undo the scene three times and then use the polyPoke command on the selected face (**Edit Mesh → Poke Face**). As you can see in the diagram, the polyExtrudeFace, convertSelectionToEdges, and bevelPolygon commands are all destroyed when this new command history pathway begins, so we are no longer able to redo to a scene state where they exist.

Recall that we pointed out earlier that the command creator method for a class derived from **MPxCommand** does not return the command object itself, but rather an **MPxPtr**. It should hopefully be clear now that Maya needs to maintain commands in memory to support undo and redo. Without this transfer of ownership, Python may garbage collect the command even though the Command Engine still needs it, which would result in a dangling pointer. Consequently, you would end up trying to undo to a state where the command object no longer exists in the undo queue!

One final important note with respect to the undo queue is that it *only exists in the current Maya session*. Creating a new file, loading an existing file, or

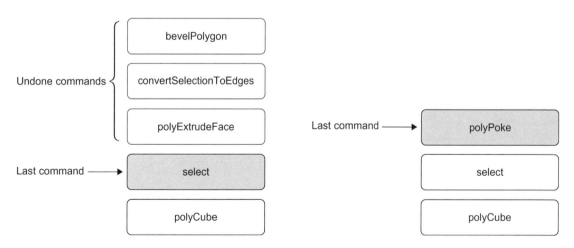

■ **FIGURE 10.6** An example command queue after three undos (left) and a new operation (right).

quitting the application will all flush the undo queue. As such, there will be no command objects in the queue when users open an existing file later.

SUPPORTING MULTIPLE COMMAND MODES AND UNDO/REDO

While adding custom syntax is almost always essential for doing anything meaningful with a command, undo and redo support, as well as command modes, are the key features that distinguish commands from ordinary Python scripts that access the API.

Undo and Redo

As we will see in the next example, supporting undo and redo is chiefly a matter of overriding three key methods in a scripted command: **isUndoable()**, **undoIt()**, and **redoIt()**.

The first of these methods, **isUndoable()**, simply returns a Boolean value (False by default). Therefore, if this method is not overridden, Maya automatically deletes the command object when the command is invoked instead of adding it to the undo queue. You may have noticed, for instance, that trying to undo after invoking the `ar_transform` command in the previous example simply skips back to whatever other operation you may have performed before executing the command. If the **isUndoable()** method returns a value of True, however, Maya will add the command to the queue when it is invoked and call the other methods, **undoIt()** and **redoIt()**, as the user moves backward and forward through the queue.

As a general rule, commands that implement undo and redo support ought to follow the same basic design philosophy. Namely, the parsing of all arguments and handling of all input errors should be done in the **doIt()** method, where the results of this process are saved to data attributes on the command object. Once all of the arguments have been successfully parsed and the command is ready to go, the **redoIt()** method should be called at the end of **doIt()**. In this way, developers do not need to recreate the same functionality in each of these methods.

When should a command include undo support? *If a command makes any changes to the Maya Dependency Graph whatsoever, it must implement undo support!* Without undo support, the command is not added to the queue, and so it could add, remove, or alter objects upon which other commands in the queue rely in a previous scene state. In essence, the command would be bound by the same limitations (and could introduce the same dangers) as an ordinary Python script implementing API functionality.

MDGModifier

While plug-in developers are responsible for implementing the steps to undo and redo, there is fortunately an incredibly useful class that can substantially simplify this process: **MDGModifier**. In addition to containing methods that allow you to make connections and set attribute values on nodes, the **MDGModifier** class and its descendant class **MDagModifier** permit the execution of other commands within a custom command, as though the custom command contained its own command queue.

These classes effectively allow developers to accumulate a series of operations on an object and then simply call that object's **doIt()** method upon execution. Correspondingly, there is also an **undoIt()** method for such objects, which can be called from within your command's **undoIt()** method to effortlessly undo the commands executed by the **MDGModifier** object. That being said, the best approach when designing a custom command is to rely on these classes wherever possible, inserting other manual API functionality only where necessary, and preferably only in situations where it is not important that it be manually undone.[7]

Command Modes

Another concept related to undoing and redoing is support for multiple command modes. As we noted in Chapter 1, many commands support the invocation of different behavior by supplying flags to specify the mode in which the command is operating (e.g., q/query for query mode and e/edit for edit mode). However, it is certainly possible for a command to exhibit the behavior of any particular mode without requiring users to supply one of the flags.

In our previous example, for instance, the ar_transform command acted like a command in query mode, though we did not require the query flag. Moreover, developers can implement these flags manually to do things other than specify a command mode. For instance, you could implement a flag q that corresponds to a flag for a quaternion if it makes sense in your command. In general, however, it is bad practice to deviate from these conventions, as most users will reasonably expect that these flags be reserved for command modes.

[7]Consider our final example in this chapter, which creates a new **transform** node and applies a series of transformations one after another in create mode. In such a case, it is useful to create the node using an **MDagModifier** object and then simply transform it directly using an **MFnTransform** function set. When the operation is undone, it is not important that each of the transformations be sequentially undone in reverse, as the undo would destroy the newly created object anyway when **undoIt()** is called on the **MDagModifier** object.

Maya has some built-in functionality for multiple command modes. This functionality comes primarily in the form of **MSyntax.enableEdit()** and **MSyntax.enableQuery()**, as well as **MArgDatabase.isEdit()** and **MArgDatabase.isQuery()**.

The primary advantage to using these methods is that they provide short-cuts for supporting these conventional flags. The **MSyntax** methods **enableEdit()** and **enableQuery()** automatically add the appropriate flags for their respective modes to the syntax definition. Additionally, the **MArgDatabase** methods **isEdit()** and **isQuery()** act as shortcuts for testing if the respective flags have been set. However, there are other advantages to using these methods. Consider the following example, which creates a sphere, changes its radius to 5, and then prints the queried radius value.

```
import maya.cmds as cmds;
sphere = cmds.polySphere()[1];
cmds.polySphere(sphere, edit=True, radius=5);
print cmds.polySphere(sphere, query=True, radius=True);
```

While it may not be as immediately obvious in Python as in MEL, the required argument type for the `radius` flag has changed in each mode.[8] In create or edit mode, the `radius` flag requires a decimal number (**MSyntax.kDouble**). In query mode, however, the `radius` flag only needs to be present.

There is no way to accomplish these unique behaviors in your own custom commands without using the **enableQuery()** method. For example, if you normally required a decimal number for a particular flag, the user would have to supply a decimal argument along with the flag in query mode if you were implementing the mode manually. Otherwise, the Command Engine would issue a syntax error for the flag in question. This behavior would be confusing and highly unconventional.

While these methods are tremendously helpful, they do introduce two problems. First, **enableQuery()** by itself precludes the possibility of including a flag that still requires an argument even in query mode. As in our previous example, for instance, you may want to specify the rotation order in which you are querying a rotation value. Fortunately, the **makeFlagQueryWithFullArgs()** method

[8]Consider the following comparison between Python and MEL. In Python, any nonzero argument after the `radius` flag would evaluate to True and allow the command to proceed (e.g., `cmds.polySphere('polySphere1', q=True, r=5)`). However, trying to issue a similar command in MEL (`polySphere -q -r 5 polySphere1`) could result in a syntax error. (On the other hand, reordering the flags could allow a MEL invocation, such as `polySphere -r 5 -q polySphere1`, to also proceed.)

on **MSyntax** objects allows you to solve precisely this problem, as we will see in the next example.

The second problem, however, is that edit and query modes do not respect any minimum or maximum object requirements in the syntax definition. In all of Maya's built-in commands, edit and query modes predictably require exactly one object to be specified. However, as of this writing (with Maya 2012 as the latest version), developers unfortunately have to manually confirm an object list when the command is operating in edit or query mode.

With all of these considerations in mind, we can now take a look at these features in action. To do so, we will be examining an expanded version of the `ar_transform` command (AR_TransformCmd2.py on the companion web site). This command builds upon the previous example by adding support for multiple command modes as well as undo and redo functionality. We will first look at a brief demonstration of the new version of this command and then examine its source code.

1. If you still have the AR_TransformCmd1.py plug-in loaded, then unload it. The command has the same name in both plug-ins, so the old plug-in must be unloaded to avoid a conflict.
2. Download the AR_TransformCmd2.py plug-in from the companion web site and load it into Maya using either the Plug-in Manager or the `loadPlugin` command (refer to the previous example if you require more detailed instructions).
3. Execute the following code in a Python tab in the Script Editor, which uses the `ar_transform` command to create a new locator at position [0, 1, 0] and print its translation using query mode.

```
loc = cmds.ar_transform(t=[0,1,0]);
print(cmds.ar_transform(loc, q=True, t=True));
```

As you can see, the `ar_transform` command now operates in create mode by default, which allows you to create a new locator with any specified default transformations applied. Moreover, specifying the q flag puts the command in query mode, which produces the same behavior as the previous example.

4. Execute the following code to edit the translation and rotation of the newly created locator and then print its translation ([2, −1, 0]) and rotation ([45, 0, 45]) values.

```
cmds.ar_transform(loc, e=True, t=[2,-1,0], r=[45,0,45]);
print(
    'Translation: %s'%
    cmds.ar_transform(loc, q=True, t=True)
);
```

```
print(
    'Rotation:    %s'%
    cmds.ar_transform(loc, q=True, r=True)
);
```

Using the e flag, you can edit multiple different transformation properties at once.

Now that you have seen the basic functionality additions in this version of the command, we can step through its source code.

Syntax Creator

The command begins, just like the previous example, by importing a series of modules and defining a dictionary for mapping rotation arguments. Because this part of the command is identical to the previous example, we will skip ahead to the syntax creator.

The first difference you will see is that we make the required calls to **enableQuery()** and **enableEdit()** to add the two additional command modes.

```
syntax.enableQuery();
syntax.enableEdit();
```

The second difference is that the translation, rotation, and rotation Quaternion flags now require arguments (three decimal numbers for tran slation and Euler rotation, and four decimal numbers for a quaternion). Additionally, as we noted earlier in our discussion of query mode, we have made a call to **makeFlagQueryWithFullArgs()** for the rotateOrder flag so it still requires the user to specify a string argument when querying.

```
syntax.addFlag(
    cls.kWorldSpaceFlag,
    cls.kWorldSpaceLongFlag,
    om.MSyntax.kNoArg
);
syntax.addFlag(
    cls.kTranslationFlag,
    cls.kTranslationLongFlag,
    om.MSyntax.kDouble,
    om.MSyntax.kDouble,
    om.MSyntax.kDouble
);
syntax.addFlag(
    cls.kRotationFlag,
    cls.kRotationLongFlag,
    om.MSyntax.kDouble,
```

```
        om.MSyntax.kDouble,
        om.MSyntax.kDouble
    );
    syntax.addFlag(
        cls.kRotateOrderFlag,
        cls.kRotateOrderLongFlag,
        om.MSyntax.kString
    );
    syntax.makeFlagQueryWithFullArgs(
        cls.kRotateOrderFlag,
        False
    );
    syntax.addFlag(
        cls.kQuaternionFlag,
        cls.kQuaternionLongFlag,
        om.MSyntax.kDouble,
        om.MSyntax.kDouble,
        om.MSyntax.kDouble,
        om.MSyntax.kDouble
    );
```

Finally, we have removed minimum and maximum argument values from the call to **setObjectType()**. In create mode, the command still needs to work whether or not the user has any objects selected. Moreover, as indicated previously, these arguments have no effect on query and edit modes, and so the object validation now exists inside the **doIt()** method, which we will examine shortly.

```
    syntax.useSelectionAsDefault(True);
    syntax.setObjectType(om.MSyntax.kSelectionList);
```

__init__() Method

The **initializePlugin()** and **uninitializePlugin()** functions are identical to the previous example, so we can also skip them. The next place in this version of the plug-in with some small differences worth noting is the __init__() method.

```
    def __init__(self):
        ommpx.MPxCommand.__init__(self)
        self.__isQueryUsed = True;
        self.__isEditUsed = False;
        self.__transformPath = om.MDagPath();
        self.__transformFn = om.MFnTransform();
        self.__matrix = om.MTransformationMatrix();
        self.__space = om.MSpace.kTransform;
        self.__rotateOrder = om.MEulerRotation.kXYZ;
        self.__translationArg = False;
```

```
        self.__rotationArg = False;
        self.__quaternionArg = False;
        self.__newLocator = om.MObject();
        self.__dagModify = None;
```

For the most part, this method looks very similar to the first version of the command. We have added two Boolean data attributes to designate the mode in which the command is operating. Their primary purpose is to keep track of the mode in which the command is operating so the command knows what to do in the **doIt()** and **redoIt()** methods, as well as whether or not the command should be undoable.

Initializing for isUndoable()

We have chosen to initialize the `__isQueryUsed` variable to True so that, if anything should fail in the argument parsing process, the command will not be added to the queue if it prematurely fails. Although the mechanics will only be entirely clear once we have looked at the **doIt()** method, it is worthwhile to briefly refer to the **isUndoable()** method.

```
    def isUndoable(self):
        return not self.__isQueryUsed;
```

As you can see, the **isUndoable()** method will only return True if the command is not in query mode (`__isQueryUsed` is False). Therefore, by initializing `__isQueryUsed` to True, we ensure that the command will not be added to the queue until it has reached a point that it will begin operating on the scene and we determine the mode in which the command is operating. You can refer to the section discussing the **doIt()** method to see where these steps happen.

Other Data Attributes

Returning to the **__init__**() method, the next new data attribute is `__matrix`. This variable stores the currently selected object's transformation matrix in edit mode before the command is executed, which allows the command to revert the object to its original transformation matrix when **undoIt()** is called. The following data attribute, `__newLocator`, is an **MObject** to store a newly created locator if the command is operating in create mode.

Finally, the command has a data attribute, `__dagModify`, which will reference an **MDagModifier** for creating and naming the new locator in create mode. Because Python works so loosely, it is not strictly necessary to declare this data attribute by assigning it a value of None. We could simply add the data attribute on-the-fly when it is needed. However, we prefer to declare it here to let our IDE recognize it as a data attribute of the class.

doIt()

At this point, we can now begin to discuss the contents of the **doIt()** method. The first step of the **doIt()** method, constructing an **MArgDatabase** object inside of a **try-except** clause, is identical to that in the previous example, so we will skip down into its **else** block, where the first step is object validation.

Object Validation

```
sList = om.MSelectionList();
argData.getObjects(sList);
if (argData.isEdit() or argData.isQuery()):
    if sList.length() is not 1:
        raise Exception('This command requires exactly 1
        argument to be specified or selected; found
        %i.'%sList.length());
    iter = om.MItSelectionList(sList, om.MFn.kTransform);
    if (iter.isDone() or
        not iter.itemType()==
        om.MItSelectionList.kDagSelectionItem):
        selectionStrings = [];
        sList.getSelectionStrings(selectionStrings);
        raise Exception(
            '%s is not a valid transform node.'%
            selectionStrings[0]
        );
    iter.getDagPath(self.__transformPath);
    self.__transformFn.setObject(self.__transformPath);
    self.__matrix = self.__transformFn.transformation();
```

Because the command does not impose any particular requirements in create mode, we first test to see if the command is in edit or query mode, where the command requires that exactly one object be selected. Once we have verified that a single object is selected, the object validation proceeds identically to that in the previous example. Finally, the selected object's transformation matrix is stored in the __matrix data attribute, so that we can revert to it if needed when undoing in edit mode.

The next block of code, which checks for the worldSpace flag and parses the argument for the rotateOrder flag, is not appreciably different from the previous example,[9] so we will skip ahead to the **if-else** clause that determines what action to take based on the command's mode.

[9]The only difference is that the __transformNode path is validated before attempting to call **getRotation()** on __transformFn. The reason for this validation is that no object yet exists when in create mode that would otherwise determine the rotation order.

Selecting Query Mode

In Maya's built-in commands, query mode takes precedence if more than one mode is specified. We have reflected this pattern in our example as well.

```
if argData.isQuery():
    self.__translationArg = argData.isFlagSet(
        AR_TransformCmd.kTranslationFlag
    );
    self.__rotationArg = argData.isFlagSet(
        AR_TransformCmd.kRotationFlag
    );
    self.__quaternionArg = argData.isFlagSet(
        AR_TransformCmd.kQuaternionFlag
    );
    self.doItQuery();
```

As you can see, if the command is in query mode, it behaves exactly the same as the previous example (moreover, the contents of the **doItQuery()** method are also identical, and so merit no further discussion).

Selecting Edit or Create Mode

If the command is not in query mode, then we need to set up the command's data attributes using the command's flag arguments as needed. The first step is to search for any provided flags to create appropriate objects for capturing their argument values (an **MVector** for translation, **MEulerRotation** for rotation, and **MQuaternion** for rotationQuaternion). Because Python supports dynamic typing, we do not need separate data attributes to store these objects even though they no longer hold Boolean values.

```
if argData.isFlagSet(AR_TransformCmd.kTranslationFlag):
    self.__translationArg = om.MVector(
        argData.flagArgumentDouble(
            AR_TransformCmd.kTranslationFlag, 0
        ),
        argData.flagArgumentDouble(
            AR_TransformCmd.kTranslationFlag, 1
        ),
        argData.flagArgumentDouble(
            AR_TransformCmd.kTranslationFlag, 2
        )
    );
if argData.isFlagSet(AR_TransformCmd.kRotationFlag):
    self.__rotationArg = om.MEulerRotation(
        math.radians(
```

```
                        argData.flagArgumentDouble(
                            AR_TransformCmd.kRotationFlag, 0
                        )
                    ),
                    math.radians(
                        argData.flagArgumentDouble(
                            AR_TransformCmd.kRotationFlag, 1
                        )
                    ),
                    math.radians(
                        argData.flagArgumentDouble(
                            AR_TransformCmd.kRotationFlag, 2
                        )
                    )
                );
            self.__rotationArg.order = self.__rotateOrder;
    if argData.isFlagSet(AR_TransformCmd.kQuaternionFlag):
        self.__quaternionArg = om.MQuaternion(
            argData.flagArgumentDouble(
                AR_TransformCmd.kQuaternionFlag, 0
            ),
            argData.flagArgumentDouble(
                AR_TransformCmd.kQuaternionFlag, 1
            ),
            argData.flagArgumentDouble(
                AR_TransformCmd.kQuaternionFlag, 2
            ),
            argData.flagArgumentDouble(
                AR_TransformCmd.kQuaternionFlag, 3
            )
        );
```

After storing these values, if the command is in create mode, then the __dagModify data attribute is created and two operations are added to it.

```
    if not argData.isEdit():
        self.__dagModify = om.MDagModifier();
        self.__newLocator = self.__dagModify.createNode(
            'locator'
        );
        self.__dagModify.renameNode(
            self.__newLocator, 'locator1'
        );
```

The first operation requests that a new locator be created, and a pointer to it is stored in the __newLocator data attribute. The second operation requests a rename of the new object with a number suffix. Note that we do not actually call the **doIt()** method on the __dagModify data attribute here, because

we want to simplify support for redo. We will show how this object works when we inspect the command's **redoIt()** method.

Finally, we set the values for __isEditUsed and __isQueryUsed and then proceed to call the **redoIt()** method.

```
self.__isEditUsed = argData.isEdit();
self.__isQueryUsed = False;
self.redoIt();
```

The reason for setting the values of these data attributes last is that, if there happens to be some sort of unexpected failure at an earlier part in the **doIt()** method, we do not want the command to be added to the undo queue. This pattern ensures that the command is not added to the undo queue until right before it actually does anything to modify the scene. It is especially important to follow this pattern when you are designing and debugging your own commands because it prevents you from having to flush the undo queue before reloading your plug-in if your command produces some kind of problem before it actually does anything to the scene.

redoIt()

The first step in the **redoIt()** method is to determine if the command is operating in create mode, and to create a new locator if it is.

Creating New Nodes

As we pointed out earlier, we added the node creation and renaming requests in the **doIt()** method, before entering **redoIt()**. The reason for issuing the **renameNode()** request was to ensure that the name of the new node would be unique, as Maya will automatically increment nonunique names. If we issued this request inside the **redoIt()** method, then every time we issued a redo, the object's name would continually increment, which would cause problems when trying to access it by name later. As such, the first step in create mode is to simply call **doIt()** on __dagModify.

```
if not self.__isEditUsed:
    self.__dagModify.doIt();
    om.MFnDagNode(self.__newLocator).getPath(
        self.__transformPath
    );
    self.__transformFn.setObject(self.__transformPath);
    self.__dagModify.commandToExecute(
        'select %s'%
        self.__transformPath.fullPathName()
    );
```

```
        self.__dagModify.doIt();
        self.setResult(self.__transformPath.partialPathName());
    else: self.setResult('Values edited.');
```

The reason for issuing this call now is to update the intermediate state of the DG to ensure we can get a current, conflict-resolved name for the new locator. Thereafter, since we are guaranteed the new object will be unique, we can store its DAG path in the __transformPath data attribute and point the __transformFn function set to it. It is critical that we reinitialize the function set using an **MDagPath**, as we may need to be able to use world space to set transformation values (later), which you cannot do if you initialize with an **MObject**.

Following Maya's convention, the command then calls **commandToExecute()** on __dagModify to add another operation to the **MDagModifier** object to select the new locator. Because we previously called **doIt()** on the __dagModify data attribute, we know that the name of our new object will be unique and up-to-date. If we had failed to do so, it would be possible that we might accidentally select the wrong object in the scene, as Maya would have renamed our new locator if a conflict were found.[10]

It is also important to stress here that Maya expects any strings passed to the **commandToExecute()** method to be in MEL syntax. If you are so inclined, you could work around this limitation by calling the MEL `python` command with a string of Python code to execute, while at the same time being cautious that these commands will be executed in the namespace of the __main__ module.

After the new locator has been created, we set the result of the command to return the locator's name, again to adhere to Maya's convention. On the other hand, if the command is operating in edit mode, then it also follows Maya convention by setting the result to a string to inform the user that values have been edited.

[10]Strictly speaking, we did not need to use the **commandToExecute()** function in this example. Rather, we could have stored the active selection list in a data attribute when the command was invoked and then manually set it and reset it in **redoIt()** and **undoIt()**, respectively. Doing so would allow us to bypass the auto-renaming problems at the expense of potentially a little more verbosity. The primary purpose of this example, however, is to illustrate the importance of issuing multiple calls to **doIt()** on an **MDGModifier** object when creating, naming, and then operating on objects by name rather than by **MObject** handle. Although a majority of cases can be solved without having to reference objects by name (e.g., without having to use **commandToExecute()**), to do so can often make the source code of your command unnecessarily verbose when an **MDGModifier** can do a great deal of the work for you.

Editing the Transform Node

At this point, we can proceed to apply any transformations necessary based on the user's input.

```
if self.__translationArg:
    self.__transformFn.setTranslation(
        self.__translationArg, self.__space
    );
if self.__rotationArg:
    self.__transformFn.setRotation(
        self.__rotationArg.asQuaternion(),
        self.__space
    );
elif self.__quaternionArg:
    self.__transformFn.setRotation(
        self.__quaternionArg,
        self.__space
    );
```

Unlike query mode, edit mode supports multiple flags simultaneously in the Maya built-in commands. As such, we have followed this same pattern. The only exception is that we have chosen to give Euler rotation precedence over quaternion rotation (with the general expectation that most users would actually prefer Euler rotation since quaternions are not otherwise regularly exposed through the Command Engine, and can also be difficult to understand conceptually). You can also see that when we set Euler rotation, we convert it to a quaternion. Just as there are no prototypes of the **getRotation()** method that accept both an **MEulerRotation** and **MSpace** argument, so, too, are there no such prototypes for **setRotation()**. Thus, the object in question, whether it was newly created or supplied as an argument in edit mode, has all of its transformations applied.

undoIt()

We can now conclude this example by examining the **undoIt()** method.

```
def undoIt(self):
    self.__transformFn.set(self.__matrix)
    if not self.__isEditUsed: self.__dagModify.undoIt()
```

Generally speaking, developers are responsible for manually implementing the mechanics of undo by systematically reversing any operations they may have performed in **redoIt()**. As we indicated earlier, offloading some work onto **MDGModifier** or **MDagModifier** objects can greatly simplify this process. Often, if commands already exist to perform a sequence of operations that you need in your own command, then it is probably worth

it to use one of these classes as opposed to storing a host of data attributes and overcomplicating your plug-in's code. In this way, the **undoIt()** method is relatively simple, as it requires only reverting our object's matrix to its original value and then additionally calling **undoIt()** on the **MDagModifier** object if the command is operating in create mode.

After reviewing this command example, you can hopefully see how knowledge of Maya commands can work hand-in-hand with knowledge of the API to produce scripted plug-ins. A combination of both tools can give you the flexibility of the API's rich feature set, without requiring that your source code become bogged down by unnecessarily verbose code. Moreover, this brief introduction to some basic transformation operations should provide a solid foundation for many future plug-ins that you may develop.

CONCLUDING REMARKS

Equipped with a better understanding of custom syntax, undo and redo functionality, and support for multiple command modes, you now have the ability to make a range of more complicated tools. Commands not only give developers access to a means of supporting undoing and redoing when using API methods, but also make custom tools easily accessible to both MEL and Python. Because command plug-ins are added to the Command Engine when they are loaded (and consequently to the cmds module), they are easy to deploy and straightforward and familiar for users. Custom commands are one of the most common types of plug-ins, and are a valuable means for exploring a great deal of the Maya API.

Nevertheless, commands represent one of the most basic types of plug-ins that developers can create, and, because Python supports object-oriented programming already, their functionality is not dramatically different from ordinary Python scripts excluding their ability to support undo alongside API operations that act upon the scene. However, Maya also supports many other types of plug-ins, including custom nodes, tools, and contexts. Some of these topics will become our focus in the remaining chapters of this book as we explore further uses of the Maya API.

Data Flow in Maya

BY THE END OF THIS CHAPTER, YOU WILL BE ABLE TO:

- Define the principal components of the Maya Dependency Graph.

- Identify the basic parts of a DG node.

- Distinguish attributes, plugs, data blocks, and data handles.

- Describe the push–pull mechanism by which the DG updates.

- Troubleshoot performance problems in the DG.

- Define what the Directed Acyclic Graph is.

- Compare and contrast DAG nodes and DG nodes.

- Describe instances and DAG paths.

While custom scripts and even commands are powerful tools for improving a user's interaction with Maya, they barely graze the surface of what is possible with Python in Maya. Maya offers many different ways to create all-new functionality with the API, including the ability to create custom dependency nodes, contexts, locators, and so on.

Before we jump right into a topic like creating custom nodes, however, it is essential that we review data flow in the Dependency Graph (DG) in greater detail. Having a solid understanding of how the Dependency Graph works not only enhances your ability to create some advanced plug-ins, but also allows you to create your own, more complex behaviors by taking advantage of its underlying mechanisms.

In this chapter, we describe the components of the Dependency Graph in greater detail, as well as the different parts of dependency nodes. Moreover, we will discuss how the Dependency Graph operates and how data move throughout the scene's node networks. Finally, we distinguish the Directed Acyclic Graph (DAG) and the Dependency Graph.

DEPENDENCY GRAPH

At the heart of every Maya scene is the Dependency Graph. The DG represents all of the data in a scene. Everything we have discussed up to this point has concerned using a set of controlled interfaces to manipulate these data.

As we have noted, the DG is composed of two key components: *nodes* and *connections*. Nodes contain the actual data in the scene as well as operations being performed on the data, while connections establish relationships among the data in the nodes. As we discussed earlier in this text, a simple operation such as creating a cube actually creates a series of dependency nodes that are connected in a systematic way. You can visualize these nodes and connections, including the direction of the connections, in the Hypergraph when you select the input and output connections button (Figure 11.1).

The Command Engine is the normal interface for creating, destroying, and manipulating data. Users must issue a command of some kind (e.g., `createNode`, `multMatrix`, `polyCube`, etc.) to create new dependency nodes. Commands such as `setAttr`, `connectAttr`, and `disconnectAttr` allow users to change data or alter connections. The `delete` command allows users to destroy a node (and thus its data).

The important consequence of this structure in the context of the DG is that new data and relationships can be easily inserted, removed, or restructured without sacrificing the integrity of the scene. Each node is simply looking

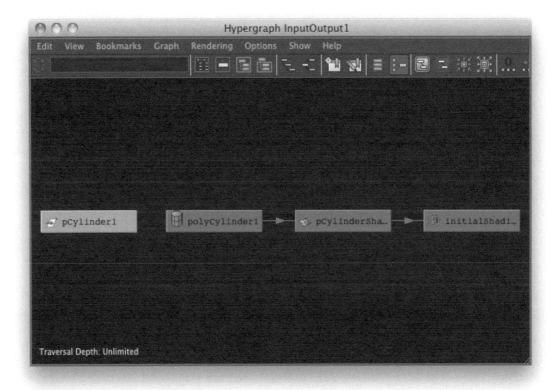

■ **FIGURE 11.1** The Hypergraph.

for some type of data, performs an operation, and then outputs some type of data. Thus, the input data for a node can be a simple static value (e.g., setting the height of a cube to a value of 5), or it can be computed using a series of connections (e.g., the height of the cube could be connected to the rotation of a dial).

This design approach is what makes implementing new functionality for Maya so easy. You can create one or more custom nodes to use as building blocks to transform data for other purposes. In fact, you can safely make certain changes to custom nodes that will be reflected the next time a user opens a scene containing them, as long as their existing interfaces all remain intact.

At this point, it is worth examining these two components—nodes and connections—in greater detail. We will now discuss the anatomy of a dependency node and the method by which the DG evaluates connections, or passes data through nodes.

Dependency Nodes

Dependency nodes are the building blocks of the DG. They are the primary mechanism for storing and accessing data in a Maya scene. A series of important questions naturally arises. How do nodes create data? How do they intercept and transmit data? How do they operate on data? The answers to these questions introduce us to the different parts of nodes. Although we will go into greater detail in Chapter 12, where we will discuss code for custom dependency nodes, it is worth distinguishing some of these key parts now to clarify the nomenclature and avoid confusion later.

At the highest level, the structure of a dependency node is defined by its attributes, and every node contains a **compute()** method (Figure 11.2). Custom dependency nodes in the API will inherit from the **MPxNode** class, which we discuss further in Chapter 12.

Attributes

While we have used the term *attribute* in a number of contexts throughout this text, it has a very particular meaning from the standpoint of an API developer. *Attributes on a node define the name and type of its data members*. For instance, on a **polyCube** node, there is a **height** attribute, which describes a decimal number. Attributes may be inputs, which describe different pieces of data the node needs to operate; they may be outputs, which describe the data that the node produces; or they may serve both functions. Attributes themselves do not store data, but rather specify data that a node will store. The API provides access to attributes as **MObject** objects that can be manipulated with the **MFnAttribute** and descendant classes.

Plugs

Instances of attributes on nodes in a scene are called *plugs*. A plug provides an interface to all aspects of an attribute instance. Plugs allow you to get and set data, make connections, and lock attributes on a node. In short, plugs allow you to access anything about an attribute that is node-specific. Thus, if you use a command such as connectAttr on the **height** attribute

■ **FIGURE 11.2** The parts of a dependency node.

of a **polyCube**, you are really connecting to a specific cube's plug for its **height** attribute. The API provides the **MPlug** and **MPlugArray** classes for working with plugs.

Data Blocks

While attributes define a node's data, the data defined by these attributes are actually stored in a node's *data block*. When you create an instance of a node, it will create space in its data block if required.[1] A node's data block may not necessarily be a fixed size when it is created, as when an attribute is declared as an array type (see Chapter 12). The API uses the **MDataBlock** class to provide access to a node's data block from within its **compute()** method.

In Figure 11.2, there are three attributes—A, B, and C. In the diagram, you can imagine the slots in which the letters are contained as chunks in the node's data block. The small squares providing interfaces outside of the node are the plugs for those attributes. Thus, you can see that plugs are your entry and exit points for the node. In the middle is the **compute()** method.

compute()

As indicated, every node has a **compute()** method. The **compute()** method is where a dependency node performs its operations on the node's data. Although we will examine its contents in greater detail in Chapter 12, where we will look at the actual code of a custom dependency node, the important point worth noting right now is that the contents of a **compute()** method are not exposed outside of the node.

All nodes are black boxes: They take in data, perform some operations, and then output new data. In Figure 11.2, we have shaded the **compute()** method to help remind you that this part of the node is the black box that is not exposed to other nodes.

Data Handles

Inside of a **compute()** method, a node will often make use of data handles to obtain data from the data block for incoming plugs and then again to set values in the data block for outgoing plugs. While a plug allows you to access all aspects of some attribute instance, a *data handle* only offers

[1]Note that not all attributes necessarily store data in the data block. Attributes that are internal to the node, and attributes that do not cache their data (e.g., just pass data through the node for computation) do not occupy space in the data block. See Chapter 12 for more information on internal attributes and caching.

access to the attribute's data. For instance, you cannot use a data handle to lock an attribute or make connections. Data handles are intrinsically linked to the data blocks from which they were created, and cease to have meaning if the data block is destroyed. Plugs, on the other hand, are independent of any data block, and will create a data block if required to access an attribute's data. Data handles are represented in the API in the **MDataHandle** and **MArrayDataHandle** classes.

In spite of the limitations of data handles compared to plugs, data handles offer at least two important advantages over plugs when used inside **compute**(). First, because they are already linked to a data block and have fewer internal checks than a plug, they can operate much faster than plugs. Second, data handles allow the retrieval of a dirty attribute without forcing the DG to be recomputed, which enables the possibility of even further internal optimization. The importance of this feature will be clearer when we discuss connections and DG evaluation later in this chapter.

Attributes and Data Flow

While we have noted that attributes can be either inputs or outputs, Maya itself does not inherently distinguish two different kinds of attributes: you create them in exactly the same way. However, as you will see in Chapter 12, nodes internally define attribute relationships that implicitly classify attributes as either inputs or outputs. You accomplish this task by establishing relationships among attributes to designate that certain attributes affect certain other attributes. In Figure 11.2, we have included dotted lines passing through the **compute**() method to indicate that attributes A and B affect the value of attribute C, and that they are used for something inside of the **compute**() method.

The reason these relationships are important is that the DG in Maya uses what is known as lazy evaluation, which we will soon be discussing in detail. *In short, only those values that are requested, as well as their dependencies, are actually evaluated.* Suppose, for instance, you have a custom node that is just a parametric sphere, and that this custom node has input attributes for **radius** and **spans** as well as an output attribute for **volume** (Figure 11.3). In this sort of node, the **volume** attribute's value would be affected by **radius**, but not by **spans**.

If you were to use the getAttr command to query the **volume** attribute, only the data for the **radius** attribute are important. For the purposes of your query, it is unimportant that the **spans** value be up-to-date, since it has no effect on the sphere's **volume** attribute. This principle is even more important when multiple nodes are networked together. Before delving

■ **FIGURE 11.3** A hypothetical parametric sphere node.

further into DG evaluation, there are a couple of additional rules worth noting about connections in node networks at this point.

First, plugs on separate nodes can generally be only connected if their attributes' data types are identical, though there are a few built-in conversions for some cases. For example, a string attribute cannot be directly piped into a double attribute, but there are built-in conversions for converting an angle or time value to a double. Note that we are only talking about *connecting plugs between nodes*. When setting up attribute relationships within a custom node, any type of attribute can affect any other type of attribute based on your node's specifications and the contents of the **compute()** method.

Second, an outgoing plug can be connected to any number of other input plugs on other nodes. For instance, using our previous sphere example, the **volume** plug could feed its data to any number of other nodes. However, input plugs can only have a single input connection. The **radius** plug, for example, could not be directly intercepting data from multiple other plugs somewhere else in the scene.

Connections

Having discussed the primary parts of dependency nodes, we can now turn our attention back to the Dependency Graph itself to better understand connections. At this point, you may have naturally concluded that the DG works almost like a visual programming environment: Data are defined and created in nodes and then passed off to other nodes to be altered or to create new data. This comparison is fairly apt, not least because many Maya users in fact use the DG in this way. With the variety of utility nodes available in Maya (e.g., **condition**, **multiplyDivide**, **vectorProduct**), it is possible to create simple programs that procedurally control the animation or shading of objects, for example.

However, this analogy introduces some complications. For instance, in contrast to ordinary programming, there is not necessarily a defined entry point. A user could change a value at any point in a node network, in which case the DG needs to know when and how to reevaluate its networks. Constantly

reevaluating everything would be incredibly taxing and would likely cause Maya to operate at a snail's pace in complex scenes. Thus, it is important to understand how the DG manages data updating, not least because it can allow some developers to creatively exploit different aspects of the DG.

Lazy Evaluation and Push–Pull

As we indicated earlier, the Maya DG uses lazy evaluation to ensure it is doing the minimum amount of work at any given time, which is especially important for large or complex scenes. Specifically, it uses what is called a push–pull system to ensure that only exactly that information that is required is actually piped through a node network. In this respect, Maya manages DG evaluation entirely on its own, while nodes only know to compute when they are asked to compute. Recall that nodes are intended to be used as building blocks, and consequently know nothing about other nodes outside of themselves. To see why the push–pull system is important, consider the illustration depicted in Figure 11.4.

If you were to think of the Maya DG as a simple program, you might conclude that information processing simply begins at the left and proceeds to the right, that all steps are simply performed one after the other until everything has been evaluated. For instance, some value is changed on node A, which then triggers an update for nodes B, C, D, and so on down the line.

The problem is that this sort of data flow model is not always the most efficient mode of evaluation. If you only actually needed updated information for a single downstream node, such as node H, you may not want B, C, E, F, and G to also reevaluate, particularly if they perform computationally intensive tasks. You would simply want A, D, and then finally H to update.

Maya implements a two-step push–pull process to ensure that only required data are updated. The first step, the push, simply propagates a flag downstream to indicate that plugs are dirty. If you were to set an attribute value

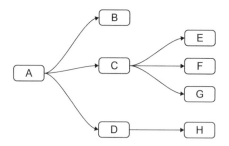

■ **FIGURE 11.4** Example of an abstract node network.

for node A, using the `setAttr` command for instance, the only thing that happens right away downstream is that any plugs that are connected to A's output plug, as well as any output plugs that are affected by these incoming connections, are marked as dirty: They are not up-to-date.

At this point, no reevaluation of anything other than A's output has yet occurred. In Figure 11.5, we will simply imagine for the sake of ease that each node only has a single incoming and single outgoing plug, where the former affects the latter. Node A has just been updated (and is colored white), while all dependent downstream plugs are marked dirty (gray).

At this point, no further computation is done until the value of some downstream plug is required. You can hopefully see how this can save huge amounts of computation time. Suppose you now use the `getAttr` command to request the value of the outgoing plug for node H. Node H first sees that its incoming plug is dirty, and so requests new information from upstream, from node D. Node D's incoming plug is also dirty, and so it also requests new information from upstream. At this time, the request for new data has reached clean data in node A, and thus the data are pulled downstream to update D and then H (Figure 11.6). In this fashion, all of the other nodes have been allowed to remain dormant since none of their data have been requested.

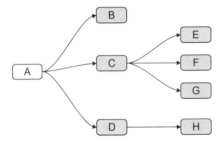

■ **FIGURE 11.5** Propagation of dirty message downstream from node A (push).

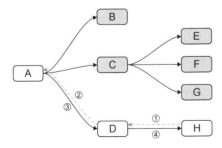

■ **FIGURE 11.6** Node H requests fresh data, which are pulled from A, through D (pull).

Understanding these concepts, you can hopefully see very quickly how important it can be to ensure that you properly establish your attribute relationships when you create your own nodes: You don't necessarily always want everything to happen each time. On the other hand, if your nodes' **compute**() methods do something interesting that you also want to expose as an attribute, you can output all your data at once instead of requiring that each attribute necessarily be requested individually. These concepts will become clearer as we move into creating our own custom dependency nodes, but the bottom line is that you can make your nodes behave quite efficiently if you take the time to understand Maya's push–pull system and exploit its power.

Triggering DG Evaluation

Having discussed the mechanics of DG evaluation, it is important that we conclude with a few points regarding when Maya actually updates the DG. As indicated up to this point, requesting the value for an attribute, either via an upstream connection or using a command such as getAttr, will trigger a DG update for any data dependencies that the specific plug in question may have. Other actions that will request a DG update include displaying a node's attribute values in the Attribute Editor or Channel Box. Finally, actions such as rendering or refreshing the scene (as when scrubbing the time slider) will request a full reevaluation of the DG.

The DG will always behave in the same way, and is always governed by a consistent set of rules, even if it does not appear to be in some circumstance. For example, if you move an object of which the transformations are controlled by animation curves, you will notice that redrawing the scene viewport, as when orbiting the camera, does not cause them to snap back to place. This behavior is not an error with the DG updating, but rather is a consequence of the fact that using the interactive transformation tools sets all of the object's appropriate transformation plugs as clean, since it is presumed that the user's manipulation of the object represents the freshest data. If you were to scrub the time slider, however, the change in the time's value is propagated downstream and the object's transformation plugs are marked as dirty. Consequently, their values are reevaluated on the basis of their animation curves' output values at the new time.

Debugging the Dependency Graph

While few in number, there are some tools you can use in Maya to debug the DG. Here we examine the Hypergraph Heat Map Display and the dgTimer command.

Heat Map Display

As we have discussed, the Hypergraph is your window into the DG. It provides many useful tools for organizing your scenes, but of interest to a developer is the Heat Map Display. If you are using Maya 2009 or later, then you can access the Heat Map Display as per the following example.

1. In Maya, create a new scene.
2. Open the Hypergraph and display connections (**Window → Hypergraph: Connections**).
3. In the Hypergraph window, select **Options → Heat Map Display** to enable Heat Map Display.
4. Open the Script Editor and execute the following lines of code in a Python tab. This code will create a polygon sphere with a large number of subdivisions.

```
import maya.cmds as cmds;
cmds.polySphere(sh=30, sa=30);
cmds.polySmooth(dv=4);
```

5. With your sphere still selected, select **Graph → Input and Output Connections** in the Hypergraph window.
6. Deselect your sphere (**Edit → Deselect**, or click in empty space in the Hypergraph).
7. Open the Heat Map Display options window (**Options → Heat Map Display** □ in the Hypergraph window).
8. In the Heat Map Controls window, ensure that Compute is selected in the Metric dropdown menu and that Self is selected in the Type dropdown menu. You should see a Hypergraph such as that seen in Figure 11.7, albeit with color coding applied to the nodes. If you do not, press the Redraw Hypergraph(s) button.

The Heat Map Display in the Hypergraph allows you to quickly see some helpful debug information in your node network. By default, it color-codes dependency nodes on the basis of computation time. A blue node has a relatively small computation time, where a red one is most computationally intense. If you move your mouse over a node in the Hypergraph, you will see its name, as usual, as well as a decimal number displaying the amount of time that was spent in that node's **compute()** method. (If you do not see the tooltips over your nodes you may be zoomed in too far in the Hypergraph.) As you can see, the polySmoothFace1 node is the most time-intensive node in our example.

While there are many options in the Heat Map Controls window, most of which are documented in the Maya help, the most interesting to developers are likely to be the first dropdown menu, which allows you to set the metric for timing, and the second dropdown menu, which allows you to set the type.

■ **FIGURE 11.7** The Hypergraph with Heat Map Display enabled.

The timing metric can be either callback, compute, dirty, or draw.

■ *Callback* measures the time spent intercepting callback messages.
■ *Compute* measures the amount of time spent in the **compute()** method.
■ *Dirty* measures the amount of time spent propagating dirty messages.
■ *Draw* represents the amount of time spent drawing the object in the viewport.

The measurement type can be either self, inclusive, or count.

■ Measuring using the *self* type simply reports the amount of time the individual node spent.
■ The *inclusive* type totals all preceding time values for each node. Thus, its value represents the total amount of time spent from the beginning of the graph update up to and including the node in question.
■ The *count* type represents the number of times each particular operation is applied on the node in question.

The dgTimer **Command**

If you want more detailed information for debugging the DG, you can also use the dgtimer command, which can provide much of the same information, as

well as a more detailed breakdown for many metrics. The `dgtimer` command is available in all versions of Maya with Python support. The following example illustrates how you can output DG evaluation statistics to a text file.

1. Create a new Maya scene.
2. In the Script Editor, open a Python tab and enter the following code. It uses `dgTimer` to record the time required to create a dense sphere mesh and subdivide it. It then saves the recorded results in a text file called polyStat.txt in your home folder.

```python
import maya.cmds as cmds;
import os;
cmds.dgtimer(on=True, reset=True);
cmds.polySphere(sh=30, sa=30);
cmds.polySmooth(dv=4);
cmds.dgtimer(off=True);
cmds.dgtimer(
    outputFile=os.path.join(
        os.getenv('HOME'),
        'polystat.txt'
    ),
    query=True
);
```

If you open the polyStat.txt file that was just written to your home folder, you can see that the `dgtimer` command provides you with an incredibly rich data set, which you could easily process using Python's text reading and regular expressions functionality if necessary.

By default, the text file contains a sorted list of all DG nodes in the scene sorted in order of most intensive to least intensive. It suffices to say that it is worth reading the detailed information for the `dgtimer` command in the Python Command Reference, as we do not have the space to cover all of its features here. It can be a great way to not only profile your own custom nodes, but also troubleshoot large and complex scenes to locate problems.

At this point, there is nothing further to say about dependency nodes and DG evaluation generally. We can thus turn our attention at last to a special class of dependency nodes: those in the Directed Acyclic Graph.

DIRECTED ACYCLIC GRAPH

The Directed Acyclic Graph (DAG) refers to the subset of nodes in the DG that can have parent–child hierarchical relationships. Examples of DAG nodes include **transform**, **joint**, and **shape** nodes. Note that the DAG is not a separate graph, and that DAG nodes are not a completely different kind of node.

DAG nodes are simply a type of dependency node, and they therefore share all the properties of dependency nodes that we have discussed up to this point.

DAG nodes differ from ordinary dependency nodes only in the respect that they also represent a transformation matrix somewhere in space and somewhere in a hierarchy. Indeed, if you consider the term *directed acyclic*, it becomes clear that these nodes simply share a special type of relationship whereby they can only exist in a single place in the hierarchy. The hierarchy goes from top to bottom, and each node can only exist once in a particular lineage. A **transform** node cannot be its own parent or grandparent.

In Maya, the parenting relationships in the DAG are not handled through connections between plugs. You can see this concept in action in the following example.

1. Open a new Maya scene.
2. Enter the following script into a Python tab in the Script Editor window, which creates three spheres in a hierarchical relationship.

```
import maya.cmds as cmds;
sphere1 = cmds.polySphere(r=1);
sphere2 = cmds.polySphere(r=0.5);
sphere3 = cmds.polySphere(r=0.25);
cmds.xform(sphere2[0], t=[0,1,0]);
cmds.xform(sphere3[0], t=[0,1.5,0]);
cmds.parent(sphere2[0], sphere1[0]);
cmds.parent(sphere3[0], sphere2[0]);
cmds.select(sphere1[0], sphere2[0], sphere3[0]);
```

3. With the newly created spheres still selected, open a Hypergraph window displaying connections (**Window → Hypergraph: Connections**). You should see a Hypergraph window like that shown in Figure 11.8.

In general, there does not appear to be anything particularly special about this node network. You can see three **polySphere** nodes piping into three different **shape** nodes, all of which are piping into a **shadingEngine** node. However, you can also see the **transform** nodes associated with each of these shapes displayed on the side of the Hypergraph, seemingly with no relationship to anything else. Up to this point, we have not focused on these nodes in particular.

4. With everything still selected, switch the Hypergraph to a hierarchy view (in the Hypergraph window, select **Graph → Scene Hierarchy**). In this view, you only see the DAG hierarchy of the **transform** nodes for each of the spheres, where pSphere1 is the parent of pSphere2, which is the parent of pSphere3. At a glance, it almost seems like Maya is telling you that there are two separate scene graphs, and the relationship between graphs is somewhat unclear.

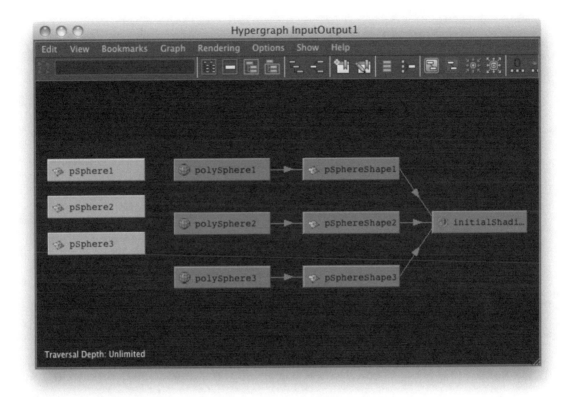

■ **FIGURE 11.8** A hierarchy of DAG nodes as seen in the connections view.

5. In the Hypergraph window, enable the display of shapes (**Options →
 Display → Shape Nodes**). You should now see something like the
 Hypergraph view shown in Figure 11.9, whereby **shape** nodes are sepa-
 rated out from **transform** nodes, and you can clearly see that each
 shape is in fact a child of its respective **transform** node.

Although Maya does not show you the scene graph in this way, DAG
nodes and ordinary DG nodes are interoperating simultaneously in the
same scene graph. You can imagine the DG working left to right, and the
DAG top to bottom, as in Figure 11.10.

In this respect, the transformations of any particular DAG node are the
result of the concatenation of all its ancestors' transformations from the root
down. Consequently, the local transformation matrix of any **shape** node is
identity: It is exactly where its corresponding **transform** node is, since its
geometry is being described in the space of that **transform** node. You can
confirm this fact by following the remainder of this example.

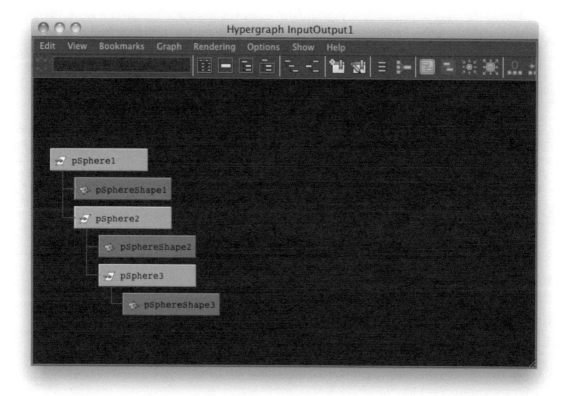

■ **FIGURE 11.9** A hierarchy of DAG nodes as seen in the hierarchy view.

6. Enter the following code in a Python tab in the Script Editor, which gets the DAG path for the **shape** node associated with sphere1.

```
import maya.OpenMaya as om;
sel = om.MSelectionList();
sel.add(sphere1[0]);
path = om.MDagPath();
sel.getDagPath(0, path);
path.extendToShape();
print(path.fullPathName());
```

You should see the following result printed to the History Panel.

```
|pSphere1|pSphereShape1
```

As you can again see, the full DAG path for the first sphere's **shape** node, pSphereShape1, begins at the scene root, and its parent is its respective **transform** node, pSphere1.

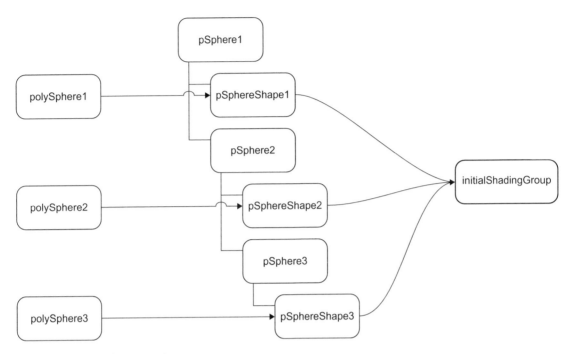

■ FIGURE 11.10 A complete scene graph.

7. Enter the following code in a Python tab in the Script Editor. This code gets the transformation matrix associated with the **shape** node and prints its position and rotation values, both of which are (0.0, 0.0, 0.0).

```
fn = om.MFnDagNode(path);
matrix = om.MTransformationMatrix(
    fn.transformationMatrix()
);
pos = matrix.getTranslation(om.MSpace.kObject);
rot = matrix.eulerRotation();
print(
    'Position: (%.1f, %.1f, %.1f)'%(
        pos.x, pos.y, pos.z
    )
);
print(
    'Rotation: (%.1f, %.1f, %.1f)'%(
        rot.x, rot.y, rot.z
    )
);
```

As we indicated previously, because **shape** nodes are part of the DAG, they too technically have their own transformation matrices. As the previous code snippet has demonstrated, this transformation matrix is identity, which, because the **shape** node is the child of a **transform** node in the scene, means that the shape is aligned to the position and orientation of its respective **transform** node in world space.

DAG Paths and Instancing

Up to this point, we have only discussed the "directed-acyclic" portion of the DAG. Another important property of the DAG is that it is a graph, rather than a tree. In this way, it is possible for a DAG node to have multiple parents as well as multiple children. This feat is accomplished via *instancing*, whereby multiple **transform** nodes can transform a particular DAG hierarchy into multiple different configurations simultaneously, all of which reference the same source DAG hierarchy and reflect any changes made to it. The following example will help illustrate this concept.

1. Create a new Maya scene.
2. Execute the following code in a Python tab in the Script Editor to create another simple hierarchy of polygon spheres.

```
import maya.cmds as cmds;
sphere1 = cmds.polySphere(r=1);
sphere2 = cmds.polySphere(r=0.5);
cmds.xform(sphere2[0], t=[0,1,0]);
cmds.parent(sphere2[0], sphere1[0]);
```

3. Execute the following code to create an instance of the sphere hierarchy. Your scene should look something like that shown in Figure 11.11.

```
sphere3 = cmds.instance(sphere1[0]);
cmds.xform(sphere3, t=[2,0,0], ro=[45,0,0]);
```

4. If you select the small sphere at the end of either hierarchy, you will see that the small sphere also highlights in the other hierarchy. Enter the following line in a Python tab in the Script Editor to transform the small sphere.

```
cmds.xform(sphere2[0], t=[0,2,0]);
```

Because each of these instances is referencing the same DAG hierarchy, adjusting the local translation of the small sphere updates in both instances, while the root object for each path serves to transform each instance of the hierarchy. If you scale, translate, or rotate either of the large spheres, the other hierarchy is not affected since the large sphere is the root for each instance path.

■ **FIGURE 11.11** Two instances of a hierarchy.

5. Open a Hypergraph panel showing the scene hierarchy (**Window →
Hypergraph: Hierarchy**). You can see that there is a dotted line drawn
from pSphere3 to pSphere2, which represents that the children of
pSphere3 are all referencing the same DAG hierarchy as that under
pSphere1. Furthermore, this sharing of hierarchy also applies to **shape**
nodes under each hierarchy.
6. Execute the following code in a Python tab in the Script Editor to trans-
form the vertex at the top of the large sphere.

```
shape = cmds.listRelatives(sphere1)[0];
cmds.moveVertexAlongDirection(
    '%s.vtx[381]'%shape,
    n=0.5
);
```

Your scene should look something like that shown in Figure 11.12.
Remember that the **shape** node of the large sphere is a child of its
transform node, and it is therefore also part of the instance hierarchy. Thus,
any modifications made to the large sphere's vertices are reflected in both
instances. Likewise, you would see the same behavior if you attempted to
transform the small sphere's vertices.

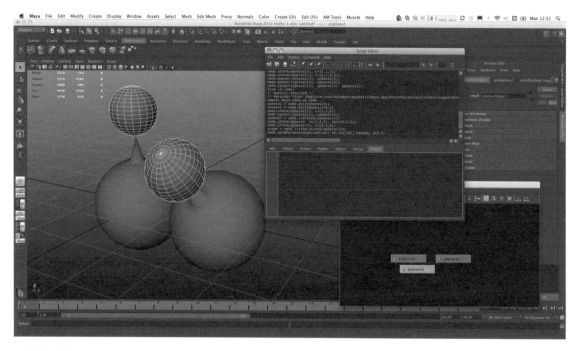

■ **FIGURE 11.12** Two instances of a hierarchy share modifications.

7. Execute the following code in a Python tab in the Script Editor.

```
import maya.OpenMaya as om;
sel = om.MSelectionList();
sel.add(cmds.listRelatives(sphere2[0])[0]);
shapeNode = om.MObject();
sel.getDependNode(0, shapeNode);
paths = om.MDagPathArray();
om.MDagPath.getAllPathsTo(shapeNode, paths);
for i in range(paths.length()):
    print(paths[i].fullPathName());
```

The small sphere's **shape** node (pSphereShape2) has two unique DAG paths to it in this scene, because its **transform** node (pSphere2) has two different parents (pSphere1 and pSphere3). You should see the following output from the previous lines.

```
|pSphere1|pSphere2|pSphereShape2
|pSphere3|pSphere2|pSphereShape2
```

Although we did not explore the subject in detail in Chapter 10 concerning the creation of commands, it is important to remember that it is possible for a single DAG node to have multiple paths to it. To take one example, if

you initialize an **MFnDagNode** function set with an **MObject** rather than with an **MDagPath**, the object's path is not yet known, and it could potentially have multiple paths. While the **getPath()** method returns the first path that the function set finds for an object, you can use the **getAllPaths()** method to return an **MDagPathArray** if it is important for your tool to distinguish objects on the basis of their location in a hierarchy.

Considering what you know about the DAG, you can think of DAG nodes like folders or files in a directory structure. Just as there can only be one folder or file with a particular name in one directory path, so too can there be only one DAG node for a particular path. Just as your operating system allows you to create symbolic links to include a particular directory structure as a subdirectory anywhere else, so too does instancing allow you to reference a single DAG hierarchy in multiple different places without actually duplicating any data.

One final item that is worth noting is that instanced attributes are propagated differently from ordinary ones. Attributes on instanced nodes do not make use of lazy evaluation. They are purely pushed, and are thus handled outside the DG's standard mechanisms.

The Underworld

The last concept worth briefly mentioning while on the topic of the DAG is the underworld. The *underworld* refers to the set of DAG nodes of which the transformations are not described in standard Cartesian coordinates (i.e., *xyz*) but in the parametric space of some other object, such as a mesh or a curve.

You can imagine parametric space as another arbitrary coordinate system. One example is UV space on a NURBS patch: A position along a NURBS surface can be obtained parametrically by evaluating it in terms of a point in UV space that is between 0 and 1 in two dimensions. When you define an object's position in this fashion in Maya, the parametric coordinates are transformed back into standard Cartesian coordinates to locate the object in 3D space. A brief example should help illustrate this concept.

1. Open a new Maya scene.
2. Create a new NURBS plane with some deformation applied to it by entering the following code in a Python tab in the Script Editor.

```
import maya.cmds as cmds;
plane = cmds.nurbsPlane(w=2, ax=[0,1,0]);
cmds.subdivDisplaySmoothness(s=3);
cvs = '%s.cv[0:3][1:2]'%plane[0];
cmds.move(0, 0.5, 0, cvs, r=True);
cvs = '%s.cv[1:2][0:3]'%plane[0];
cmds.move(0, -0.5, 0, cvs, r=True);
```

3. With the new plane still selected, select the menu option from the main application window to make the surface live (**Modify → Make Live**). Your plane should now become deselected and have a dark-green wireframe.

4. Create a new EP curve along the surface of your NURBS plane. Select **Create → EP Curve Tool** and click out some points on your NURBS surface. When you are done, you can return to the Select tool (by pressing **Q** if you have default hotkeys) to exit the tool. You should now have a curve that is conformed to the surface of your NURBS plane, as shown in Figure 11.13.

5. With your new curve still selected, enter the following code in a Python tab in the Script Editor to see the path to the curve.

```
curve = cmds.ls(sl=True);
print(curve);
```

As you can see, the DAG path for the new curve is given using an arrow symbol (->) rather than a standard vertical pipe (|).

```
[u'nurbsPlaneShape1->curve1']
```

This symbol indicates that the object is a child in the underworld of the nurbsPlaneShape1 node rather than in the scene's standard Cartesian coordinate space.

■ **FIGURE 11.13** A curve on a NURBS surface (X-ray shading).

6. Disable the live mode by selecting **Modify** → **Make Not Live** from the main application menu.

7. Select your NURBS plane. You will see the curve highlighted as though it were a child of the plane. Similarly, if you apply any transformation to the plane, such as translation or rotation, the curve still follows the plane like a child.

8. Select the curve and press the **UP Arrow Key**. As you can see, you cannot pickwalk up to the plane as in a standard hierarchy. Again, this limitation is a result of the fact that the curve is not a child of the plane in the ordinary sense.

9. Open a new Hypergraph hierarchy window (**Window** → **Hypergraph: Hierarchy**). If you only see your nurbsPlane1 object, then navigate to the Options menu in the Hypergraph window and enable shapes and underworld nodes (**Options** → **Display** → **Shape Nodes and Options** → **Display** → **Underworld Nodes**). You should see a Hypergraph display like that shown in Figure 11.14.

■ **FIGURE 11.14** A curve on a NURBS surface shown in the Hypergraph hierarchy view.

There is a dotted line connecting the curve1 **transform** node to the nurbsPlaneShape1 **shape** node. This indicates that the hierarchical relationship exists in the underworld, in parametric space, rather than in Cartesian space. Another example of a hierarchical relationship in the underworld is when constraining an object to a path (**Animation** → **Motion Paths** → **Attach to Motion Path** in the Animation menu set). Whereas a parametric coordinate on a NURBS surface is defined using two parameters (**U** and **V**), a coordinate on a motion path is described with a single parameter (**U**).

CONCLUDING REMARKS

At this point, we have covered all of the high-level concepts necessary to start using the API in more advanced ways, which will allow us to move directly into the creation of custom dependency nodes in Chapter 12. As you no doubt are aware by now, Maya's DG is simultaneously a streamlined means for representing and conveying data and a powerful and flexible tool for accomplishing advanced tasks. Taking the time to understand the concepts presented in this chapter will allow you to more easily work with advanced topics as well as troubleshoot further plug-ins you may create.

Programming a Dependency Node

BY THE END OF THIS CHAPTER, YOU WILL BE ABLE TO:

- Describe the functional requirements of a dependency node.

- Create your own custom dependency nodes.

- Describe the key properties of node attributes.

- Compare and contrast array plugs and plug arrays.

- Distinguish logical and physical indices.

- Compare and contrast simple and compound attributes.

You now have a deep understanding of Python, Maya, and the Maya API. You are nearly fully equipped to extend Maya using all of its major affordances. One of the few remaining topics worth discussing is how to program your own dependency nodes.

Because we discussed a lot of the high-level mechanics of Maya's DG in Chapter 11, you have already been introduced to some of the functional requirements of custom dependency nodes. In this chapter, we provide an overview of custom node plug-ins to enable you to develop your own building blocks for Maya's DG using Python. In this chapter, we explore a plug-in from the companion web site that contains four simple nodes to discuss the basic parts of node plug-ins, as well as how to work with plug arrays, array plugs, and compound plugs.

ANATOMY OF A SCRIPTED NODE

Just like command plug-ins, node plug-ins all share some common features. In fact, the structure of a node plug-in parallels that of a command plug-in in some important ways. For the remainder of this chapter, we will be referring to the AR_AverageNodes.py example, which you can locate on the companion web site. This plug-in contains four different nodes for averaging numbers, each represented by a different class. In this section, we examine the structure of the simplest of these classes, **AR_AverageDoublesNode**, as well as the structure of the plug-in module itself.

The ar_averageDoubles Node

Before diving right into code, you should load the example plug-in and briefly survey the first node we are going to discuss, **ar_averageDoubles**. This node has two decimal number input attributes and a single decimal number output attribute, which is the arithmetic mean of the two inputs.

1. Download the AR_AverageNodes.py module from the companion web site and save it to a location in your Maya plug-in path. (Review the "Loading Scripted Plug-ins" section in Chapter 10 if you need help finding an appropriate folder for your operating system.)
2. Use the Plug-in Manager (**Window → Settings/Preferences → Plug-in Manager**) to load the AR_AverageNodes.py plug-in and click the information button next to its entry in the Plug-in Manager to see the contents of the plug-in. In the Plug-in Features section of the dialog that appears, you should see a list of four dependency nodes. Note that any single plug-in can contain any number of commands or dependency nodes.

3. Execute the following lines of code to create three spheres called highres, lowres, and midres.

```
import maya.cmds as cmds;
sphereHigh = cmds.polySphere(name='highres', sa=20, sh=20);
cmds.setAttr('%s.tx'%sphereHigh[0], 3);
sphereLow = cmds.polySphere(name='lowres', sa=8, sh=8);
cmds.setAttr('%s.tx'%sphereLow[0], -3);
sphereMid = cmds.polySphere(name='midres');
```

4. Execute the following lines of code to create two **ar_averageDoubles** nodes that compute the average axis and height subdivision attributes of the highres and lowres spheres and pipe the result into the midres sphere.

```
avgAxes = cmds.createNode('ar_averageDoubles');
cmds.connectAttr(
    '%s.sa'%sphereHigh[1],
    '%s.input1'%avgAxes
);
cmds.connectAttr(
    '%s.sa'%sphereLow[1],
    '%s.input2'%avgAxes
);
cmds.connectAttr(
    '%s.output'%avgAxes,
    '%s.sa'%sphereMid[1]
);
avgHgt = cmds.createNode('ar_averageDoubles');
cmds.connectAttr(
    '%s.sh'%sphereHigh[1],
    '%s.input1'%avgHgt
);
cmds.connectAttr(
    '%s.sh'%sphereLow[1],
    '%s.input2'%avgHgt
);
cmds.connectAttr(
    '%s.output'%avgHgt,
    '%s.sh'%sphereMid[1]
);
```

At this point, you can adjust the subdivision attributes (**subdivisionsAxis** and **subdivisionsHeight**) of the two outer spheres (highres and lowres) and the corresponding subdivision values of the middle sphere (midres) will interactively update to be the arithmetic mean of the two extremes. Note that the **ar_averageDoubles** node automatically works with the subdivision attributes even though they are long integers rather than doubles. Maya can handle simple numeric conversions like this one automatically.

Node Class Definition

At this point, you can open up the plug-in module and we can discuss its contents. First, examine the definition of the **AR_AverageDoublesNode** class. Similar to the command examples we covered in Chapter 10, the node classes in this example all contain some class attributes and inherit from an API class. As we noted in Chapter 11, custom nodes inherit from **MPxNode**.

```
class AR_AverageDoublesNode(ommpx.MPxNode):
    # ...
```

The first two items, **kPluginNodeTypeName** and **kPluginNodeId**, are used to uniquely identify the node represented by this class in Maya.

```
kPluginNodeTypeName = 'ar_averageDoubles';
kPluginNodeId = om.MTypeId(0x00033333);
```

As you may have guessed, the former is the type name of the node in Maya, which you passed to the createNode command in the previous exercise (and that also appeared in the Plug-in Manager information dialog). The latter, however, is an object of type **MTypeId**.

While custom commands must simply have a unique name, custom nodes must have both a unique name and a unique identifying integer, which is stored in an **MTypeId** object. When Maya loads a scene from disk, it needs a mechanism to reconstruct the data in the scene (nodes, attribute values, and connections). Although Maya ASCII (.ma) files store a set of MEL commands, and thus require only the name of the node, Maya binary (.mb) files store nodes by **MTypeId** only. If a node's name and **MTypeId** are not unique, Maya could easily have problems loading a scene if it expects the node to have certain attributes that do not exist.

Consequently, plug-in developers must ensure their custom nodes have truly unique type identifiers. If another plug-in developer assigned the same identifier as you, there would be conflicts when loading scenes based on which plug-in happened to be loaded. To solve this problem, Autodesk will distribute a range of 256 values to developers upon request. You can contact the Autodesk Developer Center online to request a range of node identifiers, which you should do right away to avoid problems!

As you see here, we have passed the **MTypeId** constructor one unsigned, 32-bit integer argument (which we specify as hexadecimal). Autodesk reserves the range of identifiers from 0x00000000 to 0x0007FFFF for internal development purposes, so you can assign one of these identifiers to a node you are testing, though you should replace it with a globally unique value before you deploy your plug-in to the wide world. Because our

example is somewhat contrived for learning purposes only, we have used identifiers in this reserved range.

The remaining class attributes defined prior to the **__init__**() method are all used for attribute definitions. Similar to flags on commands, attributes for nodes have both long and short names.

```
input1Attr = None;
kInput1AttrName = 'in1';
kInput1AttrLongName = 'input1';
input2Attr = None;
kInput2AttrName = 'in2';
kInput2AttrLongName = 'input2';
output = None;
kOutputAttrName = 'out';
kOutputAttrLongName = 'output';
```

Each attribute itself is initialized to a value of None, but will eventually point to an **MObject** when the node is initialized in Maya, as we will see soon. Assigning a default value of None effectively lets us declare the class attributes without making an unnecessary assignment. Similar to the situation we discussed in Chapter 10 for a custom command's data attributes, this declaration lets our IDE recognize these names as class attributes. Recall also in Chapter 11 that we distinguished attributes from plugs, whereby attributes are merely definitions for the node's data. It is for this reason that the node's attributes are defined as class attributes rather than as instance attributes. The attribute definitions will be shared by all instances of these nodes.

Finally, the **__init__**() method simply calls **__init__**() on the base class, **MPxNode**.

```
def __init__(self):
    ommpx.MPxNode.__init__(self);
```

Just as was the case with commands, nodes inherit from a proxy class. **MPxNode** is the base class for all custom nodes, but special types of nodes may inherit functionality from a subclass, such as **MPxLocatorNode** or **MPxDeformerNode**. Any time you develop one of these special types of nodes, it is a good idea to consult the documentation so that you know what methods you need to override, and what the state of the node's data are by the time your override methods are called.[1] **MPxNode** itself contains many useful methods worth reviewing.

[1]For example, custom deformer nodes inherit some basic attributes and override the **deform**() method instead of the **compute**() method. For a class derived from **MPxDeformerNode**, **compute**() gets the input geometry, creates an iterator, and calls **deform**().

Node Creator

Just like custom commands, custom nodes all require a creator class method. The primary job of this method is to return the node as a pointer to a proxy object. Refer to the "Command Creator" section in Chapter 10 for a refresher on why this transfer of ownership is important for Python in Maya.

```
@classmethod
def nodeCreator(cls):
    return ommpx.asMPxPtr(cls());
```

Node Initializer

The node initializer is a class method that is called when the plug-in node is first loaded in Maya. It may have any name, as you will pass a pointer to it when the plug-in is initialized, much like the node creator method. The primary task of the node initializer method is to create and configure attributes. Although the class already contains names for the node's attributes as class attributes, the **MObject** for each attribute needs to be configured to link up the attribute's names, data type, relationships with other attributes, and so on.

```
@classmethod
def nodeInitializer(cls):
    nAttr = om.MFnNumericAttribute();
    cls.input1Attr = nAttr.create(
        cls.kInput1AttrLongName,
        cls.kInput1AttrName,
        om.MFnNumericData.kDouble
    );
    nAttr.setKeyable(True);
    cls.input2Attr = nAttr.create(
        cls.kInput2AttrLongName,
        cls.kInput2AttrName,
        om.MFnNumericData.kDouble
    );
    nAttr.setKeyable(True);
    cls.outputAttr = nAttr.create(
        cls.kOutputAttrLongName,
        cls.kOutputAttrName,
        om.MFnNumericData.kDouble
    );
    nAttr.setWritable(False);
    nAttr.setStorable(False);
```

The first part of this node's initializer method simply creates each attribute, specifying the attribute's long name, short name, and data type. The function set for the new attribute then specifies some properties for each attribute before creating the next one.

Although we will talk about these properties momentarily, the important point is that you will use some class that inherits from **MFnAttribute** to create your attributes and establish their properties. In this case, because both our input attributes and the output attribute are simply double values, we use an **MFnNumericAttribute** object. Note that like many function sets in the API, the **create()** method not only returns the new **MObject**, but also automatically sets the new **MObject** as the function set's target object.

compute()

As we discussed in Chapter 11, the **compute()** method is the brains of any dependency node. It is called when data are requested for a particular plug, and its job is to ensure that the data for the plug are up-to-date.

As you can see in the **AR_AverageDoublesNode** class (or in the API documentation for the **MPxNode** class), the **compute()** method is passed a plug and the node's data block.

```
def compute(self, plug, dataBlock):
    if (plug == AR_AverageDoublesNode.outputAttr):
        # ...
    else: return om.kUnknownParameter;
```

The `plug` argument is the particular **MPlug** for which data have been requested (e.g., by another node, a `getAttr` command, or one of the other various mechanisms we discussed in Chapter 11). Consequently, the first thing most **compute()** methods will do is route execution based on which plug is requested. You can accomplish this task by using the equivalence operator (**==**), which—as you can see in the API documentation—the **MPlug** class has overridden to allow for comparisons with an **MObject** representing a node attribute.

If the plug for which data are requested is one that the node does not handle, then **compute()** must return a value of **kUnknownParameter**. For example, a custom node will inherit a variety of basic attributes, such as **message**, **caching**, and so on. Returning **kUnknownParameter** in this case signals to Maya that it should attempt to evaluate data for the plug using the base class implementation.

We can look now at what happens if the plug for which data are requested is the output attribute.

```
dataHandle = om.MDataHandle(
    dataBlock.inputValue(
        AR_AverageDoublesNode.input1Attr
    )
);
```

```
input1 = dataHandle.asDouble();
dataHandle = om.MDataHandle(
    dataBlock.inputValue(
        AR_AverageDoublesNode.input2Attr
    )
);
input2 = dataHandle.asDouble();
```

The first step for computing the output attribute is to retrieve the values of the input attributes. We accomplish this task by calling the **inputValue()** method on dataBlock and passing it the **MObject** for the attribute in question to retrieve an **MDataHandle**. We have wrapped this return value in an **MDataHandle** constructor only because it allows us to get proper code completion in an IDE for the dataHandle object. We can then call the **asDouble()** method on the input data handles to retrieve the actual data as decimal numbers, which we can use to compute the output value.

```
output = (input1+input2)*0.5;
dataHandle = om.MDataHandle(
    dataBlock.outputValue(
        AR_AverageDoublesNode.outputAttr
    )
);
dataHandle.setDouble(output);
dataBlock.setClean(plug);
```

When setting the output value, we call the **outputValue()** method on dataBlock to construct an **MDataHandle**. Once we have this data handle, we use it to set the outgoing value and then finally indicate that the outgoing plug is clean. Subsequent requests for this plug's value can then rely on this value to minimize redundant DG calculations.

Best Practices

Strictly speaking, there are few restrictions on what API classes and methods you may use in the **compute()** method for custom nodes. Nevertheless, there are some practices to which you should adhere to maximize computational efficiency and stability in accord with Maya's data flow model.

First, you should always (only) use the **MDataBlock** object associated with the node to get and set any values required for computation. Trying to retrieve data from outside the data block may trigger unnecessary DG computation, or result in an infinite loop. For example, some API classes allow you to invoke MEL commands. Invoking getAttr or setAttr from inside a node's **compute()** method will cause serious problems if they (directly or indirectly) trigger computation of the very plug being computed!

Related to this first point, you should always treat your node as a black box, and never make any assumptions about other nodes in the scene. Attempting to traverse the DG and get data from other nodes can be extremely dangerous or unpredictable. Remember that altering the DG outside of a node may trigger an endless computation cycle. Nodes in Maya are intended to serve as individual building blocks, and it is best if you treat them as such.

It is also important to contrast the **inputValue()** and **outputValue()** methods in the **MDataBlock** class. As you saw in the example we just investigated, we used the former method to get input attribute values, and the latter to set the computed output value. While each of these methods returns an **MDataHandle** object, the former is read-only, while the latter allows you to write a new value.

Furthermore, the **inputValue()** method is always guaranteed to be up-to-date. Consequently, if getting a data handle for a dirty connection, it will automatically trigger necessary DG updates to ensure its data are fresh. If the plug is not connected, the value stored in the data block is returned. If there is no value in the data block for the plug, then the default value is returned.

Although the importance of this process will be clearer later in this chapter where we discuss attributes and plugs in greater detail, there may be some cases where getting a data handle using **inputValue()** may trigger a good deal of unnecessary computation. When manipulating mesh data, for instance, it can be faster to copy the input data to the output plug, and then use **outputValue()** when creating data handles, as this method will not trigger DG updates.[2]

Initialization and Uninitialization

Initialization and uninitialization proceed in a very similar way to the command plug-in examples we examined in Chapter 10. In this particular plug-in, we register four nodes, though we only print the first registration here.

```
def initializePlugin(obj):
    plugin = ommpx.MFnPlugin(
        obj,
        'Adam Mechtley & Ryan Trowbridge',
        '1.0', 'Any'
    );
```

[2]Related to note 1, the **compute()** method in a node derived from **MPxDeformerNode** will automatically copy the input data into the outputGeom plug's space in the data block. Consequently, when retrieving the input geometry from the data block inside of **deform()**, calling **outputValue()** on the data block will not trigger a dirty propagation and repeat retrieval of already fresh data. See the **MPxDeformerNode** documentation for more information.

```
try:
    plugin.registerNode(
        AR_AverageDoublesNode.kPluginNodeTypeName,
        AR_AverageDoublesNode.kPluginNodeId,
        AR_AverageDoublesNode.nodeCreator,
        AR_AverageDoublesNode.nodeInitializer
    );
except:
    raise Exception(
        'Failed to register node: %s'%
        AR_AverageDoublesNode.kPluginNodeTypeName
    );
```

Any plug-in may register any number of nodes and/or commands. As you can see here, registering a node requires that you pass its unique name, unique identifier, a pointer to its creator method, and a pointer to its initializer method.

Similarly, uninitialization proceeds similar to that for commands, and requires only that you pass the node's unique identifier for deregistration.

```
def uninitializePlugin(obj):
    plugin = ommpx.MFnPlugin(obj);
    try:
        plugin.deregisterNode(
            AR_AverageDoublesNode.kPluginNodeId
        );
    except:
        raise Exception(
            'Failed to unregister node: %s'%
            AR_AverageDoublesNode.kPluginNodeTypeName
        );
```

ATTRIBUTES AND PLUGS

As we discussed in Chapter 11, attributes effectively define templates for data that a node will pass into or out of its **compute()** method. Attributes are created and modified in the node initializer method using a descendant class of **MFnAttribute**.

The particular class you use for attribute creation depends on the data type the attribute defines. For example, as you saw in the **ar_averageDoubles** node, we used the **MFnNumericAttribute** class to define attributes with simple numeric data. Another class, **MFnEnumAttribute**, allows you to create enumerated attributes with field names, and the **MFnUnitAttribute** class allows you to create special numerical types that are affected by

unit settings, such as angle (degrees or radians) and distance (mm, cm, m, etc.) values.[3]

However, the data type of an attribute is only part of its definition, and hence part of the reason that more complex structures are needed to store attribute properties. In the remainder of this section, we discuss some further properties of attributes, their default values, and some special kinds of attributes.

Attribute Properties

In Chapter 11 we mentioned that while we conventionally refer to certain attributes as outputs and others as inputs, the Maya API does not make such a simple distinction. Rather, attributes have a variety of properties that determine their behavior, all of which can be set using **MFnAttribute** or a descendent class. While these properties are documented in the **MFnAttribute** API documentation, we have summarized some of them in Table 12.1.

Readable, Writable, and Connectable

Readability, writability, and connectability are three of the most common properties you may manipulate. Note that by default all of these properties are enabled. Consequently, a plug may be both a source and a destination (an output and an input) in the DG by default. To make a plug behave strictly like an input, you can disable readability (which ensures it will never trigger a **compute()** method). To make a plug behave strictly like an output, disable writability.

Storable Attributes and Default Values

If an attribute is storable, then its data are saved with a file in which it exists. Although this property improves loading performance, it comes with obvious disk space overhead. Attributes that you configure to operate as "outputs" should not be generally storable, as you can rely on their nodes' **compute()** methods to properly reconstruct output data when a scene is loaded.

[3]Recall in Chapter 1 when we used the `help` command in conjunction with some basic commands that some arguments were listed as type Length rather than float. Likewise, using the `getAttr` command with the `type` flag reveals that some attributes have type doubleLinear rather than simply double. Such attributes are unit attributes. If you create a node that semantically is outputting unit-dependent values (e.g., time, distance, or angles), then it is advisable that you use a unit attribute rather than simply doubles, as you cannot make assumptions about what unit settings may be in use. Maya automatically creates a **unitConversion** node between unit and nonunit plug-ins as needed.

Table 12.1 Common Attribute Properties

Property	Default	Description
Readable	True	Can be used as a source in a DG connection
Writable	True	Can be used as a destination in a DG connection Can be changed with `setAttr`
Connectable	True	Can be used on a DG connection
Storable	True	Attribute data written to file when saved
Cached	True	Attribute data are cached in data block rather than retrieved from DG traversal
Array	False	Attribute can accept multiple incoming connections
IndexMatters	True	If attribute is array, user must explicitly specify index when making connections
Keyable	False	Can be keyframed using AutoKey and Set Keyframe UI If also writable, then will display in Channel Box
ChannelBox	False	Allows nonkeyable (writable) attributes to appear in Channel Box
Hidden	False	Attribute is hidden from the UI
UsedAsColor	False	Attribute should use color picker in UI Use with **MFnNumericAttribute::createColor()**
Indeterminant	False	Attribute may or may not be used during an evaluation
RenderSource	False	Can be used as a render source
UsedAsFileName	False	Attribute displays as file selector in UI
AffectsAppearance	False	Affects the appearance of the object in the viewport
DisconnectBehavior	kNothing	Determines what happens when the plug is disconnected
UsesArrayDataBuilder	False	Attribute's data can be generated with **MArrayDataBuilder**
Internal	False	Triggers callbacks for **MPxNode::setInternalValueInContext()** and **MPxNode::getInternalValueInContext()** Attribute data can be stored in instance variables instead of data block if so desired
NiceNameOverride	None	Override display name for attribute in UI

Another affordance for node attributes that affects data storage is support for default attribute values. The **create()** methods for many different attribute function sets allow you to pass an optional default value. Although we did not make use of it in the **ar_averageDoubles** node, our attributes all had an implicit default value of 0. The importance of a default attribute value is that any particular plug associated with this attribute is assumed to have this value if, for example, the plug has not triggered the creation of a data block to store some other value.

Consequently, if a node is created and the value for a plug has not been changed (such that it still has the default value), Maya does not save this value in the scene file, but rather saves that the plug still has the default attribute value. If you were to later change the default attribute value, redeploy the plug-in, and then reopen a scene that contains nodes with default attribute

values, they will have the new default value. As such, it is important that you plan ahead to ensure that your custom nodes' attributes have sensible default values as needed, and that they are not likely to change in the future. We will show one example of using default values later in this chapter.

Cached Attributes

Recall that when examining the **compute**() method of the **ar_averageDoubles** node, we pointed out that the **inputValue**() method for **MDataBlock** objects has a specific order of data retrieval to ensure it will always return fresh data. While default values impact this process, caching does as well.

An attribute that is cached will store a copy of its data in the data block. Caching offers a speed improvement by minimizing the need for DG traversal, but comes at the cost of memory. While caching is fine for many simple numeric types, you may not want to cache large chunks of data, such as geometry. It is worth reiterating that if you do not cache some particular attribute, you will want to design your node in such a way as to minimize its retrieval of needed data as much as possible.

Working with Arrays

As you saw in Table 12.1, some attribute properties are related to working with arrays. Because arrays have a few quirks that may not be immediately obvious, they merit some focused discussion. Although the latest API documentation contains a chapter that clarifies the distinction (**Developer Resources → API Guide → Dependency graph plug-ins → Complex Attributes**), it is worth noting that Maya has support for what are called array plugs and plug arrays.

While an array plug is simply an ordinary plug corresponding to some array data type (e.g., **kDoubleArray**, **kVectorArray**, etc.), a plug array is a somewhat more complex structure. By passing a value of True to the **setArray**() method for an **MFnAttribute** function set, you can convert any type of plug into an array of plugs. Why bother with array plugs then?

Array plugs and plug arrays fundamentally serve different purposes. Some attributes inherently have an array type. For instance, a particle emitter has attributes for getting information about all of its particles. Using array plugs for such attributes is much more efficient, as the data are contained in a single structure and are contiguous therein. Consequently, a whole array of such data can be sent or received on a single plug. On the other hand, a plug array allows you to handle an arbitrary number of items with arbitrary, sparse indices in the data structure, where each item is given a separate element

plug. Apart from not being well suited to large-scale data movement, plug arrays come with a few added complications.

Logical and Physical Indices

Basic array types, such as **MDoubleArray** or **MVectorArray**, are contiguous, meaning they have no null elements. For example, if you have an **MDoubleArray** with five items (indices 0–4), and you use the **insert()** method to insert a new value at index 4, the array's length is increased, and the item currently at index 4 is simply shifted over to the new index (5). Likewise, if you were to remove element 2 using the **remove()** method, then item 3 would be shifted into index 2 and likewise to the end of the array, after which the length would be reduced by one.

Plug arrays, on the other hand, are sparse. You could make a connection to index 0 on a plug array and a connection to index 2, after which the length of the plug array would be 2, but element 1 would be null.

Plug arrays manage sparse indices by distinguishing what are known as logical and physical indices. Logical indices in a plug array correspond to the actual underlying index of the plug element (0 and 2, in our hypothetical situation), and are not guaranteed to be contiguous. Physical indices, on the other hand, are a means for mapping contiguous indices to their corresponding logical indices. In our hypothetical example, the first item has both a logical and physical index of 0, but the second item has a physical index of 1 and a logical index of 2.

As you may imagine, this distinction makes iteration through a plug array not especially straightforward. For example, the **MArrayDataHandle** class, which you may use in conjunction with plug arrays, has a **jumpToElement()** method that jumps to a specified logical index. Simply looping from 0 to the length of the array and then jumping to the current iterator index may result in jumping to a null element, which raises an exception. We cover the most straightforward technique for working with plug arrays here.

Implementing Plug Arrays

The AR_AverageNodes.py plug-in contains a node, **ar_averageArrayDoubles**, which implements a single plug array input attribute. This node is a more flexible alternative to the **ar_averageDoubles** node, because it routes any number of decimal number inputs through a plug array as opposed to two individual plugs. Before we examine the implementation details in the source code, walk through the following quick example to see the node in action.

1. Create a new Maya scene and ensure that the AR_AverageNodes.py plug-in is loaded.
2. Execute the following lines to create a row of four cones with different heights, as well as a fifth cone in front of them.

```
import maya.cmds as cmds;
numCones = 4;
cones = [
    cmds.polyCone(height=i+1)
    for i in range(numCones)
];
for i in range(numCones):
    cmds.setAttr(
        '%s.tx'%cones[i][0],
        i*2-numCones+1
    );
avgCone = cmds.polyCone(name='avgCone');
cmds.setAttr('%s.tz'%avgCone[0], 2);
```

3. With the cones still in your scene, execute the following lines to create an **ar_averageArrayDoubles** node. The height attribute for each cone in the back row pipes into a separate array plug.

```
avg = cmds.createNode('ar_averageArrayDoubles');
for i in range(len(cones)):
    cmds.connectAttr(
        '%s.h'%cones[i][1],
        '%s.in'%avg, na=True
    );
cmds.connectAttr('%s.out'%avg, '%s.h'%avgCone[1]);
```

At this point, you can adjust the height of any of the cones in the back row and the height of the cone in front will automatically adjust to the new average height. Note also that we used the `na` (or `nextAvailable`) flag to automatically append each new connection to the next available array index. We'll see how we enabled this feature shortly.

4. Execute the following lines to print the connection for each cone's height attribute.

```
for c in cones:
    print(
        cmds.listConnections(
            '%s.h'%c[1],
            p=True,
            c=True
        )
    );
```

You should see the following output lines in the Script Editor's History Panel.

```
[u'polyCone1.height', u'ar_averageArrayDoubles1.
input[0]']
[u'polyCone2.height', u'ar_averageArrayDoubles1.
input[1]']
[u'polyCone3.height', u'ar_averageArrayDoubles1.
input[2]']
[u'polyCone4.height', u'ar_averageArrayDoubles1.
input[3]']
```

As you can see, each cone's **height** attribute is connected to an incremented array index for the **ar_averageArrayDoubles** node's input attribute.

5. Execute the following lines to add another cone to the scene, connect it to index 10 in the **ar_averageArrayDoubles** node, and print the new list of connections.

```
cones.append(cmds.polyCone(height=numCones));
cmds.setAttr('%s.tz'%cones[-1][0], -2);
cmds.connectAttr('%s.h'%cones[-1][1], '%s.in[10]'%avg);
for c in cones:
    print(
        cmds.listConnections(
            '%s.h'%c[1],
            p=True,
            c=True
        )
    );
```

The output is identical to that which you saw in the previous step, except that you now also see the new cone at the end of the list of connections. The node is still able to work even though indices 4–9 are skipped.

```
[u'polyCone1.height', u'ar_averageArrayDoubles1.
input[0]']
[u'polyCone2.height', u'ar_averageArrayDoubles1.
input[1]']
[u'polyCone3.height', u'ar_averageArrayDoubles1.
input[2]']
[u'polyCone4.height', u'ar_averageArrayDoubles1.
input[3]']
[u'polyCone6.height', u'ar_averageArrayDoubles1.
input[10]']
```

At this point, we can examine the **AR_AverageArrayDoublesNode** class in the AR_AverageNodes.py plug-in to discuss implementation details for

this node. The first contrast with the **AR_AverageDoublesNode** class is
that this node contains only a single input attribute in the class definition.

```
inputAttr = None;
kInputAttrName = 'in';
kInputAttrLongName = 'input';
```

If you jump down to the node initializer class method, you can see that this
attribute is created much like the input attributes for the first example node
that we created. The only difference is that some additional properties are
configured for the attribute.

```
nAttr = om.MFnNumericAttribute();
cls.inputAttr = nAttr.create(
    cls.kInputAttrLongName,
    cls.kInputAttrName,
    om.MFnNumericData.kDouble
);
nAttr.setKeyable(True);
nAttr.setArray(True);
nAttr.setReadable(False);
nAttr.setIndexMatters(False);
nAttr.setDisconnectBehavior(
    om.MFnNumericAttribute.kDelete
);
```

As you can see, the attribute is initially created as though it were an ordin-
ary double. Passing the **setArray()** method for the **MFnNumericAttribute**
object a value of True is the key requirement to make the plug behave as
an array.

In this example, we have also passed a value of False to the **setIndexMatters()**
method. This property ordinarily defaults to True for array plugs, and thus
normally requires that users manually specify an array index when making
a connection (thereby preventing use of the `nextAvailable` flag with the
`connectAttr` command). Because computation of an arithmetic mean is a
commutative operation, this node doesn't really care about the order of
connections. On the other hand, a node that performs a noncommutative
operation such as a matrix or quaternion multiplication would likely want to
force users to specify indices. Note also that we must set the attribute's read-
ability to False to use this property, and that disabling readability has the
unfortunate side effect of making the element plug values invisible in the
Attribute Editor.

Finally, we use the **setDisconnectBehavior()** method to specify that an ele-
ment should be deleted when its plug is disconnected. Doing so effectively
removes the disconnected index. If we did not specify this behavior in this

case, then disconnecting a node would retain a cached value in the data block when a plug element is disconnected, which would skew the output value.

If you examine the **compute()** method, the first difference you see compared to the previous node example is that we retrieve an **MArrayDataHandle** for the input attribute.[4]

```
arrayDataHandle = om.MArrayDataHandle(
    dataBlock.inputValue(
        AR_AverageArrayDoublesNode.inputAttr
    )
);
```

The **MArrayDataHandle** constructor copies an **MDataHandle** for a specified attribute, and it provides functionality for working with plug arrays. As we hinted earlier, because its **jumpToElement()** method works by logical index, we cannot simply iterate from 0 to **elementCount()** and jump around, as we would encounter a null element if the array is not continuous.

```
output = 0.0;
try: output = (arrayDataHandle.inputValue()).asDouble();
except: pass;
for i in range(arrayDataHandle.elementCount()-1):
    arrayDataHandle.next();
    output += (arrayDataHandle.inputValue()).asDouble();
try: output /= arrayDataHandle.elementCount();
except: pass;
```

We wrap the initialization of the output value (as well as the division by **elementCount()**) in a **try-except** clause, as the array may contain no elements when **compute()** is called. Otherwise, the data handle will automatically point to the first logical index. Inside the loop, the **next()** method simply moves to the next logical index, whatever it happens to be.

After this point, we simply set the output value exactly as we did in the **ar_averageDoubles** node. Although our example does not show it, you can use the **MArrayDataBuilder** class in conjunction with plug arrays if you need to construct an output value that is an array. Refer to the companion web site for more information on working with output plug arrays and the **MArrayDataBuiler** class.

[4]The API documentation for the **MPlug** class shows an iteration example for a plug array. We have included a corresponding implementation in the comments of the example file. Because the index operator for the **MPlug** class works by physical index, it is easier to iterate an input array. However, recall that working with an **MPlug** is much less efficient than working with an **MDataHandle**, as a plug performs internal validation for operations since it can do more than simply get and set data.

Implementing Array Plugs

In comparison to a plug array, working with array plugs is relatively straight-forward. You can find an example in the **AR_AverageDoubleArrayNode** class in the AR_AverageNodes.py plug-in. Walk through the following short example to create a particle system and an **ar_averageDoubleArray** node to acquire the average lifetime of the particles in the system after 24 frames.

1. Create a new Maya scene and ensure that the AR_AverageNodes.py plug-in is loaded.
2. Execute the following lines to create a basic particle emitter and link up its age attribute to the input plug of an **ar_averageDoubleArray** node.

```python
import maya.cmds as cmds;
emitter = cmds.emitter();
pShape = cmds.particle()[1];
cmds.connectDynamic(pShape, em=emitter);
avg = cmds.createNode('ar_averageDoubleArray');
cmds.connectAttr('%s.age'%pShape, '%s.input'%avg);
```

3. Execute the following lines to move through 24 frames and print the current average age. If your time unit is set to film (24 fps, frames per second) then you should see a printed result around half a second.

```python
for i in range(25): cmds.currentTime(i);
print(
    'Avg. age: %.2f seconds'%
    cmds.getAttr('%s.output'%avg)
);
```

Much like the **AR_AverageDoubleArrayNode** example, this node has only a single input attribute. However, in the node initializer method, we use an **MFnTypeAttribute** function set with a data type of **kDoubleArray** to define the attribute. This type corresponds to the **MDoubleArray** type in the API. Array attributes such as this one are used frequently in particle systems, as well as for weight lists.

```python
tAttr = om.MFnTypedAttribute();
cls.inputAttr = tAttr.create(
    cls.kInputAttrLongName,
    cls.kInputAttrName,
    om.MFnData.kDoubleArray
);
tAttr.setKeyable(True);
```

In the **compute()** method, we can use the **data()** method on the **MDataHandle** we create to initialize an **MFnDoubleArrayData** function set and get the

plug's value as an **MDoubleArray**. As in the **AR_AverageDoublesNode** class, we have wrapped return values in copy constructors only to ensure we will have functional autocompletion suggestions in our IDE.

```
dataHandle = om.MDataHandle(
    dataBlock.inputValue(
        AR_AverageDoubleArrayNode.inputAttr
    )
);
doubleArrayFn = om.MFnDoubleArrayData(dataHandle.data());
doubleArray = om.MDoubleArray(doubleArrayFn.array());
```

In contrast to a plug array, an array plug that corresponds to a data type such as **MDoubleArray** will be contiguous. As such, the iteration technique for computing the output value is much more straightforward than in the previous example. We still wrap the division operation in a **try-except** clause in case the array length is 0, in which case the output will simply be 0.

```
output = 0.0;
for i in range(doubleArray.length()):
    output += doubleArray[i];
try: output /= doubleArray.length();
except: pass;
```

Compound Attributes

The final remaining topic worth covering here is compound attributes. Compound attributes allow you to group an arbitrary set of attributes under a single parent attribute, and to manage connections on individual children or on the parent plug. The **AR_WeightedAverageVectorsNode** class in the AR_AverageNodes.py plug-in demonstrates implementation of compound attributes.

1. Create a new Maya scene and ensure that the AR_AverageNodes.py plug-in is loaded.
2. Execute the following lines to create three locators.

```
import maya.cmds as cmds;
loc1 = cmds.spaceLocator()[0];
cmds.setAttr('%s.translate'%loc1, 2, 1, 0);
loc2 = cmds.spaceLocator()[0];
cmds.setAttr('%s.translate'%loc2, -3, 0, 1);
loc3 = cmds.spaceLocator()[0];
```

3. With the locators still in your scene, execute the following lines to pipe the translation of the two outermost locators into an **ar_weightedAverageVectors** node and connect the output to the center locator.

```
avg = cmds.createNode('ar_weightedAverageVectors');
cmds.connectAttr(
    '%s.translate'%loc1,
    '%s.input1Vector'%avg
);
cmds.connectAttr(
    '%s.translate'%loc2,
    '%s.input2Vector'%avg
);
cmds.connectAttr(
    '%s.output'%avg,
    '%s.translate'%loc3
);
```

You can now move the two outer locators around and the center locator's position will be locked between them. Note that we only need to connect the translate plugs directly, and do not need to individually connect their *x*, *y*, and *z* plugs.

4. Execute the following lines to set keys on the weight attributes of the **ar_weightedAverageVectors** node.

```
cmds.setKeyframe(avg, at='in1W', t=1, v=1);
cmds.setKeyframe(avg, at='in2W', t=1, v=0);
cmds.setKeyframe(avg, at='in1W', t=24, v=0);
cmds.setKeyframe(avg, at='in2W', t=24, v=1);
```

If you scrub the time slider between frames 1 and 24, you can see the center locator move between the two targets.

5. Execute the following line to see all of the node's attributes.

```
for attr in cmds.listAttr(avg): print(attr);
```

The first few attributes printed are inherited from **MPxNode**, but you can also see the names for all of this node's specific attributes.

```
input1
input1Vector
input1Vector0
input1Vector1
input1Vector2
input1Weight
input2
input2Vector
input2Vector0
input2Vector1
input2Vector2
input2Weight
output
```

```
output0
output1
output2
```

If you inspect the **AR_WeightedAverageVectorsNode** class in the AR_AverageNodes.py plug-in, you can see various class attributes in the class definition. While the output attribute variables are identical to those in previous examples, there are more items for input attributes. First, there are suffixes for the node's child attributes, to be used with long and short attribute names.

```
kInputVecAttrSuffix = 'V';
kInputVecAttrLongSuffix = 'Vector';
kInputWgtAttrSuffix = 'W';
kInputWgtAttrLongSuffix = 'Weight';
```

Second, you can see that there are three attributes defined for each input. The first for each is the parent attribute, and the other two will be children of it.

```
input1Attr = None;
input1VecAttr = None;
input1WgtAttr = None;
# ...
input2Attr = None;
input2VecAttr = None;
input2WgtAttr = None;
```

If you jump down to the node initializer method, you can see how these attributes are created. Both inputs follow the same basic pattern, so we can look at just the first one here. The first step is to create each of the child attributes.

```
nAttr = om.MFnNumericAttribute();
cls.input1VecAttr = nAttr.create(
    cls.kInput1AttrLongName+cls.kInputVecAttrLongSuffix,
    cls.kInput1AttrName+cls.kInputVecAttrSuffix,
    om.MFnNumericData.k3Double
);
nAttr.setKeyable(True);
cls.input1WgtAttr = nAttr.create(
    cls.kInput1AttrLongName+cls.kInputWgtAttrLongSuffix,
    cls.kInput1AttrName+cls.kInputWgtAttrSuffix,
    om.MFnNumericData.kDouble,
    0.5
);
nAttr.setKeyable(True);
```

As you can see, the vector attribute will have names **input1Vector** and **in1V**, and the weight attribute will have names **input1Weight** and **in1W**, which should be familiar based on the previous example steps. Note that

we assign a default value of 0.5 to the weight attributes, such that each input contributes equal weight when the node is first created.

At this point, we use an **MFnCompoundAttribute** object to create a parent attribute named **input1** (or **in1**) and add the two numeric attributes to it as children.

```
cAttr = om.MFnCompoundAttribute();
cls.input1Attr = cAttr.create(
    cls.kInput1AttrLongName,
    cls.kInput1AttrName
);
cAttr.addChild(cls.input1VecAttr);
cAttr.addChild(cls.input1WgtAttr);
```

If you skip down to the bottom of the node initializer, you can see that we only need to add the parent attribute and establish a relationship between it and the output.

```
cls.addAttribute(cls.input1Attr);
cls.addAttribute(cls.input2Attr);
cls.addAttribute(cls.outputAttr);
cls.attributeAffects(cls.input1Attr, cls.outputAttr);
cls.attributeAffects(cls.input2Attr, cls.outputAttr);
```

While older versions of the API required that each child attribute be added separately, all versions of Maya that support Python will automatically add all children when a parent compound attribute is added. Note also that our sample node is somewhat simple, such that all inputs affect the output value. You can establish individual relationships between child attributes if you so desire.

You may have noticed that we only explicitly created two compound attributes: **input1** and **input2**. However, the list of attributes you printed for the node in the example contained further indexed child attributes for the input vectors and the output. Notice that these attributes are simply numeric attributes with a special type, **k3Double**, specified.

```
cls.input1VecAttr = nAttr.create(
    cls.kInput1AttrLongName+cls.kInputVecAttrLongSuffix,
    cls.kInput1AttrName+cls.kInputVecAttrSuffix,
    om.MFnNumericData.k3Double
);
# ...
cls.input2VecAttr = nAttr.create(
    cls.kInput2AttrLongName+cls.kInputVecAttrLongSuffix,
    cls.kInput2AttrName+cls.kInputVecAttrSuffix,
    om.MFnNumericData.k3Double
);
```

```
# ...
cls.outputAttr = nAttr.create(
    cls.kOutputAttrLongName,
    cls.kOutputAttrName,
    om.MFnNumericData.k3Double
);
```

Types such as **k3Double** are essentially built-in compound attributes for dealing with common data types, such as vectors and points. Using such types saves you the trouble of having to manually create children attributes, with the caveat that their names will simply be numerically indexed versions of the parent attribute's name.

We can now jump to the **compute()** method to see how we work with these attributes. Depending on what your node does, the plug test in the **compute()** method for compound output attributes may need to be more sophisticated than when dealing with an ordinary output attribute.[5] In the **AR_AverageVectorsNode** class, we have chosen to trigger computation if either the parent or its child plugs are requested, ensuring that all output values are handled at once.

```
if (plug == AR_AverageVectorsNode.outputAttr or
    (plug.isChild() and
    plug.parent()==AR_AverageVectorsNode.outputAttr)):
        # ...
```

Presuming that data are requested for the output attribute or one of its children, the data are acquired using ordinary **MDataHandle** objects. The calculation of the output value simply normalizes the two input weight values. Like a point constraint in Maya, we simply use default values in case of a division by zero.[6]

```
totalWeight = input1Weight+input2Weight;
if (abs(totalWeight) >
    abs(totalWeight)*sys.float_info.epsilon):
    output = (input1Vector*input1Weight +
        input2Vector*input2Weight) / totalWeight;
else: output = (input1Vector+input2Vector)*0.5;
```

[5]Note that output plug arrays may need more sophisticated techniques as well, such as testing **isElement()**. See the companion web site for more information.

[6]Note that Python compares floating-point numbers bit-by-bit. Consequently, simply using the equality logical operator (==) is inadvisable here. Note also that the **sys.float_info** attribute is new in Python 2.6. Consequently, accessing this attribute in Maya 2009 and earlier would normally throw an error. We account for this problem by manually adding an attribute with this name and an **epsilon** object to the **sys** module when it is first imported in this plug-in.

After computing the result, we can output its value much like the other example nodes that we have investigated. Handily, the built-in compound numeric types, such as **k3Double**, have corresponding **MDataHandle** methods to set the entire output value in a single API call.

```
dataHandle = om.MDataHandle(
    dataBlock.outputValue(
        AR_WeightedAverageVectorsNode.outputAttr
    )
);
dataHandle.set3Double(output.x, output.y, output.z);
```

CONCLUDING REMARKS

You are now equipped with enough of the basics to accomplish just about anything you need using Python in Maya. You can build simple tools, configure an advanced work environment, and also create custom plug-ins. In addition to containing some additional materials and more advanced API examples, the companion web site provides a portal for you to get the latest information and to help contribute to the community of knowledge surrounding Python in Maya. We hope you've found this text to be informative and helpful, and we look forward to hearing from you with questions, comments, and suggestions.

Index

Page numbers followed by f indicates a figure and t indicates a table